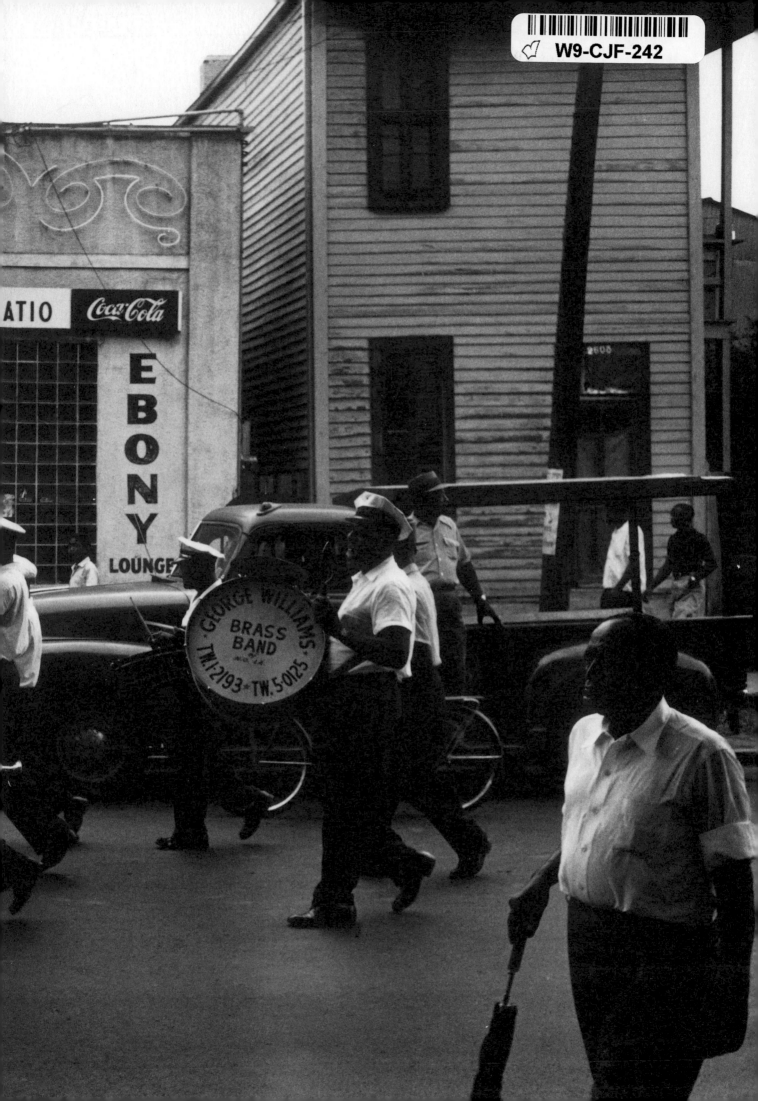

NEW ORLEANS

JAZZLIFE, 1960

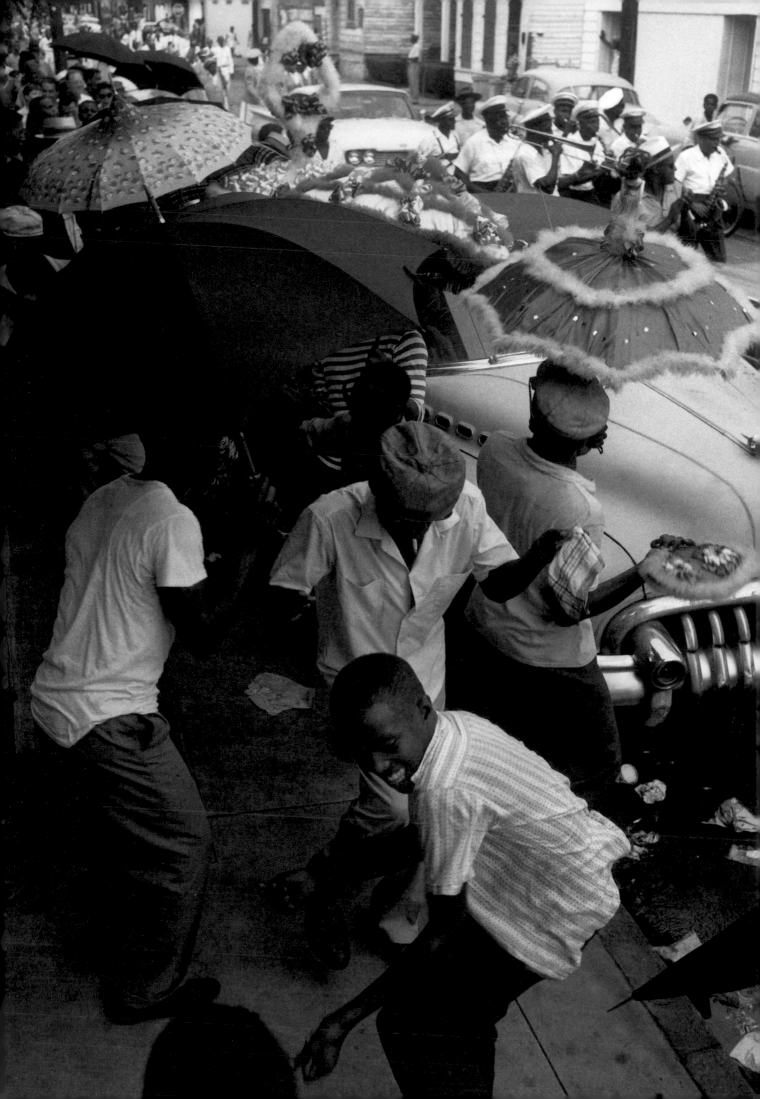

WILLIAM CLAXTON / JOACHIM E. BERENDT

NEW ORLEANS
JAZZLIFE, 1960

TASCHEN

HONGKONG KÖLN LONDON LOS ANGELES MADRID PARIS TOKYO

Page 2 A funeral procession turns into a joyous occasion and celebration for the dead with dancing in the streets.
Pages 6 – 7 Billboard as you approach New Orleans.
Pages 8 – 9 The Tuxedo Marching Band, New Orleans.
Pages 10 – 11 One of the many Creole dolls on display in the shop windows and on the streets of New Orleans. Most disappeared after the 1960s civil rights movement.

Page 2 La procession funéraire se transforme en hommage joyeux au mort, les gens dansant dans la rue derrière la grande fanfare.
Pages 6 – 7 Une affiche à l'entrée de la Nouvelle-Orléans.
Pages 8 – 9 Le Tuxedo Marching Band, Nouvelle-Orléans.
Pages 10 – 11 Une des nombreuses poupées créoles exhibées dans les vitrines et dans les rues de la Nouvelle-Orléans. La plupart ont disparu après le mouvement pour les droits civiques des années 1960.

Seite 2 Der Trauerzug wird zu einem fröhlichen Straßenfest für den Toten; die Trauergäste folgen tanzend der Musik einer großen Brassband.
Seiten 6 – 7 Werbetafel auf der Straße nach New Orleans.
Seiten 8 – 9 Die Tuxedo Marching Band, New Orleans.
Seiten 10 – 11 Eine der vielen kreolischen Puppen, die in den Schaufenstern und auf den Straßen von New Orleans zu sehen waren. Die meisten verschwanden mit der Bürgerrechtsbewegung in den 1960er Jahren.

CONTENTS

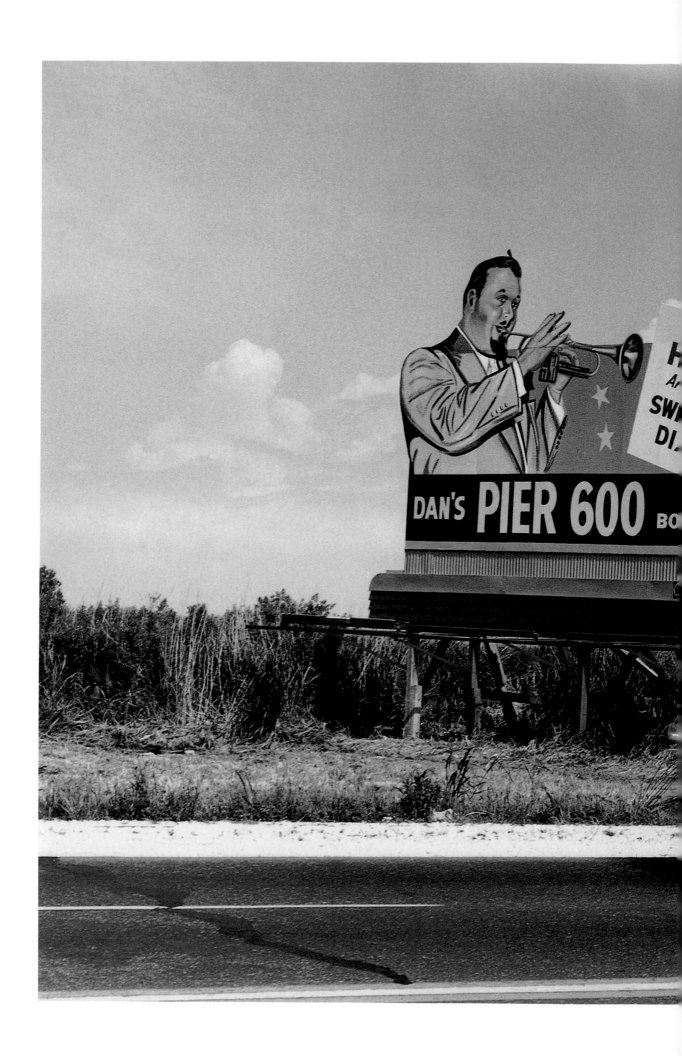

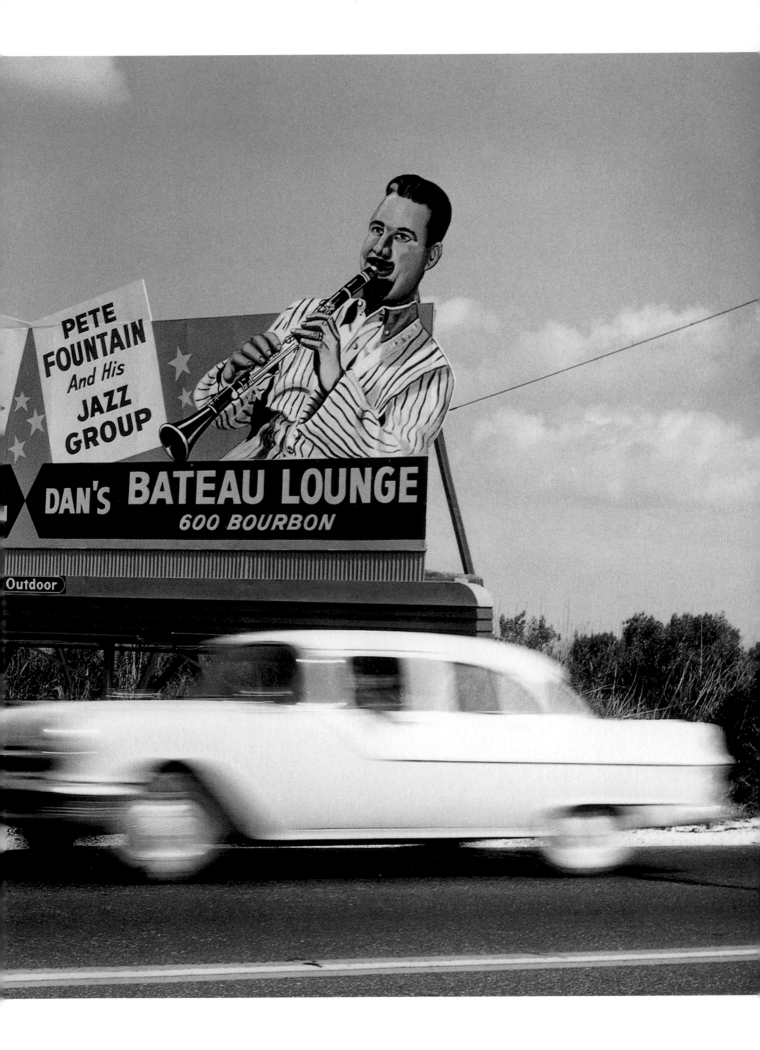

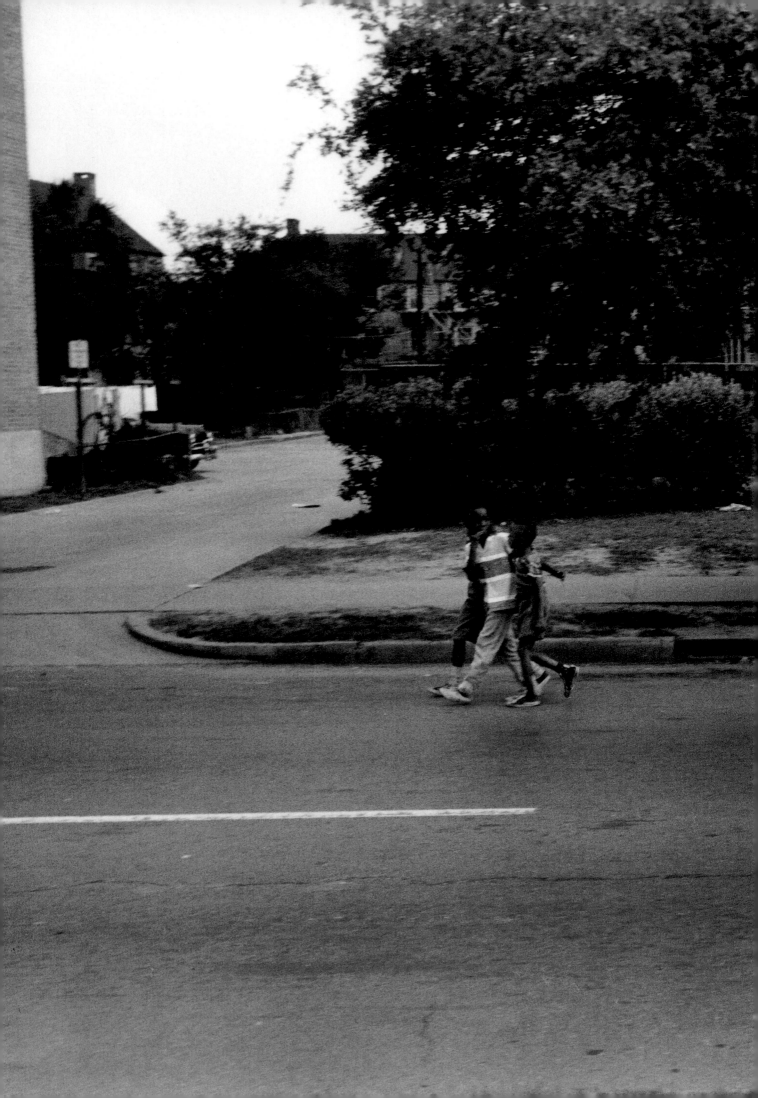

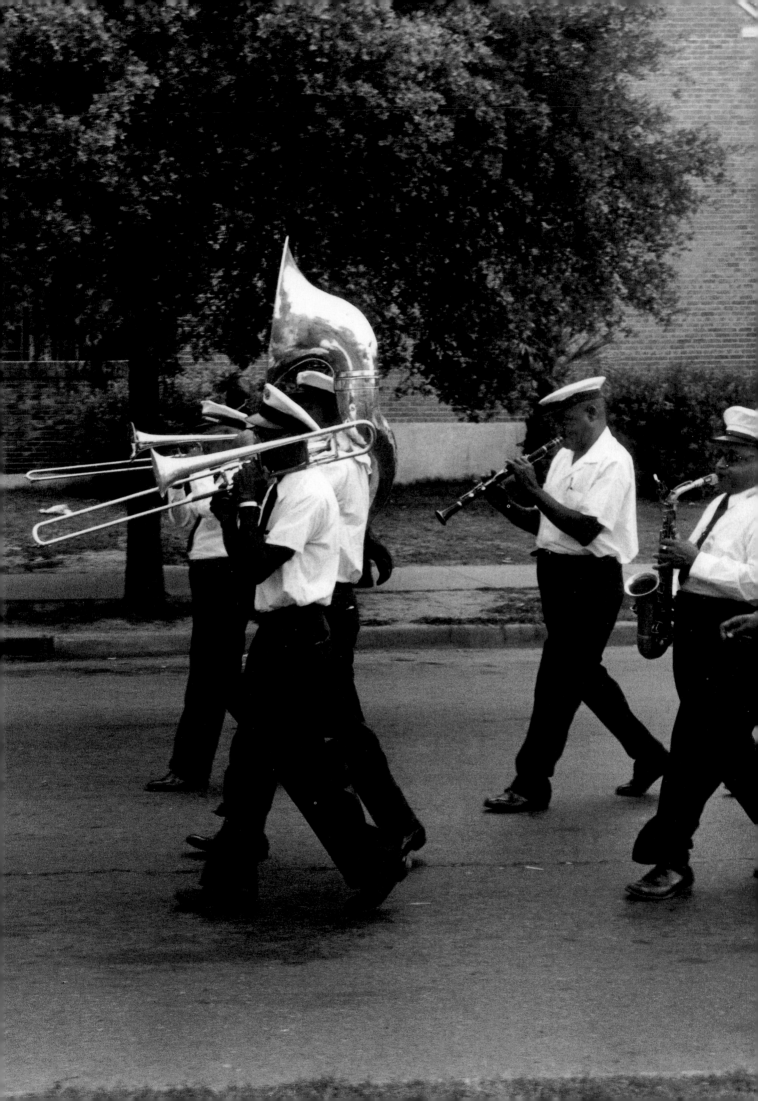

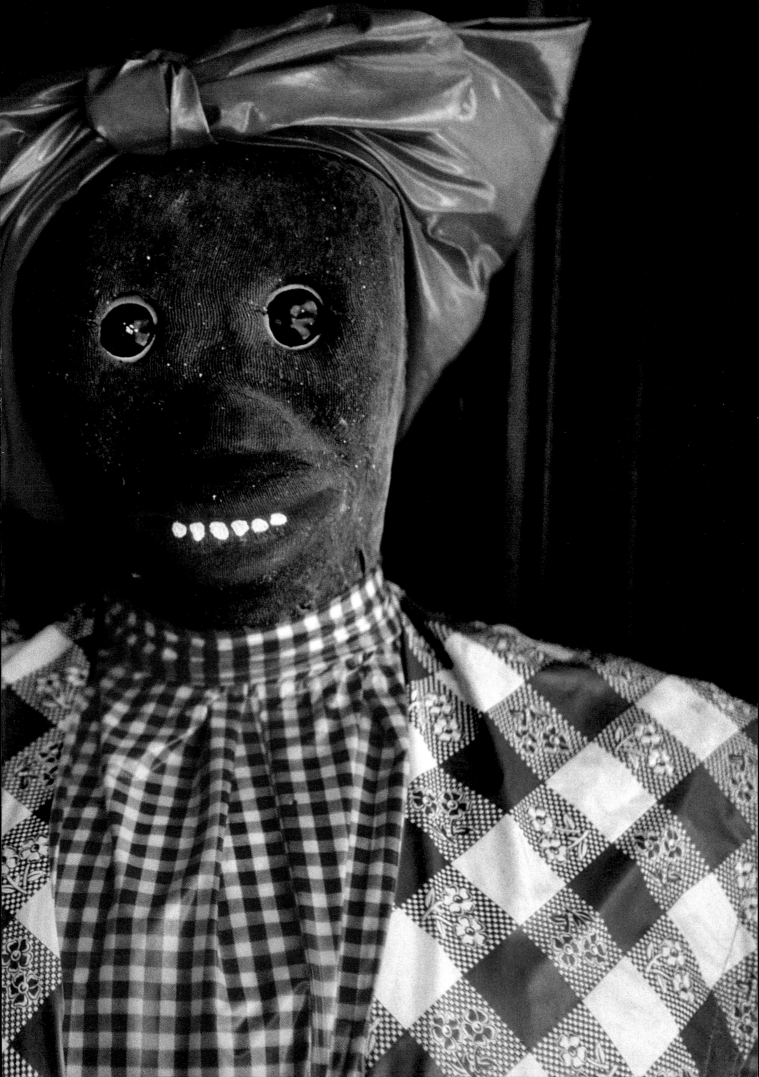

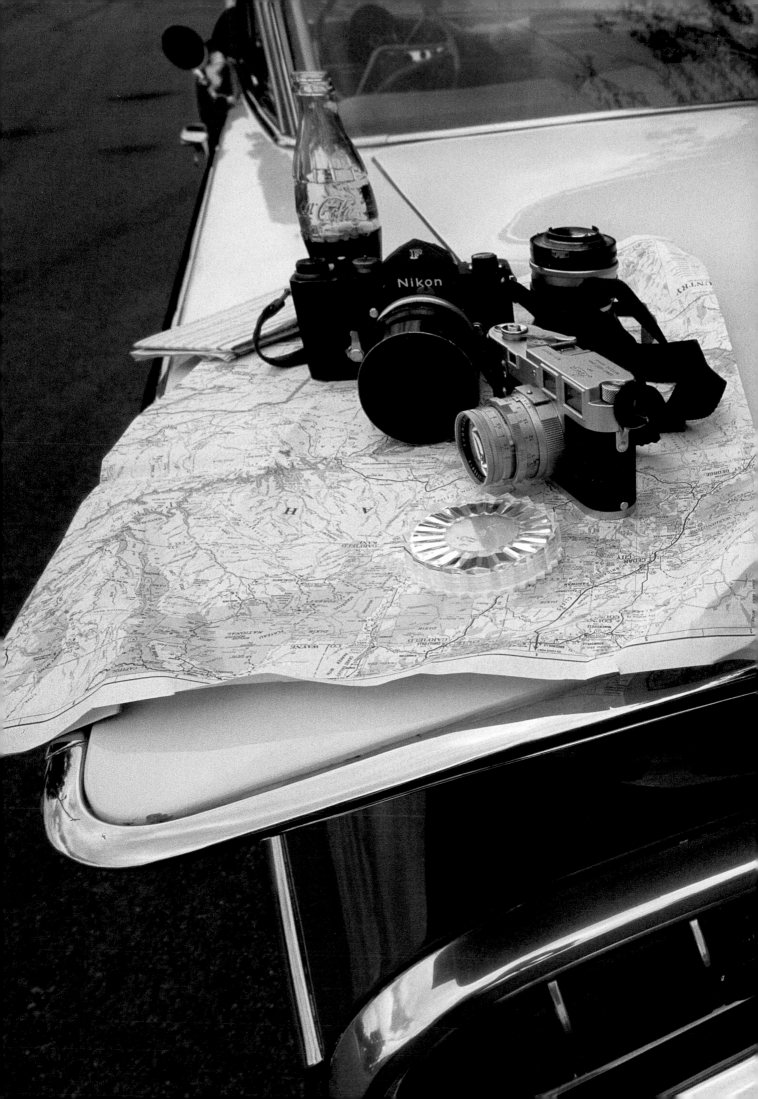

FOREWORD

William Claxton

Arriving in New Orleans, Louisiana, for the first time in May 1960 was like seeing the back lot of a large movie studio. With its motley assortment of architecture, stone and brick-paved streets, one could be in Paris, Madrid or Boston. New Orleans's boulevards were lined with Grecian, white-columned mansions and trees dripping with moss. The streets were covered by exotic magnolia trees. When you entered the French Quarter, in this land of Mardi Gras, you were surrounded by Victorian style architecture—red brick and carved timber with decorative iron filigree and latticework. In the suburbs you passed by rows of identical brick and wood-framed houses in street after street of tract homes built after the Second World War. Then before you knew it, you were surrounded by tar paper and falling-down wooden shacks, occupied mostly by the descendants of the African slaves. This was where the poor dwelled. Only the Creoles, who had earned their freedom during the slave years and intermarried most often with the French-Canadian settlers, lived an upper-middle class life and formed exclusive clubs, lodges and other social organizations.

New Orleans spreads itself across the apex of a great geographic delta interrupted by the many snake-like bends of the mighty Mississippi River. Amid this unique semi-tropical setting is a melting pot of many cultures, whose cuisine, religions (mainly Catholic and Baptist), arts and entertainments are as varied as the settlers living there. Socially its denizens are a genteel and polite people with a charming, friendly manner known as "Southern hospitality." Its music, like its eclectic Southern cuisine, reflects the European and African backgrounds of its inhabitants. The French and English brought stringed instruments and woodwinds, the Germans brought their brass instruments, and the Africans brought their heart beat with drums and their unique jungle rhythms. These instruments, beats and rhythms all came together from both black and white musicians to form what we now call jazz. This is why I had come to this wonderful place called New Orleans in the first place: to photograph the jazz scene.

Early in October of 1959 I received a telephone call from Germany. The person introduced himself as Joachim-Ernst Berendt, a musicologist living in Baden-Baden. In very good English, he explained that he was coming to America to do a study of "America's great art—jazz." He went on to say that he needed a photographer to work with him—a photographer who liked and understood jazz. There would be interviews with musicians, photographs of the players and the various places where one hears jazz, and a look at the origins of jazz as well as the art itself. He made it all sound a bit erudite, but it seemed like a very important project, and I was thrilled by his offer. The chance to photograph many of my jazz heroes, in addition to the many unknown and yet-to-be-discovered jazz musicians all around America, was too tempting to resist. Yes, I replied, I would very much like to do it.

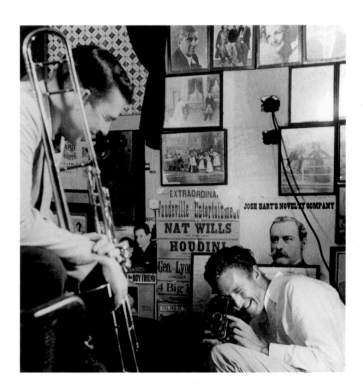

Opposite Our rented 1959 Chevrolet Impala with my photography equipment, a Nikon F camera and a Leica M3 camera with assorted lenses.
Above Photographing Bob Brookmeyer in Hollywood, California.

Ci-contre Notre Chevrolet Impala 1959 de location avec mon matériel photographique, un Nikon F et un Leica M3, plus un assortiment d'objectifs.
Ci-dessus Moi en train de photographier Bob Brookmeyer à Hollywood.

Gegenüber Unser gemieteter Chevrolet Impala, Baujahr 1959, mit meiner Fotoausrüstung, einer Nikon F und einer Leica M3 mit verschiedenen Objektiven.
Oben Beim Fotografieren von Bob Brookmeyer, Hollywood.

I shall refer to Joachim-Ernst Berendt as "Joe" from now on. Joe and I planned to meet at Idyllwild Airport (it wasn't named JFK yet) in April in New York on the day he arrived from Frankfurt, Germany. We checked into the Hotel Alwyn, on West 58th Street and Seventh Avenue. The place was slightly rundown (and wanted cash upfront) and was a notorious hangout for junkies. Joe remarked, "Isn't it a wonderful place? Musicians hang out here. That's good, no?"

After several days of recording and photographing the jazz scene, we set out in our rented 1959 Chevrolet Impala. You remember the model—it had giant tail fins bent over to a flat position and big fish-like tail lights, and somehow the rental agent had managed to leave a cardboard license cover over the official plate that read "See the U. S. A. in Your Chevrolet"— how appropriate!

Joe's plan for our jazz odyssey was to start in Manhattan; cover Philadelphia and Washington, D. C.; drive down the Eastern seaboard states and over to New Orleans and Biloxi; go up the

Mississippi to Memphis; then move on to Chicago, St. Louis, Detroit and Kansas City. After that we would head west to Los Angeles, Hollywood, San Francisco and Las Vegas.

Upon leaving Manhattan, we crossed the George Washington Bridge then headed for Newark, New Jersey, to meet with Professor Bradford and the choir he directed at the Abyssinian Baptist Church. We had never heard such wonderful and soulful music sung in unison before that visit.

We would try to entertain ourselves with the car radio, but there was no such thing as a jazz radio station once you left New York, only hillbilly and church music. At almost every little village, we would check to see if there was any local music being performed, but rarely did we find anything good except the choirs in the local churches, which seemed to be performing or practicing all day and night. Crossing Florida, Joe and I were fascinated at having to dodge the alligators that occasionally crawled across the highway. We arrived in Biloxi, Mississippi and met the leading jazz musicians at Carmen Massey's music school. It was very funny to hear these young musicians speaking like New York hipsters but with a deep Southern accent.

Visiting New Orleans was like being in Dixieland Jazz heaven, if such a place existed. There was wonderful food and music everywhere. Striptease clubs had replaced many of the famous old jazz joints, but they had jazz musicians in the pit bands. We owed much of the success of our New Orleans visit to the young jazz musicologist, Richard Allen, who, when he wasn't teaching jazz history at Tulane University, would take Joe and me around "Orlans" and introduce us to just about every celebrity in the New Orleans jazz scene. We met almost every member of the three important marching bands: the Tuxedo Brass Band, the Eureka Brass Band and the George Williams Brass Band. We photographed two funerals and two Creole club celebrations. All of the cemeteries in New Orleans have ornate above ground burial crypts because of the high water level underneath the surface of the entire city. It was the funerals that were so colorful. When a member of a band or lodge dies, his fellow band members and friends accompany the coffin from the funeral home or church to the cemetery while the band plays a dirge (a slow and solemn piece of music). After the burial ceremonies, the bands break into a joyful tune welcoming the deceased into heaven, and everyone dances and sings along with the marching bands as they head through the French Quarter to a clubhouse, where a party ensues. The young tough guys of the city, who can't play instruments, add to the gala march by dancing and swinging colorful parasols and umbrellas. They are known as the "Second Liners."

What was everyday life like in that first week of May 1960 in this great city of New Orleans? Well, Dwight Eisenhower was President, and Richard Nixon was the Vice-president. The temperatures averaged in the low 80s Fahrenheit during the day and the mid-60s at night. There was indeed a streetcar named "Desire" actually operating on schedule through the streets, going from parish to parish. The *Times-Picayune* newspaper reported that the movies playing at the first-run theatres were *Please Don't Eat the Daisies* with Doris Day and David Niven; *The Fugitive Kind* with Marlon Brando; and *Tall Story* with Jane Fonda and Anthony Perkins. The Texaco filling stations were selling gasoline at 21 cents per gallon; the top-notch Maison Blanch department store had record crowds for its Spring Sale; the savory Gumbo and Jambalaya were being served everywhere for 35 cents a bowl with prices for a four-course meal $6.95 at the top-rated Gallatoise and Antoine's restaurants; upper-middle class "quality homes" were selling for around $20,000 with track homes selling for around $12,000. The classified ads job listings in the back of the *Times-Picayune* were separated into "Colored" and "White" columns. The civil rights movement had not yet begun.

At the suggestion of Dr. Harry Oster, the folk-music specialist from Louisiana State University, we took a side trip to the Louisiana State Penitentiary in Angola. This prison was famous because it was the largest in the United States—home for over three thousand prisoners at that time, including many blues players, dating back to the great Leadbelly in the 1930s. Dr. Oster promised that we would find many excellent musicians there.

The morning we arrived at the prison gates, the guard was stern but obliging and had us ushered through to the warden's office. The warden listened as Joe explained that we wanted to photograph and record some of the jailed musicians. He took a puff on his cigar and asked which "side" we wanted to visit: "The nigger side or the white side?" Joe quickly replied, "Oh, the negro side. Aren't there more musicians there?" The warden gave us an icy look and said, "Okay, but I can't give you a guard escort; we're short of men. You are on your own." We took a long walk through high barbed-wire fences until we came to the last gate. Once inside the gate, Dr. Oster asked to see a blues singer named Hoagman Maxey. The group of black prisoners parted silently and let us through to meet Hoagman. He greeted us warmly and started to introduce us to several of the musicians. Once the music started everyone became friendly, and we photographed and recorded several of them. My fear disappeared, and we actually enjoyed ourselves, as did the prisoners. The music and stories that we heard were both depressing and inspiring, but above all authentic.

With all of its contradictions and colorful aura, we left New Orleans with a wonderful feeling. We had heard such good ol' happy jazz, dined on delicious food and met genuinely warm and friendly people. Now, with the impact and devastation from the Hurricane Katrina, much of the beautiful city and happy lifestyle has disappeared. I hope that someday it will return. This book is dedicated to the memory of the many souls who lost their lives and to the brave survivors who will rebuild this wonderful city.

William Claxton
Beverly Hills, California
Fall 2006

FOREWORD

Joachim E. Berendt

"Spare yourself the trip," they told us in New York. "All the important jazz musicians live here now. Do your photos and interviews in New York!"

But it's only from the perspective of New York City that jazz appears to be a universally American language (and with the increasing Americanization of our world, a global and international one). Or from that of Europe. In reality, the styles and performance practices of jazz belong to particular cities and landscapes, and they remain the expression of those cities and landscapes even when the music is played elsewhere. The New Orleans style and the city of New Orleans, the Midwest and Kansas City jazz, California and West Coast jazz, Chicago's South Side and the blues that is played there—all these must correspond, if indeed it is the case that in his music, a jazz musician reflects what he experiences and lives. The person who inhabits the climate of California and enjoys its "way of life" has to play differently from the person who is forced to live on the dark South Side of Chicago.

It's no different for jazz than for classical concert music. Mozart belongs to Salzburg, Grieg to Norway, and the Strausses to Vienna. Their music certainly retains its validity everywhere, but if you want to understand them completely, you must go to their cities.

There is a peculiar disparity between the fact that New York is today very much the capital of jazz and the fact that only a few jazz musicians of any style were actually born there. There has to be a reason for this disparity. We've tried to make that reason visible in the pages of this book.

At first, New York was not much more to us than the meeting place for a photographer from California and a German jazz critic who had arranged to get together at the airport. And then it was the source of a lot of addresses and many good suggestions. Not to mention the used Chevrolet that we would make our journey in. For four months we crisscrossed the United States in it—once around the eastern half, then twice straight through the western half, more than twenty-four thousand kilometers in all.

When we spent the night in a hotel somewhere in Georgia, William Claxton said, "Most books of jazz photographs are much too sad". And it's true: most photographs in jazz books beautifully capture the desolate mood, the blues atmosphere, and everything that goes to make up the jazz musician's feeling of loneliness, with the racial and social discrimination that he suffers. But jazz is also the music of *joie de vivre* and overflowing energy, the music of primordial vitality and brilliant irony, the music of youth and humor. We have tried to capture this as well.

This book has no desire to deny that it represents a "European viewpoint". Since the appearance of the first critical books on jazz—not in the United States, but in Europe—European jazz critics of every school and direction have had points of view that differ from those of American critics. It is not the case,

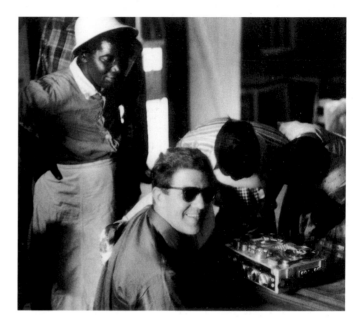

Above Joachim E. Berendt, in the Sea Islands, Georgia, with his portable Nagra recorder.

Ci-dessus Joachim E. Berendt dans les Sea Islands, en Géorgie, avec son magnétophone Nagra portable.

Oben Joachim E. Berendt auf den Sea Islands, Georgia, mit seinem tragbaren Nagra-Aufnahmegerät.

however, that one point of view is right and the other wrong. They are simply different viewpoints from different continents. The fact that jazz criticism has become more universal and more tolerant in recent years is due in no small measure to the fact that critics in Europe are increasingly listening to their colleagues in America, while the latter are also paying attention to their European counterparts.

As the shape of this book became clearer and clearer during our conversations on our endless drives through the American continent, we often noted ironically that both elements are truly present here: we have spoken of the European viewpoint, and Bill Claxton, the Californian, represented the American one—and that is indeed quite literally a "viewpoint."

Baden-Baden
Summer 1961
Joachim E. Berendt

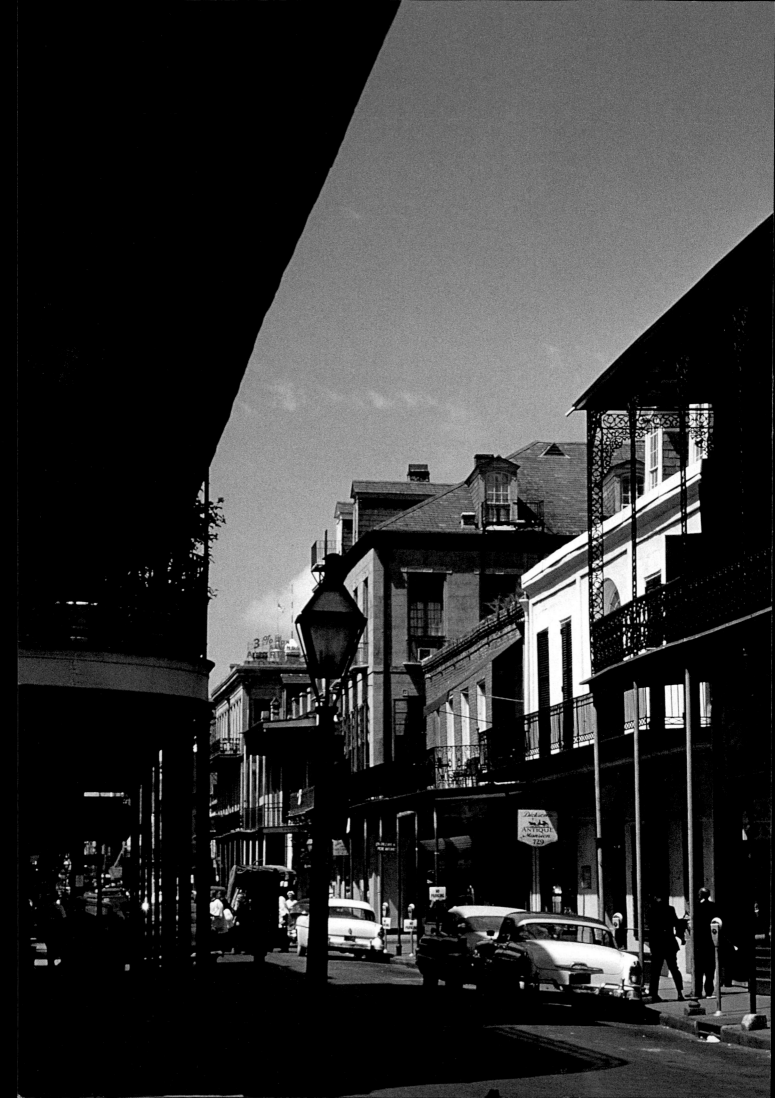

NEW ORLEANS

"New Orleans is a consummate synthesis of Europe and America, or more precisely, of French charm, Latin American love of life, North American rationality, and black vitality."

"You don't even need to bother to go to New Orleans. Jazz in New Orleans is dead," they told us in New York. We heard the same thing again in Biloxi. And Biloxi is barely eighty kilometers from New Orleans, on the Gulf of Mexico. So the people there ought to know. But in New Orleans, in the space of nine days, we experienced two street parades, a funeral, a jazz picnic, and six or seven jam sessions, all in the style of the grand old days when jazz was just beginning. But first let's talk about Biloxi. It's a little seaside resort containing three jazz clubs and more good jazz musicians than one is likely to find in any big city in Europe. One of them is pianist John Probst. As a young man, he played with Mose Allison a few miles north of Biloxi. He was also influenced by him, but now he has his own style. John was blind until just a few years ago. He restored the sight in one of his eyes with theosophical exercises of the will and says he still plans to do the same for the other one. That same strength is in his playing. The meeting place for all these Biloxi musicians is the music school of Carmen Massey, another musician who earlier played with Mose Allison. Bill Claxton refused to pass up the opportunity to photograph all the Biloxi musicians in front of Carmen's music school. They are (p.76, from left to right): drummer Bill Patey (who is playing guitar in the picture for lack of a drum set); then another "guitarist" whose actual instrument is the drums, Earl Cobble of the John Probst Quartet, who comes from New Orleans; bassist Jay Cave; pianist Don Reitan, who had his own ensemble in one of Biloxi's jazz clubs; trumpeter Mike Serpas (who also has a guitar he "shouldn't" be holding, but guitars, zithers, and harmonicas were the only instruments we found at Carmen's music school); then John Probst; and underneath in front of the balustrade, trumpeter Ben Clement; drummer Lee Charlton; and finally the director of Biloxi's music school, Carmen Massey. It goes without saying that most of these musicians are very modern. Perhaps that's why they thought jazz in New Orleans was dead.

Later, as we drove on to New Orleans, we passed several billboards like the one shown at the beginning of this chapter. Even before you get to New Orleans, you can already tell from that billboard that on Bourbon Street—the so-called "Main Street of jazz" in New Orleans—jazz is commercialized. We also passed a filling station, whose "human filling station" is nicely divided into separate fountains for Negroes and for whites. This is certainly not an unusual sight for any American who has ever been to the South. But the European who sees this kind of thing for the first time experiences a shock that, in this case, is only tinged with irony by the fact that the "black" and "white" water obviously come from the same pipe. There

Left The French Quarter

À gauche Le Vieux Carré (le quartier français)

Links Das French Quarter

was also a puddle of water in front of the "white" water fountain. A little white boy who didn't want to get his feet dirty —and who clearly hadn't yet pondered racial questions— therefore went to the water fountain for Negroes, but his father, horrified, tore him away: better to die of thirst than drink where a Negro has drunk before you!

"Most of these musicians are very modern. Perhaps that's why they thought jazz in New Orleans was dead."

The situation was similar in New Orleans. Black and white musicians rarely play together, and so they don't notice that they draw their water from the same pipe. One of them, the trumpeter Nick La Rocca (now deceased) of the Original Dixieland "Jass" Band—the famous white band that is said to have made the first records in the history of jazz in 1917— asserted in all seriousness that it was he himself and white musicians exclusively, and not the blacks, who had created jazz. For years he bombarded jazz critics throughout the world with photocopies of obscure newspaper articles, which he described as "clear evidence" for his thesis. He also sent this evidence to Tulane University in New Orleans, thus becoming able to claim that material at Tulane University "proves" that he, Nick La Rocca, invented jazz. The naïveté with which this word, "invent," crops up in jazz again and again is not the business of Nick La Rocca alone. Ever since Jelly Roll Morton said that he had "invented" jazz in 1902, someone new has always come along who claims to have "invented" it earlier or else only later. Together with their external supporters and detractors, every one of them proves that he is an incompetent thinker the moment he so much as uses the word "invent" in connection with an artistic development, or proposes a single individual as its creator. Who invented poetry? Or painting? The steam engine can be invented, or the paper clip; an art form cannot.

When I called Nick La Rocca, even before he said "hello" or "how are you," he said, "I'll tell you one thing: Niggers don't even enter the picture." And then he spent a long time railing, in a voice contorted by rage, against everyone who doesn't believe that Nick La Rocca and the whites created jazz. He would take them all to court, he said, and have them condemned. They had committed a "crime against American history." They were "Communists." Precisely the sort of complex-ridden, neurotic personality that comes into focus when someone uses the words "crime" and "Communists" in a context as innocuous as this one may actually help do justice to the late Nick La Rocca. In music that is so very much the expression of the performing musician—and only the performing musician, rather than that of a composer

whom the performing musician interprets—it is easy for the emphasis to slip. After all, this is a phenomenon that is also familiar to us from the rest of jazz history, not only from Jelly Roll Morton. Who *hasn't* claimed that they invented modern jazz? Thelonious Monk still says today that he played in a "modern" style before Charlie Parker. If seeing through "one's own lens" is something that belongs to the essence of jazz in a good sense, it is inevitable that it should sometimes also belong to it in the bad sense. And it is only human that musicians should take all the energy they have put into their music and also connect it with what they've ultimately come to think by constantly looking through "their own lens," especially if their own music is no longer viewed as "modern." And all the more when, even apart from this, the atmosphere vis-à-vis the people they feel have "robbed" them is already charged with hatred, as it is in the South between Negroes and whites!

"Who hasn't claimed that they invented modern jazz?"

Nick La Rocca once said, "The band has never lived that could play like we can. We introduced this music to the world." It is certainly true that, among the important musicians of jazz history—and Nick La Rocca and his Original Dixieland Jass Band were important—there are no two who play exactly the same. As far as "introducing" the music is concerned, the Original Dixieland Jass Band really was the first jazz band to have great success outside of New Orleans (especially in New York), as indeed it was often the case in jazz history that white orchestras and soloists took what the Negroes had created and made it successful. Nick La Rocca cannot have created jazz for the simple reason that there are a number of elements in jazz that simply cannot have originated with the white man: the phrasing, the tone production, and the rhythmic intensity. These elements did not exist anywhere in "white" music before the advent of jazz, but they were ubiquitous in "black" music. And everyone who has ever ventured a rigorous definition of jazz has concluded that these elements form part of its essence. Jazz is inconceivable without them, just as on the other hand it is also inconceivable without European instruments, the symmetry of European forms, and European harmonies. Precisely the problem of rhythm makes it clear how complicated a question the origin of jazz is. Can it be said that the rhythm of jazz comes from the Negro—perhaps from his heartbeat? The regularity of jazz rhythm is European; it comes from the march. African rhythms are more multilayered and asymmetrical. But the intensity of jazz rhythm comes from the Negro. It has no counterpart in European music. The process of amalgamation proceeded so gradually that there is never an audible or visible point where anyone could step forward and say they had completed it. And it is still being carried out today! The music of Bob Crosby has more march rhythm than even the marching bands of old New Orleans. And Art Blakey's modern *Orgy in Rhythm* has more African rhythms in it than even the most "African"-sounding example of early jazz, not excluding shouts, country blues, work songs, and spirituals. Thus, one might almost describe Nick La Rocca as a victim of the "knottiness" of the amalgamation process that produced his own music. That is the source of his complex, which even the white musicians in New Orleans laughed

about. They said he was a fanatic, someone you couldn't talk to. But there is no doubt that they too are interested in emphasizing the white contribution to the genesis of jazz. Almost every white musician in New Orleans feels that the Negroes' contribution is exaggerated. On the other hand, every Negro—if he takes the trouble to think about it—says that the whites have always picked up what the Negroes had created and brought it before the public and made money from it, so that the public could never discover the Negroes' music except through the whites.

The first and oldest of these white musicians is "Papa" Jack Laine. The New Orleans Jazz Club awarded him a certificate affirming that he is the "father of white jazz." And if it was "white" jazz that started it all, then Papa Laine, at any rate, has more claim to have "invented" jazz than Nick La Rocca. For he was already playing before La Rocca was even born. Papa Laine—or Johnny Stein, the real name of this musician descended from German immigrants—was jazz music's first successful bandleader. He led more different bands between 1889 and 1920 than Woody Herman fifty years later. Sometimes he even had several bands at once, all of which played under his name, even though he could only sit at the drums with one of them. And Papa Laine too, of course, says he was the first. Everyone in New Orleans was the first at something. Papa Laine says: "I was the one that started it all. Before me there was only a nigger band, and it was just a brass band, but I was the one who had the first real jazz band." A moment later, however, he appeals to the Negroes after all. "Even the niggers acknowledged my music." Today Papa Laine lives near the New Orleans city limits in a little shack next to a railroad line, where the trains are constantly shunted past, and makes fireman's helmets. He proudly displays a document affirming that he has been a "Lifetime Member of the David Crockett Steam Fire Company No. 1" since 1913. He joined this fire company because at the time the firemen's parades were especially splendid. For thirty years, Papa Laine has been making fireman's helmets for his company without a break. By now he's made more helmets than the company will ever have members. His wife showed us a picture dated 1895 in the family photo album of the young, not yet "Papa" Laine in a fireman's uniform of the time.

"Between 1938 and 1944, the great period of the New Orleans revival, early jazz forms were rediscovered."

It is Joe Mares who tends to the needs of the white musicians (and sometimes a few of the black ones as well) in New Orleans with his record company, Southland Records. Joe is a brother of Paul Mares, the trumpeter for the New Orleans Rhythm Kings and Nick La Rocca's great competitor. Joe's Southland Records is located right in the middle of the French Quarter, the city's old French district, on St. Louis Street. Joe invited all the musicians he was able to reach to a jam session for us there, including Harry Shields, the brother of Larry Shields, the former clarinetist of the Original Dixieland Jass Band, and his counterpart among the younger clarinetists in New Orleans today, Raymond Burke; trombonist Emile

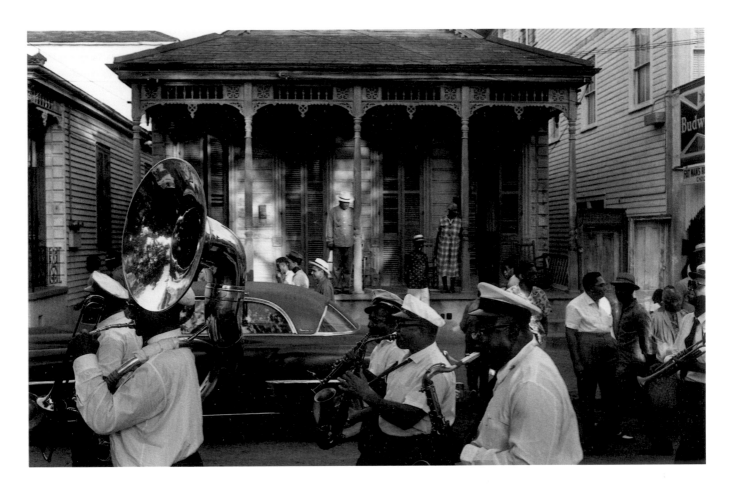

Christian, who also played with the Original Dixieland Jass Band in 1918 and then lived in France for fifteen years; trumpeter Tommy Gonsoulin, who swung in the bands of Gene Krupa and Jack Teagarden; banjo player Joe Caprano; bassist Bob Coquille; drummer Sal Gutierrez; tuba player James "Pinky" Wadlington; and two of the best-known white musicians in New Orleans today, trumpeter Sharkey Bonano and ragtime pianist Armand Hug, one of the last surviving authentic ragtime musicians. The only black guests at the session were Sister Elizabeth Eustis and her accompanist. Since Mahalia Jackson left her home city of New Orleans, Sister Elizabeth is the best spiritual and gospel singer in the city. She has her own radio show, but she still sings on the street corners of the French Quarter every Sunday just as she did in the early days, accompanied only by a tambourine.

When we walked diagonally across the street to Bill Russell's record store after the session at Joe Mares's, one of the musicians said: "No one has done more for jazz in New Orleans than Bill. But unfortunately he pays a little too much attention to the Negroes." There is no doubt that the first half of this statement is accurate. Bill is not a musician, and at bottom he is not a critic either. He is a fan who has spent all the money he has earned in his life to capture New Orleans musicians on record, and this at a time when no one else in the world had hit upon the idea that there was anything at all in New Orleans to record. At that time Bill lived in Chicago. Since then he has realized his life's dream. He has a jazz record store right in the middle of the French Quarter of New Orleans, and it is the meeting place for everyone in New Orleans who is interested in jazz. There are so many records and old pictures and even older engravings, posters, and stereoscopic optical illusions and movie stills from the 1920s lying around in the store that it is almost impossible to walk. Bill Russell sits in the midst of this chaos and repairs old violins. He takes apart two or three damaged instruments and constructs a single one from the pieces. While doing that, he listens to records, but only rarely jazz. He prefers the great violin concertos, especially Mozart. Bill Russell is the embodiment of all those who are fascinated by New Orleans, its atmosphere, and its music, the type of intellectual who is so personal and so human that he doesn't seem to be an intellectual, who comes out of European Romanticism and has recognized that Romanticism has gotten brittle, and who now needs a substitute for it that is equally strong and warm, precisely New Orleans. Someone once said Bill Russell was "all soul," and that was the first time I heard the word "soul" in connection with jazz, long before the advent of modern soul music.

There is a whole group of such personalities in the United States, and Bill Russell is their "primus inter pares." The prominent jazz magazines mention their names only rarely, and yet they have accomplished a strenuous task of collection and education that can hardly be prized too highly: David Stuart in Hollywood and Charlie Gamble in San Francisco; or earlier Lester Koenig and Nesuhi Ertegun, the current heads of the Contemporary and Atlantic record companies; or in connection

Even today you still have the sense that in the early days, jazz in New Orleans was something like a family affair. When you don't run into the musicians, you run into their relatives. For example, we ran into Louis Keppard as he was coming from the grocery store. Louis is the brother of Freddie Keppard, the second "Jazz King" of the city (after Buddy Bolden and before King Oliver). At that time—fifty years ago, when Freddie played the trumpet—Louis Keppard was a banjo player. Today, at the age of seventy-three, he plays the tuba: "After all, I've also gotten heavier myself." The fact that, despite all this, so many people say jazz in New Orleans is dead is due above all to the fact that when people talk about jazz in New Orleans, they think of Bourbon Street. The street of the Bourbons in the old French Quarter has long been regarded as the main street of jazz life in New Orleans. But when you get there you find very little jazz, and a solid half of what little there is is questionable. On the other hand, there are that many more striptease shows. I counted twenty striptease clubs and five jazz clubs on Bourbon Street. The ratio is somewhat "improved" by the fact that, in many of the striptease clubs, second-rate jazz is played as background music as the girls undress. Even the menus of the famous clubs in New Orleans—perhaps the best restaurants in the United States—are geared to the striptease tourists. We

"The New Orleans Creoles were Negroes who had been freed by the French plantation owners and colonial rulers."

ordered a "Striptease Steak," but a "Jazz Steak" was nowhere to be found. The jazz clubs include the world-renowned Famous Door, where Sharkey Bonano played for years; the Paddock Lounge; the Old Absinthe House; and the club that Pete Fountain created for himself and his clarinet. Octave Crosby's band had been playing in the Paddock Lounge for eleven years, and it's not hard to imagine what the music must sound like when a band has been playing the same pieces night after night for an audience of elderly tourists without pause for eleven years. Be that as it may, an excellent musician like the trumpeter Thomas Jefferson is also a member of the band. The best jazz, relatively speaking, that we were able to find on Bourbon Street was at the Old Absinthe House, with Sweet Emma Barrett on piano and the two brothers Willie and Percy Humphrey on clarinet and trumpet. Sweet Emma pounds the piano without a trace of subtlety, as if it were a drum set with eighty-eight keys, but the tourists don't come so much for the music as they do to see Sweet Emma. She wears bells on her scrawny feet so that it makes a nice jingling sound when she taps her feet in time to the music. The tourists see the bells and say, "Ah yes, that's old New Orleans in all its beauty and authenticity." I was at the Old Absinthe House twice, and during that time five different tourists went up to Sweet Emma and asked her, "You know *Tiger Rag*?" Each time, Sweet Emma made a face, turned to her musicians, and whispered something like "Oh brother," but still, she dutifully played *Tiger Rag* again every time.
Nevertheless, Bourbon Street is a very beautiful street, and in architectural terms, the old French Quarter is the most beautiful and most stylistically coherent "city" in the United States. The French wrought-iron grilles and Spanish patios; the

Creole dolls in the shop windows; and the excellent restaurants (Oysters Rockefeller and Bouillabaisse à la Nouvelle Orléans are the best dishes); the old Spanish and French houses; the streets, all of which still have French names; and the whole atmosphere of this "vieux carré" are unique and unmistakable. New Orleans is a consummate synthesis of Europe and America, or more precisely, of French charm, Latin American love of life, North American rationality, and black vitality. In fact, it is the only existing synthesis of these four elements, which have not come together to form a single whole anywhere else. That is why when you go to New Orleans you feel like you're not in the United States anymore. The Americans say it's "like France." But if New Orleans were in France, you would think you had left France as soon as you set foot in the city. The North American contribution to the city's temperament and atmosphere is greater than most Americans (for whom it is self-evident what is American and what is not) would like to think. The fifteen million dollars the Americans paid Napoleon for the city and for the state of Louisiana in 1803 change hands today in a single week for oil alone in the area of New Orleans. And 150 years ago, fifteen million dollars was a greatly inflated purchase price. New Orleans, with its eight thousand inhabitants, was an insignificant little island in a giant swamp that threatened to swallow everything up again sooner or later. That swamp still surrounds the city today. For New Orleans does not lie "on the Gulf of Mexico," as even the Americans say it does; 170 kilometers of swampland stretch between the city and the mouth of the Mississippi. French is still spoken in this "Bayou Country" even today. And the French-speaking families who live there still have relatives in Quebec or Montreal. For the French colonists who named the land of Louisiana after Louis XIV in 1699 came not from the sea, but down the Mississippi from Canada. You constantly encounter their names in New Orleans—d'Iberville, for example, or Bienville—which was originally supposed to be located where Biloxi is today. The instinct that led them to found the city in a bend of the Mississippi between the river and big Lake Pontchartrain—in an act of deliberate disobedience to a directive from the Paris court—is still worthy of admiration 250 years later.

But back to jazz, whose atmosphere and history in New Orleans can only be understood properly when you know the city's history. We saw the swamp surrounding the city when we went to the Branch Inn in Slidel, a few miles outside New Orleans, to experience one of the picnics that used to be common in the early days of jazz and are still held even today. You drive to the country on a Sunday morning with a basket of food and a few bottles of gin and set up camp in a meadow. There the band plays, and you dance to it. At the Branch Inn it was the band of Little Snooks Eaglin, a blind blues singer and guitarist who has assumed the striking epithet "Little Ray Charles," although his blues is much simpler and more rustic than the blues of the great Ray Charles. At first, when the picnic was starting and not many people were there yet, the musicians played extremely modern hard bop. But then the manager came and said, "Enough of that modern stuff." Then they played rhythm and blues, and only then did the people begin to dance. As was so often the case, we were the only white people at the picnic. The young black dancers were clearly disturbed by our presence. At first there were only a few

snide remarks ("Hey white man, what are you doing here?"), but then the mood became increasingly hostile, and it seemed to us it would be a better idea, and more conducive to the general peace, if we left the lovely jazz picnic in Slidel early. On the jazz excursions they make for Tulane University, Bill Russell and Dick Allen always have to have a police-issued document with them giving them legal permission to enter Negro dwellings, visit Negro restaurants, and take part in Negro gatherings. Theoretically you could be arrested without such a document, even if no "incident" actually occurs. You're arrested "for security reasons." The police find it easy to come up with a suitable cause. For example, you have supposedly personally insulted someone with your behavior; or you have disturbed, or threatened to disturb, public order; or else you were in danger and didn't know it. Of course I didn't have such a document. I was told I should get one several times. But if the police had really come, I would simply have said that in old Germany, we don't know anything about how things are done in the Deep South of the United States. When I was in New Orleans for the first time in 1950, there was still no risk at all involved in going to black restaurants, bars, or nightclubs. The tensions have only now become so palpable because of the legal abolition of school segregation and everything that unleashed. Because of that, the southerners say that Washington's school legislation (which mandates that black and white children be permitted to attend the same schools) was wrong. "It was peaceful down here before; now it isn't peaceful anymore." But the peace that reigned before was a dangerous smoldering of evil hatred, and the tensions that are played out more openly now have finally set the bad old conditions in motion, and they can and will bring about a situation in which more humane conditions will one day prevail. Once, when I had a long discussion with a typical, narrow-minded southerner, I was able to experience how all of these peaceful white "upstanding citizens" who champion racial segregation turn into wild and wicked fanatics and how the hatred appears on their faces when one defends the Negroes a bit too emphatically vis-à-vis the whites. In the end, my conversation partner gave the friendly approach one more try. He put his hand on my shoulder and said: "Good God, but you're from Germany. You've got to understand us. After all, you solved your problem. You with your Jews!"

We experienced a funeral and two street parades in New Orleans. In the old New Orleans funerals, sad music was played on the way to the cemetery, and happy music was played on the way home with that much more swing and exuberance. In the street parades, the brass bands marched through the streets to celebrate everything under the sun. Both the funerals and the street parades have become a symbol, not only in musical but also in social terms, for the atmosphere that enabled New Orleans to become the capital of the early days of jazz. The two New Orleans street parade bands that are richest in tradition still exist today, the Tuxedo Brass Band and the Eureka Brass Band. They are effectively the same age as the century. Many of the famous early jazz musicians played in them. Many long-famous names are still present in them even today, trumpeter Alvin Alcorn and drummer Louis Barbarin in the Tuxedo Brass Band, for example. Younger musicians joined their ranks later. Until just a few years ago, George Lewis played with the Eureka Band. In addition to these two old bands there is a third band that

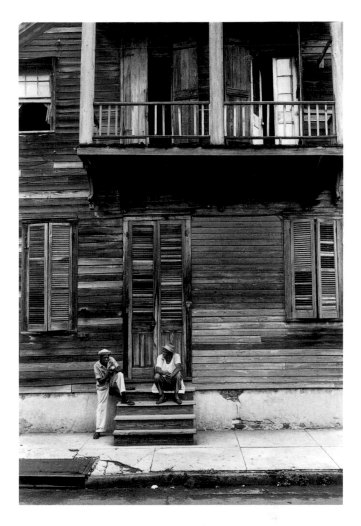

Above A typical old structure in the French Quarter.

Ci-dessus Une vieille bâtisse typique du Vieux Carré.

Oben Ein typisches altes Gebäude im French Quarter.

can be heard in the street parades, the George Williams Brass Band. Paul Barbarin, incidentally, who was a preferred drummer of Louis Armstrong and Jelly Roll Morton in the 1920s and 1930s, is simply *the* drummer in New Orleans today. You hear him and run into him everywhere. The banners that were carried in our first street parade indicated that it was organized by the Creole Fiesta Association, an organization that seeks to cultivate the old Creole culture and its traditions. When I call to mind the countless societies and associations, small groups, sects, and interest groups in New Orleans and the areas of the United States where Negroes are concentrated, I am often reminded of the fact that people say of us Germans that we are particularly fond of associations. That may be, but nowhere are there more associations and societies than among the Negroes of the USA, and nowhere is the consciousness of social standing and social status more pronounced. The barrier that separates blacks and whites is only as conspicuous as it is because the problems it gives rise to affect our entire civilization. But on the other side of that barrier, the Negroes separate among themselves behind barriers at least as high and at least as insurmountable, and those barriers will certainly still exist when the racial problem has long since been resolved. Schools and Boy Scout troops, boys' and girls' clubs, even the military dispatched its delega-

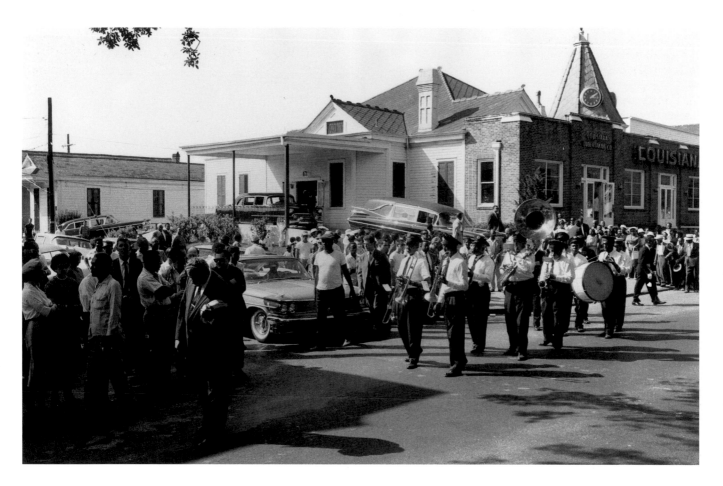

Above The funeral of William E. Pajaud with the Eureka Brass Band.

Ci-dessus L'enterrement de William E. Pajaud avec l'Eureka Brass Band.

Oben Beerdigung von William E. Pajaud mit der Eureka Brass Band.

tions to the parade. In the military's delegation, blacks and whites marched peacefully side by side. Otherwise only Negroes took part in the parade. The festive procession gathered near the intersection of North Claiborn and St. Bernard Avenues, and soon, after many groups in brilliantly colorful uniforms joined the contingent, it was six or seven hundred meters long. The police had to block off the entire neighborhood. Traffic was diverted. Everyone seemed to be involved in the street parade. People were dancing everywhere, alone, in couples, and in groups. Old people and children danced too. The most enthusiastic partici- pants came marching and dancing immediately behind the band. They were the so-called "second line," which follows the "first line," that is, the musicians. One of the most popular accessories of the true "second liner" is an umbrella, although it almost never rains. You see them again and again, in every shape and color, at the street parades and, in general, every- where that Negroes have fun. They are the symbol of a little sky, under whose friendly container there is safety and security. Outside this "sky" lies the hostile white world. Or is there some other explanation for the highly symbolic popularity of the umbrella and the parasol among the Negroes.

When the parade was over, the Creole Fiesta Association gave a party at its clubhouse. The party began with a formal meal, and afterwards people danced and went on eating. The cake was one and a half meters in diameter, and a piece was cut for

everyone at the party. Dignified old ladies commanded the scene and saw to it that everything went according to custom and convention. Everyone seemed to know in advance exactly whom he was supposed to dance with, and yet everything was relaxed and happy. The president of this Creole association was quite open about what she saw as the organization's purpose: "We cultivate the old traditions so that the young people see how beautiful the traditions are and continue to keep them." I asked her if only Creole Negroes could join her association. She said, "Everyone can come to us who feels they belong." But the older gentlemen, at least, made a point of speaking Creole—a bastardized French with bits of Spanish, English, and African languages—with everyone they had reason to think might understand it. The high point of the party was a large quadrille. To begin with, the dancers separated by sex into two long rows, which found their way to each other and then separated again, and as the couples turned they gave the impression of a minuet at an eighteenth-century French court rather than that of a jazz dance. For the older dancers, the point was clearly to execute the little classical minuet steps exactly right. The fact that the Tuxedo Brass Band was playing the music for this dance definitely only struck outsiders as a contradiction. None of these dancers would have had any doubt that the New Orleans music of the Tuxedo Brass Band was a perfect musical expression of old French courtly dance culture. When the musi- cians announce that they are about to play a minuet, a polonaise, or a gavotte, they do not place these words in quota- tion marks. They really believe they are playing minuets, polonaises, and gavottes. But what they are playing is New Orleans jazz, and only music-ologists are able to recognize that elements of old courtly dance music once flowed into it by ana-

lyzing the music in great detail. A Creole party like this one certainly means more than the transmission of a beautiful old tradition to the younger generation. The luster that surrounds the Creole tradition is also bound up with the racial situation. The Creoles were free Negroes before the Civil War and the pseudo-emancipation from slavery. They were freer under slavery than the Negroes are today, one hundred years after slavery's abolition. The New Orleans Creoles were Negroes who had been freed by the French plantation owners and colonial rulers. They were often children of the black mistresses that it was part of good form for men of the French upper class to have. These Creoles were soon among the city's most capable tradespeople. They kept the French culture alive even after Napoleon had sold New Orleans to the United States. They were more cultivated, more educated, and better raised under slavery than the Negroes—and most white people—are in the South today. For this reason, a fondness for Creole traditions does not mean purely a fondness for tradition today. It is repressed emancipation and protest in disguise.

On May 12, 1960, William E. Pajaud died, "beloved husband of Mrs. Sallie Pajaud, father of William Pajaud, brother of Albert Pajaud…," and then the newspaper goes on to fill twelve lines with the entire extended family. Then it says: "Relatives and friends of the family; pastors, church elders, and members of the King Salomon Baptist Church; sons and daughters of the society of the resurrection 'Die freundliche Acht,' 'The Bells of Joy,' the 'Star of Bethlehem Loge,'" and ten other associations of which the deceased had been a member, "are invited to attend the funeral on Saturday, May 14, 1960 at 3:00. The procession will begin at the Louisiana Undertaking Company, 1449 North Claiborn Avenue." William E. Pajaud was a trumpeter with the Eureka Brass Band all his life. His specialty was the "dirges," the slow, sad pieces that were played at funerals on the way to the cemetery. For decades, many in New Orleans hoped William E. Pajaud would be the solo trumpeter and play the dirges at their funeral. There was nothing he liked to do better: "I'd rather play a funeral than eat a turkey dinner." On the very day before he died he had played a funeral. He was fifty-eight years old. The interest shown in his burial was correspondingly large. People gathered at the Louisiana Undertaking Company building, and then the long procession set off to the St. Louis Cemetery No. 2. Out in front walked the "Grand Marshall" of the funeral with steps that were slow and dignified yet dancelike. Next came the Eureka Brass Band, then the survivors, and afterwards everyone else. The band played all the dirges that William E. Pajaud had played especially beautifully, not least the old hymn *Just a Closer Walk with Thee*.
At one time the ground of the city of New Orleans was so swampy that it was impossible to bury the dead underground. From this time comes the custom of interring the dead above ground in massive stone graves. As the urn was slid into the stone structure, the scenes in the cemetery were heartbreaking. Mrs. Pajaud wept and stammered and shouted, "Good-bye Willie," over and over. And the other women were hardly less demonstrative. Children had climbed over the cemetery wall from without and watched. Others were already waiting for the Eureka Brass Band at the exit, ready to form a "second line" immediately and dance along behind the band, whose strains now belonged to the living again, swinging and happy. But at this juncture too, music was a classic compo-

nent of all New Orleans funerals: *Just a Little While to Stay Here*, the song about the short span of time that is all one has to linger on this earth. Originally it was a chorale, but here it was "swung" as if it were *When the Saints Go Marchin' In*. It goes without saying that the band played that song too. There was another street parade on the following Sunday. It was organized by the True Love Missionary Baptist Church School. Once again, the Grand Marshall marched in front at the head of the procession. There were two bands, the Tuxedo and the George Williams Brass Bands. The instruments, as always, were trombones, trumpets, saxophones, clarinets, sousaphone, and other wind instruments, as well as big drums and a number of smaller drums. Children, mothers, and fathers walked behind the bands in their Sunday best. And of course, here too there was an enthusiastic "second line." A few boys climbed trees in order to get a better view of everything. A few horse-drawn carriages also formed part of the procession, for the distinguished ladies who wished to show that they do not find it necessary to walk. There were banners everywhere, which were carried along in the procession. A few of them were still in French, in another gesture towards the old French-Creole tradition. The procession led directly into the church. The Tuxedo Brass Band positioned itself in front of the congregation in the choir of the church and framed the sermon with New Orleans jazz.

"In the old New Orleans funerals, sad music was played on the way to the cemetery, and happy music was played on the way home."

Of course, we also visited Louis Armstrong's birthplace. James Alley, where Satchmo was born, is far away from the French Quarter in a poor and disreputable area between the Perdido and Gravier Street. Even Dr. Souchon, the great man of the New Orleans Jazz Club, warned us not to go there. The whole area looks like a landscape of ruins after a bombing raid, when the first makeshift huts have just been built. It is astonishing that people have already been living in these huts for seventy or eighty years. At first we only saw hostile, angry faces in James Alley. No one wanted to give us information. When we finally found Satchmo's birthplace anyway—it is a narrow, shabby wooden hut at 723 James Alley—and even before we knew exactly which house it was, we heard very modern trumpet improvisations. And now the truly astonishing thing happened. In the very same room (if one can call it a "room") where Louis Armstrong was born, a fourteen-year-old boy was practicing the trumpet. His name was Jerry McGhee. Naturally, we asked him about Louis Armstrong, but he didn't have the slightest interest in old Satchmo. At one time he had certainly heard that Armstrong was born in this room, but that means no more to him than if Mr. Meier or Mr. Schulze had lived there. "I like Clifford Brown much better than him," he said. Later we met Jerry's mother. The young woman lives with her husband (a truck driver) and nine children in two small rooms. She said: "I'd like Jerry to play the guitar and not the trumpet. Then he can become the next Elvis Presley!"

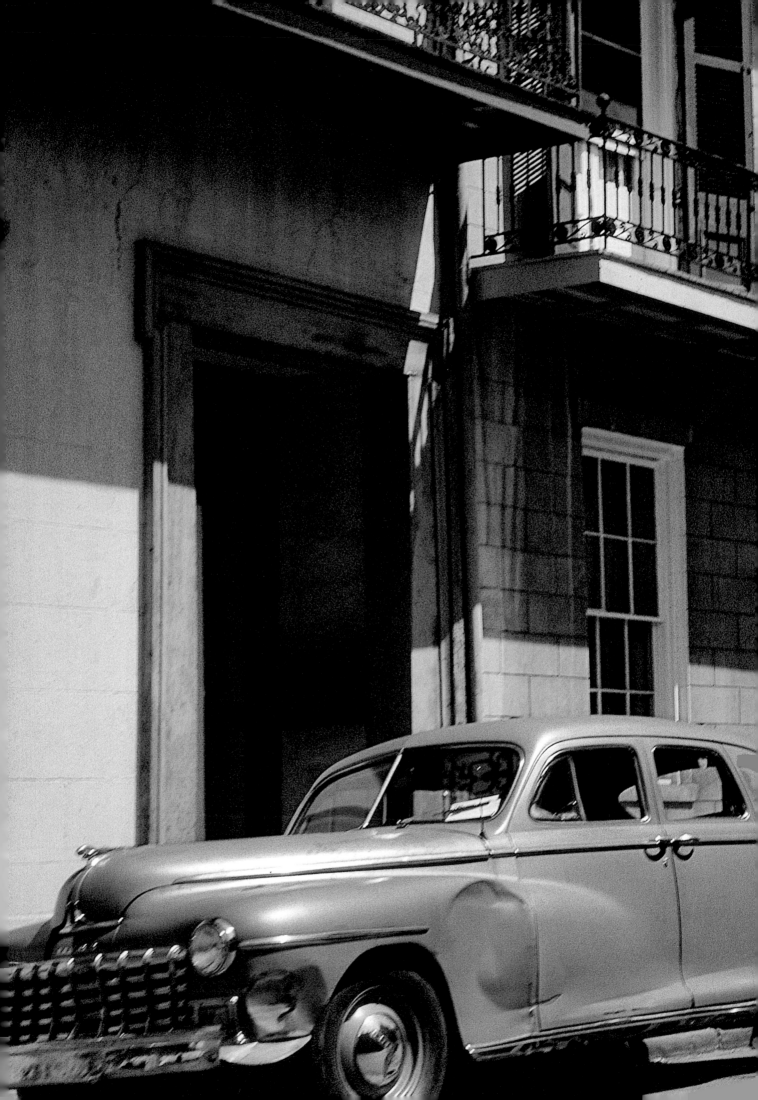

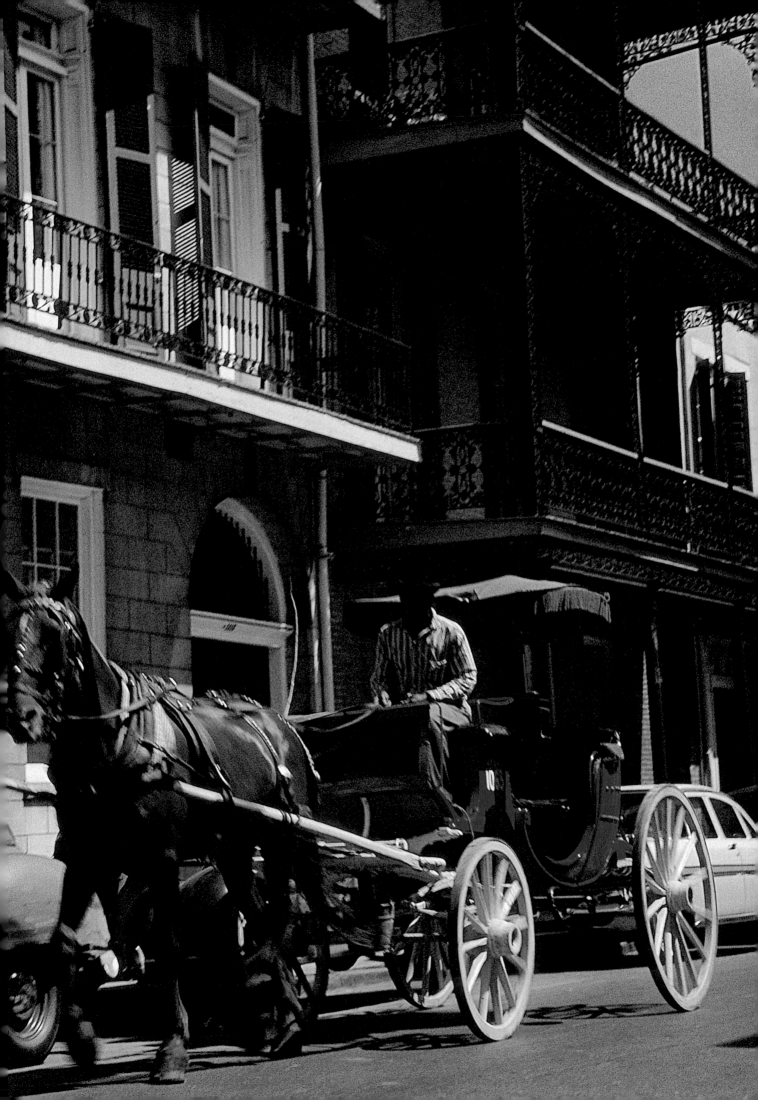

PRÉFACE

William Claxton

Quand je suis arrivé la première fois à la Nouvelle-Orléans (Louisiane) en mai 1960, on se serait cru dans les contre-allées d'un grand studio de cinéma. Avec son assortiment disparate de bâtiments de tous styles et ses rues pavées, on aurait pu être à Paris, Madrid ou Boston. Les boulevards étaient bordés d'arbres croulant sous la mousse et d'hôtels particuliers néo-classiques aux colonnades blanches. Les rues transversales étaient ombragées par de grands magnolias au parfum exotique. Quand on pénétrait dans le Vieux Carré, le sanctuaire du Mardi Gras, on se retrouvait entouré d'une architecture victorienne : briques rouges, poutres sculptées, balcons en fer forgé. Dans les banlieues, on passait, rue après rue, devant des rangées de pavillons identiques en briques et bois, construits après la Deuxième Guerre mondiale. Puis, soudain, ce n'était plus que des taudis délabrés en bois et papier goudronné, habités principalement par les descendants des esclaves africains. C'était là que vivaient les pauvres. Seuls les Créoles, affranchis à l'époque de l'esclavage et s'étant souvent mariés avec des colons franco-canadiens, jouissaient d'une vie bourgeoise et possédaient leurs propres clubs, cercles et autres organisations sociales.

La Nouvelle-Orléans s'étend à la pointe d'un grand delta traversé de part en part par les nombreux méandres du puissant fleuve Mississippi. Dans ce décor unique semi-tropical, elle forme un creuset de nombreuses cultures dont les cuisines, les religions (principalement catholiques et baptistes), les arts et les divertissements sont aussi variés que ses habitants. Ces derniers, aux manières distingués et courtoises, sont de dignes représentants de la fameuse « hospitalité sudiste ». Sa musique, à l'instar de l'éclectique « cuisine du grand Sud », reflète les racines européennes et africaines des néo-orléanais. Les Français et les Anglais ont apporté leurs instruments à vent et à cordes, les Allemands leurs cuivres et les Africains leur cœur qui bat au rythme de leurs tambours et des tempos uniques de la jungle. Les musiciens noirs et blancs ont uni ces instruments, battements et rythmes pour créer ce qu'on appelle désormais le jazz. C'est lui qui m'a conduit dans cet endroit merveilleux qu'est la Nouvelle-Orléans : je suis venu photographier l'univers du jazz.

Début octobre 1959, je reçus un appel d'Allemagne. Mon interlocuteur se présenta : Joachim-Ernst Berendt, musicologue habitant à Baden-Baden. Dans un anglais parfait, il m'expliqua qu'il s'apprêtait à venir aux États-Unis pour réaliser un ouvrage sur « ce grand art américain, le jazz ». Il cherchait un photographe pour travailler avec lui – un photographe qui aimait et comprenait le jazz. Son livre comporterait des interviews et des portraits de musiciens, des photos des différents lieux où l'on écoutait du jazz, une étude des origines du jazz et du jazz en tant qu'art à part entière. À l'entendre, tout ça me paraissait bien savant mais, d'un autre côté, il s'agissait d'un projet colossal. Son offre me ravit. L'occasion de photographier bon nombre de mes héros jazzmen et d'en découvrir d'autres en voyageant dans tous les États-Unis était tout simplement irrésistible. Je répondis que j'aimerais beaucoup en être.

Joachim Ernst-Berendt (que j'appellerai désormais « Joe ») et moi avions convenu de nous retrouver à l'aéroport Idyllwild (il ne s'appelait pas encore JFK) à New York le jour de son arrivée depuis Francfort. Nous avions réservé une chambre à l'hôtel Alwyn, au coin de la 58e Rue et de la 7e Avenue. L'établissement était assez délabré (il fallait payer cash dès l'arrivée) et connu pour être fréquenté par des junkies. Joe observa : « Vous ne trouvez pas que c'est un endroit formidable ? Ça grouille de musiciens. C'est bon signe, non ? »

Après plusieurs jours de travail à New York pendant lesquels Joe enregistra des entretiens et je pris des photos de jazzmen, nous nous sommes mis en route dans une Chevrolet Impala 159 d'occasion. Tout le monde connaît le modèle, c'est celle avec les ailerons géants incurvés presque à l'horizontale et de gros feux arrière en forme de poissons. L'homme qui nous l'avait louée avait laissé un cache en carton sur la plaque d'immatriculation sur lequel était écrit : « Visitez les USA dans votre Chevrolet ». Ça tombait bien.

Le plan de Joe pour notre odyssée du jazz était de partir de Manhattan, de passer par Philadelphie et Washington D. C., de descendre vers la Nouvelle-Orléans et Biloxi, de remonter le long du Mississippi jusqu'à Memphis, puis de continuer vers Chicago, St. Louis, Detroit et Kansas City. Après quoi, nous mettrions le cap vers l'ouest pour Los Angeles, Hollywood, San Francisco et Las Vegas.

En sortant de Manhattan, nous avons pris le pont George Washington en direction de Newark, dans le New Jersey, pour rencontrer le professeur Bradford et le chœur qu'il dirigeait pour l'Abyssinian Baptist Church. Pour Joe comme pour moi, ce fut notre première occasion d'entendre une musique aussi magnifique et inspirée chantée à l'unisson.

Nous essayions de nous distraire avec la radio de la voiture mais, une fois sorti de New York, il n'y avait plus de station de jazz, rien que de la musique country ou religieuse. Dans presque tous les villages, nous demandions s'il y avait un endroit où l'on jouait de la musique mais nous entendions rarement quelque chose de bon en dehors des chœurs des églises locales, qui semblaient répéter et chanter à longueur de journée et de nuit. En Floride, Joe et moi sommes restés fascinés par les alligators qui traversaient parfois la route, nous obligeant à zigzaguer entre eux. Une fois arrivés à Biloxi, nous avons rencontré les principaux jazzmen du cru à l'école de musique de Carmen Massey. C'était très drôle de voir ces jeunes musiciens utiliser le jargon des branchés new-yorkais avec un fort accent du Sud.

Visiter la Nouvelle-Orléans était comme de se retrouver dans le paradis du dixieland, s'il existe. Partout, la cuisine et le jazz étaient excellents. Les boîtes de strip-tease avaient remplacé bon nombre des anciens clubs de jazz célèbres, mais leurs

fosses d'orchestre étaient pleines de jazzmen. Nous dûmes en grande partie la réussite de notre séjour à la Nouvelle-Orléans au jeune musicologue de jazz Richard Allen qui, quand il n'enseignait pas l'histoire du jazz à l'université de Tulane, nous emmenait, Joe et moi, à travers la ville pour rencontrer pratiquement toutes les célébrités locales du monde de jazz. Nous avons fait la connaissance de presque tous les membres de trois grandes *marching bands* : le Tuxedo Brass Band, le Eureka Brass Band et le George Williams Brass Band. Nous avons photographié deux enterrements et deux kermesses de clubs créoles. Dans tous les cimetières de la ville, les morts sont déposés dans des cryptes richement décorées *au-dessus* du sol en raison du fort risque d'inondation. Les enterrements étaient les plus pittoresques. Quand le membre d'un orchestre ou d'une loge meurt, ses compagnons musiciens et ses amis accompagnent son cercueil des pompes funèbres, de sa maison ou de son église jusqu'au cimetière pendant que l'orchestre joue un *dirge*, un chant funèbre lent et solennel. Puis, la cérémonie achevée, les musiciens entonnent des airs joyeux et tout le monde se met à danser et à chanter, prenant la direction d'un club du Vieux Carré, le quartier français, où la fête se poursuit. Les jeunes durs à cuire de la ville qui ne savent pas jouer d'un instrument participent à la procession en dansant et en agitant des ombrelles et des parapluies colorés. On les appelle « la deuxième vague ».

À quoi ressemblait la vie quotidienne en ce début du mois de mai 1960 dans la belle Nouvelle-Orléans ? Dwight Eisenhower était alors président, et Richard Nixon son vice-président. Les températures oscillaient entre 18 et 26°C. Il y avait effectivement un tramway nommé « Désir » qui reliait les différentes paroisses à heures fixes. Selon le quotidien *The Times-Picayune*, les films qui passaient dans les principales salles de cinéma étaient *Ne Mangez pas les marguerites*, avec Doris Day et David Niven ; *L'Homme à la peau de serpent*, avec Marlon Brando ; et *La Tête à l'envers*, avec Jane Fonda et Anthony Perkins. Les stations-services Texaco vendaient l'essence à 21 cents le gallon ; le grand magasin de luxe Maison Blanch battit des records d'affluence pour ses soldes de printemps ; on pouvait déguster n'importe où de délicieux *gumbo* et *jambalaya* pour 35 cents le bol et, dans les restaurants hauts de gamme Gallatoise et Antoine, s'offrir des dîners gastronomiques pour 6,95 dollars. Des « maisons bourgeoises de qualité » se vendaient autour de 20 000 dollars et les pavillons autour de 12 000 dollars. Les petites annonces d'emploi à l'arrière du *Times-Picayune* étaient séparées en colonnes pour « gens de couleur » et

pour « blancs ». Le mouvement pour les droits civiques n'était pas encore né.

Suivant le conseil du professeur Harry Oster, spécialiste de musique folklorique à la Louisiana State University, nous avons fait un détour par le pénitencier d'État de la Louisiane à Angola. La prison était célèbre pour être la plus grande des États-Unis, accueillant plus de trois mille détenus, parmi lesquels de nombreux bluesmen. Le grand Leadbelly y avait été incarcéré dans les années trente. Le professeur nous avait promis que nous y trouverions de nombreux excellents musiciens.

Le matin de notre arrivée devant les portes du pénitencier, le gardien nous accueillit avec froideur mais accepta néanmoins de nous conduire dans le bureau du directeur. Celui-ci écouta Joe lui expliquer que nous voulions photographier et enregistrer quelques-uns des musiciens détenus. Il tira sur son cigare, expira un nuage de fumée, puis demanda quel côté nous voulions visiter. « Le côté des nègres ou celui des blancs ? » Joe répondit aussitôt : « Oh, les quartiers noirs ! Ce n'est pas là qu'il y a le plus de musiciens ? » Le directeur nous lança un regard glacial et rétorqua : « Comme vous voudrez, mais je ne peux pas vous donner d'escorte, on manque d'effectifs. Vous serez livrés à vous-mêmes. » Nous avons parcouru un long chemin entre de hautes rangées de fils de fer barbelé jusqu'à parvenir devant la dernière porte. Une fois de l'autre côté, le professeur Oster demanda à rencontrer un chanteur de blues nommé Hoagman Maxey. Le groupe de détenus noirs s'écarta en silence pour nous laisser passer. Hoagman nous salua chaleureusement et nous présenta à plusieurs autres musiciens. Dès la première note de musique, toute hostilité se dissipa. Nous pûmes enregistrer et photographier plusieurs d'entre eux. Ma peur s'envola et nous passâmes un bon moment, comme les détenus. Leur musique et leurs histoires étaient à la fois déprimantes et inspirantes mais, surtout, elles étaient authentiques.

Nous avons quitté la Nouvelle-Orléans sous le charme de ses contradictions et de son aura pittoresque. Nous y avions entendu du bon vieux jazz entraînant, dîné merveilleusement bien et rencontré des gens sincèrement chaleureux et sympathiques. Aujourd'hui, après le passage dévastateur de l'Ouragan Katrina, elle a perdu une grande partie de sa beauté et de son insouciance. J'espère qu'elle les retrouvera un jour. Ce livre est dédié à la mémoire des nombreuses victimes et aux courageux survivants qui reconstruiront cette ville merveilleuse.

William Claxton
Beverly Hills, Californie
Automne 2006

PRÉFACE

Joachim E. Berendt

« Épargnez-vous le voyage », nous avait-on dit à New York. « Tous les jazzmen importants vivent ici désormais. Faites vos photos et vos interviews à New York ! »

Mais il n'y a qu'à New York que le jazz est perçu comme un langage musical universellement américain (et, avec l'américanisation croissante de notre monde, comme un langage international et planétaire). C'est aussi assez l'impression qu'on en a en Europe. En réalité, les styles et les manières de jouer du jazz diffèrent selon les villes et les paysages et demeurent l'expression de ces villes et de ces paysages même quand ils sont joués ailleurs. La Nouvelle-Orléans et le style Nouvelle-Orléans, le Midwest et le jazz de Kansas City, la Californie et le jazz west coast, le South Side de Chicago et le blues qu'on y joue sont autant d'expressions distinctes, reflétant ce que les musiciens vivent et ressentent dans un environnement donné.

Celui qui vit sous le climat de Californie et apprécie son « art de vivre » ne peut jouer de la même manière que celui contraint d'habiter dans les quartiers sombres du South Side de Chicago. Il en est pour le jazz comme pour la musique classique. Mozart appartient à Salzbourg, Grieg à la Norvège et les Strauss à Vienne. Leur musique est universelle, certes, mais si vous voulez vraiment les comprendre, vous devez vous rendre dans leur ville. On constate un étrange paradoxe dans le fait que New York est aujourd'hui la capitale du jazz alors que seule une poignée de jazzmen tous styles confondus y sont nés. Il doit bien y avoir une raison à cela et c'est ce que nous avons tenté de montrer au fil des pages de ce livre.

Au départ, New York ne représentait pour nous qu'un lieu de rendez-vous entre un photographe californien et un critique de jazz allemand, qui s'étaient entendus pour se retrouver à l'aéroport. Puis ce fut un endroit où obtenir bon nombre d'adresses et de bonnes suggestions. C'est aussi là que nous avons déniché la Chevrolet d'occasion dans lequel nous avons effectué notre périple. À son bord, nous avons sillonné les États-Unis pendant quatre mois, faisant d'abord le tour des états de l'est, puis deux fois l'allée et retour jusqu'à la côte Ouest, parcourant en tout plus de vingt-quatre mille kilomètres.

Un critique new-yorkais a parlé d'une « expédition de jazz, une aventure en jazz ». Avec ce que nous avons collecté, nous aurions de quoi remplir cinq volumes de la taille de celui-ci. Nous avons photographié des milliers de musiciens, en avons interviewés des centaines, avons enregistré des montagnes de bandes magnétiques. Compte tenu de l'abondance d'informations glanées sous forme d'entretiens et de conversations, il est frustrant de ne pouvoir en présenter ici qu'une petite partie mais cet ouvrage cherche surtout à documenter la vitalité du jazz au travers des photographies de William Claxton.

Une nuit que nous étions quelque part dans un hôtel en Georgie, William Claxton m'a dit : « La plupart des livres de photos sur le jazz sont beaucoup trop tristes. » Le fait est : d'innombrables clichés dans les livres sur le jazz capturent parfaitement l'humeur désespérée, l'ambiance cafardeuse et tout ce qui contribue au sentiment de solitude du jazzman, y compris la discrimination raciale et sociale qu'il subit. Mais le jazz est également une musique pleine de joie de vivre et d'une énergie débordante, d'une vitalité primordiale et d'une ironie pétillante. C'est la musique de la jeunesse et de l'humour. C'est aussi ce que nous avons essayé de traduire.

Ce livre ne cache aucunement sa « perspective européenne ». Depuis la parution des premiers ouvrages critiques sur le jazz – non pas aux États-Unis mais en Europe – les critiques européens, toutes écoles et orientations confondues, ont présenté des points de vue les démarquant de leurs confrères américains. Ce qui ne veut pas dire pour autant que les uns ont raison et les autres tort. Ce sont simplement différentes perspectives depuis différents continents. Le fait que la critique de jazz soit devenue de plus en plus universelle et tolérante ces dernières années est en grande partie due au fait que les critiques européens se sont enfin mis à écouter leurs confrères américains et que ces derniers leur prêtent d'avantage attention.

À mesure que, au fil de nos interminables conversations tandis que nous roulions sur les routes d'Amérique, ce livre prenait forme, nous avons souvent remarqués, avec une certaine pointe d'ironie, que nous rassemblions les deux éléments : nous avons déjà parlé plus haut de la perspective européenne. Bill Claxton, le Californien, représentait la vision américaine : son objectif offrant, littéralement, un « point de vue ».

Baden-Baden
Été 1961
Joachim E. Berendt

Pages 26 – 27 The French Quarter
Pages 29 Joachim E. Berendt (center), with our New Orleans jazz authority Richard Allen, conversing with members of the Eureka Brass Band.

Pages 26 – 27 Le Vieux Carré (le quartier français)
Page 29 Joachim E. Berendt (au milieu) avec notre expert en jazz de la Nouvelle-Orléans, Richard Allen, discutant avec des membres de l'Eureka Brass Band.

Seiten 26 – 27 Das French Quarter
Seite 29 Joachim E. Berendt (Mitte) und Richard Allen, unser Jazzexperte aus New Orleans, im Gespräch mit Mitgliedern der Eureka Brass Band.

LA NOUVELLE-ORLÉANS

« La Nouvelle-Orléans est une synthèse accomplie de l'Europe et de l'Amérique ou, plus précisément, du charme français, de l'appétit de vivre sud-américain, de la rationalité nord-américaine et de la vitalité noire. »

« Pas la peine d'aller à la Nouvelle-Orléans », nous avait-on dit. « Là-bas, le jazz est mort. » On nous a redit la même chose à Biloxi. Or, Biloxi n'est qu'à quatre-vingts kilomètres de la Nouvelle-Orléans, au bord du golfe du Mexique. Pourtant, une fois à la Nouvelle-Orléans, en l'espace de neuf jours nous avons assisté à deux processions musicales, à un enterrement, à un pique-nique de jazzmen et à six ou sept jam-sessions – tous dans le grand style de ce bon vieux temps où le jazz en était encore à ses premiers balbutiements. Mais parlons d'abord de Biloxi. C'est une petite station balnéaire comprenant trois clubs de jazz et plus de bons jazzmen qu'on peut espérer en trouver dans n'importe quelle grande ville d'Europe. Parmi eux, le pianiste John Probst. Jeune homme, il a joué avec Mose Allison à quelques kilomètres au nord de Biloxi. Il fut fortement influencé par ce dernier, même si, aujourd'hui, il a un style qui n'appartient qu'à lui. Il y a quelques années encore, John était aveugle. Il a recouvré la vue à un œil grâce à des exercices théosophiques de volonté et affirme qu'il compte en faire autant pour l'autre.

« La plupart de ces musiciens sont très modernes. C'est peut-être pourquoi ils considèrent qu'à la Nouvelle-Orléans, le jazz est mort. »

On retrouve la même force dans son jeu. Le lieu de rencontre de tous les musiciens de Biloxi est l'école de musique de Carmen Massey, un autre musicien qui a joué autrefois avec Mose Allison. Bill Claxton ne pouvait laisser passer l'occasion de photographier tous les jazzmen de Biloxi devant l'école (p.76). De gauche à droite : le batteur Bill Patey (qui, sur la photo, tient une guitare, à défaut d'une batterie) ; Earl Cobble, originaire de la Nouvelle-Orléans, un autre « guitariste » dont le véritable instrument est la batterie et qui fait partie du quartette John Probst ; le bassiste Jay Cave ; le pianiste Don Reitan, qui possède son propre ensemble dans un des clubs de jazz de Biloxi ; le trompettiste Mike Serpas (qui tient lui aussi une guitare d'emprunt, les seuls instruments disponibles dans l'école étant des guitares, des cithares et des harmonicas) ; John Probst ; puis, dessous, devant la balustrade ; le trompettiste Ben Clement ; le batteur Lee Charlton ; et enfin le directeur de l'école de musique de Biloxi, Carmen Massey. Il va sans dire que la plupart de ces musiciens sont très modernes. C'est peut-être pourquoi ils considèrent qu'à la Nouvelle-Orléans, le jazz est mort.
Plus tard, en nous rendant à la Nouvelle-Orléans, nous sommes passés devant plusieurs grandes affiches comme celle figurant au début de ce chapitre. Avant même d'entrer dans la ville, on sait grâce à ces affiches que, sur Bourbon Street – la « grand-rue du jazz » – ce dernier est commercialisé. Nous sommes également passés devant une station essence avec des fontaines bien séparées pour les Noirs et les Blancs. Cela n'a rien de surprenant pour un Américain qui s'est déjà rendu dans le Sud

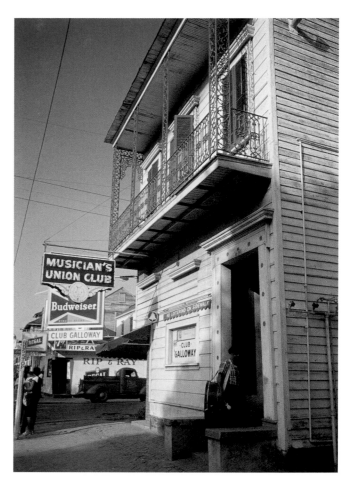

Above Paul Barbarin at the Musicians Union.

Ci-dessus Paul Barbarin au syndicat des musiciens.

Oben Paul Barbarin bei der Musikergewerkschaft.

mais l'Européen qui voit ce genre de chose pour la première fois ressent un choc qui, dans ce cas, n'est que légèrement teinté d'ironie par le fait que l'eau des Noirs et celle des Blancs s'écoule manifestement du même tuyau. Il y avait également une flaque d'eau sous la fontaine des blancs. Un petit garçon blanc qui ne voulait pas salir ses chaussures et qui ne s'était clairement pas encore penché sur les questions raciales a voulu boire à la fontaine des Nègres. Son père, horrifié, l'a rattrapé de justesse. Plutôt mourir de soif que boire là où un Nègre a bu avant vous !
La situation à la Nouvelle-Orléans était similaire. Les musiciens noirs et blancs jouent rarement ensemble et, du coup, ne se rendent pas compte qu'ils puisent leur eau à la même source. L'un d'eux, le trompettiste Nick La Rocca (aujourd'hui décédé) de L'Original Dixieland « Jass » Band, le célèbre orchestre blanc dont on dit qu'il aurait enregistré le premier disque de l'histoire

du jazz en 1917, a affirmé le plus sérieusement du monde que c'était lui avec d'autres musiciens blancs, et non les Noirs, qui avaient créé le jazz. Pendant des années, il a bombardé les critiques de jazz du monde entier de photocopies d'obscurs articles de presse qu'il décrivait comme «une démonstration claire» de sa thèse. Il les a également envoyées à la Tulane University de la Nouvelle-Orléans afin de pouvoir affirmer ensuite que celle-ci détenait les «preuves» que lui, Nick La Rocca, avait inventé le jazz. La naïveté avec laquelle ce terme «inventer» est utilisé régulièrement n'est pas le seul fait de Nick La Rocca. Depuis que Jelly Roll Morton a déclaré qu'il avait «inventé» le jazz en 1902, il s'est toujours trouvé quelqu'un pour soutenir qu'il l'avait inventé plus tôt, ou parfois plus tard. Tous, chacun avec sa clique de défenseurs et de détracteurs, prouvent surtout qu'ils sont des penseurs incompétents en appliquant le mot «inventer» à un développement artistique ou en attribuant sa création à un individu isolé. Qui a inventé la poésie? Ou la peinture? On peut inventer le moteur à vapeur, ou le trombone, pas un art.

«Qui n'a pas prétendu avoir inventé le jazz moderne?»

Quand j'ai téléphoné à Nick La Rocca, avant même de dire «bonjour» ou «comment ça va?», il m'a asséné: «Laissez-moi vous dire une chose, les nègres n'ont rien à voir dans cette histoire.» Puis il a déblatéré un long moment, la voix tremblante de rage, contre tous ceux qui doutaient que Nick La Rocca et les Blancs étaient les inventeurs du jazz. Il allait tous les traîner devant les tribunaux, affirmait-il, et les faire condamner. Ils commettaient un «crime contre l'histoire des États-Unis d'Amérique»; c'était tous des «communistes». Le type de complexes et de névroses perceptibles dans la personnalité de quiconque parle de «crime» et de «communistes» dans un contexte aussi inoffensif que celui-ci permet peut-être de mieux comprendre l'entêtement de feu Nick La Rocca. Dans une musique qui repose tant sur l'expression du musicien qui la joue, plutôt que sur celle du compositeur dont il interprète le morceau, il est facile de déraper. Après tout, c'est un phénomène que l'on retrouve tout au long de l'histoire du jazz, et pas seulement chez Jelly Roll Morton. *Qui* n'a pas prétendu avoir inventé le jazz moderne? Encore aujourd'hui, Thelonious Monk affirme qu'il jouait dans un style «moderne» avant Charlie Parker. Si ne voir les choses que par le bout de «sa» lorgnette est dans l'essence même du jazz et sert l'interprétation, il est inévitable que cela ait aussi un côté négatif. Il est humain qu'un musicien qui consacre toute son énergie à sa musique finisse par l'associer à ce qu'il en est venu à *penser* à force de regarder constamment par le petit bout de sa lorgnette, surtout quand sa musique a cessé d'être considérée par les autres comme «moderne». C'est d'autant plus vrai quand, indépendamment de la musique elle-même, l'atmosphère entre eux et ceux qu'ils accusent de les avoir «volés» est chargée de haine, comme c'est le cas dans le Sud avec les Noirs et les Blancs!

Nick La Rocca a dit un jour: «L'orchestre capable de jouer comme nous n'a pas encore vu le jour. C'est nous qui avons introduit cette musique dans le monde.» Il est indéniable que, parmi les musiciens qui ont compté dans l'histoire du jazz – et Nick La Rocca et l'Original Dixieland Jazz Band *ont* compté – il n'y en a jamais eu deux qui jouaient exactement de la même

manière. Pour ce qui est d'avoir «introduit» la musique, l'Original Dixieland Jazz Band fut le premier orchestre de jazz à rencontrer un grand succès en dehors de la Nouvelle-Orléans (notamment à New York) et l'histoire du jazz est marquée par les exemples d'orchestres et de solistes blancs qui ont su reprendre ce que les Noirs avaient créé pour en faire des succès. Mais Nick La Rocca ne peut avoir créé le jazz pour la simple raison que celui-ci comporte certains éléments qui ne peuvent avoir vu le jour entre les mains de Blancs: le phrasé, la tonalité et l'intensité rythmique. Ces éléments n'existaient pas dans la musique «blanche» avant l'avènement du jazz alors qu'ils sont omniprésents dans la musique «noire». Tous ceux qui ont tenté un jour de donner une définition rigoureuse du jazz en ont conclu que ces éléments faisaient partie de son essence. Sans eux, le jazz ne se conçoit pas, tout comme, d'un autre côté, il est inconcevable sans les instruments européens, la symétrie des formes européennes et les harmonies européennes. C'est précisément le problème du rythme qui montre à quel point la question de l'origine du jazz est complexe. On ne peut pas dire du rythme du jazz qu'il vient des Nègres. Sa régularité est européenne: elle vient de la marche. Les rythmes africains sont plus multicouches et asymétriques. Mais l'intensité de son rythme, en revanche, vient des Nègres. Elle n'a pas d'équivalent dans la musique européenne. L'amalgame s'est fait si progressivement qu'il n'y a jamais eu un moment visible ou audible où quelqu'un a pu lever la main en affirmant en être responsable. Et cela continue aujourd'hui. La musique de Bob Crosby contient plus de rythmes de marche que les anciennes *marching bands* de la Nouvelle-Orléans. L'*Orgy in Rhythm* d'Art Blakey comporte plus de rythmes africains que même les exemples les plus «africains» des premiers airs de jazz, y compris les *shouts*, le blues country, les chants de travail et les spirituals. On pourrait donc presque dire que Nick La Rocca est victime du sac de nœuds qu'est l'amalgame à l'origine de sa propre musique. C'est de là qu'il tient son complexe, qui fait rire même les musiciens blancs de la Nouvelle-Orléans. Ils l'ont traité de fanatique, d'individu avec qui il était impossible de discuter. Mais il ne fait aucun doute qu'eux aussi, ils tiennent à souligner la contribution des Blancs à la genèse du jazz. Presque tous les musiciens blancs à la Nouvelle-Orléans estiment que la contribution des Nègres au jazz a été exagérée. D'un autre côté, chaque Nègre – s'il se donne la peine d'y réfléchir – soutient que les Blancs ont toujours récupéré ce que les Noirs avaient créé, le présentant au grand public et gagnant de l'argent avec, si bien que le public n'a pu découvrir la musique des Nègres qu'au travers des Blancs.

Le premier et le plus âgé de ces musiciens blancs est «Papa» Jack Laine. Le New Orleans Jazz Club lui a remis un certificat stipulant qu'il était le «père du jazz blanc». Le fait est que s'il existe quelque chose comme le «jazz blanc», Papa Laine est certainement mieux placé que Nick La Rocca pour revendiquer sa paternité, dans la mesure où il en jouait avant que La Rocca ne soit né. Papa Laine, de son vrai nom Johnny Stein, descendant d'une famille allemande, fut le premier grand chef d'orchestre de jazz. Il a dirigé plus de formations différentes entre 1889 et 1920 que Woody Herman cinquante ans plus tard. Parfois, il avait plusieurs orchestres à la fois, tous sous son nom même s'il ne pouvait tenir la batterie que dans un seul à la fois. Naturellement, Papa Laine affirme lui aussi avoir été le premier. Tout le monde à la Nouvelle-Orléans a été le premier à faire quelque chose. Selon Papa Laine: «C'est moi qui ait tout commencé. Avant moi, il y avait juste un orchestre de nègres qui ne

comportait que des cuivres, mais c'est moi qui ai monté le premier vrai orchestre de jazz. » Néanmoins, il en appelle à la reconnaissance des Nègres, déclarant dans la foulée : « Même les Nègres ont salué ma musique. » Aujourd'hui, Papa Laine habite un peu en dehors de la Nouvelle-Orléans, dans une petite bicoque près de la voie ferrée où les trains passent sans arrêt. Il fabrique des casques de pompier. Il nous a fièrement montré un document attestant qu'il est : « Membre à vie de la David Crockett Steam Fire Company No. 1 » depuis 1913. Il a rejoint la brigade de pompiers parce que, à l'époque, leurs défilés étaient particulièrement splendides. Cela fait trente ans sans interruption qu'il confectionne des casques pour sa compagnie. Il en a aujourd'hui fabriqué plus que sa brigade ne comptera jamais de membres. Sa femme nous a montré une photo de 1895 dans l'album de famille, montrant le jeune Laine pas encore « Papa » dans son uniforme de pompier.

C'est Joe Mares qui veille sur les besoins des musiciens blancs (et de quelques noirs) à la Nouvelle-Orléans avec sa maison de disques, Southland Records. Joe est le frère de Paul Mares, le trompettiste des New Orleans Rhythm Kings et le grand concurrent de Nick La Rocca. La maison de disques de Joe est située en plein cœur du « Vieux Carré », l'ancien quartier français de la ville, sur St. Louis Street. Il a invité pour nous tous les musiciens qu'il pouvait rassembler pour une jam-session, y compris Harry Shields, le frère de Larry Shields, l'ancien clarinettiste de l'Original Dixieland Jass Band ; Raymond Burke, son équivalent parmi les jeunes clarinettistes néo-orléanais d'aujourd'hui ; le tromboniste Emile Christian, qui a également joué dans l'Original Dixieland Jass Band vers 1918 avant de partir vivre en France pendant quinze ans ; le trompettiste Tommy Gonsoulin, qui a joué dans les orchestres de Gene Krupa et de Jack Teagarden ; le banjoïste Joe Caprano ; le contrebassiste Bob Coquille ; le batteur Sal Gutierrez ; le tubiste James « Pinky » Wadlington ; et deux des plus célèbres musiciens blancs du moment à la Nouvelle-Orléans, le trompettiste Sharkey Bonano et le pianiste de ragtime Armand Hug, un des derniers vrais musiciens de ragtime encore vivant. Les seuls invités noirs à la session étaient Sister Elizabeth Eustis et son accompagnateur. Depuis que Mahalia Jackson a quitté sa Nouvelle-Orléans natale, Sister Elizabeth est la meilleure chanteuse de spirituals et de gospels de la ville. Elle possède sa propre émission radiophonique mais continue de chanter au coin des rues du Vieux Carré tous les dimanches comme à ses débuts, s'accompagnant d'un simple tambourin.

« 1938 et 1944, la grande époque du New Orleans Revival, quand les formes des débuts du jazz ont été redécouvertes. »

Alors que nous traversions la rue en diagonale pour rejoindre le magasin de disques de Bill Russell après la session chez Joe Mares, un des musiciens a dit : « Personne n'en a fait plus pour le jazz à la Nouvelle-Orléans que Bill. Malheureusement, il s'intéresse un peu trop aux Nègres. » La première partie de cette affirmation ne fait aucun doute. Bill n'est pas un musicien, et au fond, ce n'est pas un critique non plus. C'est un mordu, qui a dépensé jusqu'à son dernier sou à capturer les musiciens de la Nouvelle-Orléans sur disque et, ce, à une époque où personne

n'aurait jamais imaginé qu'il y avait quelque chose à enregistrer à la Nouvelle-Orléans. Bill vivait alors à Chicago. Depuis, il a réalisé le rêve de sa vie. Il possède une boutique de disques de jazz en plein milieu du Vieux Carré, le lieu de rendez-vous de tous ceux en ville qui s'intéressent au jazz. Dans le magasin, on pouvait à peine avancer entre les piles de disques, de vieilles photos, de gravures, d'affiches, d'illusions d'optiques stéréoscopiques et de clichés de cinéma des années vingt. Assis au milieu de ce chaos, Bill Russell répare de vieux violons. Il démonte deux ou trois instruments abîmés et en construit un neuf avec les pièces récupérées. Tout en travaillant, il écoute des disques, mais rarement du jazz. Il préfère les grands concertos pour violons, surtout ceux de Mozart. Bill Russell est l'incarnation de tous ceux qui sont fascinés par la Nouvelle-Orléans, son atmosphère, sa musique. C'est un intellectuel si personnel et humain qu'il n'a pas l'air d'un intellectuel. Il est de ces êtres nourris au romantisme européen mais conscients que ce romantisme s'effrite. Ils se cherchent alors un substitut qui soit aussi fort et chaleureux, et trouvent la Nouvelle-Orléans. Quelqu'un a dit un jour que Bill Russell était tout « âme ». C'était la première fois que j'entendais ce terme d'âme – soul – associé au jazz, longtemps avant l'avènement de la musique soul moderne.

Il existe tout un groupe de personnalités de ce genre aux États-Unis, Bill Russell étant leur *primus inter pares*. Les grands magazines de jazz ne mentionnent leurs noms que rarement, pourtant, ils ont accompli un travail ardu de collecte et d'éducation qu'on ne saurait trop louer aujourd'hui : David Stuart à Hollywood, Charlie Gamble à San Francisco ; avant eux, Lester Kœnig et Nesuhi Ertegun, qui dirigent aujourd'hui les maisons de disques Contemporary et Atlantic ; à Chicago, John Steiner pour le style propre à la ville ; plus récemment à New York, Frank Driggs, pour le jazz de Kansas City. Autant d'hommes qui, à une certaine période de leur vie, se sont donnés corps et âmes pour défendre une forme particulière du jazz, sans jamais cesser d'être cosmopolites, ouverts d'esprit, dépourvus du fanatisme ou des complexes qui, encore aujourd'hui, incitent certains individus en Europe à croire qu'il faut « lutter » pour le jazz traditionnel. Ce combat a déjà été mené, et la victoire remportée entre 1938 et 1944, la grande époque du New Orleans Revival, quand les formes des débuts du jazz ont été redécouvertes. Ceux qui « luttent » encore aujourd'hui sont comme ces anciens combattants qui ressassent sans cesse leurs vieilles batailles, obnubilés par leurs souvenirs de guerre et leurs complexes, indépendamment de la victoire ou de la défaite, et qui sont toujours membres du « Stahlhelm ». Bill Russell et son jeune collaborateur, Dick Allen – sorte de double de Russell en plus jeune et typique homme du Sud – collectent des documents pour constituer les archives du jazz de la Tulane University (pour cette seule raison, il est impensable que ces documents « prouvent » que le jazz a été inventé par des musiciens blancs).

Quand on se promène avec eux dans les rues de la Nouvelle-Orléans on rencontre tous les dix pas quelqu'un associé au jazz, directement ou indirectement. Sur Burgundy Street, par exemple, nous sommes tombés sur « Brother » Percy Randolph, un marchand ambulant qui circule dans une simple charrette chargée de camelote et attire les chalands en chantant des blues et en jouant de l'harmonica. Autrefois, il jouait de la planche à laver mais la police le lui a interdit en raison du vacarme. Il existe encore d'autres chanteurs de rue comme lui à la Nouvelle-Orléans, comme Blind Snooks Eaglin et Lucius Bridges. Sans parler de Sister Elizabeth, mentionnée plus haut,

qui chante des spirituals au coin des rues le dimanche. Parmi les musiciens de blues qui se produisaient souvent dans la rue mais sont aujourd'hui trop vieux pour continuer de le faire, on compte la chanteuse et pianiste Billie Pierce et le trompettiste Dee Dee Pierce. Dee Dee vient d'une vieille famille francophone de Louisiane, sa femme, de Floride. Billie a accompagné Bessie Smith, entre autres, et Dee Dee a joué avec d'autres musiciens célèbres de la Nouvelle-Orléans dont Kid Rena et Buddy Petit. Le répertoire de ces deux émouvants vieillards inclut aujourd'hui des chansons folkloriques et des blues créoles. Ils chantent la bonne cuisine créole, l'époque où les Créoles incarnaient une véritable culture néo-orléanaise que les Blancs, sans parler des Nègres, ont perdu de vue aujourd'hui. Pendant vingt ans, Billie et Dee Dee se sont produits au Luthjen's Dance Hall, un de ces vieux dancings trop souvent oubliés dans l'histoire du jazz de la Nouvelle-Orléans. Le fait est que le « quartier chaud » et les bordels de Lulu White impressionnent beaucoup plus les esprits mais il n'empêche que la musique qu'on y jouait a d'abord été testée sur un public noir avant d'être présentée aux clients des maisons closes et aux touristes.

La dernière et, on pourrait presque dire la seule, grande chanteuse de blues de la Nouvelle-Orléans encore parmi nous est Lizzie Miles. Elle chantait déjà avec King Oliver en 1915, avant qu'Oliver ne parte pour Chicago. Elle a ensuite travaillé avec Jelly Roll Morton et Fats Waller puis est allée vivre à Paris. Aujourd'hui, elle habite dans un appartement immaculé, mais on ne l'y trouve que rarement car elle se rend à l'église plusieurs fois par jour.

C'est là un autre aspect trop souvent négligé dans les histoires du jazz néo-orléanais. Elles s'attardent sur la réputation de « pécheresse » de la ville en oubliant de décrire son catholicisme. Or, ce dernier nous a plus frappé que son goût pour le péché. Certes, le rapport entre les deux a sans doute changé au fil du temps mais, la ville industrielle moderne étant encore très catholique, tout laisse penser que la Nouvelle-Orléans d'antan l'était encore plus. Si Lizzie Miles est la seule grande chanteuse de blues de la Nouvelle-Orléans, c'est parce que la ville a été la capitale du jazz mais jamais un grand centre du blues. Ici, le côté heureux, jovial, du jazz a toujours occupé le devant de la scène. Le blues, lui, dont la structure et l'harmonie n'était pas encore totalement développés, se trouvait surtout dans la campagne, sous forme de *country blues* ou de « blues rural ».

À la Nouvelle-Orléans, le Nègre jouait moins le rôle de « l'amoureux éconduit » que dans le blues. En effet, c'est bien là la principale distinction entre l'amour tel qu'il est présenté dans les paroles du blues et dans celles des chansons sentimentales européennes. Chez nous, le chanteur parle de la femme qu'il désire. Dans le blues, il évoque les femmes qu'il a connues, qui lui ont appris à aimer puis l'ont trahi ou abandonné. On ne peut pas expliquer cette différence de manière superficielle en arguant que les rapports amoureux obéissaient ici à une logique à part. Ce n'est certainement plus le cas aujourd'hui alors que les anciens thèmes d'autrefois persistent dans le blues moderne. La raison en est probablement que, dans ce contexte, la femme incarne une

sorte de substitut ou symbolise la civilisation blanche. Ce n'est pas vis-à-vis de ses femmes mais de l'homme blanc que le Nègre se retrouve dans la position de l'amoureux éconduit, celui qu'on aguiche de temps en temps sans jamais lui permettre de rien posséder définitivement. À la Nouvelle-Orléans, seuls les Créoles étaient autorisés à devenir propriétaires et encore, pas à titre permanent. Toutefois, ils conservèrent ce droit jusque dans les années qui suivirent « l'émancipation » des esclaves, quand les Blancs commencèrent à faire de moins en moins de distinctions entre les Nègres, pour des raisons de « simplification » autant que de « principe ».

« Quand on arrive à la Nouvelle-Orléans, on a toujours la sensation de ne plus être aux États-Unis. »

Ce n'est pas un hasard si *Burgundy Street Blues* de George Lewis, avec son atmosphère créole, en est venu à symboliser le blues de la Nouvelle-Orléans. C'est certainement un des plus beaux enregistrements de blues dans l'histoire du jazz mais, comme l'a démontré le professeur Ingolf Wachler, il est « arrangé pour faire beau », sans la lourdeur, la noirceur, la désolation et, surtout, le réalisme qui caractérisent le blues authentique. Dans la « belle tristesse » du *Burgundy Street Blues* on retrouve les superbes ornements élégants et fantasques des balcons en fer forgé, des vérandas, les terrasses de la ville, ses patios ombragés et paisibles. George Lewis est aujourd'hui le représentant le plus en vue du jazz néo-orléanais. À l'heure actuelle, il ne reste plus dans le monde que trois orchestres de haut niveau à jouer un authentique jazz de la Nouvelle-Orléans en s'inspirant de leurs propres traditions et expériences plutôt que de servir une resucée sous forme de revival ou de reconstitution de seconde ou troisième main à partir de disques anciens. Ces trois orchestres sont le George Lewis Band à la Nouvelle-Orléans, le Wilbur De Paris « new » New Orleans Band à New York et le Kid Ory's Creole Jazz Band à San Francisco. Le George Lewis Band peut s'enorgueillir d'avoir deux solistes hors pairs : le tromboniste Jim Robinson et le contrebassiste Slow Drag Pavageau. Les détracteurs de George Lewis lui reprochent toujours d'émettre un nombre alarmant de fausses notes. Le miracle de sa musique fait que cela ne l'empêche pas de créer une atmosphère d'une sensibilité rare et d'une grande culture, à savoir, cette atmosphère même qui, en temps normal, paraît incompatible avec l'incompétence technique (alors que l'expressivité, la vitalité et la sincérité s'accommodent fort bien des fausses notes). Il y a peu de musiciens à la Nouvelle-Orléans qui produisent une musique aussi sensible et sophistiquée que celle de George Lewis. Elle rappelle celle du Modern Jazz Quartet aujourd'hui. La vieille culture créole et la tradition française des bois est à George

Lewis ce que la musique baroque est à John Lewis du Modern Jazz Quartet.
La tradition des bois, qui jouit encore d'un statut très élevé dans le monde de la musique symphonique, est entrée à la Nouvelle-Orléans principalement à travers son célèbre French Opera. Les musiciens français qui jouaient des instruments à vent eurent un rôle tout aussi déterminant dans le jazz de la Nouvelle-Orléans que les allemands qui jouaient des cuivres dans celui de St. Louis. Ce n'est pas un hasard si les plus grands clarinettistes néo-orléanais étaient créoles. Contrairement aux autres Nègres, ils étaient plus proches de la culture française qu'américaine.

À la Nouvelle-Orléans, on constate sans cesse à quel point ces vieilles traditions sont encore vitales et vivantes aujourd'hui, et pas seulement dans le monde du jazz. Le rythme frénétique et la structure du 20ᵉ siècle ne sont pas parvenus à les affaiblir. Pour chaque note de leurs improvisations, les jeunes clarinettistes comme Raymond Burke ou – sur un plan plus commercial – Pete Fountain, puisent directement dans l'ancienne tradition française des bois. Au moment de notre voyage, un clarinettiste des débuts du jazz – peut-être le plus grand de tous – vivait encore à la Nouvelle-Orléans, Alphonse Picou, dont le nom à lui seul trahit les origines créoles. Né en 1878, il a joué dans toutes sortes d'orchestres depuis 1894, de l'Olympia Band and Bunk Johnson au début du siècle à Papa Celestin au milieu du siècle. Son célèbre solo dans *High Society* est sans doute le plus imité de l'histoire du jazz. Pratiquement tout musicien interprétant *High Society* le cite ou en utilise des fragments. Alphonse Picou avait un petit bar dans la Ursuliner Street où les musiciens se rencontraient souvent. On nous avait conseillé de nous présenter avant onze heures du matin si nous voulions le trouver à jeun, mais, même ainsi, c'était déjà trop tard. Alphonse Picou était ravi que quelqu'un se souvienne encore de lui. Il a pris sa clarinette équipée de sa cloche étrange qui lui donne l'air d'un saxophone (« Le son est beaucoup plus puissant comme ça ») et s'est mis à danser dans son club désert. Après quelques couacs initiaux, il nous a joué des phrases entières comme le solo de *High Society*, limpides et parfaites. Alphonse Picou est mort en février 1961 à l'âge de quatre-vingt-deux ans.
Paul Barnes est un autre de ces clarinettistes qui incarne encore l'ancienne tradition française des bois. Il joue principalement dans le Kid Thomas New Orleans Jazz Band, que beaucoup décrivent comme le digne successeur du George Lewis Band maintenant que George Lewis se fait vieux. Lors d'une fête universitaire, nous avons eu l'occasion d'apprécier la puissante trompette de Kid Thomas, éclatante de vigueur. Sa formation était composée de Louis Nelson (trombone), de Paul Barnes (clarinette), de Manuel Paul (saxophone ténor), de Sammy Penn (batterie), de « Kid Twat » Joseph Butler (basse) et de George Guesnon (banjo). Guesnon est également chanteur sous le nom de scène « Creole Blues ». Avec son beau blues mélodieux, il transmet ce lien cultivé, indirect et si typiquement créole au blues dont nous avons parlé plus haut.
Aujourd'hui encore, on a l'impression que, dès ses débuts, le jazz à la Nouvelle-Orléans a toujours été une affaire de famille. En se promenant dans la rue, quand on ne tombe pas sur les musiciens, on tombe sur leurs parents. Nous avons croisé Louis Keppard, par exemple, sortant d'une épicerie. Louis est le frère de Freddie Keppard, le second « roi du Jazz » de la ville, (après Buddy Bolden et avant King Oliver). À l'époque, il y a cinquante ans, quand Freddie jouait de la trompette, Louis était banjoïste.

Left Although the Preservation Hall Jazz Band Foundation wasn't formed until 1961, this band played in this store front space for many years prior.

À gauche Bien que le Preservation Hall Jazz Band Foundation ne s'est constitué qu'en 1961, cet orchestre jouait déjà devant la vitrine de ce magasin depuis de longues années.

Links Die Preservation Hall Jazz Band Foundation wurde erst 1961 gegründet, aber die Band spielte schon viele Jahre vorher im vorderen Teil dieses Ladenlokals.

ment jamais. On en voit de toutes les formes et couleurs, non seulement dans les défilés mais partout où des Nègres se retrouvent pour s'amuser. Ils symbolisent un petit ciel amical sous lequel on est en sécurité. Hors de ce ciel s'étend un monde blanc hostile. À moins qu'il n'y ait une autre explication à la popularité parmi les Nègres de ces parapluies et ombrelles très symboliques ?

Après le défilé, la Creole Fiesta Association a donné une fête dans ses locaux. Cela a commencé par un repas formel puis les gens ont dansé et continué à manger. Le gâteau mesurait un mètre et demi de diamètre et tout le monde a eu sa part. De vieilles dames dignes contrôlaient les opérations, veillant à ce que tout ce passe conformément aux usages et aux conventions. Tout le monde semblait savoir à l'avance avec qui il ou elle était censé danser et, pourtant, tous paraissaient détendus et heureux. La présidente ne cachait pas ce qu'elle considérait être le but de l'association : « Nous cultivons les anciennes traditions pour que les jeunes constatent à quel point elles sont belles et continuent à les entretenir. » Quand je lui ai demandé si seuls les Créoles noirs pouvaient adhérer à l'association, elle m'a répondu : « Nous accueillons tous ceux qui considèrent qu'ils sont ici à leur place. » Mais les messieurs âgés, eux, mettaient un point d'honneur à parler en créole, une sorte de français abâtardi incluant des fragments d'espagnol, d'anglais et de langues africaines, avec tous ceux dont ils avaient de bonnes raisons de penser qu'ils le comprendraient. Le grand quadrille a marqué le moment fort de la fête. Les danseurs se sont séparés, les hommes formant une rangée, les femmes une autre, puis se sont rejoints et séparés à nouveau. Chaque fois que les couples se reformaient, ils tournoyaient sur place. On serait cru à la cour du roi de France au 18e siècle plutôt que dans un bal jazz. Les vieux danseurs s'appliquaient à exécuter minutieusement des petits pas classiques de menuet. Seuls les étrangers semblaient décontenancés par le paradoxe de les voir danser sur la musique du Tuxedo Brass Band. Aucun des danseurs ne doutaient que le jazz néo-orléanais joué par l'orchestre était la parfaite expression musicale de la vieille culture de danse courtoise française. Quand les musiciens annoncent qu'ils vont jouer un menuet, une polonaise ou une gavotte, ils ne plaisantent pas. Ils croient vraiment jouer des menuets, des polonaises et des gavottes. En fait, ils jouent du jazz de la Nouvelle-Orléans. Seuls les musicologues sont à même de reconnaître des éléments des danses formelles d'autrefois en décomposant minutieusement leur musique. Une fête créole telle que celle-ci représente beaucoup plus que la simple transmission d'une belle tradition ancienne à la nouvelle génération. L'éclat dont jouit la tradition créole est également lié à la situation raciale. Les Créoles étaient libres avant la guerre de Sécession et la pseudo émancipation des Nègres. Plus libres sous l'esclavage que les Nègres ne le sont aujourd'hui, un siècle après son abolition. Les Créoles de la Nouvelle-Orléans étaient des Nègres affranchis par les planteurs et les dirigeants coloniaux français. Ils étaient souvent les enfants des maîtresses noires qu'il était de bon ton d'avoir quand on était un homme d'une classe supérieure. Ils devinrent bientôt les commerçants les plus habiles et les plus prospères de la ville. Ils entretinrent la culture française même après que Napoléon eut vendu la Louisiane aux États-Unis. Ils étaient plus cultivés, mieux éduqués et mieux élevés sous l'esclavage que les Nègres – et la plupart des Blancs – du Sud aujourd'hui. Pour cette raison, le goût pour les traditions créoles ne signifie pas

uniquement le goût de la tradition, c'est une forme cachée d'émancipation refoulée et de protestation.

William E. Pajaud nous a quittés le 12 mai 1960, « époux aimé de Mme Sallie Pajaud, père de William Pajaud, frère d'Albert Pajaud … ». La notice nécrologique du journal continuait ainsi sur douze lignes, citant toute la famille élargie, avant de conclure : « Les parents et amis de la famille, les pasteurs, les anciens, et les membres de la King Salomon Baptist Church, les fils et les filles de la résurrection, ‹ Die freundliche Acht ›, ‹ The Bells of Joy ›, la ‹ Star of Bethlehem Loge › … (Suivaient dix autres associations dont le défunt avait fait partie) … sont invités à la cérémonie funèbre le 14 mai 1960 à 15h. La procession partira des pompes funèbres Louisiana Undertaking, au 1449 North Claiborn Avenue. » Toute sa vie durant, William E. Pajaud avait été trompettiste dans l'Eureka Brass Band. Sa spécialité, c'était les « chants funèbres », ces airs lents et tristes joués lors des processions funéraires en route vers le cimetière. Pendant des décennies, nombreux furent ceux à la Nouvelle-Orléans qui espéraient qu'il pourrait les accompagner avec sa trompette jusqu'à leur dernière demeure. Rien ne lui faisait plus plaisir. « Je préfère jouer à un enterrement que manger de la dinde au dîner. » La veille de sa mort encore, il avait joué à un enterrement. Il avait cinquante-huit ans. Pour cette raison, ses propres funérailles ont attiré les foules. Les gens se sont rassemblés devant le salon funéraire, puis la longue procession s'est mise en marche vers le St. Louis Cemetery No. 2. Le « grand maréchal » ouvrait la voie, avançant d'un pas lent et digne mais néanmoins dansant. Puis venait l'Eureka Brass Band, la famille du défunt et, enfin, tous les autres. L'orchestre a joué tous les chants funèbres qui avaient fait la renommée de William E. Pajaud et qu'il jouait particulièrement bien, notamment le vieil hymne *Just a Closer Walk with Thee*.

« Traditionnellement, on jouait de la musique triste en route vers le cimetière, puis gaie en revenant à la maison, très rythmée et exubérante. »

Il fut un temps où le sol de la ville était si marécageux qu'il était impossible d'ensevelir les morts. C'est de là qu'est venue l'habitude de les placer au-dessus de la surface dans de massives structures en pierre. L'installation de l'urne dans la tombe a donné lieu à une scène déchirante. Mme Pajaud pleurait et bégayait encore et encore : « Adieu, Willie ». Les autres femmes étaient tout aussi démonstratives. Des enfants avaient escaladé les murs du cimetière pour observer. D'autres attendaient déjà l'Eureka Brass Band à la sortie, prêts à former la « seconde vague » et à danser derrière l'orchestre, dont les accords étaient revenus parmi les vivants, swinguant et jovials. Là encore, on a entendu des standards de tous les enterrements néo-orléanais comme *Just a Little While to Stay Here*, une chanson sur le bref laps de temps qui nous est donné à vivre sur cette terre. À l'origine, c'était un choral mais, ici, il était swingué comme s'il s'agissait de *When the Saints Go Marchin' In*. Il va s'en dire que ce denier morceau a également été joué.
Le dimanche suivant, il y a eu une autre parade, organisée cette fois par la True Love Missionary Baptist Church School. Une fois de plus, le « grand maréchal » ouvrait la marche. Il y avait deux

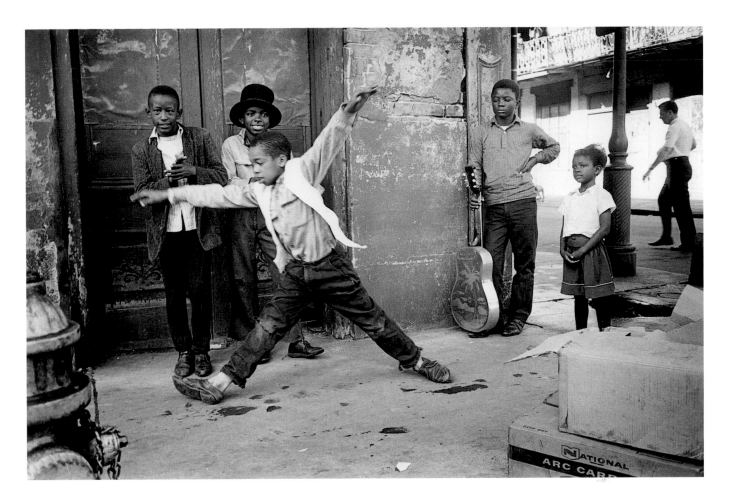

fanfares, la Tuxedo et la George Williams Brass Band. Comme d'habitude, il y avait des trombones, des trompettes, des saxophones, des clarinettes, des sousaphones et d'autres instruments à vent ainsi qu'une série de grands et petits tambours. Des enfants, des mères et des pères marchaient derrière les orchestres dans leurs habits du dimanche. Naturellement, il y avait là aussi une « seconde vague » enthousiaste. Des gamins s'étaient perchés dans les arbres pour mieux voir. La procession incluait également quelques voitures tirées par des chevaux, pour les dames distinguées qui souhaitaient montrer que marcher était indigne d'elles. Un peu partout, on voyait se balancer des étendards, certains encore en français, encore un geste vers la vieille tradition créole. Quand la procession s'est engouffrée dans l'église, la Tuxedo Brass Band s'est placé dans le chœur face aux fidèles et a ponctué tout le sermon d'airs de jazz de la Nouvelle-Orléans.

Naturellement, nous avons voulu visiter le lieu de naissance de Louis Armstrong. James Alley, où Satchmo a vu le jour, se trouve loin du Vieux Carré, dans un quartier pauvre et mal famé coincé entre le Perdido et Gravier Street. Même le professeur Souchon, le grand monsieur du New Orleans Jazz Club, nous avait déconseillé de nous y rendre. La zone toute entière ressemble à un champ de ruines après un bombardement aérien, juste après qu'on ait construit quelques abris de fortune. On a du mal à imaginer que des gens vivent dans ces cabanes depuis soixante-dix ou quatre-vingts ans. Au début, nous n'avons croisé que des visages hostiles, en colère. Personne dans James Alley n'a voulu nous donner d'indications. Nous avons quand même fini par trouver la maison natale de Satchmo,

Above / Pages 40–41 Street performers in New Orleans.

Ci-dessus / Pages 40–41 Des artistes de rue à la Nouvelle-Orléans.

Oben / Seiten 40–41 Straßenkünstler in New Orleans.

une bicoque délabrée en bois, au n°723. Avant même de l'avoir repérée, avons entendu des improvisations très modernes à la trompette. C'est alors que nous avons vu l'incroyable : dans la même chambre (si on peut l'appeler une « chambre ») qui avait vu naître Louis Armstrong, un adolescent de quatorze ans jouait de la trompette. Il s'appelait Jerry McGhee. Naturellement, nous l'avons interrogé sur Louis Armstrong mais le vieux Satchmo ne l'intéressait pas le moins du monde. Certes, il avait entendu dire un jour qu'Armstrong était né dans cette pièce mais cela ne l'impressionnait pas plus que si on lui avait dit que M. Meier ou M. Schulze y avait habité. « Je préfère de loin Clifford Brown », nous a-t-il annoncé. Plus tard, nous avons rencontré la mère de Jerry. La jeune femme vit avec son mari (un chauffeur routier) et leurs neuf enfants dans deux pièces. Elle nous a dit : « J'aimerais bien que Jerry joue de la guitare plutôt que de la trompette. Il pourrait devenir le prochain Elvis Presley ! »

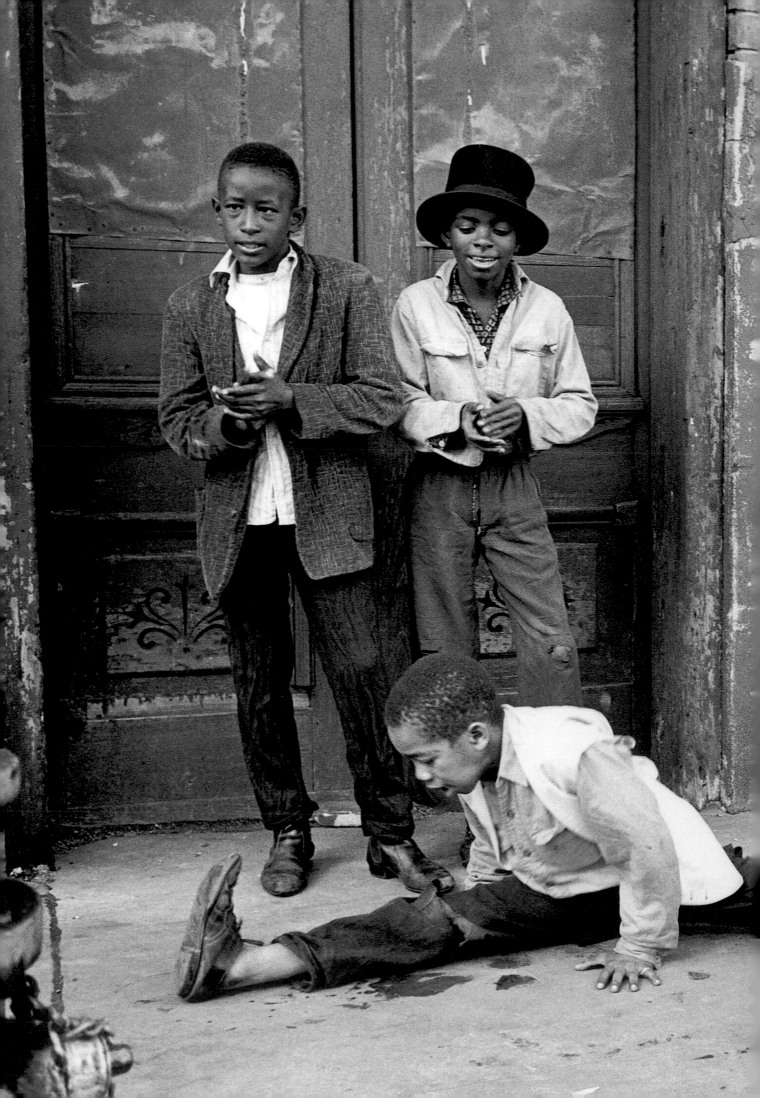

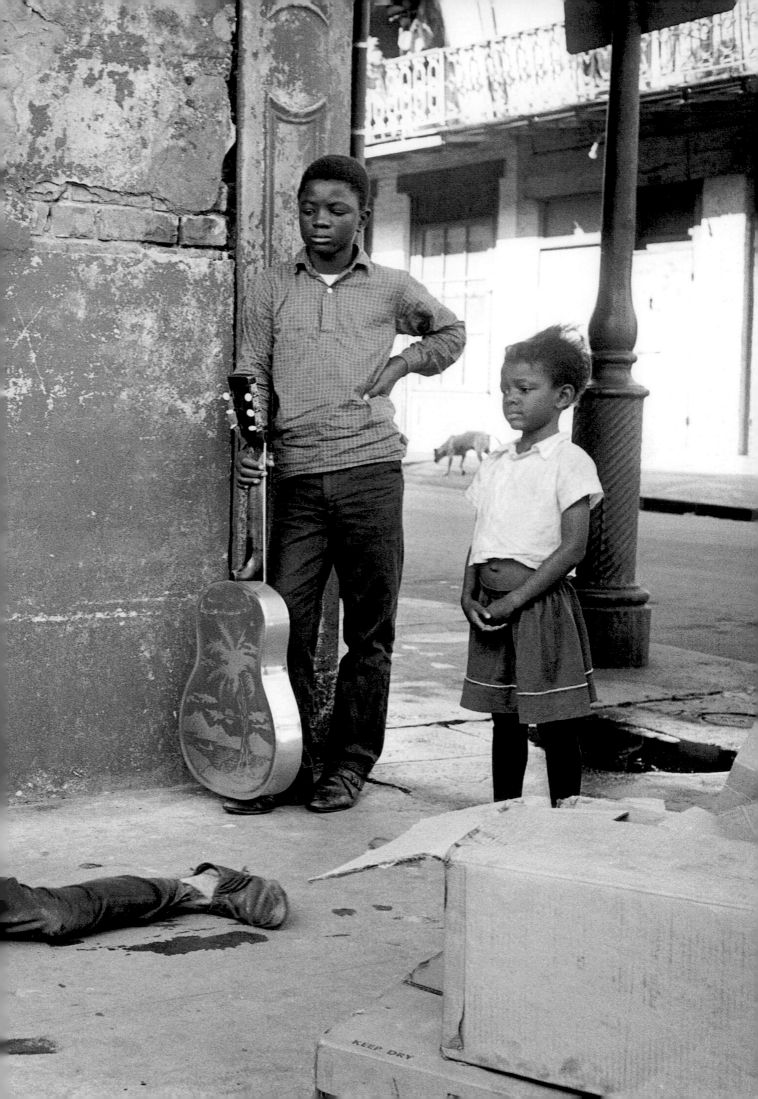

VORWORT
William Claxton

Als ich im Mai 1960 zum ersten Mal nach New Orleans, Louisiana, kam, war mir, als sähe ich den hinteren Teil eines riesigen Filmstudios. Mit dieser bunt gemischten Architektur, den mit Natursteinen und Ziegeln gepflasterten Straßen hätte man genausogut in Paris, Madrid oder Boston sein können. Entlang der Boulevards von New Orleans standen griechische Villen mit weißen Säulen und moosbehangene Bäume. Die Straßen waren von exotischen Magnolien überdacht. Wenn man ins French Quarter kam, jenes Land des Mardi Gras, war man von Architektur im viktorianischen Stil umgeben – roter Backstein und geschnitztes Holz mit dekorativen filigranen Eisengittern. In den Vororten folgte eine Straßenreihe auf die andere, gesäumt von der gleichen Art von Backsteinhäusern mit Holzrahmen, die nach dem Zweiten Weltkrieg erbaut worden waren. Und ehe man sich's versah, war man von Teerpappe und verfallenden Holzhütten umgeben, die zum überwiegenden Teil von den Nachfahren der afrikanischen Sklaven bewohnt wurden. Das war der Teil, wo die Armen wohnten. Nur die Kreolen, die in den Sklavenjahren ihre Freiheit gewonnen und sich hauptsächlich mit französisch-kanadischen Siedlern vermischt hatten, lebten ein Leben der gehobenen Mittelklasse und fanden sich in exklusiven Clubs, Bruderschaften und anderen sozialen Organisationen zusammen.

Geografisch gesehen erstreckt sich New Orleans über den Kegel eines grandiosen Deltas, unterbrochen von den zahlreichen schneckenartigen Windungen des mächtigen Mississippi. Inmitten dieser einzigartigen halbtropischen Szenerie liegt ein Schmelztiegel vieler Kulturen, deren Küche, Religionen (hauptsächlich Katholiken und Baptisten), Künste und Unterhaltungen so vielfältig sind wie die hier lebenden Siedler. Die Bewohner der Stadt sind vornehme und höfliche Menschen von liebenswürdiger Freundlichkeit, die als ›südliche Gastlichkeit‹ bekannt ist. Ihre Musik, genau wie ihre multikulturell geprägte südliche Küche, verrät den europäischen und afrikanischen Hintergrund der Bewohner. Die Franzosen und Engländer brachten Streich- und Holzblasinstrumente mit, die

Deutschen ihre Blechblasinstrumente und die Afrikaner ihren Herzschlag mit Trommeln und ihren einzigartigen Urwaldrhythmen. Diese Instrumente, Taktschläge und Rhythmen stammten alle von schwarzen und von weißen Musikern und fügten sich zu dem, was wir heute Jazz nennen. Und das ist der Grund, warum ich einfach an diesen wunderbaren Ort namens New Orleans kommen mußte – um die Jazzszene zu fotografieren.

Anfang 1959 erhielt ich einen Anruf aus Deutschland. Der Anrufer stellte sich als Joachim-Ernst Berendt vor, er sei Musikwissenschaftler und wohne in Baden-Baden. In sehr gutem Englisch erklärte er mir, er plane in den Vereinigten Staaten eine Studie über ›Amerikas große Kunst – Jazz‹. Dafür, fuhr er fort, benötige er einen Fotografen, der mit ihm arbeiten würde – einen Fotografen, der Jazz mochte und verstand. Es würde Interviews mit Musikern geben, Fotografien der Künstler und der verschiedenen Orte, wo Jazz zu hören ist, und dazu einen Überblick über die Ursprünge des Jazz und die Kunstform selbst. Er ließ das alles ein bißchen gelehrt klingen, aber es schien mir ein sehr bedeutendes Projekt zu sein, und daher faszinierte mich sein Angebot. Der allzu verlockenden Gelegenheit, viele meiner Jazzhelden zu fotografieren, dazu die vielen unbekannten und noch zu entdeckenden Jazzmusiker in ganz Amerika, konnte ich nicht widerstehen. Ja, erwiderte ich, ich würde das gern machen.

Ich werde Joachim-Ernst Berendt von jetzt an ›Joe‹ nennen. Joe und ich wollten uns im April am Tag seiner Ankunft aus Frankfurt am Idyllwild Airport (er hieß damals noch nicht JFK) in New York treffen. Wir stiegen im Hotel Alwyn an der Ecke West 58th Street and Seventh Avenue ab. Die Unterkunft wirkte ziemlich heruntergekommen (verlangte Bares im voraus) und war ein berüchtigter Junkietreff. »Ist das hier nicht wunderbar?«, meinte Joe. »Hier treffen sich Musiker. Das ist doch gut, oder?« Nachdem wir ein paar Tage lang die Jazzszene auf Tonband aufgenommen und fotografiert hatten, fuhren wir los in unserem gemieteten Chevrolet Impala, Baujahr 1959. Sie erinnern sich an das Modell: Es hatte riesige, flach gebogene Heckflossen und große fischäugige Rücklichter, und über dem offiziellen Nummernschild hatte der Leihwagenhändler doch tatsächlich eine Pappabdeckung gelassen, auf der zu lesen stand: »Sehen Sie die USA in Ihrem Chevrolet« – wie passend!

Joes Plan für unsere Jazzodyssee sah vor, daß wir von Manhattan aus Philadelphia und Washington D.C. besuchen, dann durch die Oststaaten die Küste entlang und bis hinüber nach New Orleans und Biloxi fahren würden, dann den Mississippi hinauf nach Memphis, weiter nach Chicago, St. Louis, Detroit und Kansas City und schließlich westwärts nach Los Angeles, Hollywood, San Francisco und Las Vegas.

Wir verließen Manhattan über die George Washington Bridge in Richtung Newark, New Jersey, wo wir Professor Bradford und den Chor treffen wollten, den er in der Abyssinian Baptist

Church leitete. Wir hatten vor diesem Besuch noch nie eine so wunderbare und seelenvoll gesungene Chormusik gehört. Wir versuchten das Autoradio zu unserer Unterhaltung zu nutzen, aber einen Sender, der Jazz brachte, fanden wir nicht mehr, sobald wir New York verlassen hatten, es gab nur Hillbilly und Kirchenmusik. In fast jedem noch so kleinen Ort erkundigten wir uns, ob dort irgendwelche Musikveranstaltungen stattfänden, aber selten fanden wir wirklich etwas Gutes, abgesehen von den Chören in den Dorfkirchen, die offensichtlich Tag und Nacht auftraten oder probten. Auf dem Weg durch Florida faszinierten uns die Alligatoren, durch die wir uns durchschlängeln mußten, wenn sie über den Highway krochen. Wir erreichten Biloxi, Mississippi, und trafen die führenden Jazzmusiker in der Carmen Massey's Music School. Es war sehr lustig, diese jungen Musiker wie New Yorker Hipster sprechen zu hören, aber mit einem Akzent aus dem tiefen Süden.

Der Aufenthalt in New Orleans kam einem Besuch im Himmel des Dixieland-Jazz gleich, wenn es einen solchen Ort gab. Köstliches Essen in reicher Auswahl und überall herrliche Musik. In viele der berühmten alten Jazzlokale waren Stripteaseclubs eingezogen, aber sie hatten Jazzmusiker im Orchester. Den Erfolg unseres Besuchs in New Orleans hatten wir zu einem guten Teil dem jungen Musikwissenschaftler Richard Allen zu verdanken, der Joe und mich in ›Orlans‹ herumführte und uns so gut wie allen berühmten Leuten der New Orleanser Jazzszene vorstellte, wenn er nicht gerade Jazzgeschichte an der Tulane University unterrichtete. Wir lernten fast jedes Mitglied der drei großen Marching Bands – Tuxedo Brass Band, Eureka Brass Band und George Williams Brass Band – kennen, fotografierten zwei Beerdigungen und zwei Feiern kreolischer Clubs. Alle Friedhöfe in New Orleans haben die prachtvollen überirdischen Grabgewölbe, weil unterhalb der ganzen Stadt der Grundwasserspiegel so hoch liegt. Die Beerdigungen waren sehr farbenprächtig. Wenn ein Mitglied einer Band oder einer Bruderschaft stirbt, begleiten die Kollegen und Freunde aus der Band den Sarg vom Trauerhaus oder der Kirche aus zum Friedhof, während die Band ein Dirge spielt (ein langsames und feierliches Musikstück). Nach der Trauerfeier stimmen die Bands eine fröhliche Melodie an und heißen den Verstorbenen im Himmel willkommen, alle tanzen und singen mit den Marching Bands und eilen durch das French Quarter zu einem Clubhaus, wo anschließend eine Party stattfindet. Die harten Burschen der Stadt, die kein Instrument spielen können, begleiten den Festzug tanzend und bunte Regen- und Sonnenschirme schwenkend. Sie werden ›Second Liners‹ genannt, die Leute aus der zweiten Reihe.
Wie war in jener ersten Woche im Mai 1960 der Alltag in dieser großen Stadt New Orleans? Nun, Dwight Eisenhower war Präsident, Richard Nixon war Vizepräsident. Die Temperatur lag im Durchschnitt tagsüber knapp unter 30° C und nachts um 20° C. Es gab wirklich ein ›Streetcar named Desire‹, das gemäß einem Fahrplan von Gemeinde zu Gemeinde pendelte. Die Zeitung Times-Picayune meldete, welche Filme in den Premierentheatern liefen: Please Don't Eat the Daisies mit Doris Day und David Niven; The Fugitive Kind mit Marlon Brando; und Tall Story mit Jane Fonda und Anthony Perkins. Die Texaco-Tankstellen verkauften Sprit für 21 Cent/Gallone; das erlesene Kaufhaus Maison Blanche verzeichnete Rekordumsätze beim Frühjahrsschlußverkauf; die pikanten Gumbo- und Jambalaya-Gerichte wurden überall für 35 Cent die Portion

serviert, und ein Vier-Gänge-Menü in den führenden Restaurants Gallatoise und Antoine kostete $6.95; ›Qualitätshäuser‹ der oberen Mittelklasse wurden für rund $20,000 verkauft, und Reihenhäuser gab es für $12,000. Die Stellenanzeigen hinten in der Times-Picayune waren in Spalten für ›Farbige‹ und ›Weiße‹ unterteilt. Die Bürgerrechtsbewegung hatte noch nicht begonnen.

Auf Vorschlag von Dr. Harry Oster, Spezialist für Folkmusic von der Louisiana State University, machten wir einen Abstecher zum Louisiana State Penitentiary in Angola. Diese Strafanstalt war als das größte Gefängnis in den Vereinigten Staaten berühmt und hatte damals über dreitausend Insassen, darunter viele Bluesspieler aus dem Umfeld des großen Leadbelly in den 1930er Jahren. Dr. Oster versicherte uns, wir würden dort sehr viele ausgezeichnete Musiker finden.
An dem Morgen, als wir an den Gefängnistoren ankamen, war der Bedienstete an der Pforte streng, aber zuvorkommend und ließ uns zum Büro des Direktors führen. Der Direktor hörte sich an, wie Joe erklärte, wir wollten fotografieren und einige der einsitzenden Musiker auf Tonband aufnehmen. Er nahm einen Zug aus seiner Zigarre und fragte, welche ›Seite‹ wir besuchen wollten: »Die Seite mit den Niggern oder die mit den Weißen?« Joe erwiderte schnell: »Oh, die mit den Negern. Sind dort nicht mehr Musiker?« Der Direktor warf uns einen eisigen Blick zu und sagte: »Okay, aber ich kann Ihnen niemanden mitgeben; wir sind knapp an Leuten. Sie sind sich selbst überlassen.« Wir legten durch hohe Stacheldrahtzäune einen langen Weg zurück, bis wir zum letzten Tor kamen. Als wir es passiert hatten, erkundigte sich Dr. Oster nach einem Bluessänger namens Hoagman Maxey. Die Gruppe schwarzer Gefangener trat schweigend auseinander und ließ uns zu Hoagman durch. Er begrüßte uns herzlich und begann uns verschiedenen Musikern vorzustellen. Als erst einmal die Musik eingesetzt hatte, wurden alle freundlich. Wir fotografierten und nahmen einige von ihnen auf Band auf. Meine Furcht wich, und wir hatten tatsächlich Spaß an der Sache, genau wie die Gefangenen. Die Musik und die Geschichten, die wir hörten, waren deprimierend und inspirierend zugleich, aber vor allem authentisch.

Wir verließen New Orleans, die Stadt der Gegensätze und farbenprächtigen Aura, mit einem wunderbaren Gefühl. Wir hatten guten alten Happy Jazz gehört, Köstlichkeiten gegessen und warmherzige und freundliche Menschen getroffen. Nun, da der Hurrikan Katrina seine Verwüstungen hinterlassen hat, ist ein großer Teil der schönen Stadt und des glücklichen Lebensgefühls verschwunden. Ich hoffe, daß es eines Tages dorthin zurückkehren wird. Dieses Buch ist dem Gedächtnis der vielen Seelen gewidmet, die ihr Leben verloren haben, und den tapferen Überlebenden, die diese wunderbare Stadt wieder aufbauen werden.

William Claxton
Beverly Hills, Kalifornien
Herbst 2006

VORWORT

Joachim E. Berendt

»Ihr könnt euch eure Reise sparen«, sagte man uns in New York. »Alle wichtigen Jazzmusiker leben heute hier. Macht eure Fotos und Interviews in New York!«

Aber: Daß der Jazz eine universalamerikanische – und mit der zunehmenden Amerikanisierung unserer Welt eine allgemein internationale – Musiksprache ist, scheint ja nur so, wenn man es von New York aus sieht. Oder auch von Europa aus. In Wirklichkeit gehören die Stile und Spielweisen des Jazz in bestimmte Städte und Landschaften, deren Ausdruck sie auch dann bleiben, wenn sie anderswo gespielt werden. Der New Orleans-Stil und die Stadt New Orleans, der Mittelwesten und der Kansas City Jazz, Kalifornien und der Westcoast Jazz, Chicagos Southside und der Blues, den es dort gibt – das alles muß einander entsprechen, wenn es stimmt, daß ein Jazzmusiker in seiner Musik das reflektiert, was er lebt und erlebt.

Wer in dem kalifornischen Klima und »Way of life« lebt, *muß* anders spielen, als wer auf der dunklen Southside Chicagos zu leben gezwungen ist. Das ist im Jazz nicht anders als in der Konzertmusik. Mozart gehört nach Salzburg, Grieg nach Norwegen, die »Sträuße« nach Wien. Gewiß bleibt ihre Musik überall gültig; aber wenn man sie ganz verstehen will, muß man in ihre Städte gehen.

Es besteht ein seltsames Mißverhältnis zwischen der Tatsache, daß New York heute durchaus die Hauptstadt des Jazz ist, und der anderen Tatsache, daß nur wenige Jazzmusiker aller Stile, selbst der modernsten, in New York geboren wurden. Dieses Mißverhältnis muß einen Grund haben. Wir haben versucht, den Grund auf den Seiten dieses Buches sichtbar zu machen.

New York war für uns zunächst nicht viel mehr als der Treffpunkt eines kalifornischen Fotografen und eines deutschen Jazzkritikers, die sich auf dem Flughafen verabredet hatten. Und dann stammten ein Haufen Adressen und viele gute Ratschläge von dort. Nicht zu vergessen auch der alte Chevrolet, mit dem wir unsere Reise machten. Vier Monate sind wir mit ihm kreuz und quer durch die USA gefahren – einmal rings um die östliche Hälfte und zweimal quer durch die westliche, insgesamt mehr als 24 000 Kilometer.

Ein New Yorker Kritiker nannte es eine »Jazzexpedition – ein Abenteuer in Jazz«. Das Material, das wir gesammelt haben, könnte fünf Bücher dieser Größe füllen. Tausende von Musikern wurden fotografiert, Hunderte interviewt, Stöße von Magnetofonbändern aufgenommen. Dem Autor ist es schmerzlich, daß von der Fülle des in Interviews und Gesprächen gesammelten Materials hier nur ein kleiner Teil vorgelegt werden kann. Dieses Buch soll in erster Linie eine Dokumentation der Lebendigkeit der Jazzmusik in den Fotos von William Claxton sein.

Als wir in einem Hotel irgendwo in Georgia übernachteten, sagte William Claxton: »Die meisten Jazzfotobücher sind viel zu traurig.« In der Tat ist die Verlorenheitsstimmung, die Blues-atmosphäre und all das, was zum Einsamkeitsgefühl des rassisch und sozial diskriminierten Jazzmusikers gehört, auf zahllosen Jazzfotos in vielen Jazzbüchern hervorragend eingefangen. Aber der Jazz ist auch die Musik der Lebensfreude und überschäumenden Kraft, die Musik ursprünglicher Vitalität und geistvoller Ironie, die Musik der Jugend und des Humors. Wir haben versucht, auch dies einzufangen.

Was in diesem Buch geschrieben wurde, will den »European point of view« nicht verleugnen. Die europäischen Jazzkritiker aller Schulen und Richtungen haben, seit die ersten kritischen Bücher über den Jazz nicht etwa in den USA, sondern in Europa entstanden, Gesichtspunkte, die sich von denen der amerikanischen Kritiker unterscheiden. Dabei ist nicht etwa der eine Gesichtspunkt richtig und der andere falsch; es sind lediglich verschiedene Gesichtspunkte aus verschiedenen Kontinenten. Daß die Jazzkritik in den letzten Jahren universaler und toleranter geworden ist, liegt nicht zuletzt daran, daß man in Europa immer mehr auf die amerikanischen Kritiker hört und daß man in den USA auch die europäischen Kritiker beachtet.

Wir haben oft, wenn bei unseren Gesprächen auf den endlosen Fahrten durch den amerikanischen Kontinent dieses Buch immer mehr Gestalt annahm, voll Ironie bemerkt, daß es hier eigentlich beides gibt: vom europäischen Gesichtspunkt haben wir gesprochen, und den amerikanischen vertrat Bill Claxton, der Kalifornier – und das ist ja nun buchstäblich ein »Gesichtspunkt«.

Baden-Baden
Sommer 1961
Joachim E. Berendt

Page 42 Orleans Street

Page 42 Orleans Street

Seite 42 Orleans Street

NEW ORLEANS

»New Orleans ist eine vollkommene Synthese aus Europa und Amerika – oder genauer: aus französischem Charme und lateinamerikanischer Lebenslust, nordamerikanischer Rationalität und schwarzer Vitalität.«

»Ihr braucht gar nicht erst nach New Orleans zu fahren. Der Jazz in New Orleans ist tot«, sagte man uns in New York. Noch in Biloxi sagte man das gleiche. Und Biloxi liegt knappe 80 km von New Orleans entfernt am Golf von Mexiko. Die Biloxianer müßten es also wissen. Aber in New Orleans erlebten wir in neun Tagen zwei »Street Parades«, ein »Funeral«, ein »Jazz Picnic« und sechs oder sieben Jamsessions – alle im Stil der großen alten Zeit, in der der Jazz entstand. Doch sprechen wir zuerst von Biloxi. Das ist ein kleiner Badeort, in dem es drei Jazzlokale und so viele gute Jazzmusiker wie kaum in einer europäischen Großstadt gibt. Einer von ihnen ist der Pianist John Probst. Als Junge hat er ein paar Meilen weiter nördlich zusammen mit Mose Allison gespielt. Er wurde auch von ihm beeinflußt, aber jetzt hat er seinen eigenen Stil. John war noch vor wenigen Jahren blind. Er hat durch theosophische Willensstudien sein eines Auge wieder sehend gemacht und sagt, das andere würde er auch noch sehend machen. Entsprechend ist die Kraft, die in seinem Spiel steckt. Treffpunkt all der Biloxi-Musiker ist die Musikschule von Carmen Massey – auch er ein Musiker, der früher mit Mose Allison zusammen gespielt hat. Bill Claxton ließ es sich nicht nehmen, all die Biloxi-Musiker vor Carmens Musikschule aufzunehmen (S. 76). Von links nach rechts sind es: der Schlagzeuger Bill Patey (der auf dem Bild mangels Drums Gitarre spielt); dann noch ein »Gitarrist«, dessen eigentliches Instrument das Schlagzeug ist, der aus New Orleans stammende Earl Cobble vom John Probst Quartet; der Bassist Jay Cave; der Pianist Don Reitan, der in einem der Jazzlokale von Biloxi ein eigenes Ensemble hatte; der Trompeter Mike Serpas (der auch wieder »zu Unrecht« eine Gitarre in der Hand hält, aber Gitarren, Zithern und Harmonikas waren die einzigen Instrumente, die wir in Carmens Musikschule fanden); dann John Probst; und unten an der Terrassen-Balustrade der Trompeter Ben Clement; der Schlagzeuger Lee Charlton; und schließlich Biloxis Musikschulleiter Carmen Massey. Versteht sich, daß die meisten dieser Musiker sehr modern sind. Vielleicht meinten sie deshalb, der Jazz in New Orleans sei tot.

»Versteht sich, daß die meisten dieser Musiker sehr modern sind. Vielleicht meinten sie deshalb, der Jazz in New Orleans sei tot.«

Als wir dann nach New Orleans weiterfuhren, kamen wir mehrfach an einer Reklame vorbei, wie sie am Anfang dieses Kapitels zu sehen ist. Man kann schon daraus, noch bevor man dort anlangt, auf die Kommerzialisierung des Jazz auf der Bourbon Street – der sogenannten »Hauptstraße des Jazzlebens« in New Orleans – schließen. Wir kamen auch an einer Tankstelle vorbei, deren »menschlicher Tankplatz« schön getrennt ist für Neger und Weiße. Sicher ist dies kein außergewöhnlicher Anblick für einen Amerikaner, der einmal in den Südstaaten war, aber wer aus Eu-

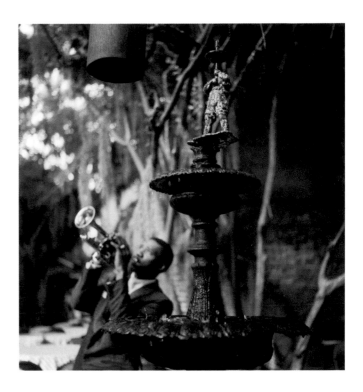

Above Melvin Lastie

Ci-dessus Melvin Lastie

Oben Melvin Lastie

ropa kommt, erfährt – wenn er so etwas zum erstenmal sieht – einen Schock, der in diesem Falle nur dadurch ironisiert wird, daß das »schwarze« und das »weiße« Wasser doch offenbar aus derselben Leitung kommt. Vor der »weißen« Trinkstelle übrigens war eine Wasserpfütze; ein kleiner weißer Junge, der sich die Füße nicht schmutzig machen wollte und offensichtlich noch nicht über Rassenprobleme nachgedacht hatte, ging deshalb an die Trinkstelle für Neger, aber sein Vater riß ihn entsetzt zurück: lieber verdursten als trinken, wo vorher ein Neger getrunken hat! Entsprechend war es dann in New Orleans. Schwarze und weiße Musiker spielen selten zusammen und merken deshalb nicht, daß sie aus der gleichen Leitung zapfen. Einer von ihnen, der inzwischen verstorbene Trompeter Nick La Rocca von der Original Dixieland »Jass« Band – dem berühmten weißen Orchester, von dem es heißt, daß es 1917 die ersten Plattenaufnahmen in der Geschichte des Jazz gemacht hat –, erklärte allen Ernstes, daß er selbst und überhaupt ausschließlich weiße Musiker den Jazz geschaffen hätten, nicht etwa die Schwarzen. Jahrelang bombardierte er die Jazzkritiker in der ganzen Welt mit Fotokopien von obskuren Zeitungsartikeln, die er als »eindeutiges Beweismaterial« für seine These bezeichnete. Er hat dieses Beweismaterial auch an die Tulane University in New Orleans geschickt, und deshalb konnte er behaupten, das Material der Tulane Uni-

versity »beweise«, er – Nick La Rocca – habe den Jazz erfunden. Die Naivität, mit der immer wieder dieses Wort »erfinden« im Jazz auftaucht, ist nicht allein Nick La Roccas Angelegenheit. Seit Jelly Roll Morton gesagt hat, er habe den Jazz 1902 »erfunden«, ist immer wieder irgend jemand gekommen, der ihn schon vorher oder auch erst später »erfunden« haben will, und jeder von ihnen – einschließlich ihrer außenstehenden Mit- und Verfechter – hat seine inkompetente Denkungsart schon in dem Augenblick unter Beweis gestellt, in dem er das Wort »erfinden« im Zusammenhang mit einer künstlerischen Entwicklung auch nur verwendet oder eine Einzelpersönlichkeit als Schöpfer in Betracht zieht. Wer hat die Dichtkunst geschaffen? Oder die Malerei? Man kann die Dampfmaschine erfinden oder die Büroklammer, aber keine Kunst.

»Wer hat nicht alles behauptet, den modernen Jazz erfunden zu haben!«

Als ich Nick La Rocca anrief, sagte er, noch bevor er »Hallo« oder »How are you?« sagte: »Ich sage Ihnen eins: Der Nigger kommt überhaupt nicht in Frage.« Und dann schimpfte er lange mit wutverzerrter Stimme auf alle, die nicht glauben, daß Nick La Rocca und die Weißen den Jazz geschaffen hätten. Er würde sie alle vor Gericht bringen und verurteilen lassen. Sie hätten ein »Verbrechen an der amerikanischen Geschichte« begangen. Sie seien »Kommunisten«. Gerade der komplexhafte Charakter, der deutlich wird, wenn jemand in so harmlosem Zusammenhang die Worte »Verbrechen« und »Kommunisten« gebraucht, hilft vielleicht, dem verstorbenen Nick La Rocca Gerechtigkeit widerfahren zu lassen. In einer Musik, die so sehr Ausdruck des spielenden Musikers ist – und nur des Musikers, nicht eines Komponisten, der interpretiert wird –, verschieben sich leicht die Akzente. Das weiß man ja auch sonst aus der Geschichte des Jazz – nicht nur von Jelly Roll Morton her. Wer hat nicht alles behauptet, den modernen Jazz erfunden zu haben! Thelonious Monk sagt heute noch, daß er vor Charlie Parker »modern« gespielt habe. Wenn das Sehen durch die »eigene Brille« im guten Sinne zum Wesen des Jazz gehört, dann ist es unvermeidlich, daß es auch manchmal im schlechten Sinne dazu gehört. Und menschlich ist es, daß man all die Energie, die man in seine Musik steckt, auch mit dem verbindet, was man schließlich durch das ständige Sehen durch die »eigene Brille« zu denken gelernt hat – zumal dann, wenn die eigene Musik nicht mehr als »modern« gilt. Und noch stärker dann, wenn die Atmosphäre gegenüber dem, von dem man sich »bestohlen« glaubt, ohnehin schon mit Haß aufgeladen ist – wie im Süden zwischen Negern und Weißen!
Nick La Rocca hat einmal gesagt: »Die Band, die spielen konnte wie wir, hat niemals gelebt. Wir haben diese Musik in die Welt eingeführt.« Gewiß gibt es bei den wichtigen Musikern der Jazzgeschichte – und Nick La Rocca und seine Original Dixieland Jazz Band waren wichtig – niemals zwei, die genau gleich spielen. Was das »Eingeführt-Haben« betrifft, so war die Original Dixieland Jazz Band ja wirklich die erste Jazzband, die außerhalb von New Orleans – und vor allem in New York – großen Erfolg hatte, wie es ja oft in der Jazzgeschichte die weißen Orchester und Solisten waren, die das zum Erfolg geführt haben, was die Neger geschaffen haben. Geschaffen haben kann Nick La Rocca den Jazz schon deshalb nicht, weil es ein paar Elemente in ihm gibt, die einfach nicht vom weißen Mann stammen können: die Phrasierungsweise, die Tonbildung und die rhythmische

Intensität. Diese Elemente gab es vor dem Jazz nirgendwo in der »weißen«, aber allenthalben in der »schwarzen« Musik. Und wer immer eine wissenschaftliche Definition des Jazz versucht hat, hat ausgesprochen, daß diese Elemente zum Wesen des Jazz gehören. Jazz ist nicht denkbar ohne sie – wie er andererseits auch nicht ohne die europäischen Instrumente, die Symmetrie der europäischen Formen und die europäischen Harmonien denkbar ist. Wie verzwickt die Frage nach der Herkunft des Jazz ist, macht gerade dieses rhythmische Problem deutlich. Man kann nicht sagen, der Rhythmus des Jazz kommt vom Neger. Die Regelmäßigkeit des Jazzrhythmus ist europäisch – sie kommt vom Marsch her; die afrikanischen Rhythmen sind vielschichtiger und asymmetrischer. Aber die Intensität des Jazzrhythmus kommt vom Neger; für sie gibt es keinen Vergleich in der europäischen Musik. Der Amalgamationsprozeß ging so schrittweise vonstatten, daß kein Punkt sichtbar oder hörbar ist, an dem irgend jemand auftreten und sagen könnte, er habe die Amalgamation vollzogen. Und sie wird heute noch weiter vollzogen! So viel Marschrhythmen wie bei Bob Crosby hat es nicht einmal bei den Marching Bands im alten New Orleans gegeben. Und so viel afrikanische Rhythmen wie in Art Blakeys moderner *Orgy in Rhythm* hat es in keinem noch so »afrikanisch« klingenden Beispiel des alten Jazz – und nicht einmal des Shouts, Folkblues, Worksongs und Spirituals – gegeben. Man kann also fast sagen: Der arme Nick La Rocca ist der »Verzwicktheit« des Amalgamationsprozesses seiner eigenen Musik zum Opfer gefallen. Von hierher hat er seinen Komplex, über den selbst die weißen Musiker in New Orleans lachten. Sie sagten, daß er ein Fanatiker sei, mit dem man nicht sprechen könne. Aber auch sie sind gewiß daran interessiert, daß der weiße Anteil an der Jazzentstehung unterstrichen wird. Fast jeder weiße Musiker in New Orleans findet, daß die Neger überbewertet werden. Jeder Neger andererseits (wenn er sich die Mühe macht, darüber nachzudenken) sagt, daß die Weißen immer das aufgepickt haben, was die Neger geschaffen haben, und daß sie es dann in die Öffentlichkeit gebracht und daran verdient hätten, so daß die Öffentlichkeit die Musik der Neger immer erst durch die Weißen kennenlernen konnte.
Der erste und älteste dieser weißen Musiker ist »Papa« Jack Laine. Der New Orleans Jazz Club hat ihm eine Urkunde verliehen, nach der er der »Vater des weißen Jazz« ist. Und wenn überhaupt »weißer« Jazz am Anfang stand, dann hat immerhin Papa Laine mehr Anspruch, den Jazz »erfunden« zu haben, als Nick La Rocca. Denn Laine hat bereits gespielt, als La Rocca noch gar nicht geboren war. Papa Laine – oder, wie der von deutschen Einwanderern abstammende Musiker eigentlich heißt, Johnny Stein – war der erste erfolgreiche Bandleader der Jazzmusik. Er hat zwischen 1889 und 1920 mehr verschiedene Bands gehabt als fünfzig Jahre später Woody Herman. Manchmal hatte er auch mehrere Bands zur gleichen Zeit, die alle auf seine Rechnung spielten, selbst wenn er immer nur bei einer am Schlagzeug sitzen konnte. Und selbstverständlich sagt auch Papa Laine, er sei der erste gewesen. Jeder ist in New Orleans mit irgend etwas der erste gewesen. Papa Laine meint: »Ich war derjenige, der mit allem begann. Vor mir gab's nur eine Niggerband, und das war bloß eine Brass Band, aber ich war es, der die erste richtige Jazzband hatte.« Einen Augenblick später benötigt er die Neger dann aber doch: »Selbst die Nigger erkannten meine Musik an.« Heute lebt Papa Laine an der Stadtgrenze von New Orleans in einer kleinen Hütte an einer Eisenbahnlinie, wo ununterbrochen die Züge vorbeirangiert werden, und macht Feuerwehrhelme. Stolz zeigt er

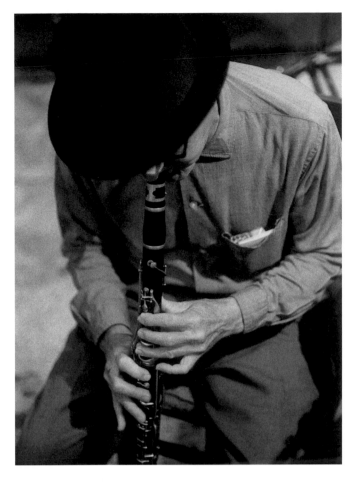

Above Jam session with Raymond Burke, at Joe Mares's place, New Orleans.

Ci-dessus Jam-session avec Raymond Burke, chez Joe Mares à la Nouvelle-Orléans.

Oben Jamsession mit Raymond Burke bei Joe Mares, New Orleans.

eine Urkunde darüber, daß er seit 1913 »Mitglied auf Lebenszeit bei der David Crockett Steam Fire Company No. 1« ist. Zu diesem Feuerwehrverein kam er, weil damals die Paraden der Feuerwehrleute musikalisch besonders glanzvoll waren. Papa Laine macht für seinen Verein seit dreißig Jahren ununterbrochen Feuerwehrhelme: er hat inzwischen mehr Helme gemacht, als der Verein je Mitglieder gewinnen kann. Seine Frau zeigte uns im Familienalbum ein Bild von 1895: der junge Nochnicht-»Papa« Laine in einer damaligen Feuerwehruniform.

Der weißen Musiker in New Orleans nimmt sich Joe Mares mit seiner Plattenfirma Southland Records an (und manchmal auch einiger schwarzer). Joe ist ein Bruder von Paul Mares, dem Trompeter der New Orleans Rhythm Kings und großen Konkurrenten von Nick La Rocca. Joe's Southland-Plattenfirma befindet sich mitten im French Quarter, dem alten französischen Viertel der Stadt, in der St. Louis Street. Dorthin lud Joe alle Musiker, die er erreichen konnte, zu einer Jamsession für uns ein: Harry Shields, den Bruder von Larry Shields, dem alten Klarinettisten der Original Dixieland Jazz Band, und sein Gegenstück unter den jüngeren Klarinettisten im heutigen New Orleans, Raymond Burke; den Posaunisten Emile Christian, der ebenfalls um 1918 mit der Original Dixieland Jazz Band gespielt und dann fünfzehn Jahre in Frankreich gelebt hat; den Trompeter Tommy Gonsoulin,

der in den Orchestern von Gene Krupa und Jack Teagarden gejazzt hat; den Banjospieler Joe Caprano; den Bassisten Bob Coquille; den Schlagzeuger Sal Gutierrez; den Tubaspieler James »Pinky« Wadlington; und zwei der bekanntesten weißen Musiker im heutigen New Orleans: den Trompeter Sharkey Bonano und den Ragtime-Pianisten Armand Hug, einen der letzten, authentischen Ragtime-Musiker, die es noch gibt. Die einzigen schwarzen Gäste der Session waren Sister Elizabeth Eustis und ihre Begleiterin. »Schwester Elisabeth« ist, seit Mahalia Jackson ihre Heimatstadt New Orleans verlassen hat, die beste Spiritual- und Gospelsängerin der Stadt. Sie hat eine eigene Radio-Show, aber noch immer singt sie – wie in der alten Zeit – allsonntäglich an den Straßenecken des French Quarter, begleitet von nur einem Tambourin.

Als wir nach der Session bei Joe Mares schräg über die Straße in den Schallplattenladen von Bill Russell gingen, sagte einer der Musiker: »Niemand hat mehr für den Jazz in New Orleans getan als Bill. Nur kümmert er sich leider ein wenig zu viel um die Neger.« An der Richtigkeit der ersten Hälfte dieses Ausspruches besteht kein Zweifel. Bill ist kein Musiker und im Grunde auch kein Kritiker. Er ist ein Enthusiast, der alles Geld, was er in seinem Leben verdient hat, ausgegeben hat, um New Orleans-Musiker auf Platten aufzunehmen – bereits zu einer Zeit, als niemand sonst in der Welt auf den Gedanken kam, daß es irgend etwas in New Orleans auf Platten aufzunehmen gebe. Damals lebte Bill in Chicago. Inzwischen hat er den Traum seines Lebens verwirklicht: Er hat einen Jazz-Schallplattenladen mitten im French Quarter von New Orleans, und dieser Laden ist der Treffpunkt all derer, die sich in New Orleans für Jazz interessieren. In dem Laden liegen so viele Schallplatten und alte Bilder und noch ältere Stiche und Plakate und stereoskopische Trickbilder und Kintoppfotos aus den zwanziger Jahren herum, daß man kaum gehen kann. Bill Russell sitzt mitten in diesem Tohuwabohu und repariert alte Geigen, indem er zwei oder drei lädierte Instrumente auseinandernimmt und daraus eines zusammenbaut. Dazu hört er Schallplatten – aber nur selten Jazz; am liebsten hört er die großen Violinkonzerte und vor allem Mozart. Bill Russell ist die Verkörperung all derer, die von New Orleans, seiner Atmosphäre und seiner Musik fasziniert sind: der Typ von Intellektuellen, der so persönlich und menschlich ist, daß er nicht als Intellektueller wirkt, und der von der europäischen Romantik herkommt und erkannt hat, daß die Romantik brüchig geworden ist, und der nun einen ebenso starken und warmen Ersatz dafür braucht: eben New Orleans. Irgend jemand hat einmal gesagt, Bill Russell sei »all soul«, ganz und gar Seele, und das war das erstemal, daß ich das Wort »Soul« im Zusammenhang mit Jazz gehört habe – lange vor der modernen Soul-Musik.

Es gibt in den USA eine ganze Gruppe solcher Persönlichkeiten, deren »Primus inter pares« Bill Russell ist. Ihre Namen werden nur selten von den bekannten Jazz-Zeitschriften erwähnt, und doch haben sie eine mühsame und kaum hoch genug einzuschätzende Sammler- und Aufklärungsarbeit geleistet: David Stuart in Hollywood und Charlie Gamble in San Francisco oder früher Lester Koenig und Nesuhi Ertegun, die heutigen Chefs der Schallplattenfirmen Contemporary und Atlantic oder – in bezug auf den Chicagostil – John Steiner in Chicago und neuerdings Frank Driggs in New York für den Kansas City Jazz – Männer, die sich in einem gewissen Abschnitt ihres Lebens einer bestimmten Jazzform mit Haut und Haaren verschrieben haben und die doch weltoffene, aufgeschlossene Persönlichkeiten geblieben sind – ohne den Fanatismus oder die Komplexe, aus denen heraus es in Europa

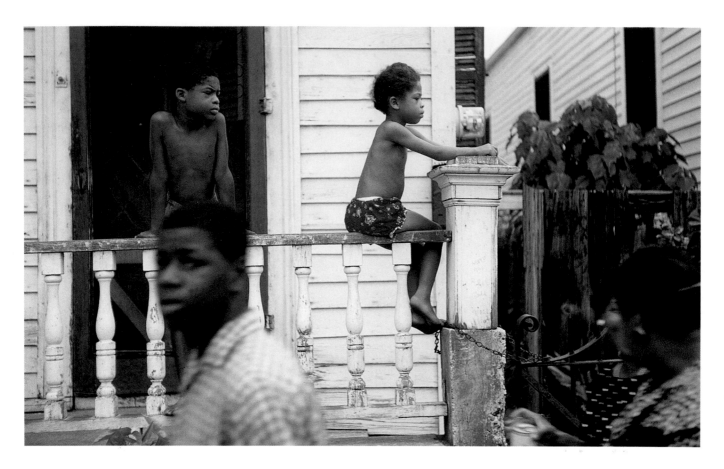

immer noch Leute gibt, die glauben, man müßte für traditionellen Jazz »kämpfen«. Dieser Kampf und diese Schlacht sind in der großen Zeit des New Orleans Revival – der Wiederentdeckung der alten Jazzformen – geschlagen und triumphal gewonnen worden – zwischen 1938 und 1944. Wer jetzt immer noch »kämpft«, gleicht jenen alten Soldaten, die – unbetroffen von Sieg oder Niederlage – nach jedem Krieg immer noch in Gedanken, Erinnerungen und Komplexen weiterkämpfen und Mitglied beim »Stahlhelm« sind. Bill Russell und sein junger Mitarbeiter Dick Allen – eine Art verjüngter Ausgabe von Russell und obendrein noch ein typischer Südstaatler – tragen das Material für das Jazzarchiv der Tulane University zusammen (und schon deshalb kann keine Rede davon sein, daß dieses Material »beweise«, der Jazz sei von Weißen geschaffen). Wer mit ihnen durch die Straßen von New Orleans geht, trifft alle paar Minuten irgend jemanden, der direkt oder indirekt mit Jazz zu tun hat. In der Burgundy Street etwa trafen wir »Brother« Percy Randolph, einen Straßenhändler, der auf einem einfachen Karren Ramschwaren durch die Straßen zieht und sie mit Blues-Gesang und Mundharmonikaspiel anpreist. Früher spielte er Waschbrett, aber das hat ihm die Polizei verboten, weil es zu laut ist. Es gibt in New Orleans noch andere solcher Straßensänger. Blind Snooks Eaglin und Lucius Bridges gehören zu ihnen. Und wie gesagt: Am Sonntag singt Sister Elizabeth auf der Straße Spirituals. Zu denen, die früher den Blues oft genug auch auf der Straße sangen und spielten und die heute zu alt sind, dies zu tun, gehören auch die Sängerin und Pianistin Billie Pierce und der Trompeter Dee Dee Pierce. Dee Dee stammt aus einer alten, französisch sprechenden Familie aus Louisiana, seine Frau ist aus Florida. Billie hat unter anderem Bessie Smith begleitet und Dee Dee hat mit so berühmten New Orleans-Musikern wie Kid Rena und Buddy Petit gespielt. Kreolische Volks-

Above Children of all ages wait in anticipation for the next parade to pass by.

Ci-dessus Des enfants de tout âge attendent le passage de la prochaine procession.

Oben Kinder aller Altersgruppen warten auf die nächste Parade.

lieder und Blues gehören auch heute noch zum Repertoire der beiden rührenden alten Leute – Lieder auch über das gute kreolische Essen aus einer Zeit, in der die Kreolen in New Orleans eine Kultur repräsentierten, von der heute selbst die Weißen Louisianas weit entfernt sind, von den Negern ganz zu schweigen. Billie und Dee Dee haben zwanzig Jahre lang in Luthjen's Dance Hall gespielt und gesungen, einer der alten Tanzhallen, die in der Geschichte des New Orleans Jazz allzuoft vergessen werden. Es ist so viel effektvoller, vom »Red Light District« und den Prostituierten-»Saloons« der Lulu White zu sprechen, aber die Musik, die dort erklang, wurde zuerst einmal in den Negertanzhallen vor einem ausschließlich schwarzen Publikum ausprobiert, bevor sie den Gästen der »Saloons« und den Touristen vorgestellt wurde.

Auch die letzte – man kann fast sagen: einzige große – New Orleans-Blues-Sängerin ist immer noch da: Lizzie Miles. Sie hat bereits um 1915 mit King Oliver gesungen, noch bevor Oliver nach Chicago ging. Und sie hat dann mit Jelly Roll Morton und Fats Waller gearbeitet und in Paris gelebt. Heute hat sie im French Quarter eine blitzsaubere Wohnung, in der man sie allerdings selten antrifft, weil sie täglich mehrere Male zur Kirche geht. Das ist auch so ein Aspekt, der in den Geschichten des New Orleans Jazz zu oft übersehen wird: Man kokettiert mit der »Sündigkeit« der Stadt, aber spricht nicht von ihrem Katholizismus. Uns ist der Katholizismus stärker aufgefallen als die »Sündigkeit«. Sicher mag das Verhältnis früher anders gewesen sein, aber wenn

selbst die moderne Industriestadt New Orleans noch sehr katholisch ist, sprechen alle Anzeichen dafür, daß das alte New Orleans noch viel katholischer gewesen sein muß. Lizzie Miles ist deshalb die einzige große aus New Orleans stammende Blues-Sängerin, weil New Orleans zwar eine Hauptstadt des Jazz, aber gewiß nie eine Hauptstadt des Blues war. Die fröhliche, lebenslustige Seite des Jazz stand hier im Vordergrund. Blues gab es vor allem draußen auf dem Land in Gestalt des Folkblues, bei dem Struktur und Harmonik des Blues meist noch nicht recht ausgeprägt waren.

Der Neger war in New Orleans nicht so sehr der »verschmähte Liebhaber«, als der er im Blues erscheint. Denn das ist doch der entscheidende Unterschied zwischen der Liebe in den Blues-Texten und der Liebe in europäischen Liebesliedern: Bei uns wird eine Frau besungen und bedichtet, die man gern haben will; in den Texten des Blues werden Frauen besungen, die man gehabt und darüber liebengelernt hat und die einen dann betrügen oder verlassen. Dieser Unterschied ist nur sehr oberflächlich damit erklärt, daß sich die Liebe dort vielleicht anders abspielt oder abgespielt hat. Heute spielt sie sich kaum noch anders ab, und trotzdem besteht die alte Thematik auch in den modernen Blues weiter. Wahrscheinlich besteht sie deshalb weiter, weil die Frau hier nur eine Art »Ersatzfunktion« für die weiße Zivilisation bedeutet – oder auch ein Symbol dafür. Nicht seinen Frauen, sondern dem »weißen Mann« gegenüber befindet sich der Neger in der Situation des verschmähten Liebhabers, der zwar ab und zu mal Kostproben erhaschen, aber nie auf die Dauer besitzen darf. Nur die Kreolen in New Orleans durften besitzen – zwar auch nicht auf die Dauer, aber doch immerhin so lange, bis in den Jahren nach der Sklaven-»Befreiung« mehr und mehr zwischen Neger und Neger kein Unterschied gemacht wurde: der »Einfachheit« halber und aus »prinzipiellen« Gründen.
Nicht umsonst ist George Lewis' *Burgundy Street Blues* mit seiner kreolischen Atmosphäre zu einem Symbol des Blues in New Orleans geworden: gewiß eine der schönsten Blues-Aufnahmen der Jazzgeschichte, aber, wie Dr. Ingolf Wachler gezeigt hat, »auf schön zurechtgetrimmt«, ohne die lastende Verlorenheitsstimmung und vor allem ohne den Realismus des echten Blues. Man spürt in dieser »schönen Traurigkeit« des *Burgundy Street Blues* die wunderschönen, eleganten und verspielten Eisengitterverzierungen an den Balkons, Veranden und Terrassen der Stadt und die schattigen, friedlichen Patios in den Hinterhöfen. George Lewis ist heute der überragende Repräsentant des Jazz in New Orleans. Und man kann sagen, daß es überhaupt in der ganzen Welt nur noch drei Orchester gibt, die authentischen New Orleans Jazz auf einem ganz hohen Niveau spielen, aus eigener Tradition und Erfahrung, nicht aufgewärmt in irgendeinem Revival der aus zweiter oder dritter Hand nach Plattenaufnahmen nachkonstruiert; diese drei Bands sind: die George Lewis Band in New Orleans, die Wilbur De Paris »new« New Orleans Band in New York und Kid Ory's Creole Jazzband in San Francisco. Zwei der besten Solisten der George Lewis Band sind der Posaunist Jim Robinson und der Bassist Slow Drag Pavageau. Die Gegner von George Lewis sagen oft, daß George schrecklich falsch spiele. Das Wunder seiner Musik liegt darin, daß er das tut und trotzdem die Atmosphäre einer hohen Sensibilität und großen Kultiviertheit vermittelt – also gerade jene Atmosphäre, die sonst unvereinbar mit technischer Inkompetenz scheint (während sich beispielsweise Expressivität, Vitalität und Aufrichtigkeit durchaus mit »falschen Noten« vertragen). Es gibt wenige New Orleans-

Musiker, in deren Musik so viel sensible »sophistication« schwingt wie in der von George Lewis; es ist eine ähnliche »sophistication«, wie sie heute das Modern Jazz Quartet hat. Was für John Lewis vom Modern Jazz Quartet die Barockmusik ist, das sind für George Lewis die alte kreolische Kultur und die französische Holzbläsertradition.
Diese Holzbläsertradition, die ja auch heute noch in der Welt der sinfonischen Musik hoch anerkannt wird, drang vor allem durch das Orchester der berühmten Französischen Oper von New Orleans in die Stadt. Die französischen Holzbläser waren für den Jazz in New Orleans so wichtig wie die deutschen Blechbläser für den Jazz in St. Louis. Nicht umsonst waren die besten New Orleans-Klarinettisten Kreolen, das heißt, sie waren mehr mit der französischen und weniger – wie die anderen Neger – mit der amerikanischen Kultur verbunden.

Man erfährt in New Orleans ständig – innerhalb und außerhalb des Jazz –, wie lebendig diese alten Traditionen auch heute noch sind. Das 20. Jahrhundert mit all seinem Tempo und seiner Organisiertheit konnte ihnen nur wenig anhaben. Ein junger Musiker wie Raymond Burke oder – auf kommerziellerer Ebene – Pete Fountain zehren in ihren Klarinettenimprovisationen in jeder Note von der alten französischen Holzbläsertradition. Aber auch ein Klarinettist aus der alten Zeit – einer der allerwichtigsten – lebte zur Zeit unserer Reise immer noch in New Orleans: Alphonse Picou. Schon der Name verrät, daß er kreolischer Neger war. 1878 geboren, hatte er seit 1894 mit den verschiedensten New Orleans-Orchestern gespielt – von der Olympia Band und Bunk Johnson um die Jahrhundertwende bis hin zu Papa Celestin in der Jahrhundertmitte. Sein berühmtes Solo über *High Society* ist das vielleicht meistkopierte Solo der Jazzgeschichte. Fast jeder Musiker, der *High Society* spielt, zitiert es oder verwendet Teile daraus. Alphonse Picou besaß eine kleine Bar in der Ursulines Street, wo sich die Musiker oft trafen. Man sagte uns, daß wir nicht nach elf Uhr morgens kommen dürften, wenn wir ihn noch nüchtern antreffen wollten, aber auch elf Uhr war offenbar zu spät. Alphonse Picou war glücklich, daß es noch Leute gab, die sich seiner entsannen. Er nahm seine Klarinette mit dem eigentümlichen, saxophonartigen Trichter (»es klingt viel lauter so«) und tanzte in seinem leeren Lokal herum. Zuerst brachte er nur piepsende Töne hervor, aber mit einemmal waren, kristallklar und fehlerlos, Phrasen aus dem *High Society*-Solo da. Alphonse Picou ist im Februar 1961, 82jährig, gestorben.

»Deshalb glaubt man, wenn man nach New Orleans kommt, nicht mehr in den USA zu sein.«

Ein anderer Klarinettist, der viel von dieser alten französischen Holzbläsertradition vermittelt, ist Paul Barnes. Er spielt zumeist in der Kid Thomas New Orleans Jazz Band, die – nachdem George Lewis nun immer älter wird – von vielen als der legitime Nachfolger der George Lewis Band bezeichnet wird. Wir erlebten Kid Thomas' starke, kraftstrotzende Trompete bei einer College-Party. In seiner Band spielten Louis Nelson (Posaune), Paul Barnes (Klarinette), Manuel Paul (Tenorsaxophon), Sammy Penn (Schlagzeug), »Kid Twat« Joseph Butler (Baß) und George Guesnon (Banjo). Guesnon tritt auch als Vokalist hervor und trägt den Beinamen »Creole Blues«. In seinen schönen, melo-

diösen Blues vermittelt er etwas von dem gepflegten, indirekten, so typisch kreolischen Verhältnis zum Blues, von dem wir gesprochen haben.

Auch heute spürt man immer noch, daß der Jazz in der alten Zeit in New Orleans so etwas wie eine Familienangelegenheit war. Wenn man die Musiker nicht trifft, trifft man ihre Verwandten. So rannte uns beispielsweise Louis Keppard über den Weg, als er gerade vom Einkaufen kam. Louis ist der Bruder von Freddie Keppard, dem zweiten »Jazz King« der Stadt (nach Buddy Bolden und vor King Oliver). Damals – vor 50 Jahren, als Freddie Trompete spielte – war Louis Keppard Banjospieler. Heute, mit 73 Jahren, bläst er Tuba: »Ich bin schließlich auch selbst schwerer geworden.« Daß trotzdem so viele Leute sagen, der Jazz in New Orleans sei tot, liegt vor allem daran, daß man an die Bourbon Street denkt, wenn man vom Jazz in New Orleans spricht. Die Straße der Bourbonen im alten französischen Viertel gilt seit langem als die Hauptstraße des Jazzlebens in New Orleans. Aber wenn man dorthin kommt, findet man nur wenig Jazz, und von diesem Wenigen ist gut die Hälfte fragwürdig. Dafür gibt es um so mehr Striptease-Shows. Ich habe auf der Bourbon Street zwanzig Stripteaselokale und fünf Jazzlokale gezählt. Das Verhältnis »verbessert« sich dadurch, daß in manchen der Stripteaseplätze zweitrangiger Jazz als Backgroundmusik für die sich ausziehenden Mädchen gespielt wird. Selbst die Speisekarten der berühmten Lokale in New Orleans – vielleicht die besten Eßlokale in den USA – richten sich nach den Stripteasetouristen. Wir bekamen ein »Striptease Steak«, aber nirgends gab es ein »Jazz Steak«. Zu den Jazzlokalen gehören das weltberühmte »Famous Door«, in dem Sharkey Bonano jahrelang gespielt hat, die »Paddock Lounge«, das »Old Absinthe House« und das Lokal, das sich Pete Fountain für sich und seine Klarinette eingerichtet hat. In der Paddock Lounge spielte Octave Crosbys Band seit elf Jahren, und man kann sich vorstellen, wie die Musik sein muß, wenn eine Band elf Jahre lang ohne Unterbrechung Nacht für Nacht vor einem ältlichen Touristenpublikum die gleichen Stücke spielen muß. Immerhin ist ein so vorzüglicher Musiker wie der Trompeter Thomas Jefferson Mitglied der Band.

»Die New Orleans-Kreolen waren Neger, die von den reichen französischen Pflanzern und Kolonialherren freigelassen worden waren.«

Den verhältnismäßig besten Jazz, den wir auf der Bourbon Street hören konnten, gab es im »Old Absinthe House« von Sweet Emma Barrett am Piano und den beiden Brüdern Willie und Percy Humphrey auf Klarinette und Trompete. Sweet Emma schlägt nuancenlos auf das Klavier, als sei es ein Schlagzeug mit 88 Tasten, aber die Touristen kommen weniger um der Musik willen, als um Sweet Emma zu sehen: An den dürren Füßen trägt sie Schellen, damit es schön klingelt, wenn sie den Rhythmus stampft. Die Touristen sehen die Schellen und sagen: Tja, das ist das alte, wunderschöne, richtige New Orleans. Ich war zweimal im »Old Absinthe House«, und während dieser Zeit gingen fünf verschiedene Touristen zu Sweet Emma und fragten: »You know *Tiger Rag*?« Sweet Emma verzog jedesmal das Gesicht und flüsterte, zu ihren Musikern gewendet, so etwas wie »O je«, aber trotzdem spielte sie jedesmal wieder fleißig den *Tiger Rag*. Trotzdem ist die Bourbon Street eine wunderschöne Straße, und

das alte French Quarter ist die architektonisch schönste und geschlossenste »Stadt«, die es in den USA gibt. Die französischen Eisengitter und die spanischen Patios, die kreolischen Puppen in den Schaufenstern und die hervorragenden Lokale – Oysters Rockefeller und Bouillabaisse à la Nouvelle Orléans sind am meisten zu empfehlen –, die alten spanischen und französischen Häuser, die Straßen, die noch alle französische Namen tragen, und die ganze Atmosphäre dieses »Vieux Carré« sind einzigartig und unverwechselbar. New Orleans ist eine vollkommene Synthese aus Europa und Amerika – oder genauer: aus französischem Charme und lateinamerikanischer Lebenslust, nordamerikanischer Rationalität und schwarzer Vitalität. Es ist überhaupt die einzige Synthese aus diesen vier Elementen, die sich sonst nirgendwo zu einem Ganzen gefügt haben. Deshalb glaubt man, wenn man nach New Orleans kommt, nicht mehr in den USA zu sein. Die Amerikaner meinen, es sei »wie Frankreich«. Aber wenn New Orleans in Frankreich läge, würde man, sobald man die Stadt beträte, glauben, Frankreich verlassen zu haben. Der nordamerikanische Anteil am Temperament und an der Atmosphäre der Stadt ist größer, als es die meisten Amerikaner (für die sich das Amerikanische von selbst versteht) wahrhaben wollen. Die 15 Millionen Dollar, die die Amerikaner im Jahre 1803 für die Stadt und den Staat Louisiana an Napoleon zahlten, werden heute in der Umgebung von New Orleans allein an Erdöl innerhalb von acht Tagen umgesetzt. Dabei waren 15 Millionen Dollar vor 150 Jahren ein vielfach überhöhter Kaufpreis. New Orleans war mit seinen 8000 Einwohnern eine dürftige Insel in einem riesigen Sumpf, der früher oder später alles wieder zu verschlingen drohte. Der Sumpf umgibt auch heute noch die Stadt. Denn New Orleans liegt nicht, wie selbst die Amerikaner sagen, »am Golf von Mexiko«. Zwischen der Stadt und der Mississippimündung breiten sich 170 Kilometer Sumpf. In diesem »Bayou Country« wird auch heute noch französisch gesprochen. Und die französisch sprechenden Familien, die dort leben, haben auch heute noch Verwandte in Quebec oder Montreal. Denn die französischen Kolonisatoren, die das Land Louisiana im Jahre 1699 nach Ludwig XIV. benannten, kamen nicht vom Meer her, sondern den Mississippi herab aus Kanada. Ihren Namen – d'Iberville etwa oder Bienville – begegnet man ständig in New Orleans (das zunächst dort liegen sollte, wo heute Biloxi liegt). Der Instinkt, mit dem sie die Stadt – einer Direktive des Pariser Hofes bewußt entgegenhandelnd – in einer Biegung des Mississippi zwischen dem Strom und dem großen See Pontchartrain gründeten, ist auch 250 Jahre später noch bewundernswert.

Aber zurück zum Jazz, dessen Atmosphäre und Geschichte in New Orleans man nur recht verstehen kann, wenn man die Historie der Stadt kennt. Den Sumpf, der die Stadt umgibt, sahen wir, als wir in der Branch Inn in Slidel – ein paar Meilen außerhalb von New Orleans – eines der »Picnics« erlebten, wie sie in der Entstehungszeit des Jazz üblich waren und wie sie gelegentlich auch heute noch gefeiert werden. Am Sonntagvormittag fährt man mit einem Korb Verpflegung und ein paar Flaschen Gin aufs Land und lagert sich auf einer Wiese. Dort spielt die Band, und man tanzt dazu. In der Branch Inn war es die Band von Little Snooks Eaglin, einem blinden Blues-Sänger und Gitarristen, der sich den effektvollen Beinamen »Little Ray Charles« zugelegt hat, aber seine Blues sind viel rustikaler und einfacher als die des großen Ray Charles. Die Musiker seiner Band spielten zuerst – als es losging und noch nicht viele Leute da waren – hochmodernen Hard Bop. Aber dann kam der Manager und sagte:

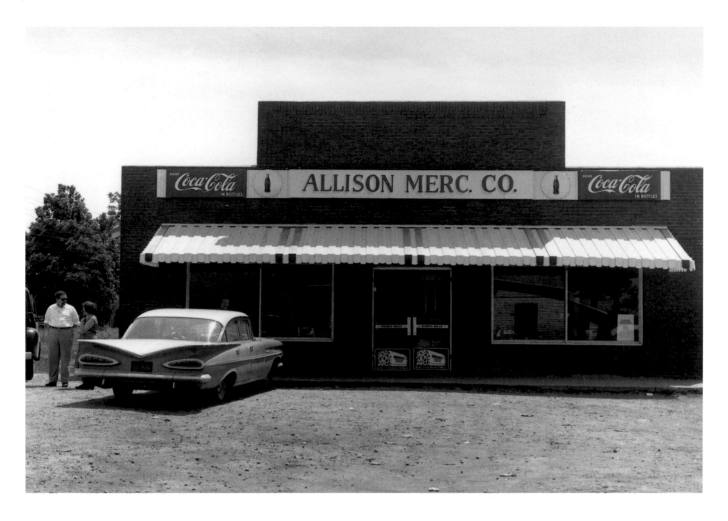

»Enough of that modern stuff« – genug von diesem modernen Zeug. Darauf wurde Rhythm and Blues gespielt. Erst dann fingen die Leute zu tanzen an. Auf diesem Picnic waren wir – wie so oft – die einzigen Weißen. Die jungen schwarzen Tänzer und Tänzerinnen fühlten sich offensichtlich gestört. Zuerst gab es nur ein paar abfällige Bemerkungen: »Hey white man, was willst du hier«, aber dann wurde die Stimmung immer feindseliger, und es schien uns richtiger und friedfertiger, das schöne Jazz Picnic in Slidel vorzeitig zu verlassen.

Bill Russel und Dick Allen müssen bei ihren Jazzexkursionen, die sie für die Tulane University durchführen, ständig einen polizeilichen Ausweis bei sich haben, wonach sie berechtigt sind, Negerwohnungen zu betreten, Negerlokale zu besuchen und an Negerversammlungen teilzunehmen. Theoretisch könnte man ohne einen solchen Ausweis verhaftet werden – auch dann, wenn es gar keine Zwischenfälle gibt. Man wird »sicherheitshalber« verhaftet; den entsprechenden Anlaß findet die Polizei mit Leichtigkeit: Man habe beispielsweise jemanden durch sein Verhalten persönlich verletzt, oder man habe die öffentliche Ordnung gestört oder zu stören gedroht, oder man sei persönlich in einer Gefahr gewesen, von der man nichts ahnte. Natürlich hatte ich keinen solchen Ausweis. Ein paarmal wurde ich darauf aufmerksam gemacht, daß ich ihn mir beschaffen müßte. Aber wenn wirklich die Polizei gekommen wäre, hätte ich einfach gesagt, daß man in Old Germany von diesen Dingen im tiefen Süden der USA nichts wisse. Als ich im Jahre 1950 das erstemal in New Orleans war, war es noch mit keinerlei Risiko verbunden, in schwarze Restaurants, Lokale und Night Clubs zu gehen. Die Spannungen sind erst jetzt durch die gesetzliche Aufhebung der

Schultrennung und durch all das, was dadurch ausgelöst wurde, so spürbar geworden. Die Südstaatler sagen deshalb, daß die Schulgesetzgebung Washingtons (wonach schwarze und weiße Kinder die gleichen Schulen besuchen dürfen) falsch gewesen sei. Denn: »Vorher war es hier unten friedlich, jetzt ist es nicht mehr friedlich.« Aber der Friede, der vorher herrschte, war ein gefährliches Schwelen bösen Hasses, und die Spannungen, die jetzt offener ausgetragen werden, haben die alten schlimmen Verhältnisse nun endlich in Bewegung gebracht und können und werden dazu führen, daß eines Tages menschlichere Verhältnisse herrschen. Einmal, als ich eine lange Diskussion mit einem typischen, engherzigen Südstaatler hatte, konnte ich erleben, wie all diese friedlichen weißen Bürger, die da die Rassentrennung vertreten, wilde und böse Fanatiker werden und wie der Haß auf ihren Gesichtern erscheint, wenn man die Neger gegenüber den Weißen gar zu nachdrücklich in Schutz nimmt. Schließlich versuchte es mein Gesprächspartner nochmals auf die freundliche Tour. Er legte mir die Hand auf die Schulter und sagte: »Herrgott, Sie kommen doch aus Deutschland. Sie müssen uns doch verstehen. Sie haben ja Ihr Problem gelöst. Sie mit Ihren Juden!«

Wir erlebten in New Orleans ein Funeral und zwei Street Parades. Die alten Funerals, bei denen es mit trauriger Musik zum Friedhof hinaus und mit fröhlicher Musik um so swingender und ausgelassener vom Friedhof wieder heimging, und die Street Parades, bei denen die Brass Bands durch die Straßen marschierten, um alles mögliche zu feiern, sind nicht nur in musikalischer, sondern auch in sozialer Hinsicht zum Symbol geworden für jene Atmosphäre, aus der heraus New Orleans die Hauptstadt der Jazzentstehung werden konnte. Die beiden traditionsreichsten Bands der New Orleans-Straßenparaden bestehen immer noch: die Tuxedo Brass Band und die Eureka Brass Band. Sie bestehen im Grunde, solange es unser Jahrhundert gibt. Viele der alten berühmten Jazzmusiker haben in ihnen gespielt. Manche altbekannte Namen sind auch heute noch in ihnen vertreten – in der Tuxedo Brass Band etwa der Trompeter Alvin Alcorn und der Schlagzeuger Louis Barbarin; jüngere Musiker sind hinzugekommen. Bis vor wenigen Jahren hat George Lewis in der Eureka Band mitgespielt. Neben diesen beiden alten Bands gibt es noch ein drittes Orchester, das auf den Street Parades zu hören ist: die George Williams Brass Band. Paul Barbarin übrigens, der in den zwanziger und dreißiger Jahren ein bevorzugter Schlagzeuger von Louis Armstrong und Jelly Roll Morton war, ist heute einfach der Schlagzeuger in New Orleans. Überall trifft und hört man ihn. Auf den Transparenten, die im Zug unserer ersten Street Parade mitgeführt wurden, hieß es, daß diese Parade von der Creole Fiesta Association organisiert sei, einer Vereinigung, die die alte kreolische Kultur und Tradition pflegen will. Ich muß, wenn ich mir die zahllosen Vereine und Vereinigungen, Grüppchen und Sekten und Interessenverbände in New Orleans und in den schwarzen Wohnbezirken der USA vergegenwärtige, oft daran denken, daß man uns Deutschen nachsagt, wir seien ein besonders vereinsträchtiges Volk. Das mag so sein, aber nirgends gibt es mehr Vereine und Vereinigungen als bei den Negern der USA, und nirgends ist das Standes- und Sozialbewußtsein größer als bei ihnen. Die Barriere, die Schwarze und Weiße voneinander trennt, ist nur deshalb so auffällig, weil die Probleme, die dadurch entstehen, unsere ganze Zivilisation betreffen. Aber jenseits davon trennen sich die Neger untereinander durch Barrieren, die mindestens ebenso hoch und unüberwindlich sind und die gewiß auch dann weiterbestehen werden, wenn das Rassenproblem längst gelöst ist. Schulen und Pfadfinderverbände, Jungengruppen und Jungmädchenvereine, auch das Militär hatte zu der Parade seine Abordnungen geschickt. In der Abordnung des Militärs marschierten Schwarze und Weiße einträchtig nebeneinander. Sonst nahmen nur Neger an der Parade teil. Der Festzug sammelte sich nahe der Kreuzung der North Claiborn und der St. Bernard Avenue und war bald, nachdem viele verschiedene, farbenprächtig uniformierte Gruppen dazugestoßen waren, 600 oder 700 Meter lang. Das ganze Stadtviertel mußte von der Polizei abgesperrt werden. Der Verkehr wurde umgeleitet. Jedermann schien an der Street Parade beteiligt. Überall wurde getanzt – allein, zu zweit und in Gruppen. Auch alte Leute und Kinder tanzten. Unmittelbar hinter der Band marschierten und tanzten die am meisten Begeisterten: die sogenannte »Second Line«, die zweite Reihe, die der »ersten Reihe« – nämlich den Musikern – nachfolgt. Eines der beliebtesten Requisiten eines rechten »Second Liners« ist der Regenschirm, obwohl es doch fast nie regnet. Man sieht ihn in allen Formen und Farben immer wieder bei den Street Parades und überhaupt überall, wo Neger lustig sind: Symbol eines kleinen Himmels, unter dessen freundlicher Abgeschlossenheit man geborgen sein darf. Außer-

halb des »Himmels« herrscht die feindliche, die weiße Welt. Oder gibt es noch eine andere Erklärung für die symbolträchtige Beliebtheit des Regen- und Sonnenschirms bei den Negern?

Als die Parade zu Ende war, gab die Creole Fiesta Association in ihrem Clubhaus eine große Party. Die Party begann mit einem festlichen Essen, und danach wurde getanzt und weitergegessen. Die Torte, die für alle Besucher der Party angeschnitten wurde, hatte einen Durchmesser von anderthalb Metern. Alte, würdige Damen beherrschten die Szene und achteten darauf, daß alles genau nach Konvention und Sitte ablief. Jeder schien genau vorher zu wissen, mit wem er zu tanzen hatte, und trotzdem war alles gelöst und fröhlich. Die Präsidentin dieser kreolischen Vereinigung sagte unumwunden, worauf es ihr ankam: »Wir pflegen die alten Traditionen, damit die Jungen sehen, wie schön die Traditionen sind, und in ihnen weiterleben.« Ich fragte sie, ob nur kreolische Neger Mitglied ihrer Vereinigung werden könnten? Sie sagte: »Jeder kann zu uns kommen, der sich als zugehörig empfindet.« Aber zumindest die älteren Herrschaften legten Wert darauf, mit jedem, von dem sie annehmen konnten, daß er es verstünde, Kreolisch zu sprechen – ein bastardisiertes Französisch mit spanischen, englischen und afrikanischen Sprachbrocken. Höhepunkt des Festes war eine große Quadrille. Zunächst wurden – nach Geschlechtern getrennt – zwei lange Reihen gebildet, die zueinanderfanden und sich wieder voneinander lösten, und als sich dann die Paare im Kreise drehten, mochte man eher an ein Menuett an einem französischen Hof des 18. Jahrhunderts als an einen Jazztanz denken. Den älteren Tänzern kam es offensichtlich darauf an, die kleinen, klassischen Menuettschritte genau richtig zu machen. Daß dazu die Tuxedo Brass Band spielte, erschien gewiß nur Außenstehenden als Widerspruch. Keiner dieser Tänzer und Tänzerinnen würde daran zweifeln, daß die New Orleans-Musik der Tuxedo Brass Band ein präziser musikalischer Ausdruck alter, höfischer, französischer Tanzkultur ist. Wenn die Musiker sagen, sie spielten jetzt ein Menuett oder eine Polonäse oder eine Gavotte, so setzen sie diese Worte nicht in Anführungszeichen. Sie glauben wirklich, sie spielen Menuette, Polonäsen und Gavotten. Aber was sie spielen, ist New Orleans Jazz, von dem nur noch Musikwissenschaftler in genauer Analyse ausmachen können, daß einmal Elemente alter höfischer Tanzmusik in ihn hineingeflossen sind. Gewiß bedeutet ein solches kreolisches Fest nicht nur das Weitergeben einer alten, schönen Tradition an die jüngere Generation. Der Glanz, der die kreolische Tradition umgibt, hängt auch mit der rassischen Situation zusammen. Die Kreolen waren freie Neger, bevor es den Bürgerkrieg und die Pseudobefreiung von der Sklaverei gab. Sie waren in der Zeit der Sklaverei freier als die Neger heute, hundert Jahre nach Aufhebung der Sklaverei. Die New Orleans-Kreolen waren Neger, die von den reichen französischen Pflanzern und Kolonialherren freigelassen worden waren – oft Kinder der schwarzen Mätressen, die zu haben für einen Angehörigen der französischen Oberschicht zum guten Ton gehörte. Diese Kreolen gehörten bald zu den tüchtigsten Händlern der Stadt. Sie hielten die französische Kultur auch dann lebendig, als Napoleon New Orleans an die USA verkauft hatte. Sie waren in der Zeit der Sklaverei kultivierter, gebildeter und wohlerzogener, als es die Neger – und auch die meisten Weißen – in den Südstaaten heute sind. Deshalb bedeutet heute die Vorliebe für die kreolische Tradition nicht nur Traditionsliebe; sie ist verdrängte Emanzipation und verkappter Protest.

Am 12. Mai 1960 starb William E. Pajaud, »geliebter Ehemann von Mrs. Sallie Pajaud, Vater von William Pajaud, Bruder von Albert Pajaud …«, und dann folgt in der Zeitung die ganze Verwandtschaft, zwölf Zeilen lang. Danach heißt es: »Verwandte und Freunde der Familie, Pastoren, Kirchenälteste und Mitglieder der King Salomon Baptist Church, Söhne und Töchter der Auferstehungsgesellschaft ›Die freundliche Acht‹, ›Die Glocken der Freude‹, die ›Stern von Bethlehem-Loge‹« und zehn andere Vereine, denen der Verstorbene angehört hatte, »werden aufgefordert, das Funeral am Samstag, dem 14. Mai 1960, um 3 Uhr zu besuchen. Der Zug beginnt bei der Louisiana Undertaking Company, 1449, North Claiborn Avenue«. William E. Pajaud war sein Leben lang Trompeter bei der Eureka Brass Band. Seine Spezialität waren die »Dirges«, die langsamen, traurigen Stücke, die bei den Funerals auf dem Weg zum Friedhof gespielt wurden. Jahrzehntelang haben viele Menschen in New Orleans sich gewünscht, daß William E. Pajaud bei ihrem Funeral der Solotrompeter sein möchte und die Dirges spielen solle. Er hat nichts lieber getan als dies: »Ich spiele lieber ein Funeral, als daß ich ein Truthahndinner esse.« Noch am Tage, bevor er starb, hatte er ein Funeral gespielt. Er war 58 Jahre alt. Der Anteil, der an seiner Beerdigung genommen wurde, war entsprechend groß. Man sammelte sich am Gebäude der Louisiana-Bestattungsgesellschaft, und dann ging der lange Zug zum »St. Louis-Friedhof Nummer zwei«. Vorn weg ging mit langsamen, würdevollen und gleichwohl tänzerischen Schritten der »Grand Marshall« des Funerals, dann kam die Eureka Brass Band, danach die Hinterbliebenen und dann alle übrigen. Die Band spielte alle die Dirges, die William E. Pajaud besonders meisterhaft beherrscht hatte – nicht zuletzt die alte Hymne *Just a Closer Walk with Thee*.

»Die alten Funerals, bei denen es mit trauriger Musik zum Friedhof hinaus und mit fröhlicher Musik um so swingender und ausgelassener vom Friedhof wieder heimging.«

In früherer Zeit war der Boden der Stadt New Orleans so sumpfig, daß man die Verstorbenen nicht unter der Erde beerdigen konnte. Aus dieser Zeit stammt die Sitte, die Toten über der Erde in mächtigen Steingräbern zu bestatten. Als die Urne in den Steinbau hineingeschoben wurde, waren die Szenen auf dem Friedhof herzzerreißend. Mrs. Pajaud weinte und stammelte und schrie immer wieder: »Good-bye, Willie.« Und die anderen Frauen standen ihr kaum nach. Kinder waren von außen über die Friedhofsmauer geklettert und schauten zu. Andere warteten bereits am Ausgang auf die Eureka Brass Band, um dann sofort eine »Second Line« zu bilden und der Band, deren Klänge nun wieder den Lebenden gehörten, swingend und fröhlich hinterherzutanzen. Aber auch jetzt war die Musik ein klassischer Bestandteil aller New Orleans Funerals: *Just a Little While to Stay Here*, das Lied von der kleinen Weile, die man sich nur auf dieser Erde aufhalten kann. Ursprünglich war es ein Choral, aber nun wurde es »geswingt«, als sei es *When the Saints Go Marchin' In*. Daß auch dies gespielt wurde, versteht sich von selbst.
Am Sonntag darauf gab es eine weitere Straßenparade. Sie wurde von der True Love Missionary Baptist Church School veranstaltet, der Missions-Baptistenschule ›Wahre Liebe‹. Voran marschierte wieder der »Grand Marshall«. Es gab zwei Bands – die Tuxedo und die George Williams Brass Band. Die Instrumente

waren – wie immer – Posaunen, Trompeten, Saxophone, Klarinetten, Sousaphon und sonstige Blasinstrumente sowie große Trommeln und mehrere kleinere Trommeln. Kinder, Mütter und Väter zogen im Sonntagsstaat hinter den Bands her. Und selbstverständlich gab es auch hier eine begeisterte »Second Line«. Ein paar Jungen kletterten auf die Bäume, um alles besser sehen zu können. Auch ein paar Pferdekutschen zogen im Zug mit: für die vornehmen Damen, die zeigen wollten, daß sie es nicht nötig haben zu gehen. Überall gab es Transparente, die im Zug mitgetragen wurden. Ein paar davon waren noch in französischer Sprache – auch darin an die alte französisch-kreolische Tradition anknüpfend. Der Zug führte direkt in die Kirche. Die Tuxedo Brass Band stellte sich vor der Gemeinde im Chor der Kirche auf und umrahmte die Predigt mit New Orleans Jazz.

Natürlich besuchten wir auch das Geburtshaus Louis Armstrongs. Die James Alley, in der Satchmo geboren wurde, liegt, entfernt vom French Quarter, in einer ärmlichen und anrüchigen Gegend – zwischen der Perdido und der Gravier Street. Selbst Dr. Souchon, der große Mann des New Orleans Jazz Club, warnte uns, dorthin zu gehen. Die ganze Gegend sieht wie eine Ruinenlandschaft nach einem Bombenangriff aus, wenn man gerade die ersten behelfsmäßigen Hütten wiederaufgebaut hat. Es ist verwunderlich, daß diese Hütten bereits siebzig oder achtzig Jahre lang bewohnt werden. Zunächst sahen wir in der James Alley nur feindselige und böse Gesichter. Keiner wollte uns Auskunft geben. Als wir Satchmos Geburtshaus – eine schmale, ärmliche Holzhütte: James Alley 723 – schließlich doch fanden, hörten wir, noch bevor wir genau wußten, welches Haus es war, sehr moderne Trompetenimprovisationen. Und nun geschah das Erstaunliche: In dem gleichen Zimmer (wenn man das »Zimmer« nennen darf), in dem Louis Armstrong geboren wurde, übte ein vierzehnjähriger Junge Trompete. Jerry McGhee war sein Name. Natürlich fragten wir ihn nach Louis Armstrong, aber er war nicht im geringsten an Old Satchmo interessiert. Sicher hatte er einmal gehört, daß dieser Raum die Geburtsstube von Armstrong sei, aber das bedeutet ihm nicht mehr, als wenn Herr Meier oder Herr Schulze dort gewohnt hätte. »Ich mag Clifford Brown viel lieber als ihn«, sagte er. Später lernten wir Jerrys Mutter kennen. Die junge Frau lebt mit ihrem Mann – einem Lastwagenchauffeur – und neun Kindern in zwei kleinen Räumen. Sie meinte: »Ich möchte, daß Jerry Gitarre spielt und nicht Trompete. Dann kann er doch ein neuer Elvis Presley werden!«

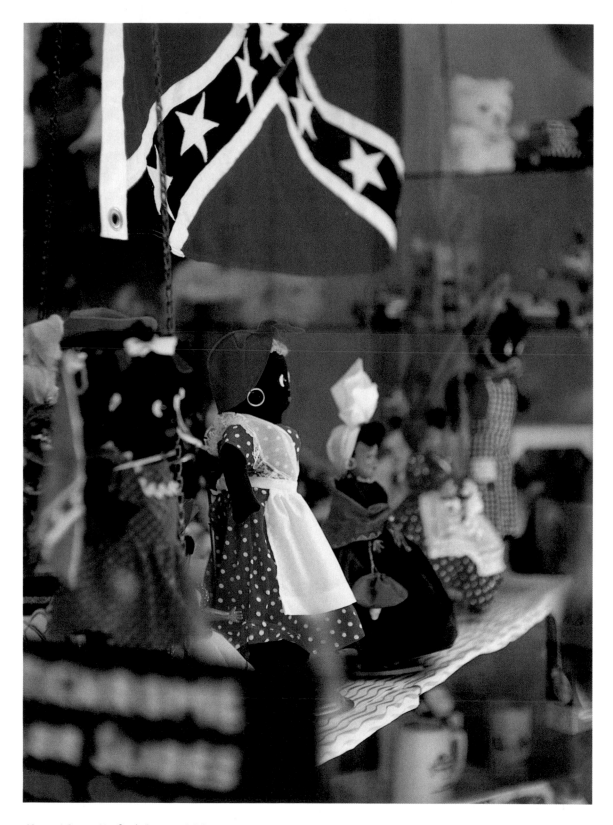

Above / Opposite Creole "mammy dolls".

Ci-dessus / Ci-contre Des poupées créoles représentant
la « nounou noire ».

Oben / Gegenüber Kreolische »Mammy«-Puppen.

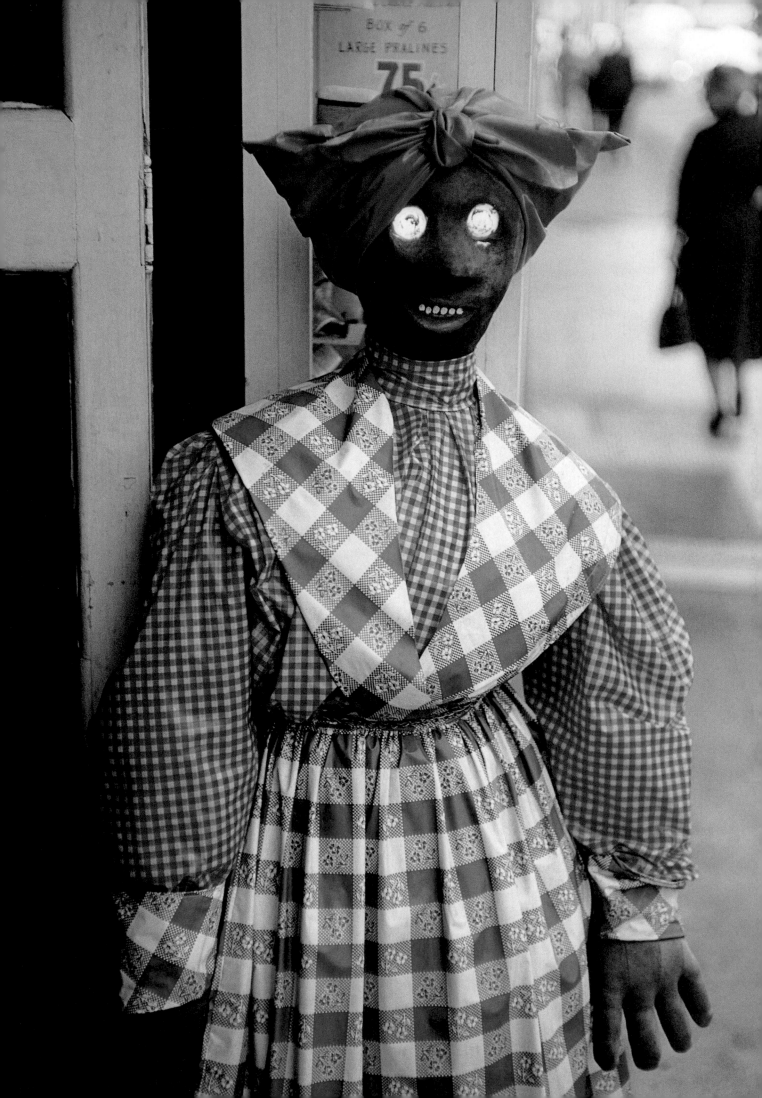

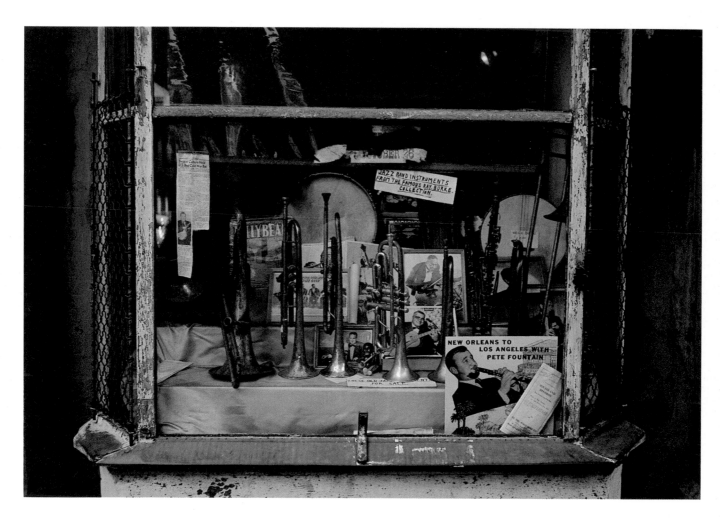

Above / Opposite Window displays on Bourbon Street,
New Orleans.

Ci-dessus / Ci-contre Vitrines dans Bourbon Street, à la
Nouvelle-Orléans.

Oben / Gegenüber Schaufensterauslage in der Bourbon
Street, New Orleans.

THOMAS JEFFERSON

BOB OGDEN

ALBERT BURBANK

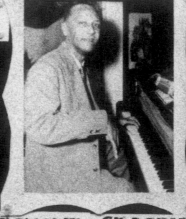

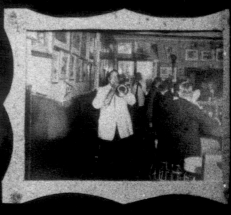

OCTAVE CROSBY

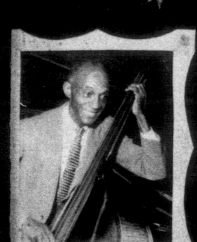

PADDOCK DIXIELAND JAZZ BAND

RICHARD McLEAN

CLEM TREVALORE

ASCAP

YOU'VE SEEN THEM ON T.V.
HEARD THEM ON RADIO

YOU'VE SEEN THEM IN MOVIES
HERE THEY ARE IN PERSON

NO MINIMUM

NO COVER!

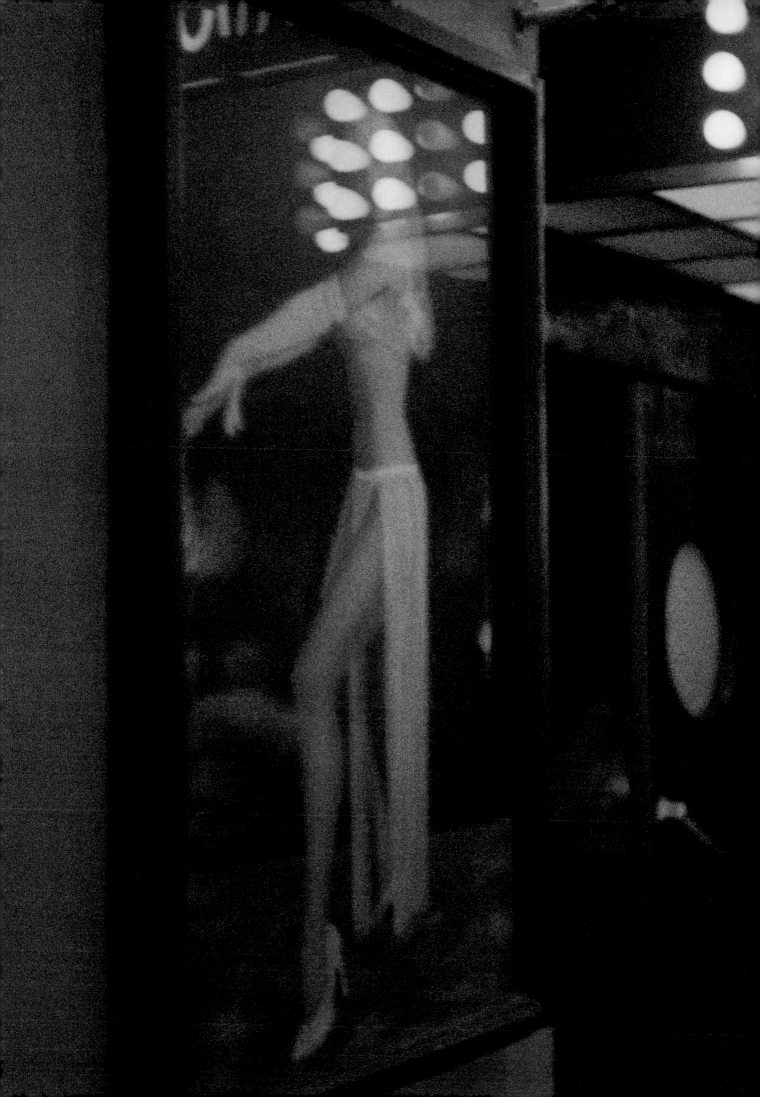

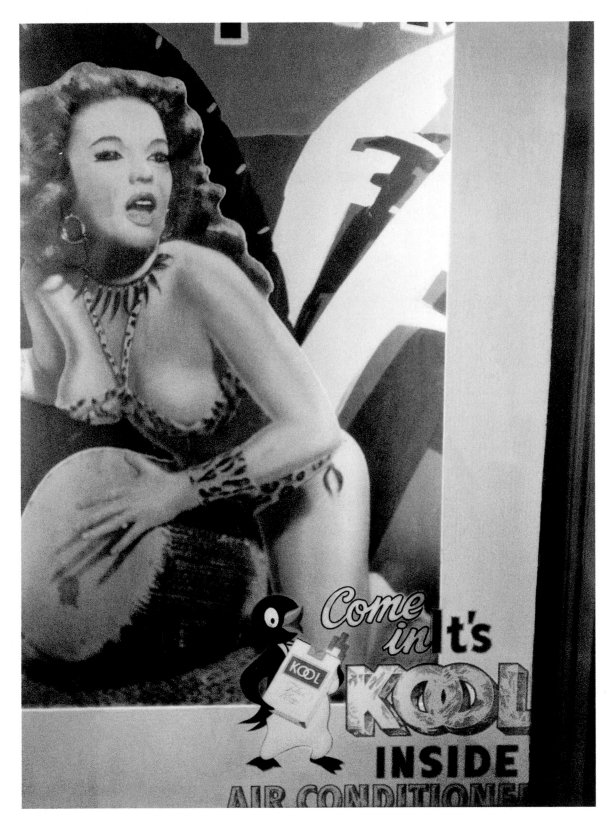

Opposite / Above Strip tease joints have replaced many jazz clubs on Bourbon Street.

Ci-contre / Ci-dessus Sur Bourbon Street, les boîtes de strip-tease ont remplacé bon nombre de clubs de jazz.

Gegenüber / Oben Stripteaselokale haben viele Jazzclubs auf der Bourbon Street verdrängt.

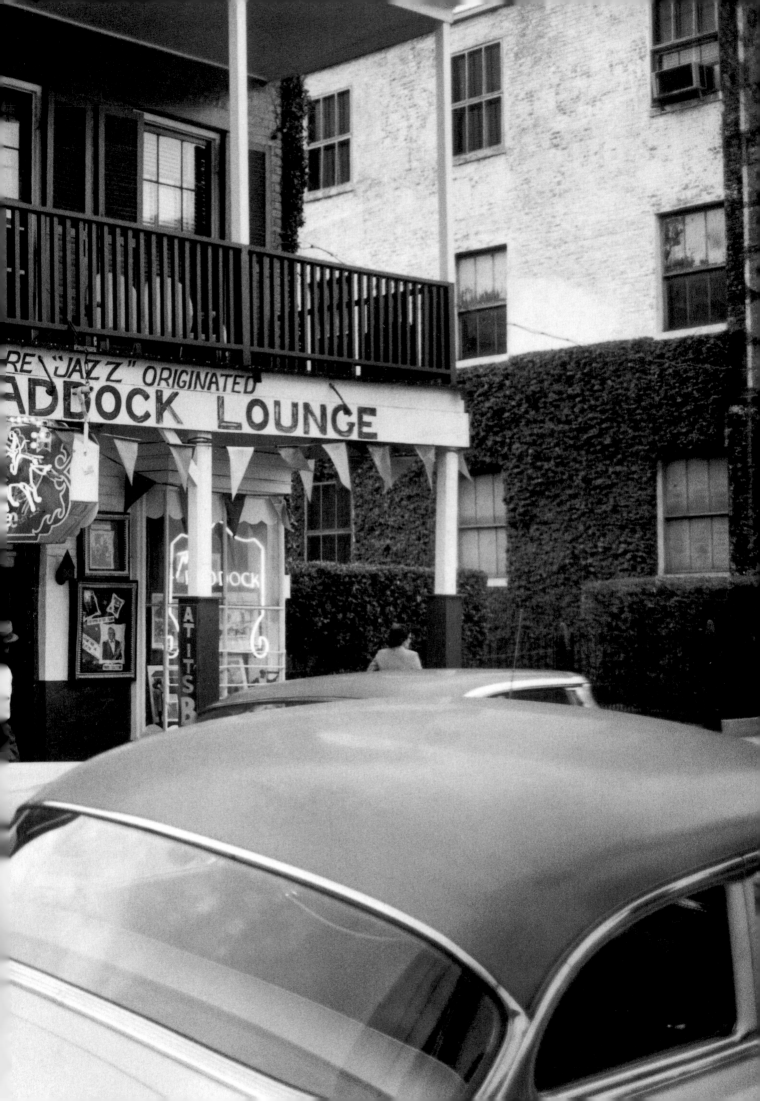

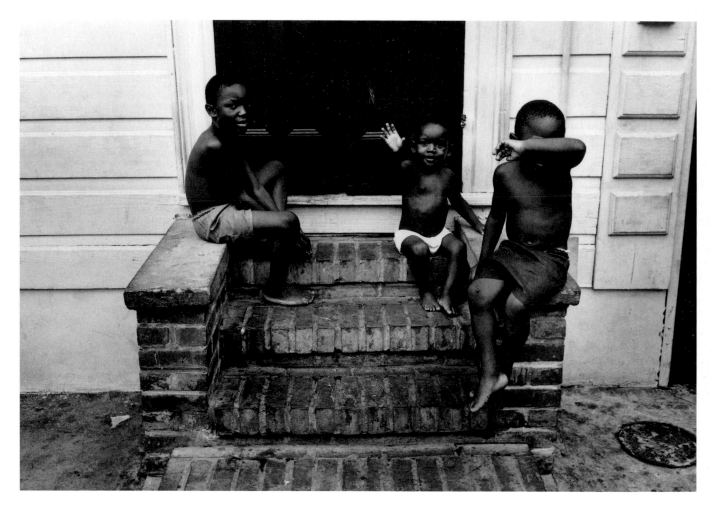

Pages 60–61 Paddock Lounge jazz club.
Above Children in the French Quarter, New Orleans.
Opposite Dee Dee and Billie Pierce in front of the remains of the old Luthjen's Dance Hall.

Pages 60–61 Le club de jazz Paddock Lounge.
Ci-dessus Des enfants dans le Vieux Carré de la Nouvelle-Orléans.
Ci-contre Dee Dee et Billie Pierce devant les vestiges du vieux dancing Luthjen's.

Seiten 60–61 Der Jazzclub Paddock Lounge.
Oben Kinder im French Quarter, New Orleans.
Gegenüber Dee Dee und Billie Pierce vor den Resten der alten Luthjen's Dance Hall.

Above Jack Laine in his family photo album from around 1885.
Opposite Papa Jack Laine (with one of his many hand-made fireman's helmets) and Mrs. Laine, New Orleans.

Ci-dessus Un portrait de Jack Laine datant d'environ 1885, dans son album de photos de famille.
Ci-contre Papa Jack Laine (avec l'un des nombreux casques de pompiers qu'il réalise lui-même), et Mme Laine, Nouvelle-Orléans.

Oben Jack Laine in seinem Familienalbum aus der Zeit um 1885.
Gegenüber Papa Jack Laine (mit einem seiner vielen selbst hergestellten Feuerwehrhelme) und Mrs. Laine, New Orleans.

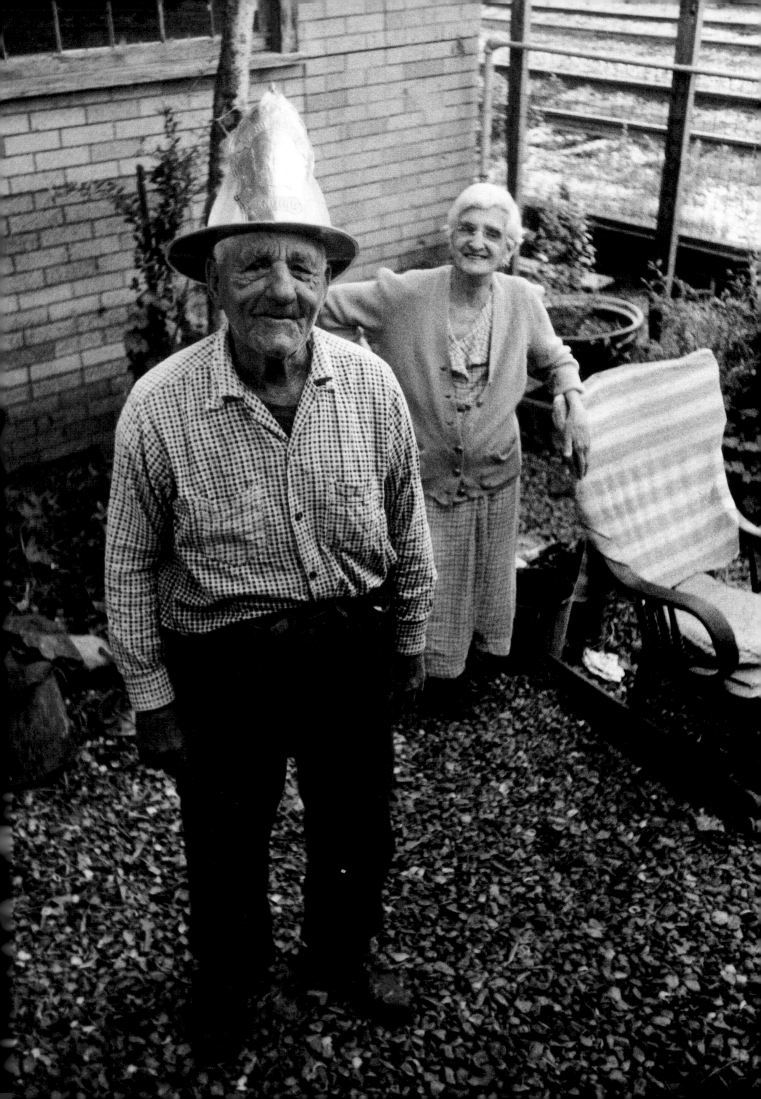

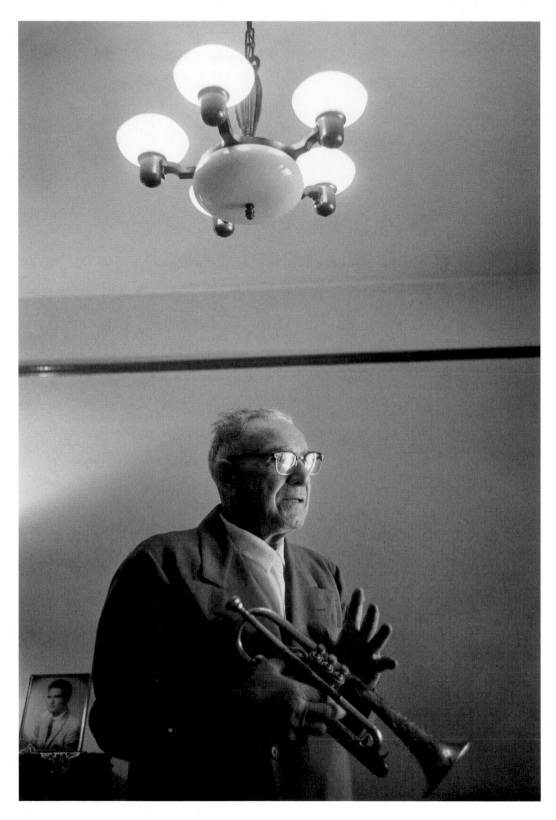

Above / Opposite Nick La Rocca claimed to have "invented jazz" with his all-white Original Dixieland Jazz Band.

Ci-dessus / Ci-contre Nick La Rocca soutient avoir « inventé le jazz » avec son orchestre entièrement composé de Blancs, l'Original Dixieland Jazz Band.

Oben / Gegenüber Nick La Rocca nahm für sich in Anspruch mit seiner nur aus Weißen bestehenden Original Dixieland Jazz Band den Jazz »erfunden« zu haben.

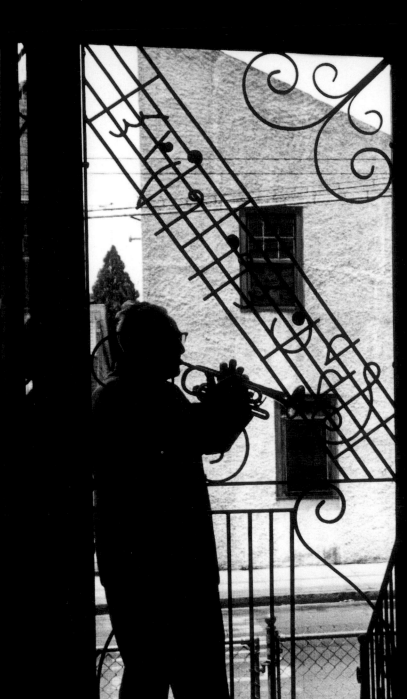

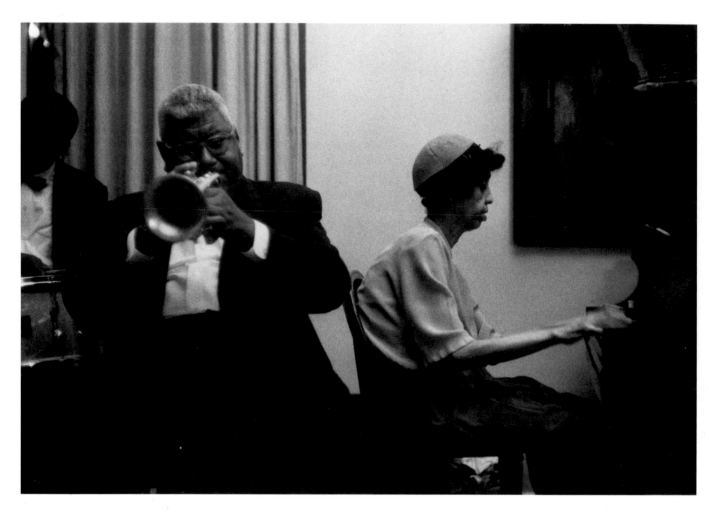

Above Brother Percy Humphrey with Sweet Emma Barrett at the
Old Absinthe House on Bourbon Street.
Opposite "Colored" and "White" drinking fountains were
everywhere in the Deep South.

Ci-dessus Brother Percy Humphrey avec Sweet Emma Barrett
à l'Old Absinthe House sur Bourbon Street.
Ci-contre Dans le Sud profond, il y avait partout des fontaines
séparées pour «gens de couleur» et «Blancs».

Oben Bruder Percy Humphrey mit Sweet Emma Barrett am Old
Absinthe House auf der Bourbon Street.
Gegenüber Brunnen mit Trinkwasser für »Farbige« und »Weiße«
gab es im tiefen Süden überall.

COLORED WHITE

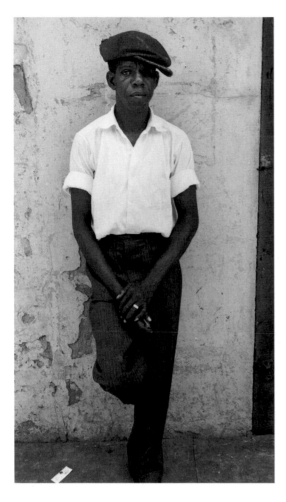

Above / Right Brother Percy Randolph plays harmonica while selling junk from his cart on Burgundy Street.
Pages 72 – 73 The George Williams Brass Band, New Orleans.

Ci-dessus / À droite Brother Percy Randolph joue de l'harmonica tout en vendant de la camelote dans sa carriole de colporteur sur Burgundy Street.
Pages 72 – 73 La George Williams Brass Band, Nouvelle-Orléans.

Oben / Rechts Bruder Percy Randolph spielt Mundharmonika, während er mit seinem Karren auf der Burgundy Street Krimskrams verkauft.
Seiten 72 – 73 Die George Williams Brass Band, New Orleans.

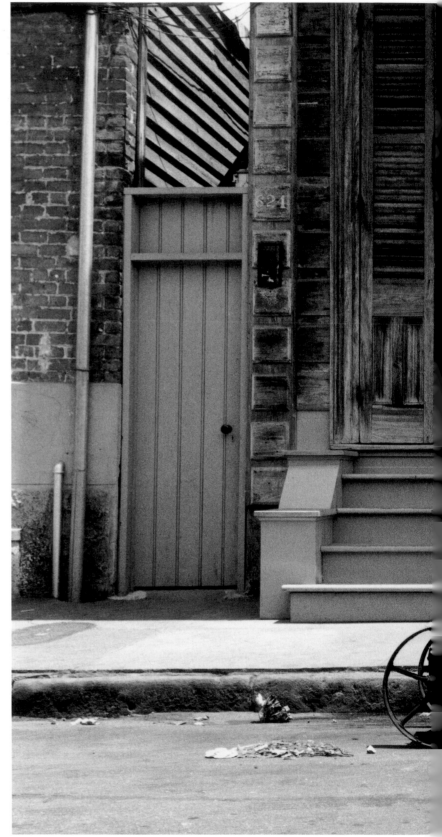

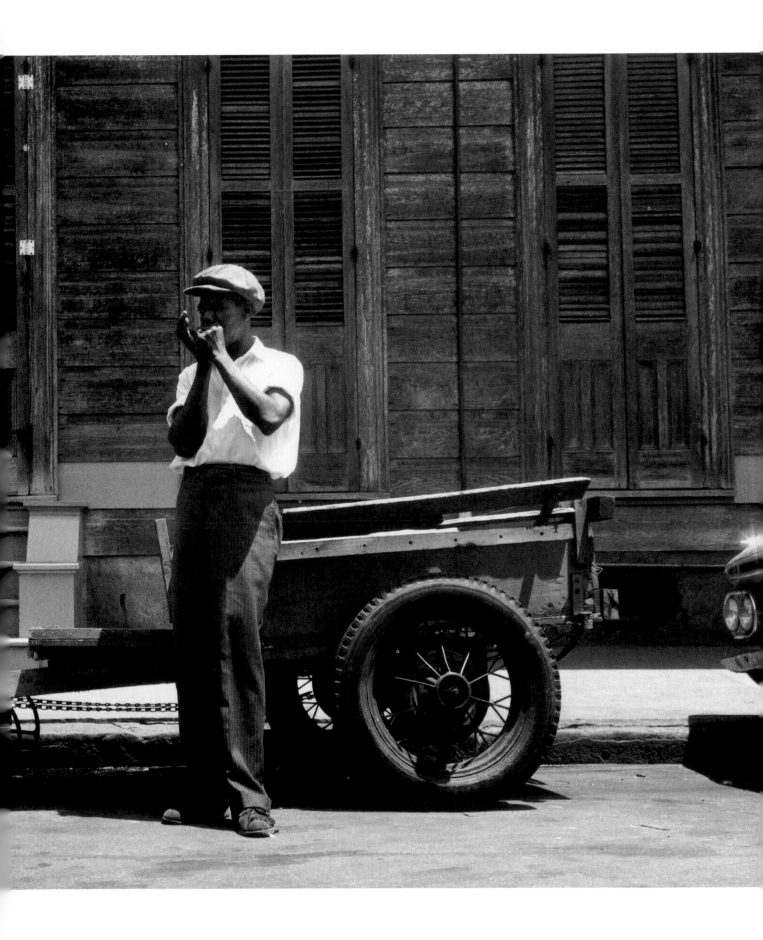

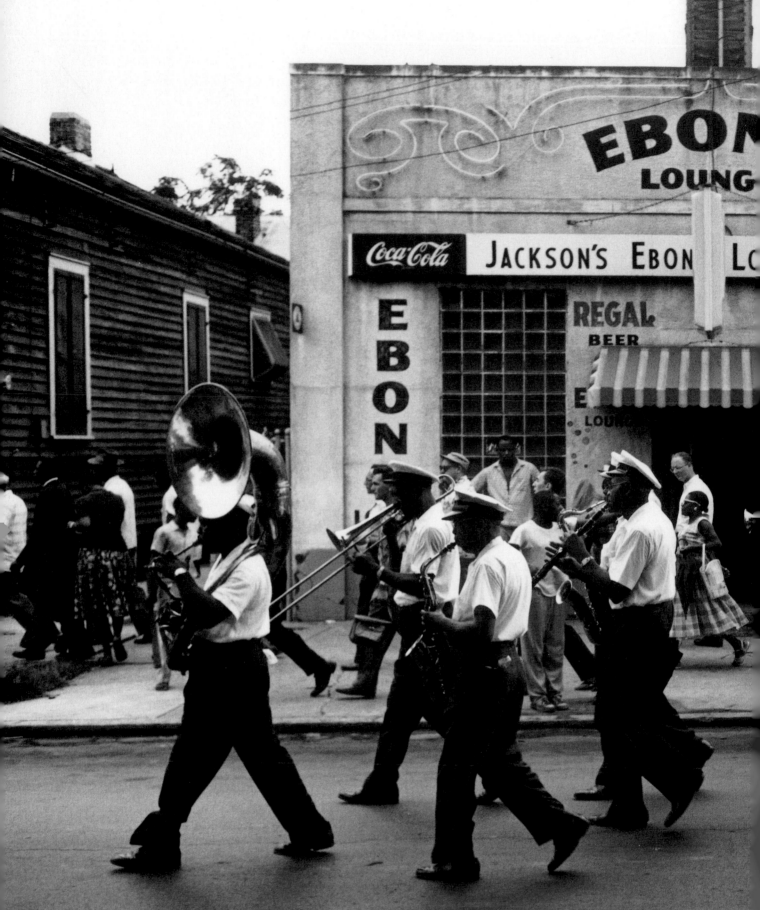

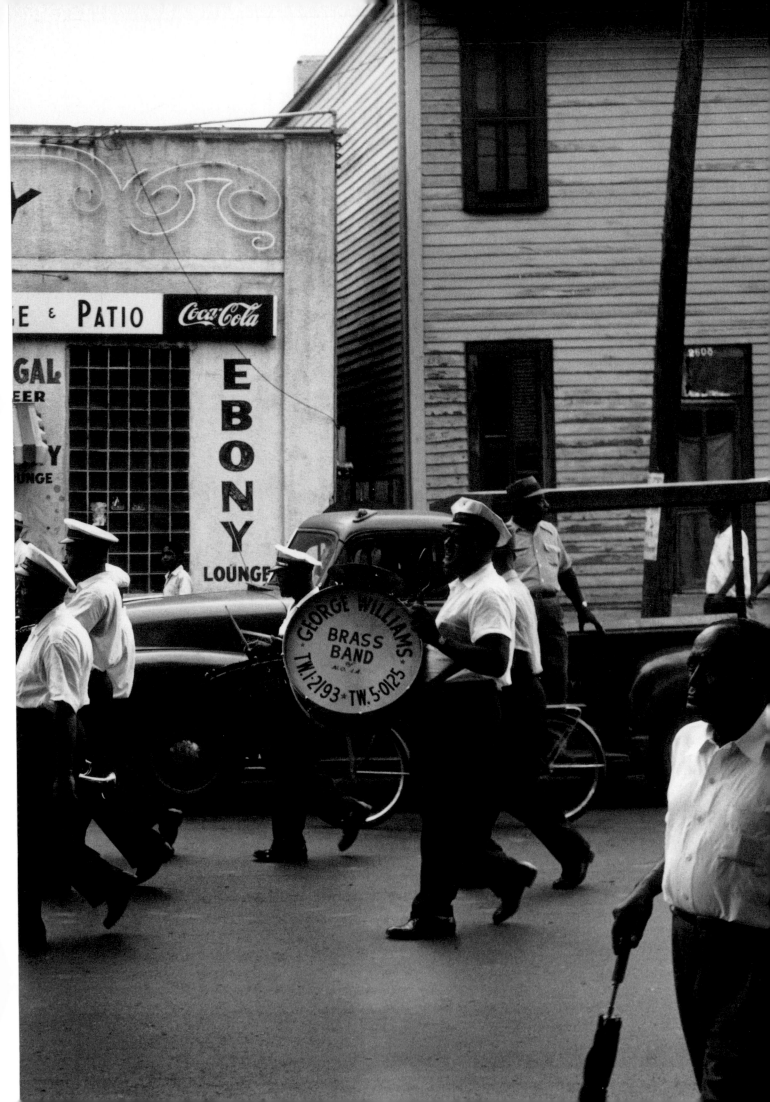

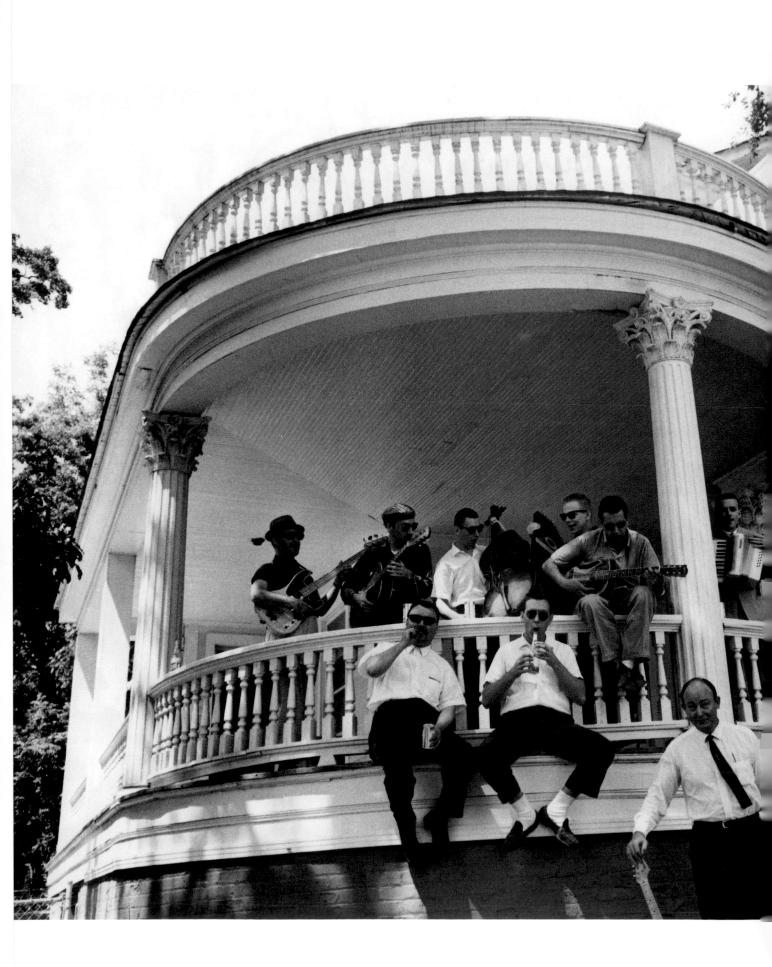

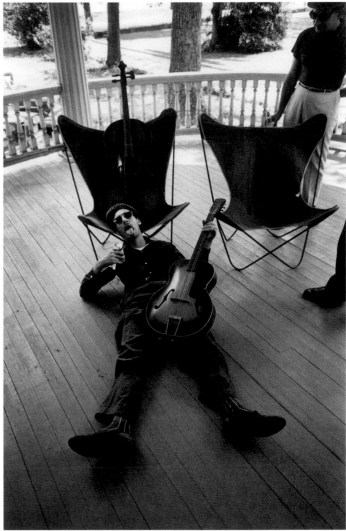

Left / Above Some of Biloxi's young jazzmen in front of Carmen Massey's music store.

À gauche / Ci-dessus De jeunes jazzmen de Biloxi devant le magasin de musique de Carmen Massey.

Links / Oben Einige junge Jazzmusiker aus Biloxi vor Carmen Masseys Musikgeschäft.

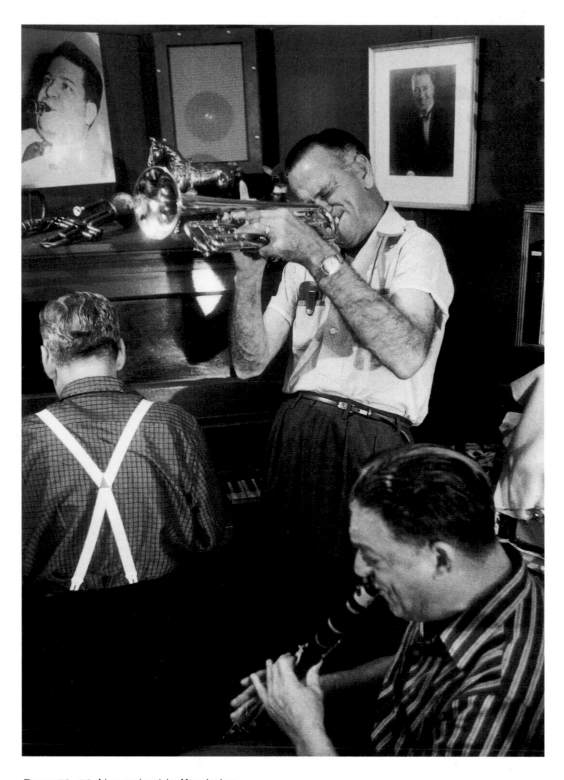

Pages 78–79 A jam session at Joe Mares's place.
Above: Armand Hug (piano), Tommy Gonsoulin (trumpet), Raymond
Burke (clarinet). Opposite: Sister Elizabeth Eustis (vocalist), Evelyn
Williams (piano), Sal Gutierrez (drums).

Pages 78–79 Une jam-session chez Joe Mares.
Ci-dessus: Armand Hug (piano), Tommy Gonsoulin (trompette),
Raymond Burke (clarinette). Ci-contre: Sister Elizabeth Eustis (chant),
Evelyn Williams (piano), Sal Gutierrez (batterie).

Seiten 78–79 Eine Jamsession zu Hause bei Joe Mares.
Oben: Armand Hug (Klavier), Tommy Gonsoulin (Trompete), Raymond
Burke (Klarinette). Gegenüber: Schwester Elizabeth Eustis (Sängerin),
Evelyn Williams (Klavier), Sal Gutierrez (Schlagzeug).

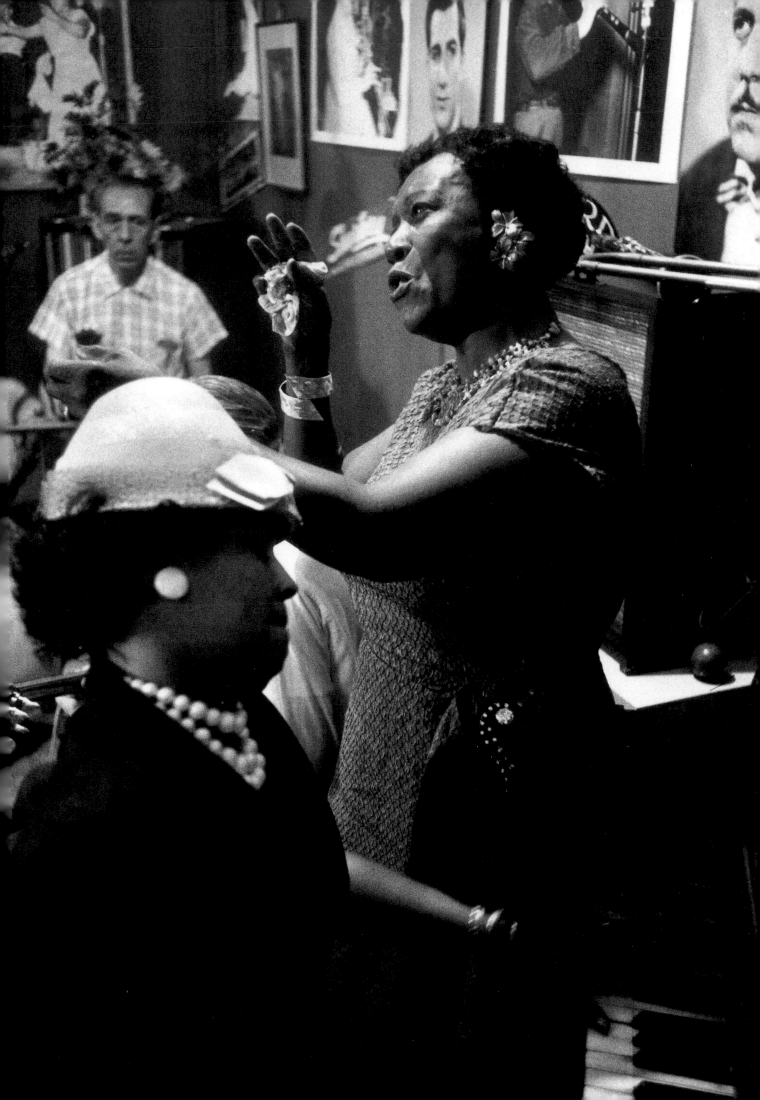

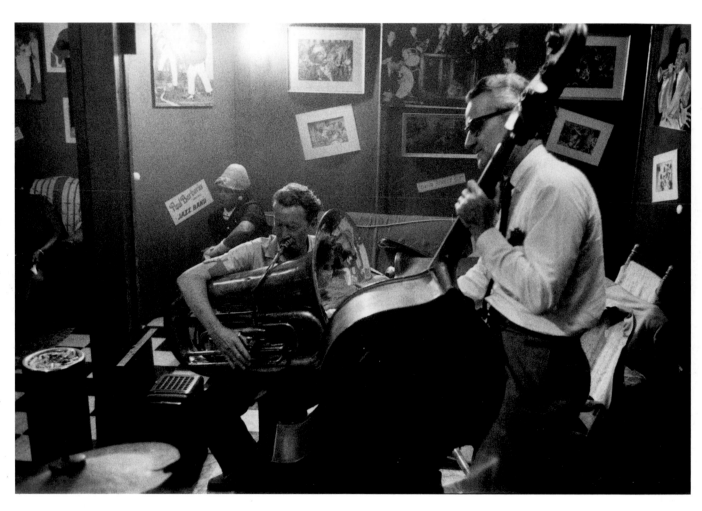

Above James "Pinky" Wadlington (tuba), Bob Coquille (bass).

Ci-dessus James « Pinky » Wadlington (tuba), Bob Coquille (basse).

Oben James »Pinky« Wadlington (Tuba), Bob Coquille (Baß).

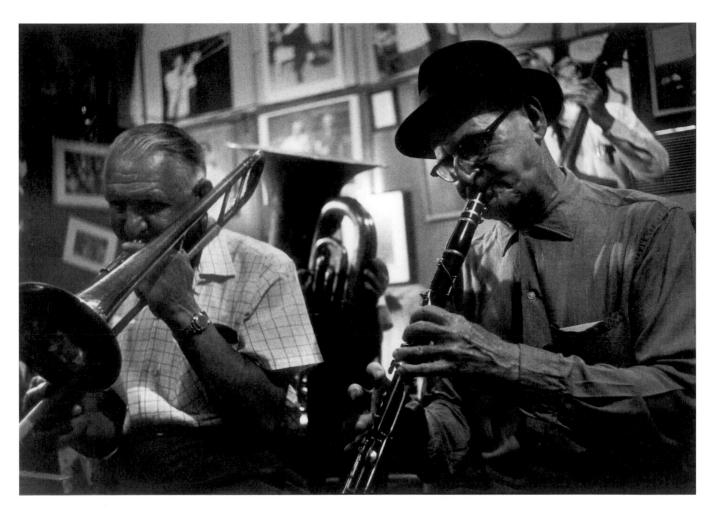

Above Harry Shields (clarinet), Sharkey Bonano (trumpet).

Ci-dessus Harry Shields (clarinette), Sharkey Bonano (trompette).

Oben Harry Shields (Klarinette), Sharkey Bonano (Trompete).

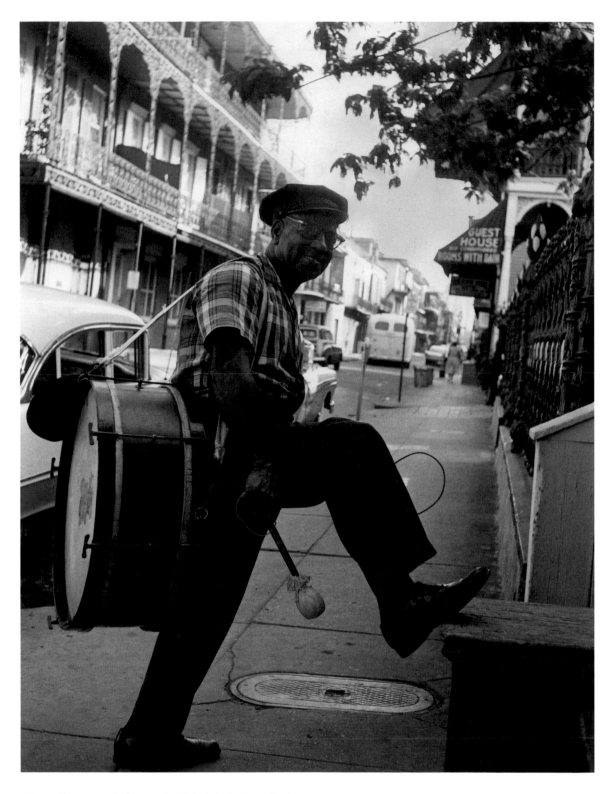

Above The very popular drummer Paul Barbarin in the French Quarter.
Opposite Louis Armstrong's birth place in James Alley with
fourteen-year-old Jerry McGhee (trumpet).

Ci-dessus Paul Barbarin, batteur vedette, dans le quartier français.
Ci-contre La maison natale de Louis Armstrong dans James Alley
avec Jerry McGhee, quatorze ans (trompette).

Oben Der berühmte Schlagzeuger Paul Barbarin im French Quarter.
Gegenüber Louis Armstrongs Geburtshaus in der James Alley mit
dem vierzehnjährigen Jerry McGhee (Trompete).

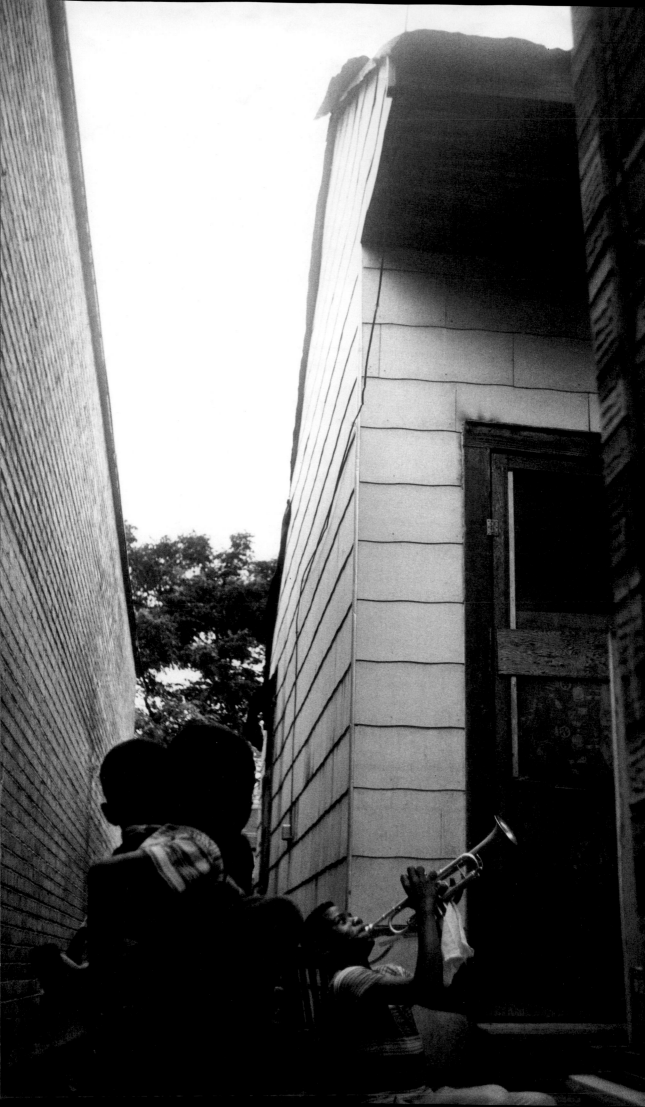

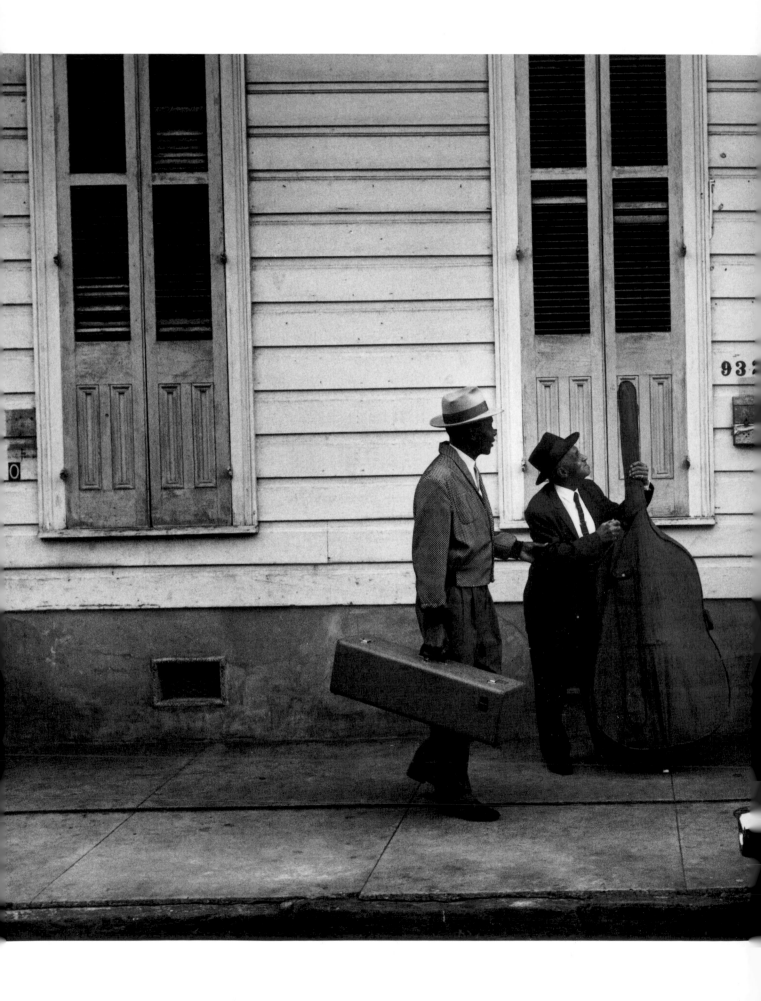

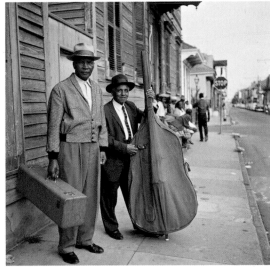

Left / Above Jim Robinson (trombone) and Slow Drag Pavageau (bass) near their home on Dumaine Street.

À gauche / Ci-dessus Jim Robinson (trombone) et Slow Drag Pavageau (basse) près de chez eux dans Dumaine Street.

Links / Oben Jim Robinson (Posaune) und Slow Drag Pavageau (Baß) vor ihrem Haus in der Dumaine Street.

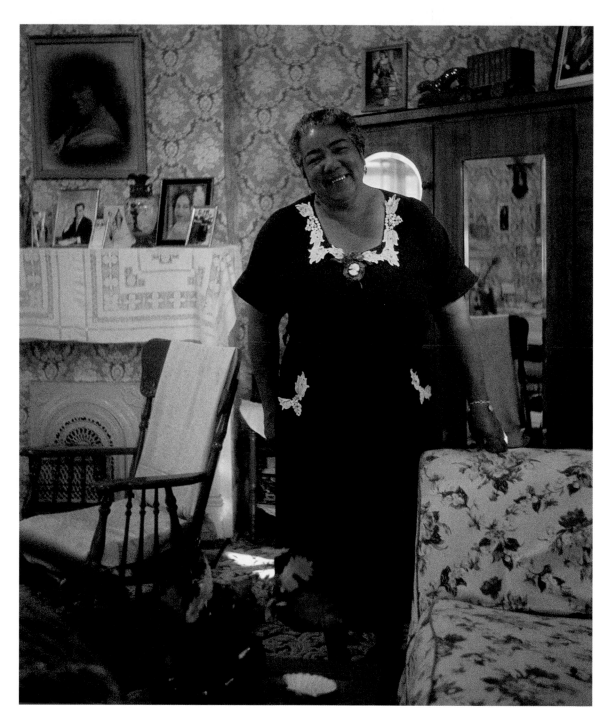

Above Lizzie Miles is considered to be the only great blues
singer in New Orleans. Ms. Miles here in her home on Tonti Street.
Opposite Jim Robinson in his home on Dumaine Street in New
Orleans.

Ci-dessus Lizzie Miles est considérée comme la seule grande
chanteuse de blues de la Nouvelle-Orléans. Mlle Miles ici chez elle
dans Tonti Street.
Ci-contre Jim Robinson chez lui dans Dumaine Street à la
Nouvelle-Orléans.

Oben Lizzie Miles gilt als die einzige große Bluessängerin aus
New Orleans. Ms. Miles hier zu Hause in der Tonti Street.
Gegenüber Jim Robinson zu Hause in der Dumaine Street in
New Orleans.

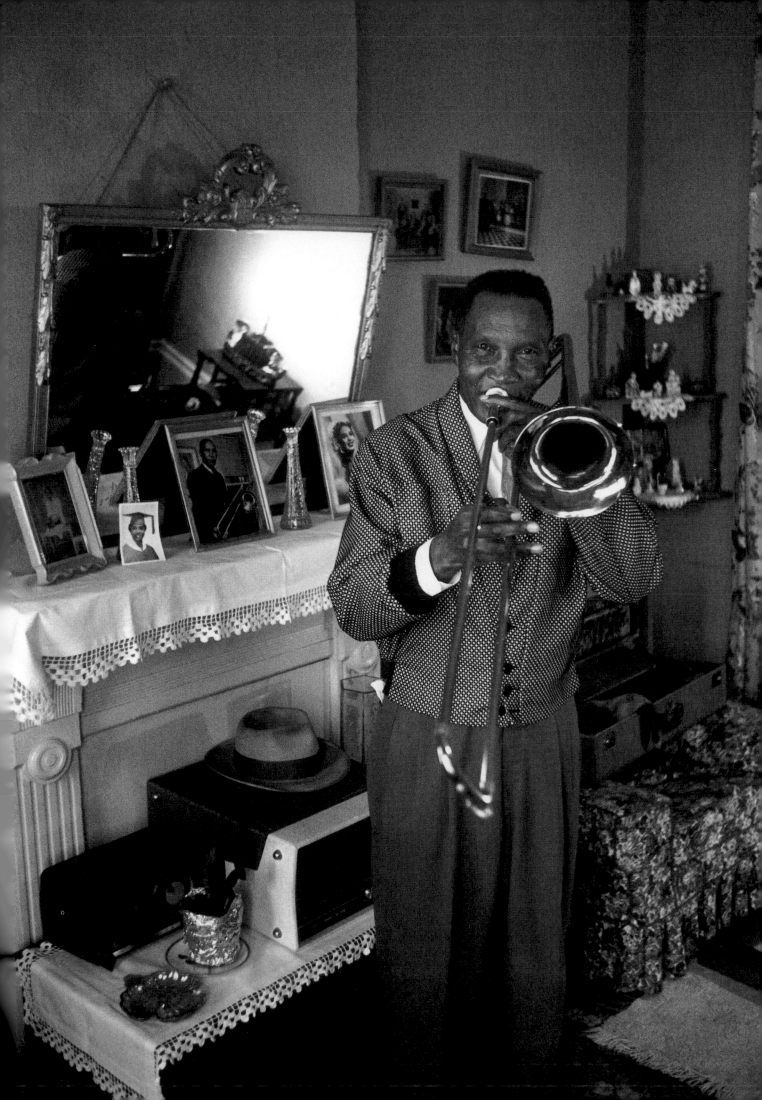

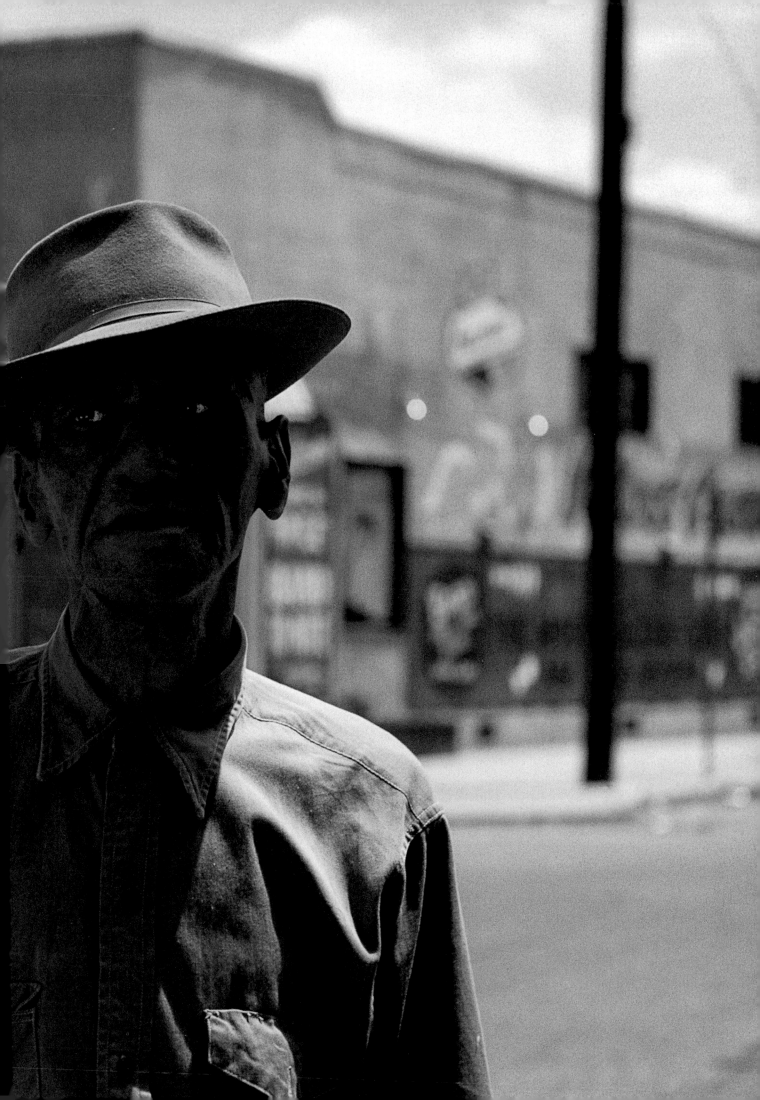

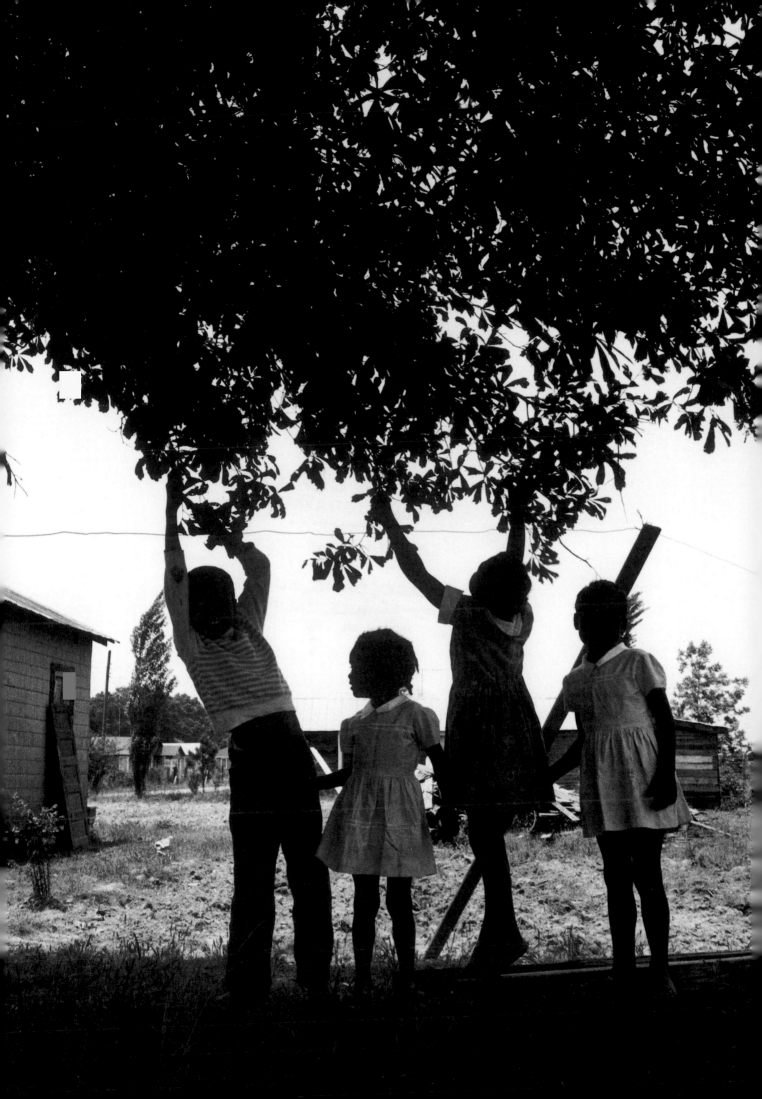

Pages 88 – 89 Louis Keppard, banjo player who switched
to tuba, grocery shopping in New Orleans.
Opposite / Above On the road to Algiers, a suburb of New
Orleans.

Pages 88 – 89 Louis Keppard, banjoïste passé au tuba, ici
faisant ses courses à la Nouvelle-Orléans.
Ci-contre / Ci-dessus En route vers Algiers, une banlieue
de la Nouvelle-Orléans.

Seiten 88 – 89 Louis Keppard, Banjospieler, der zur Tuba
übergewechselt ist, beim Einkauf in New Orleans.
Gegenüber / Oben Unterwegs nach Algiers, einem Vorort
von New Orleans.

Above Mrs. George Lewis comforts Mr. Lewis' one-hundred-plus-year-old mother, who is enjoying a smoke on her pipe.

Ci-dessus Mme George Lewis veille sur sa belle-mère, cent ans et des poussières, pendant que celle-ci fume sa pipe.

Oben Mrs. George Lewis kümmert sich um die über hundertjährige Mutter von Mr. Lewis, die genüßlich ihre Pfeife raucht.

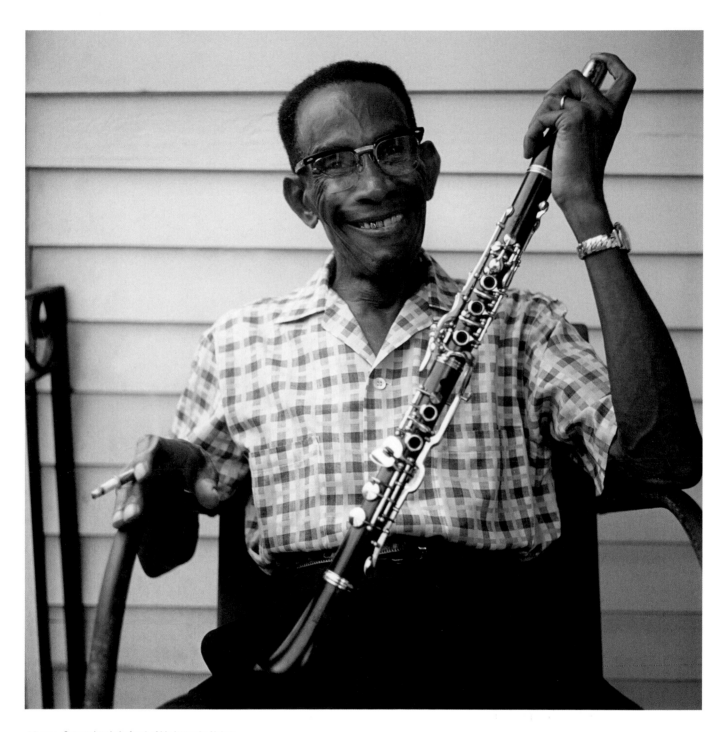

Above George Lewis in front of his home in Algiers.

Ci-dessus George Lewis devant chez lui à Algiers.

Oben George Lewis vor seinem Haus in Algiers.

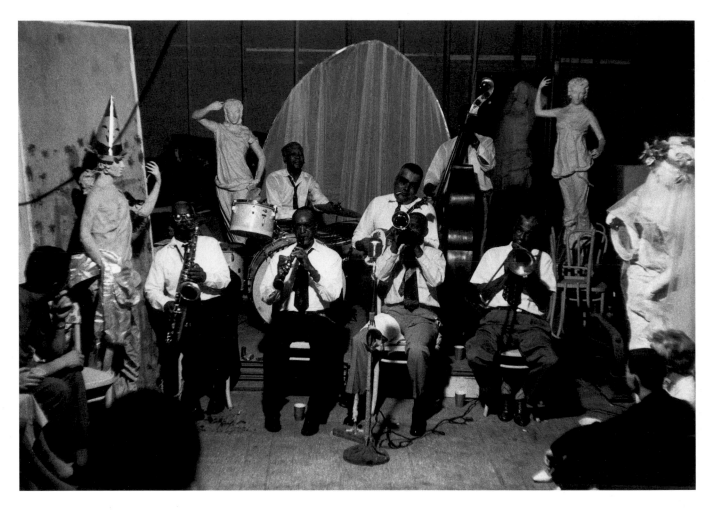

Above Kid Thomas' New Orleans Band: Manuel Paul (tenor saxophone), Sammy Penn (drums), Paul Barnes (clarinet), George "Creole Blues" Guesnon (banjo), Kid Thomas (trumpet), "Kid Twat" Joseph Butler (bass), Louis Nelson (trombone).
Opposite George "Creole Blues" Guesnon at his home with his best friend.

Ci-dessus Le Kid Thomas' New Orleans Band : Manuel Paul (saxophone ténor), Sammy Penn (batterie), Paul Barnes (clarinette), George « Creole Blues » Guesnon (banjo), Kid Thomas (trompette), « Kid Twat » Joseph Butler (basse), Louis Nelson (trombone).
Ci-contre George « Creole Blues » Guesnon chez lui avec son meilleur ami.

Oben Kid Thomas mit seiner New Orleans Band: Manuel Paul (Tenorsaxophon), Sammy Penn (Schlagzeug), Paul Barnes (Klarinette), George »Creole Blues« Guesnon (Banjo), Kid Thomas (Trompete), »Kid Twat« Joseph Butler (Baß), Louis Nelson (Posaune).
Gegenüber George »Creole Blues« Guesnon zu Hause mit seinem besten Freund.

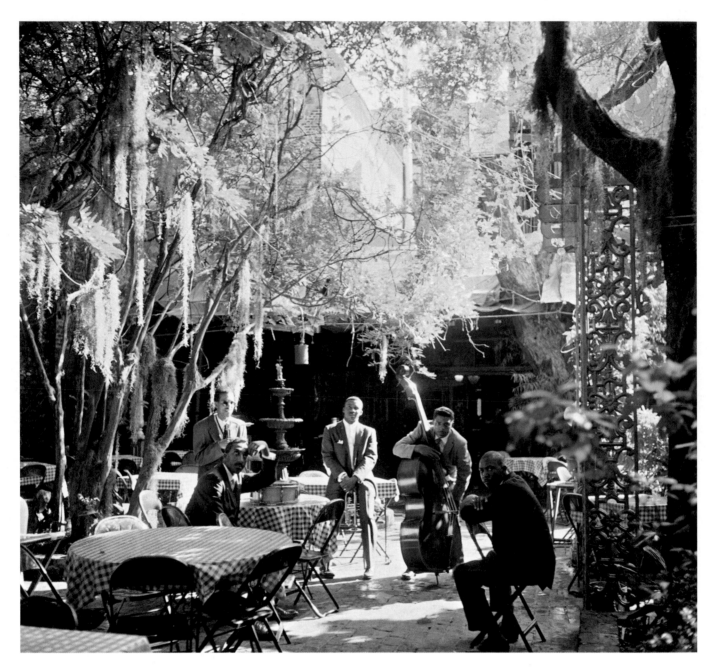

Above The Melvin Lastie Quintet on a patio in the French Quarter in
New Orleans: Emile Verret (piano), Lawrence Guyton (bass), Melvin Lastie
(cornet), Charles Otis (drums), Charles Fairley (tenor saxophone).
Opposite Alphonse Picou in Picou's bar on Ursulines Street.
He was born in 1878. His famous solo from *High Society* recorded with
the Olympia Band is perhaps the most imitated solo in the history of jazz.

Ci-dessus Le Melvin Lastie Quintet dans un patio du Vieux Carré de la
Nouvelle-Orléans : Emile Verret (piano), Lawrence Guyton (basse), Melvin
Lastie (cornet), Charles Otis (batterie), Charles Fairley (saxophone ténor).
Ci-contre Alphonse Picou dans son bar de la Ursulines Street. Il est né
en 1878. Son célèbre solo dans *High Society*, enregistré avec le Olympia
Band, est sans doute le solo le plus imité de l'histoire du jazz.

Oben Das Melvin Lastie Quintet auf einer Terrasse im French Quarter in
New Orleans: Emile Verret (Klavier), Lawrence Guyton (Baß), Melvin Lastie
(Kornett), Charles Otis (Schlagzeug), Charles Fairley (Tenorsaxophon).
Gegenüber Alphonse Picou in seiner Bar in der Ursulines Street. Er
wurde 1878 geboren. Sein berühmtes Solo aus *High Society*, das mit der
Olympia Band aufgenommen wurde, ist das wohl am häufigsten imitierte
Solo in der Geschichte des Jazz.

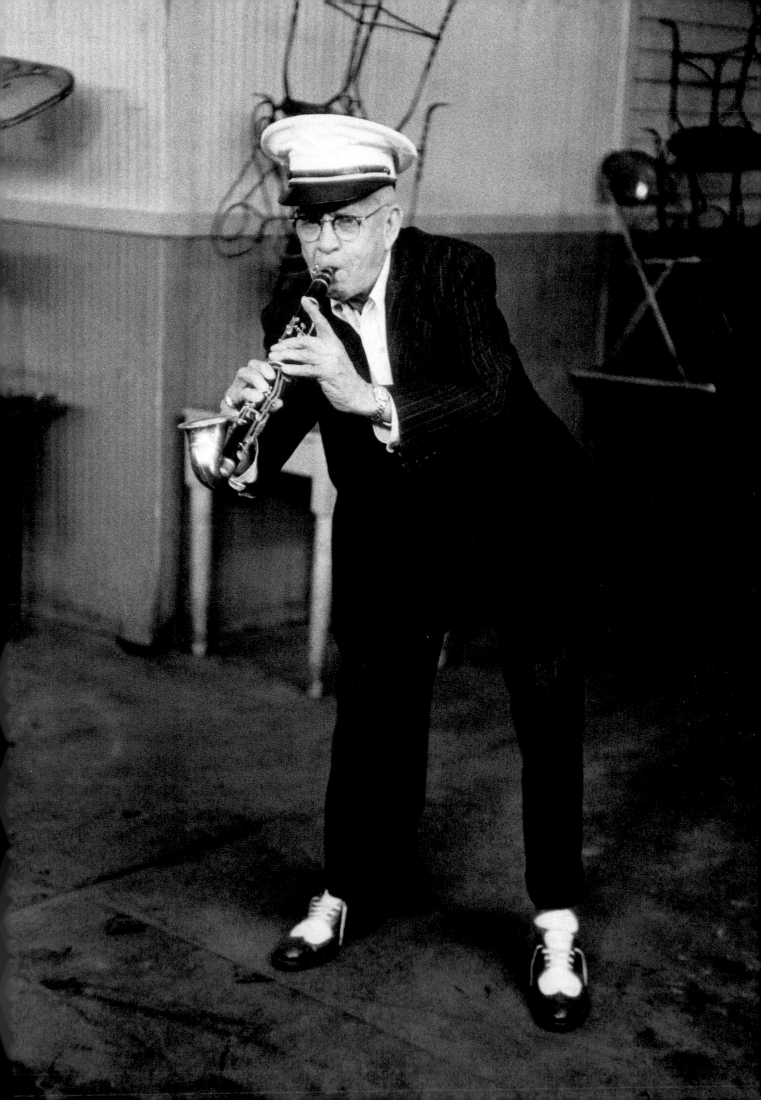

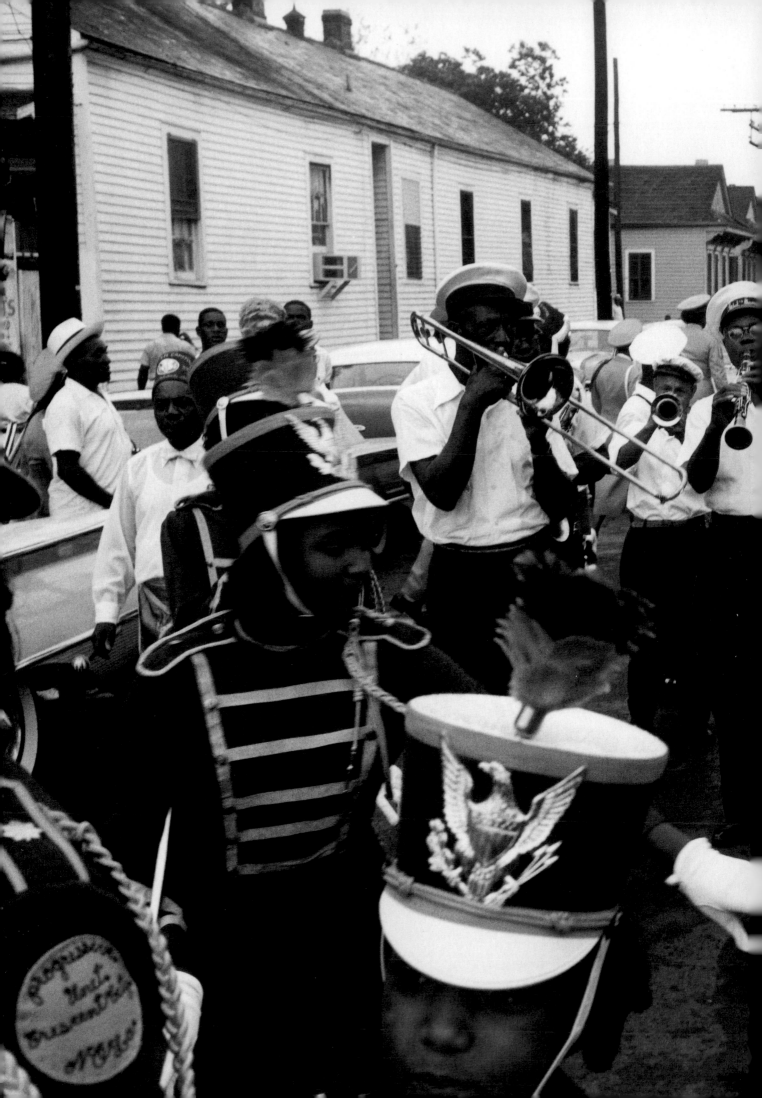

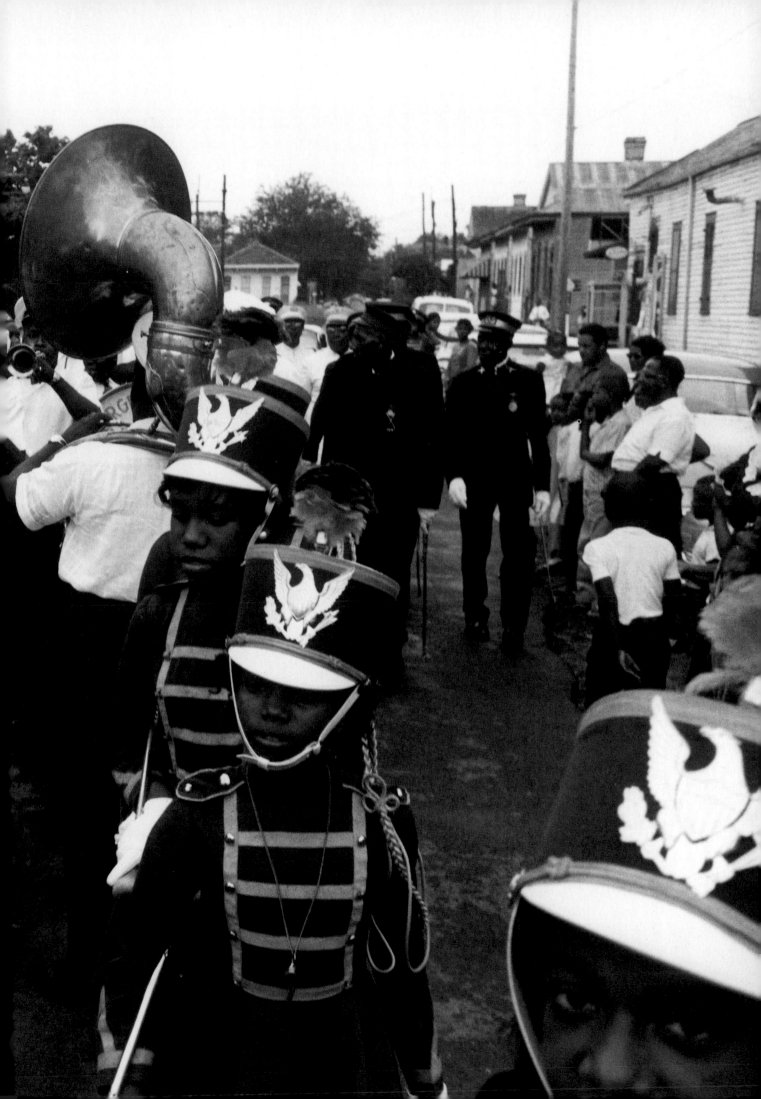

Pages 98–99 The Tuxedo Brass Band warms up for a parade, New Orleans.
Pages 100–103 The onlookers and participants of a street parade for the True Love Missionary Baptist Church School.

Pages 98–99 Le Tuxedo Brass Band s'échauffe avant une procession, Nouvelle-Orléans.
Pages 100–103 Les badauds et les participants d'une procession organisée par la True Love Missionary Baptist Church School.

Seiten 98–99 Die Tuxedo Brass Band bereitet sich auf eine Parade vor, New Orleans.
Seiten 100–103 Zuschauer und Teilnehmer einer Street Parade der True Love Missionary Baptist Church School.

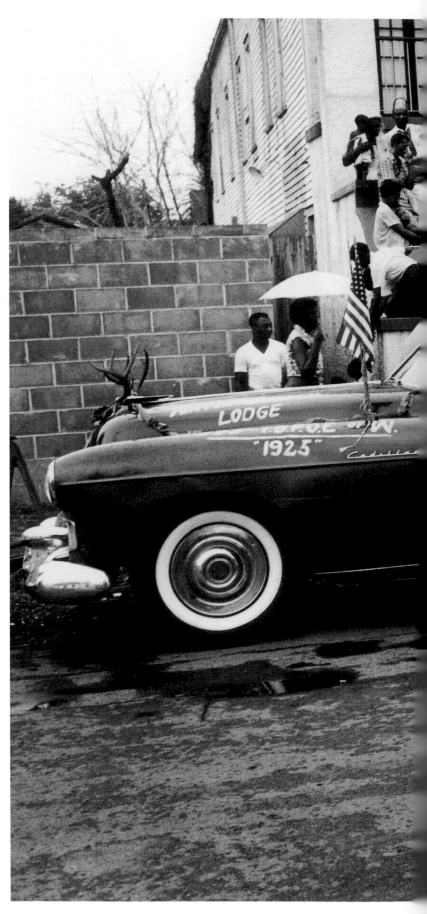

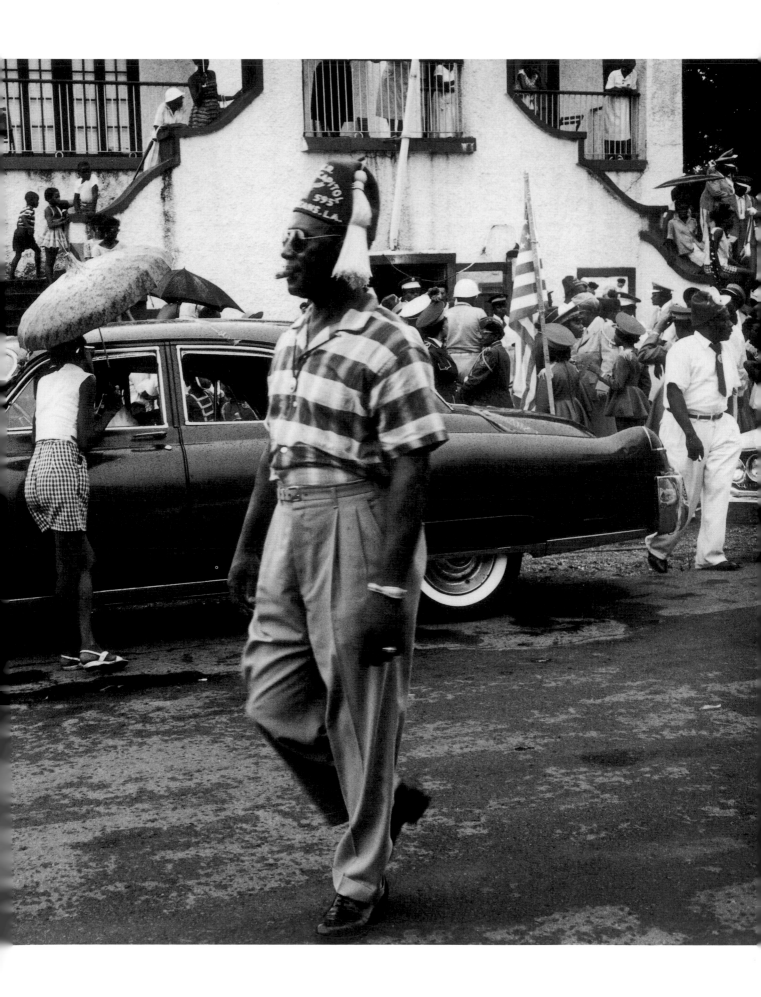

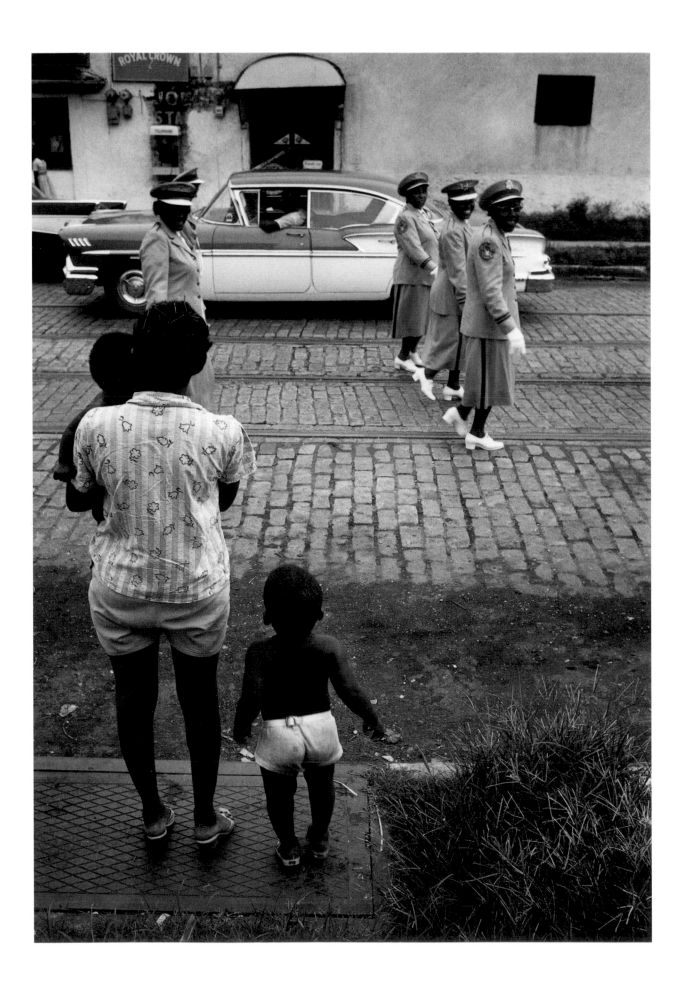

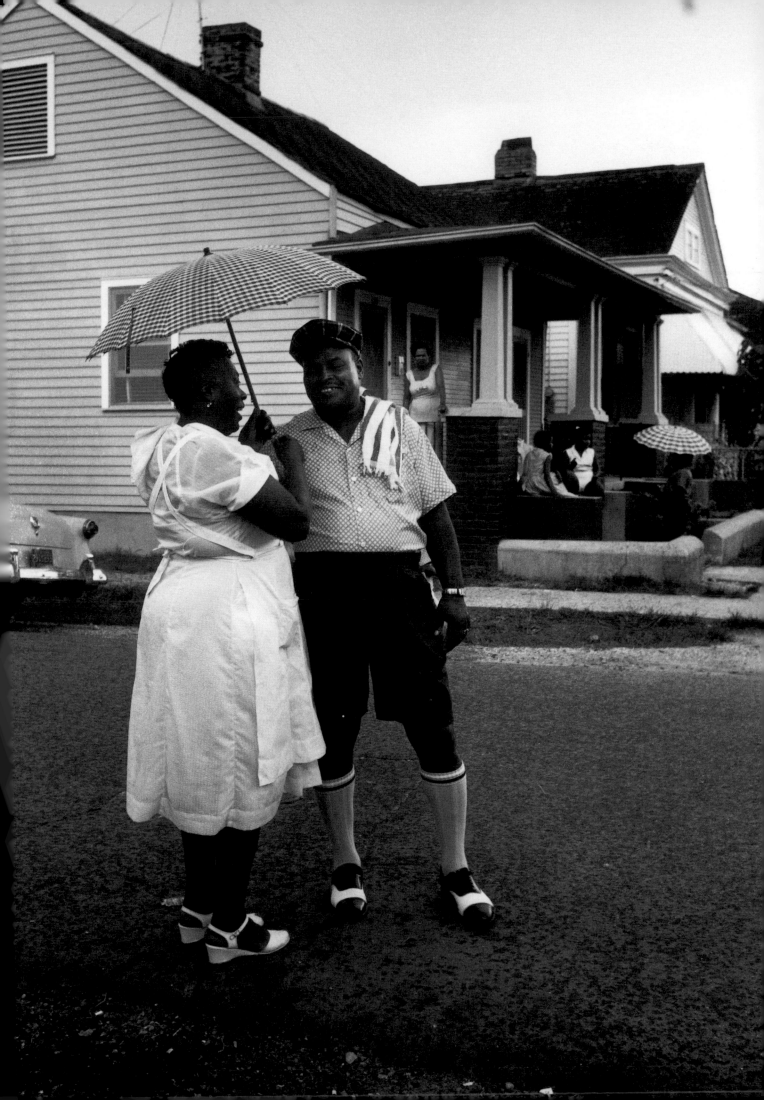

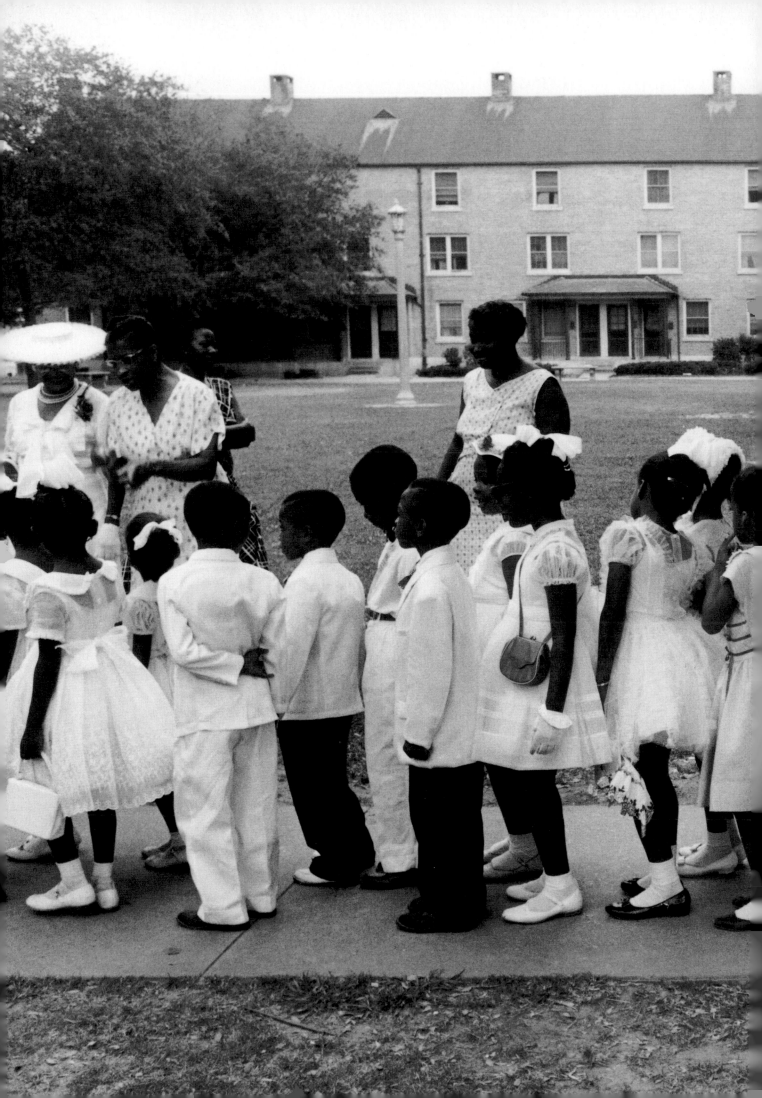

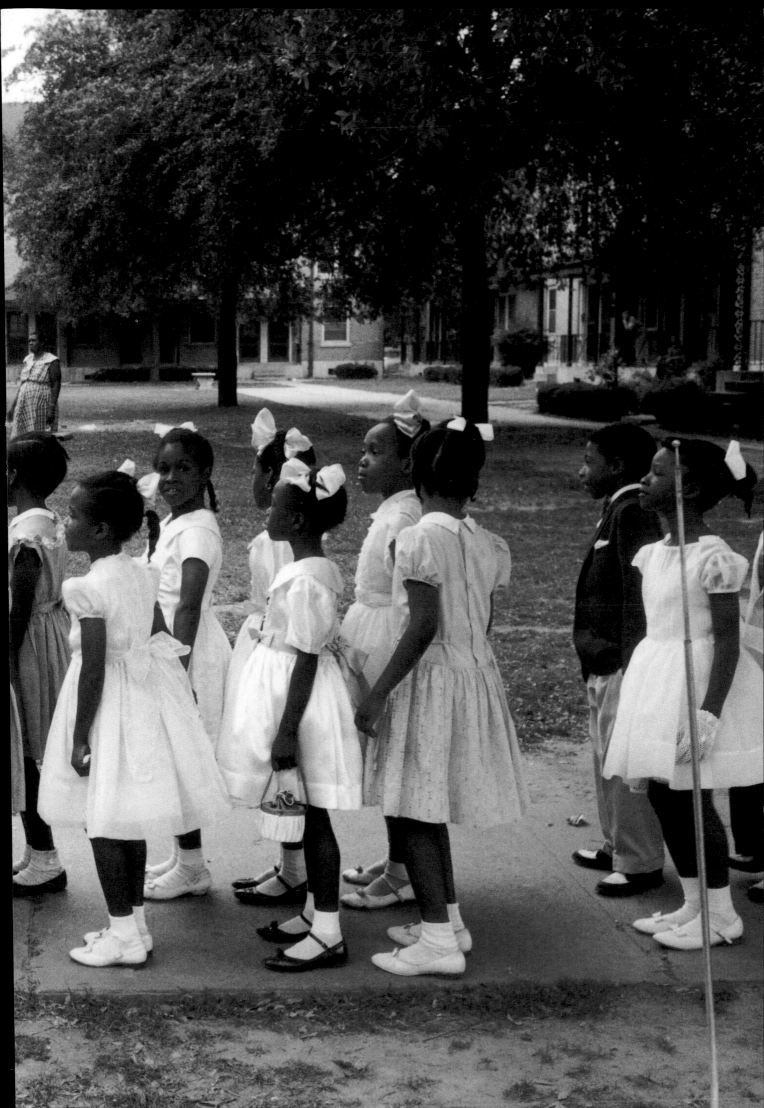

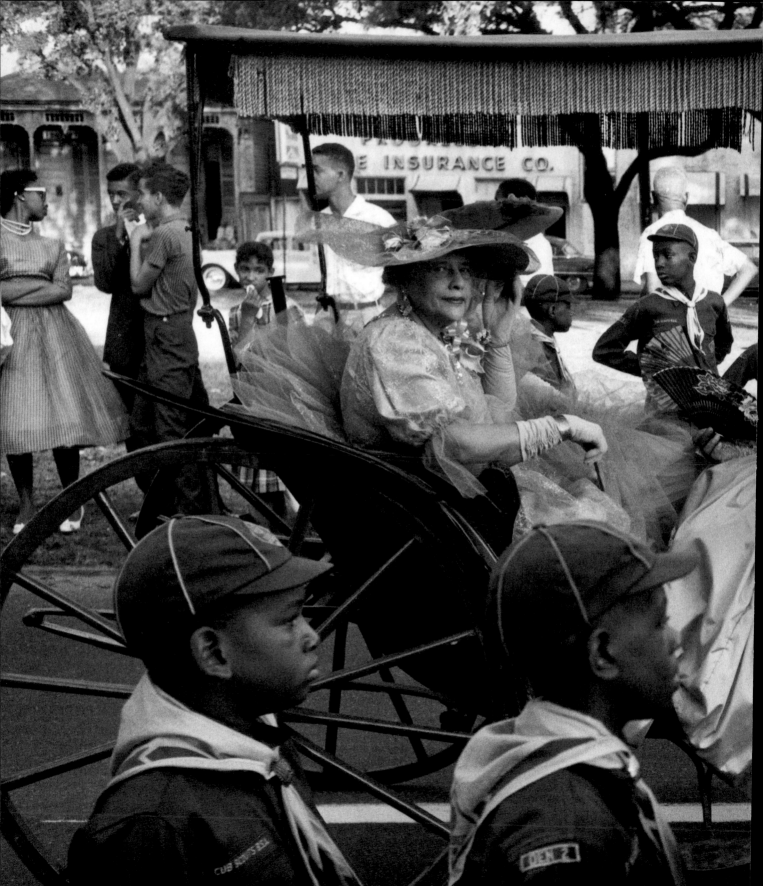

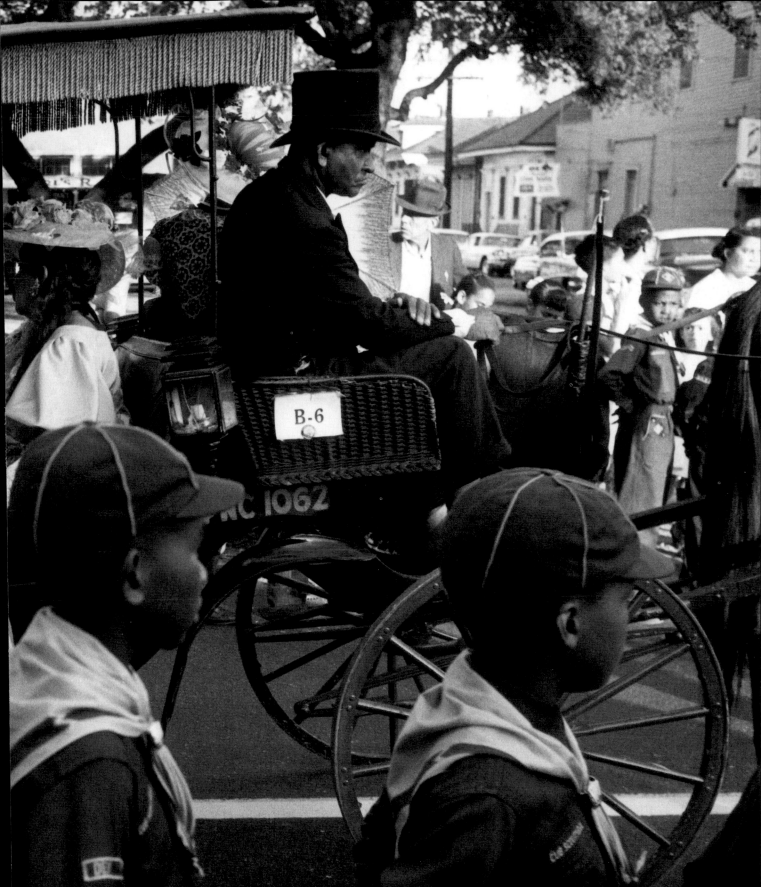

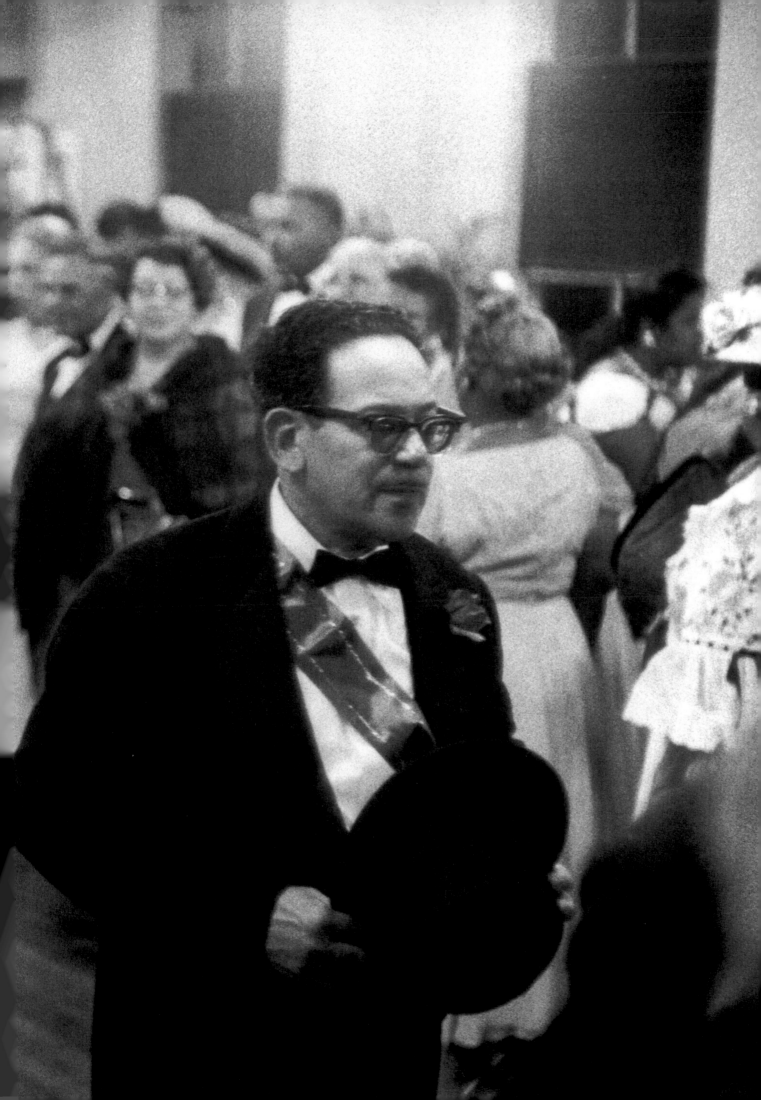

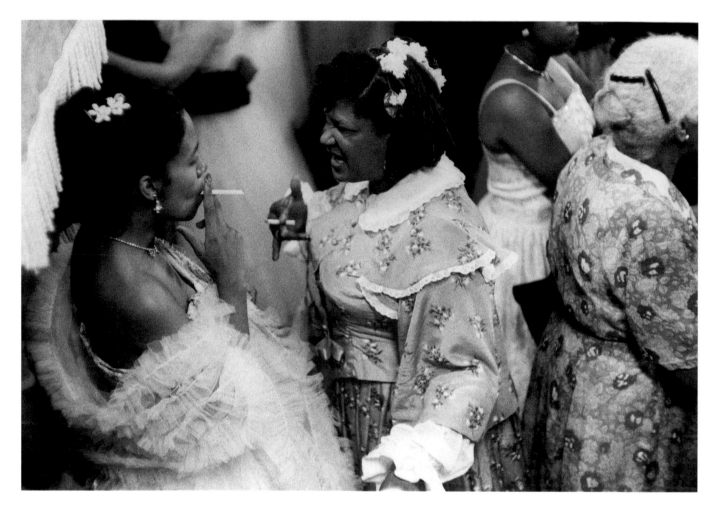

Pages 104 – 105 School children dressed in their Sunday best
in preparation for a parade for a Creole Fiesta, New Orleans.
Pages 106 – 107 Elegant Creole ladies in the parade on the way to
the Creole Fiesta.
Pages 108 – 109 A Creole Fiesta Association party, New Orleans.

Pages 104 – 105 Des écoliers en habits du dimanche se préparent
pour un défilé à l'occasion d'une fête créole, Nouvelle-Orléans.
Pages 106 – 107 D'élégantes dames créoles dans le défilé qui les
mènera à la fête.
Pages 108 – 109 Une réception de la Creole Fiesta Association,
Nouvelle-Orléans.

Seiten 104 – 105 Schulkinder im Sonntagsstaat stellen sich für
eine Parade bei einer kreolischen Fiesta auf, New Orleans.
Seiten 106 – 107 Elegante Kreolinnen in der Parade unterwegs
zur kreolischen Fiesta.
Seiten 108 – 109 Eine Party der Creole Fiesta Association,
New Orleans.

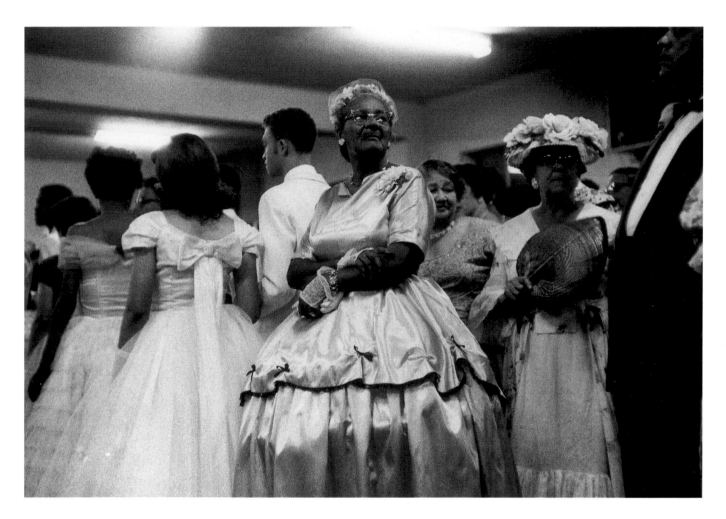

Above / Opposite Members of the Creole Fiesta Association in their elegant costumes.

Ci-dessus / Ci-contre Des membres de la Creole Fiesta Association en grande tenue.

Oben / Gegenüber Mitglieder der Creole Fiesta Association in ihren eleganten Kostümen.

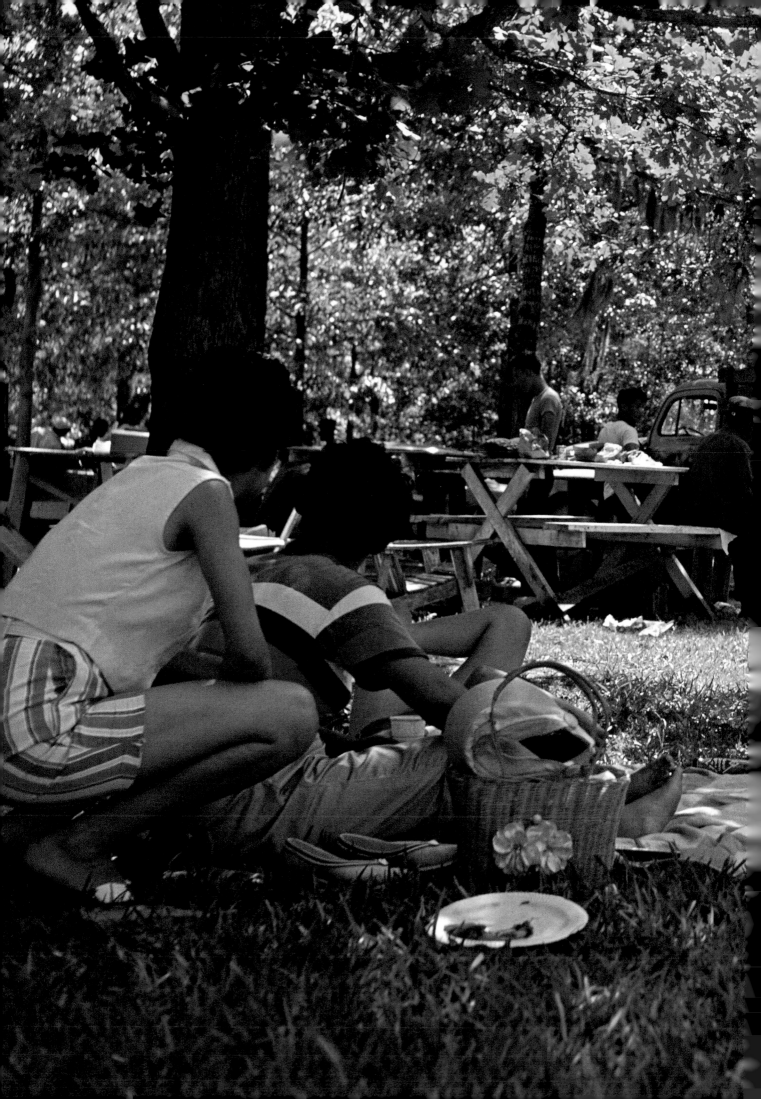

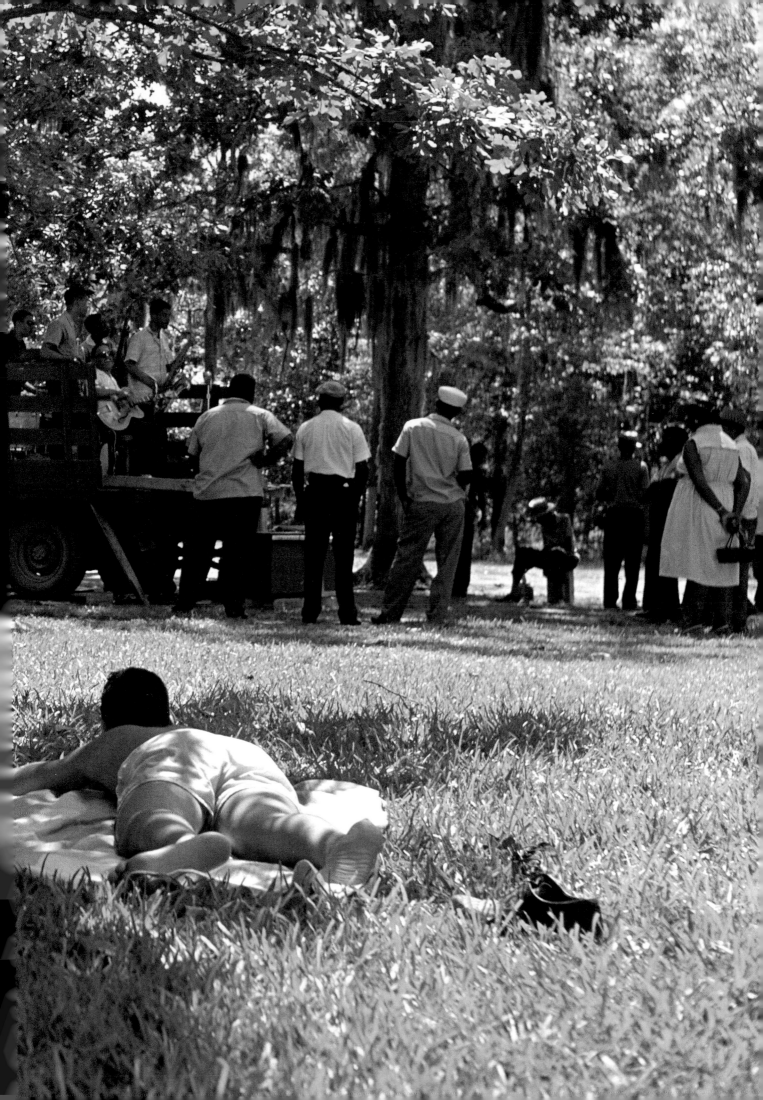

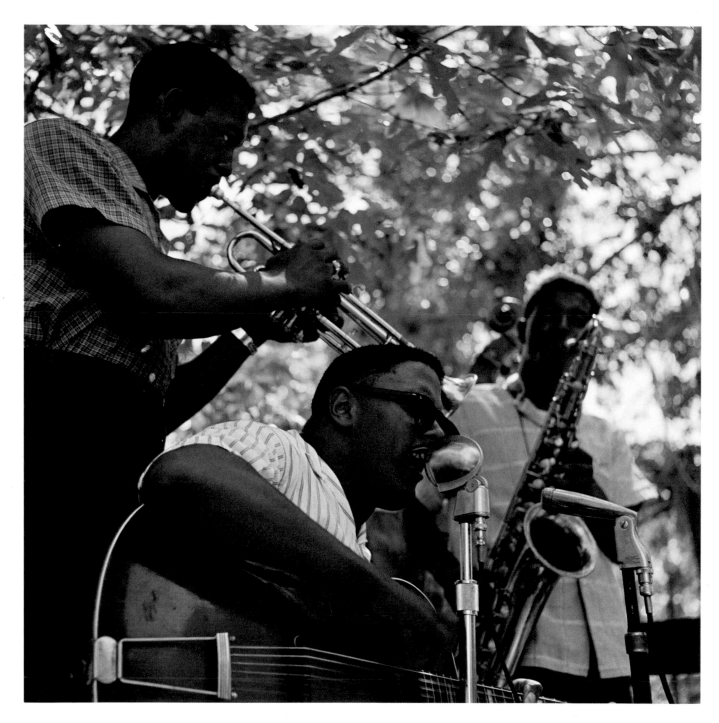

Pages 112 – 114 Picnic at the Branch Inn in Slidell, just outside of New Orleans, with the Li'l Snooks Eaglin Band.

Pages 112 – 114 Pique-nique à la Branch Inn à Slidell, juste à la sortie de la Nouvelle-Orléans, avec le Li'l Snooks Eaglin Band.

Seiten 112 – 114 Picknick in der Branch Inn in Slidell, außerhalb von New Orleans, mit der Li'l Snooks Eaglin Band.

Above The riverboat President in New Orleans harbor.

Ci-dessus Le bateau President dans le port de la Nouvelle-Orléans.

Oben Der Flußdampfer President im Hafen von New Orleans.

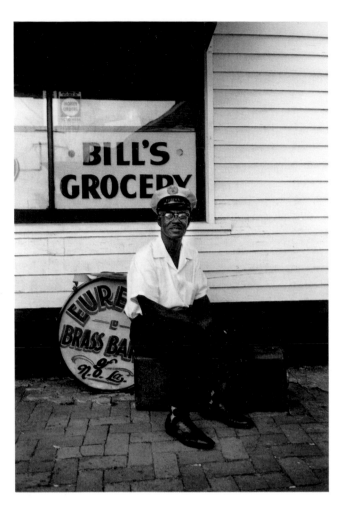

Above / Right Members of the Eureka Brass Band prepare for
a funeral procession, New Orleans.

Ci-dessus / À droite Des membres de l'Eureka Brass Band se
préparent pour une procession funéraire, Nouvelle-Orléans.

Oben / Rechts Mitglieder der Eureka Brass Band bereiten sich
auf einen Trauerzug vor, New Orleans.

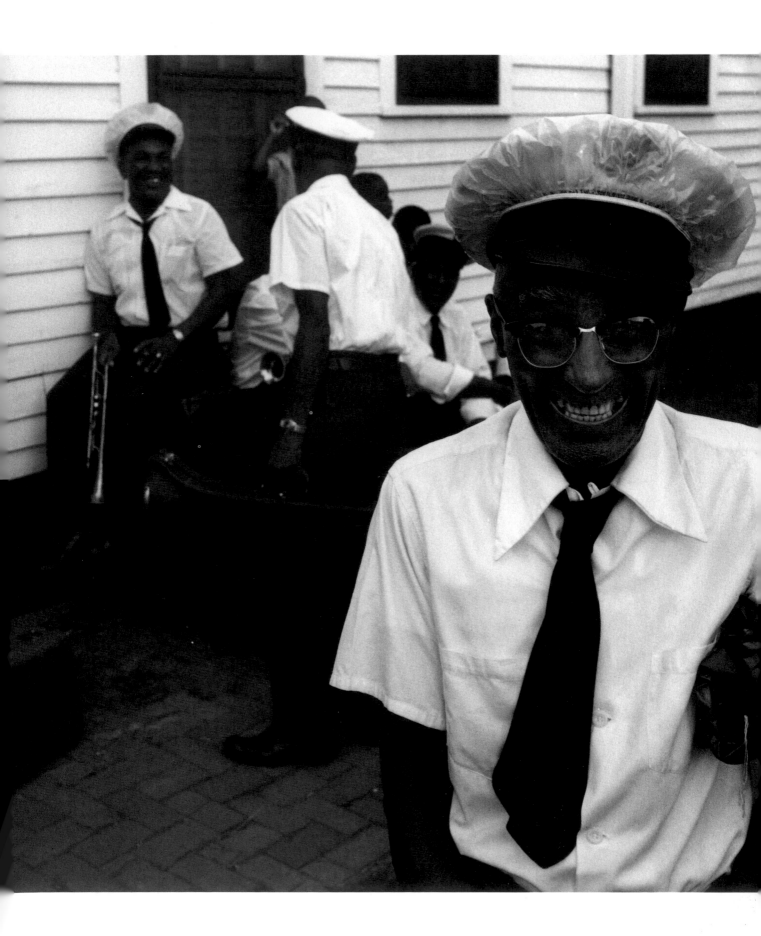

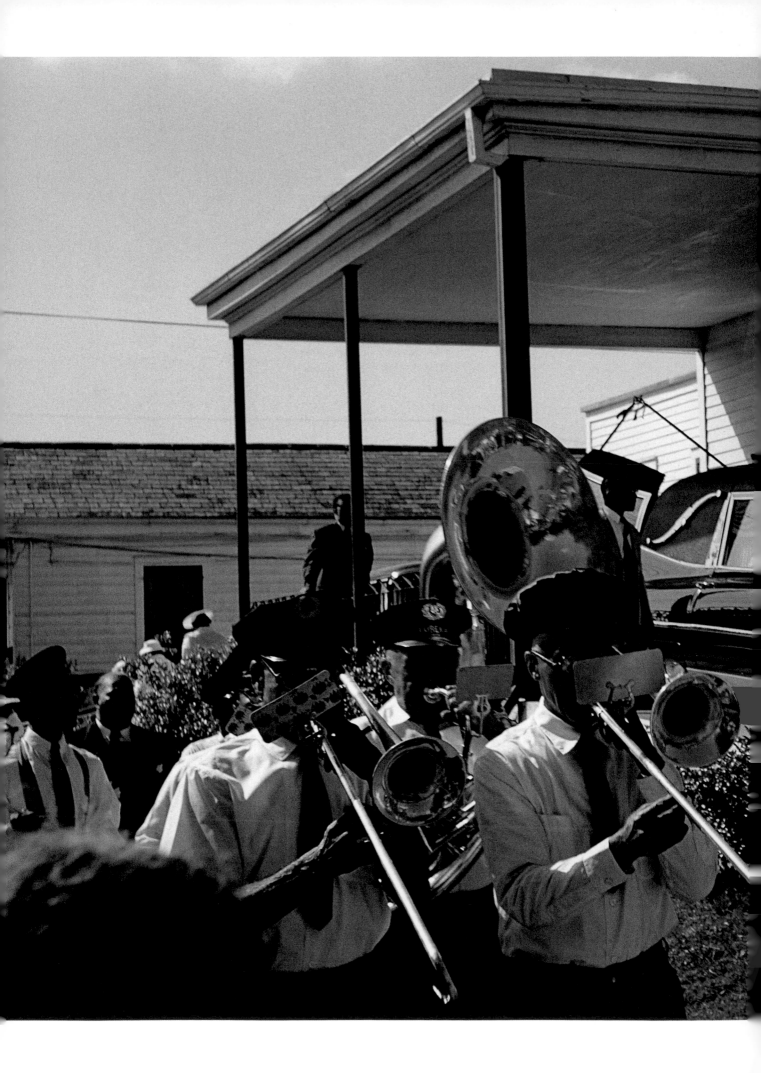

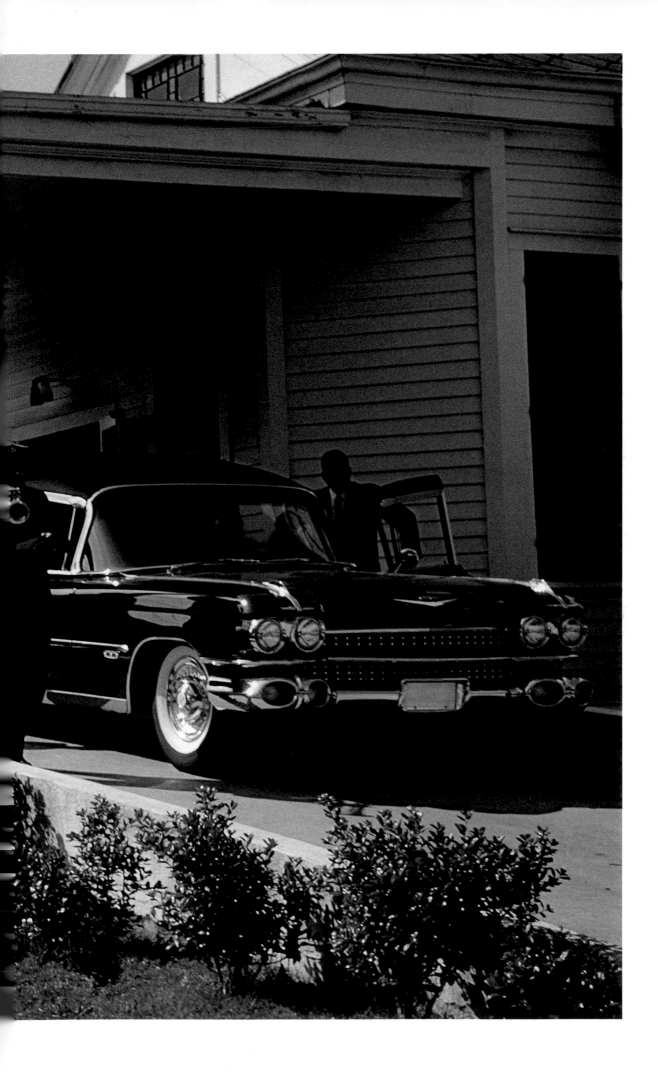

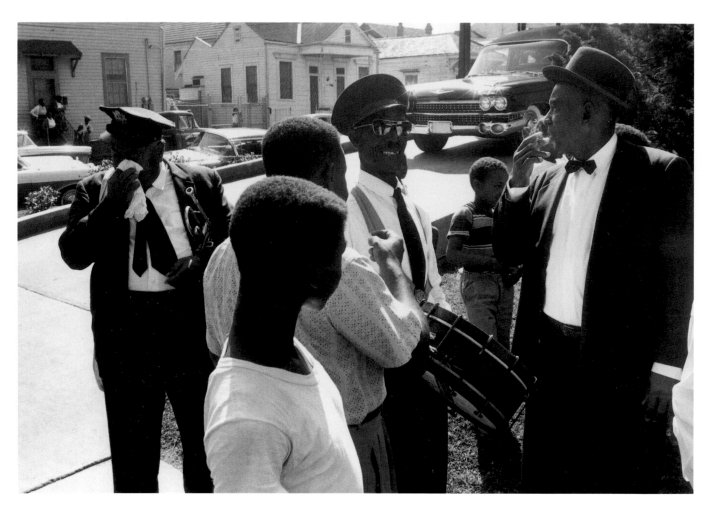

Pages 118–127 The funeral procession from Claiborn Avenue
to St. Louis Cemetery No. 2.

Pages 118–127 La procession funéraire marche lentement de
Claiborn Avenue au St. Louis Cemetery No. 2.

Seiten 118–127 Der Trauerzug auf dem Weg von der Claiborn
Avenue zum St. Louis Cemetery No. 2.

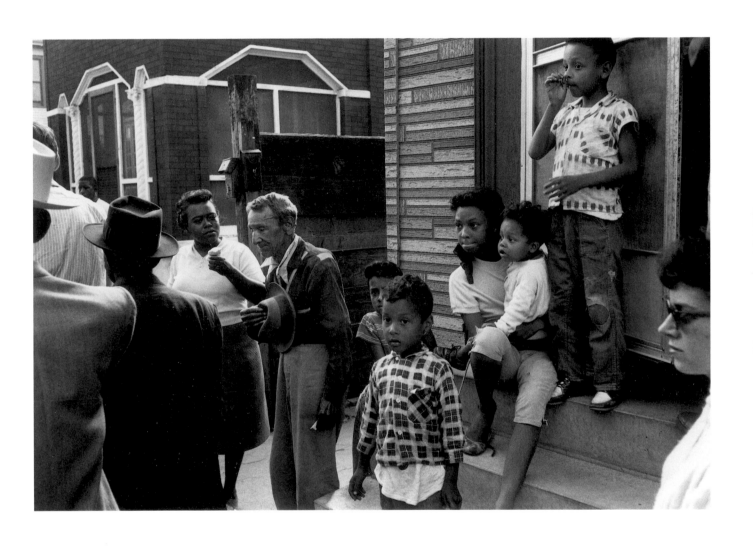

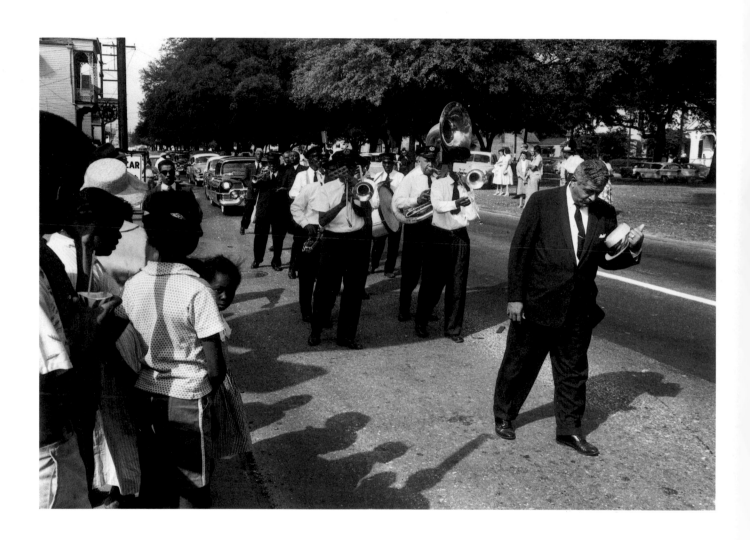

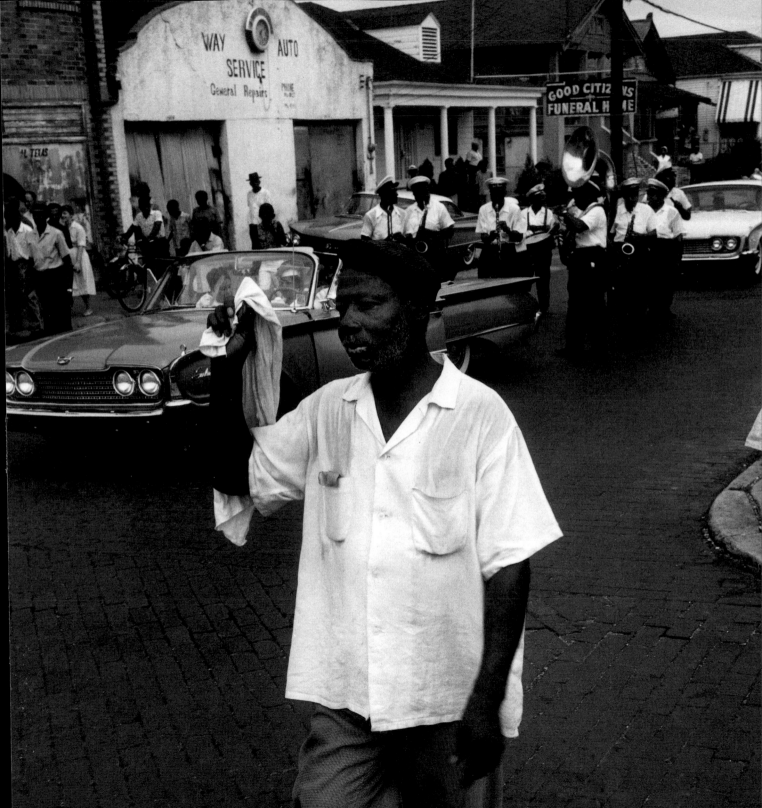

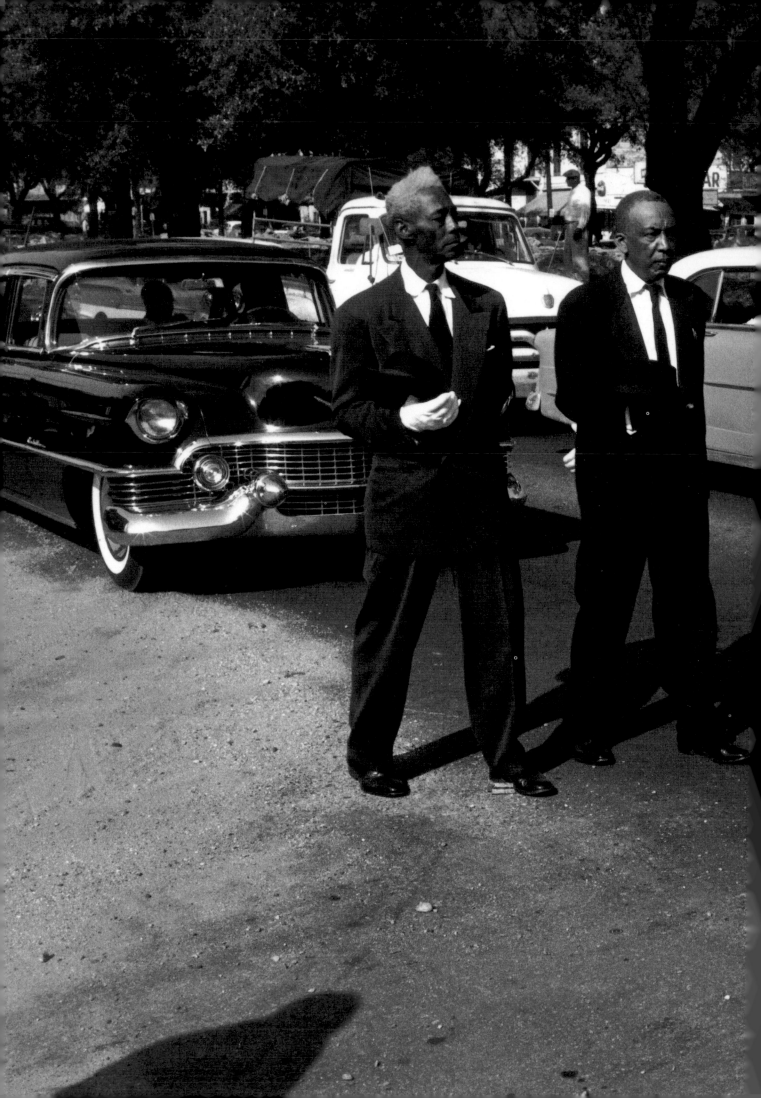

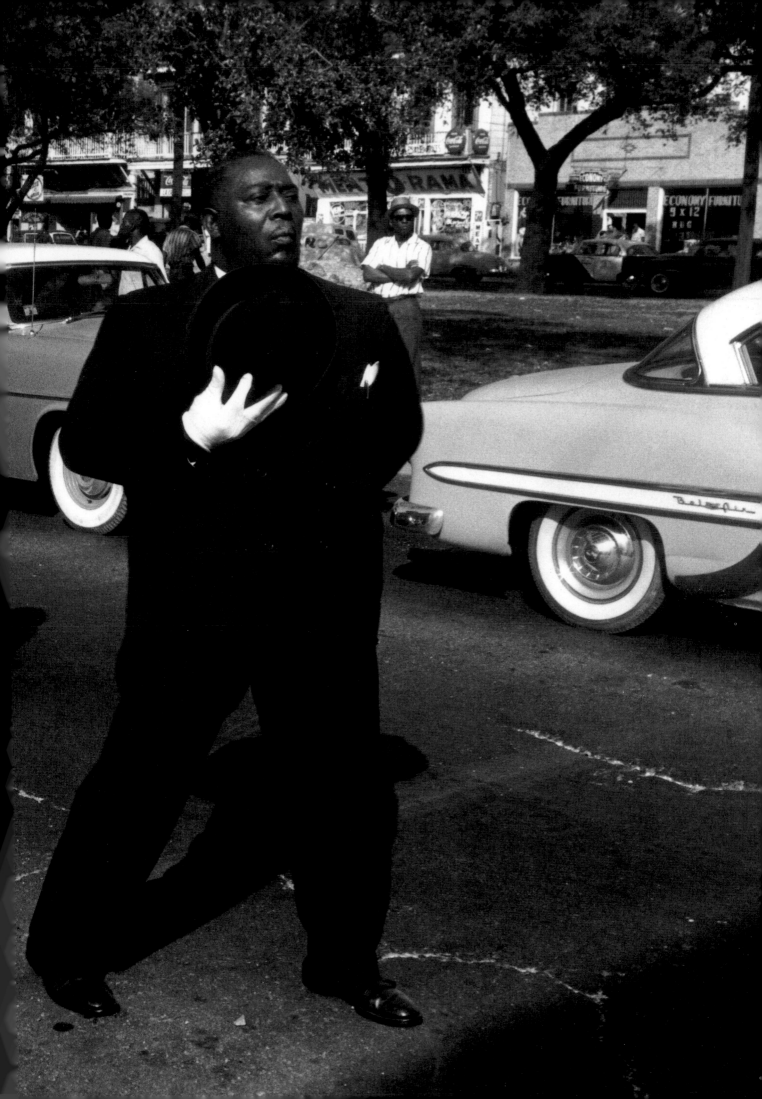

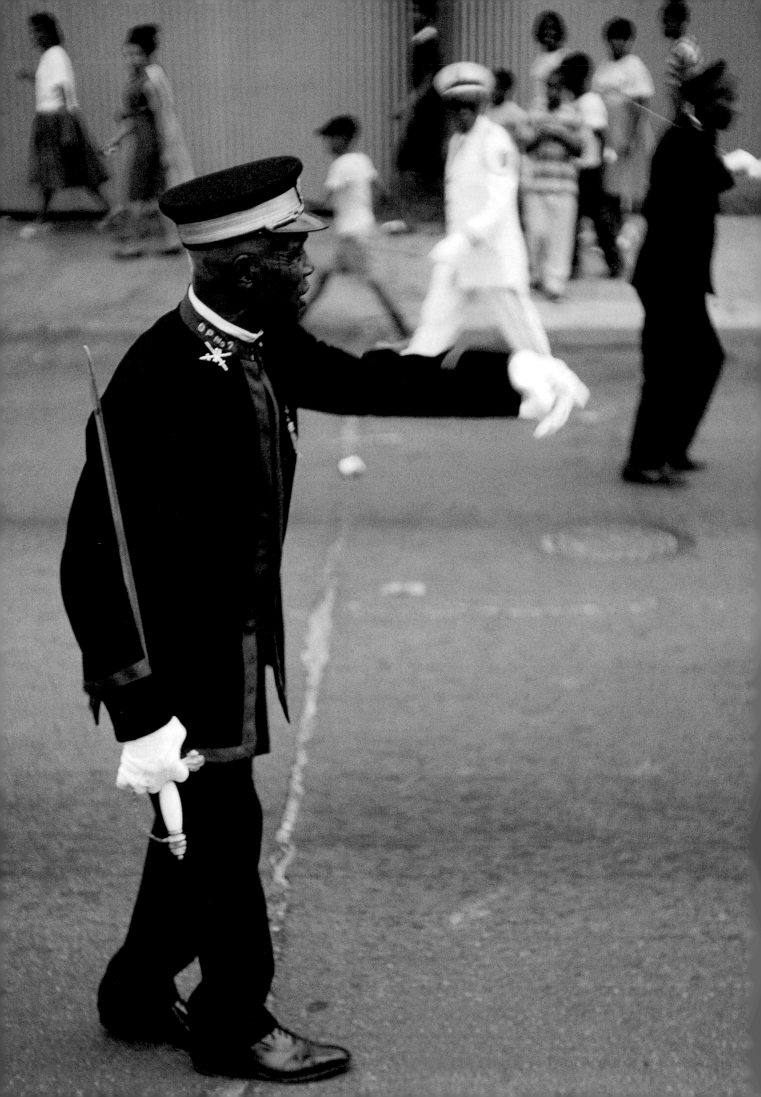

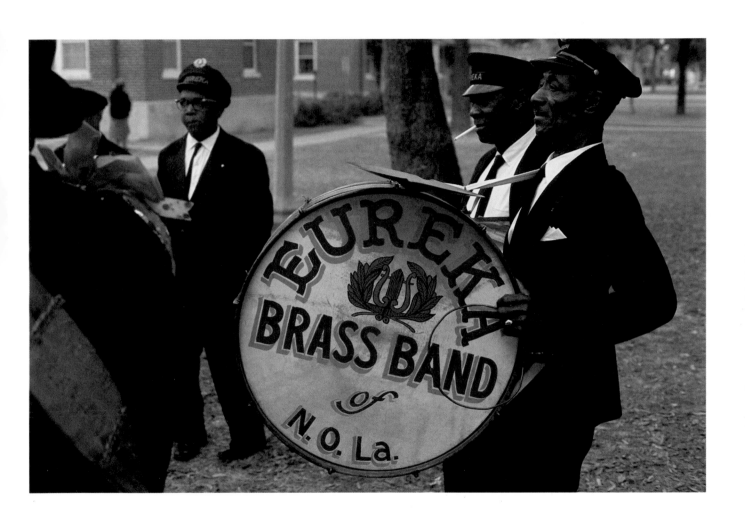

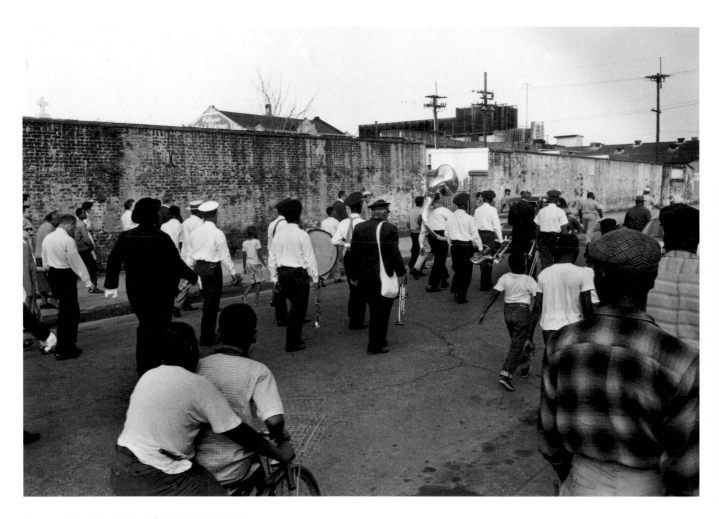

Pages 128 – 133 Arriving at St. Louis Cemetery No. 2.

Pages 128 – 133 L'arrivée au St. Louis Cemetery No. 2.

Seiten 128 – 133 Ankunft am St. Louis Cemetery No. 2.

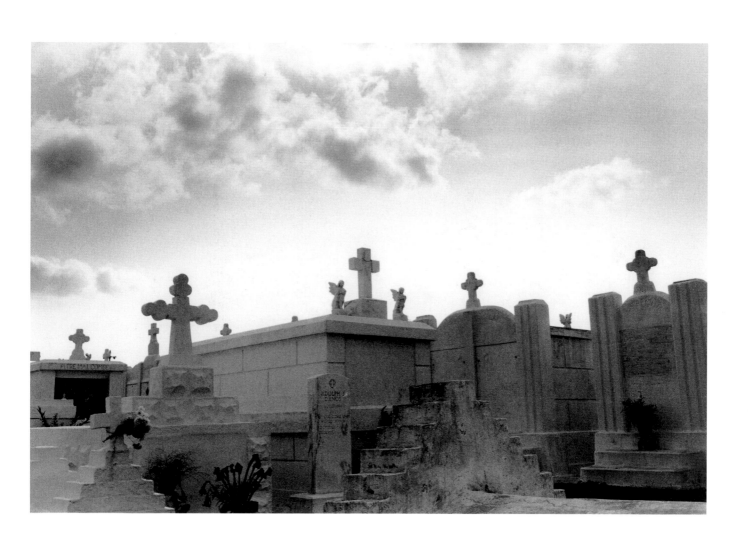

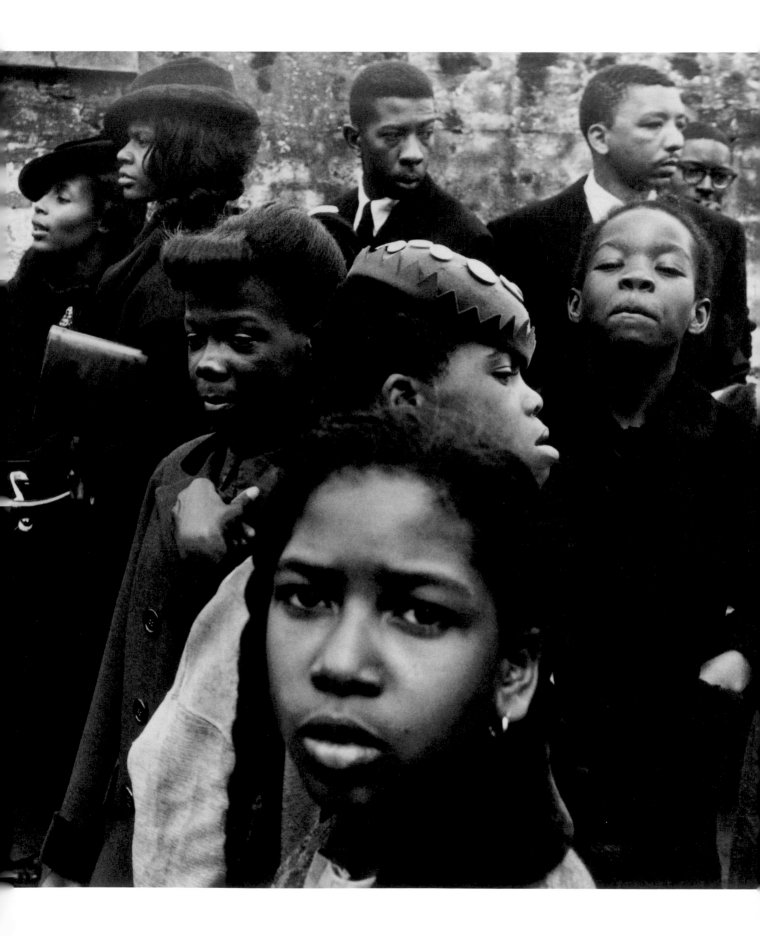

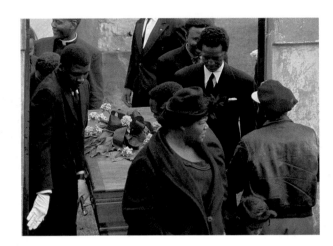

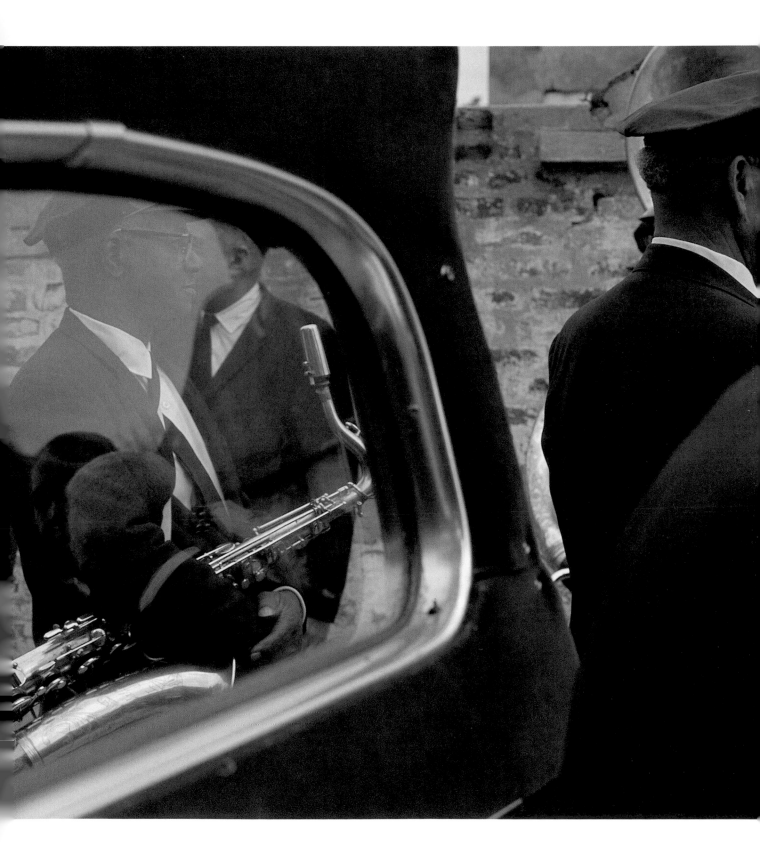

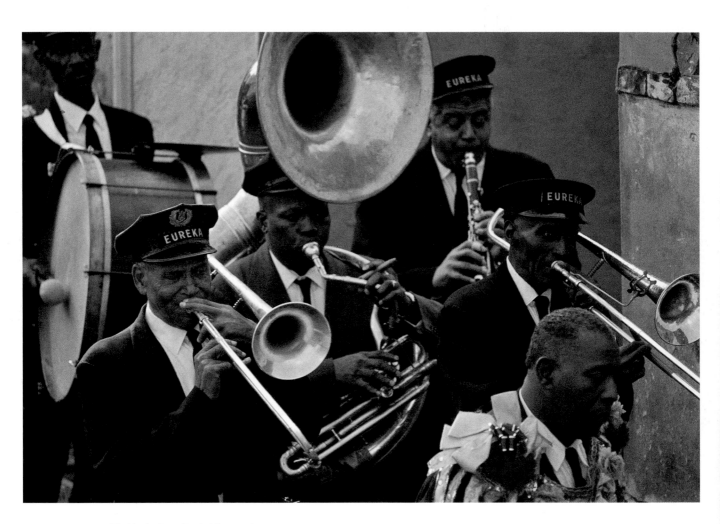

Pages 134–139 The Eureka Brass Band at the cemetery.

Pages 134–139 L'Eureka Brass Band au cimetière.

Seiten 134–139 Die Eureka Brass Band auf dem Friedhof.

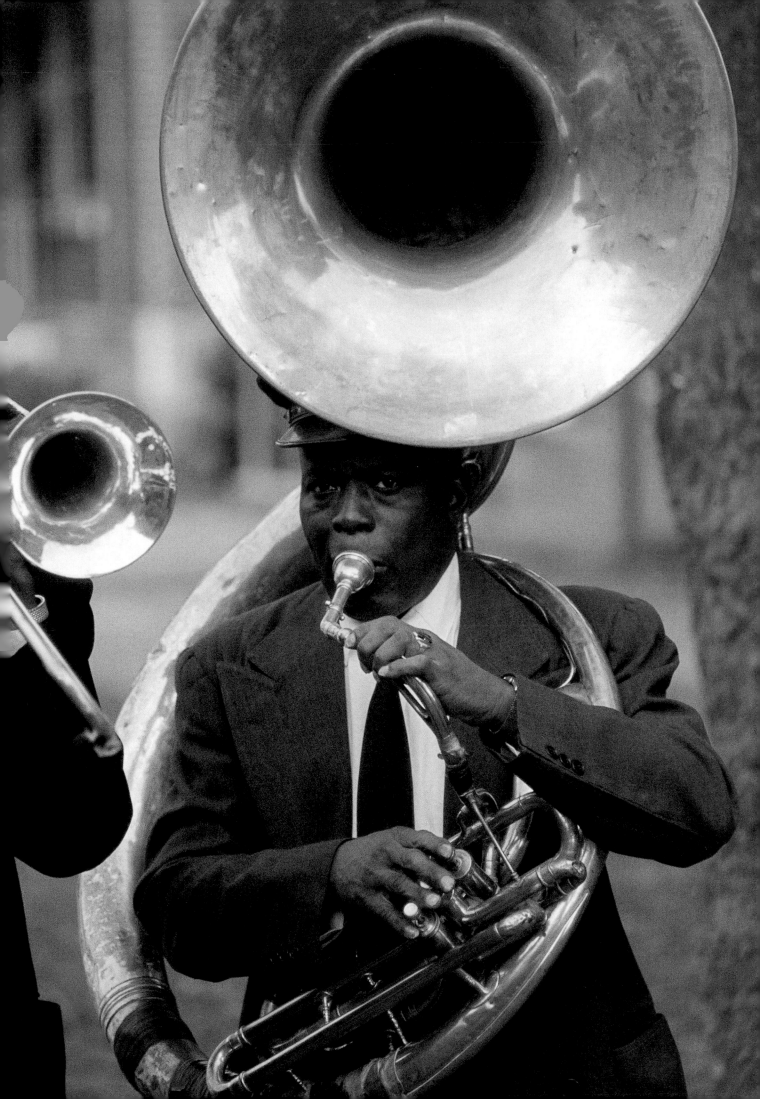

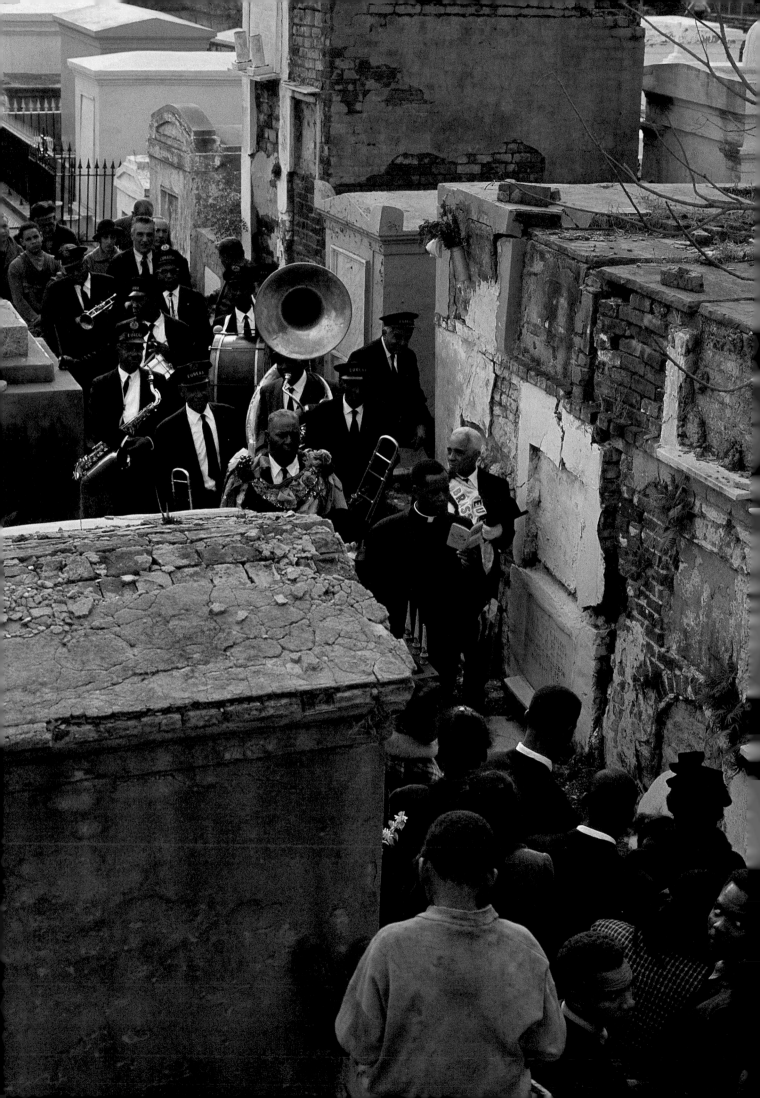

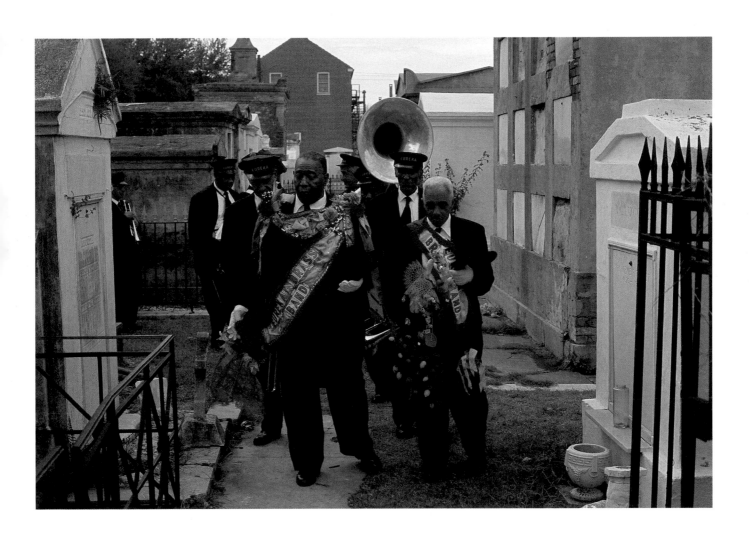

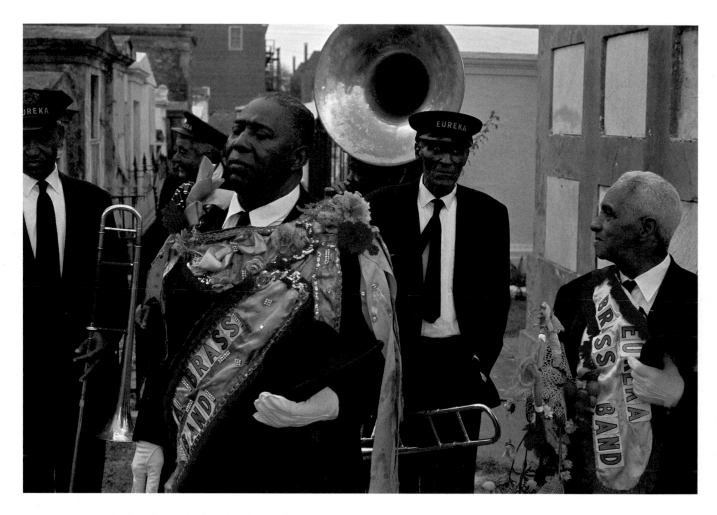

Pages 140–157 The funeral procession home from the cemetery turns into a joyous occasion and celebration for the dead with dancing in the streets while following the music of the brass band.
Pages 142–145 The Second Liners (tough guys who can't play musical instruments) dance along with their bright colored parasols and umbrellas.

Pages 140–157 La procession funéraire, de retour du cimetière, se transforme en hommage joyeux au mort, les gens dansant dans la rue derrière la grande fanfare.
Pages 142–145 La «seconde vague» (les petits durs qui ne savent pas jouer d'un instrument) danse en agitant des parapluies et des ombrelles aux couleurs vives.

Seiten 140–157 Der Trauerzug wird auf dem Rückweg vom Friedhof zu einem fröhlichen Straßenfest für den Toten; die Trauergäste folgen tanzend der Musik der großen Brassband.
Seiten 142–145 Die Second Liners (harte Burschen, die kein Instrument spielen können) tanzen hinter dem Zug her und schwenken ihre bunten Sonnen- und Regenschirme.

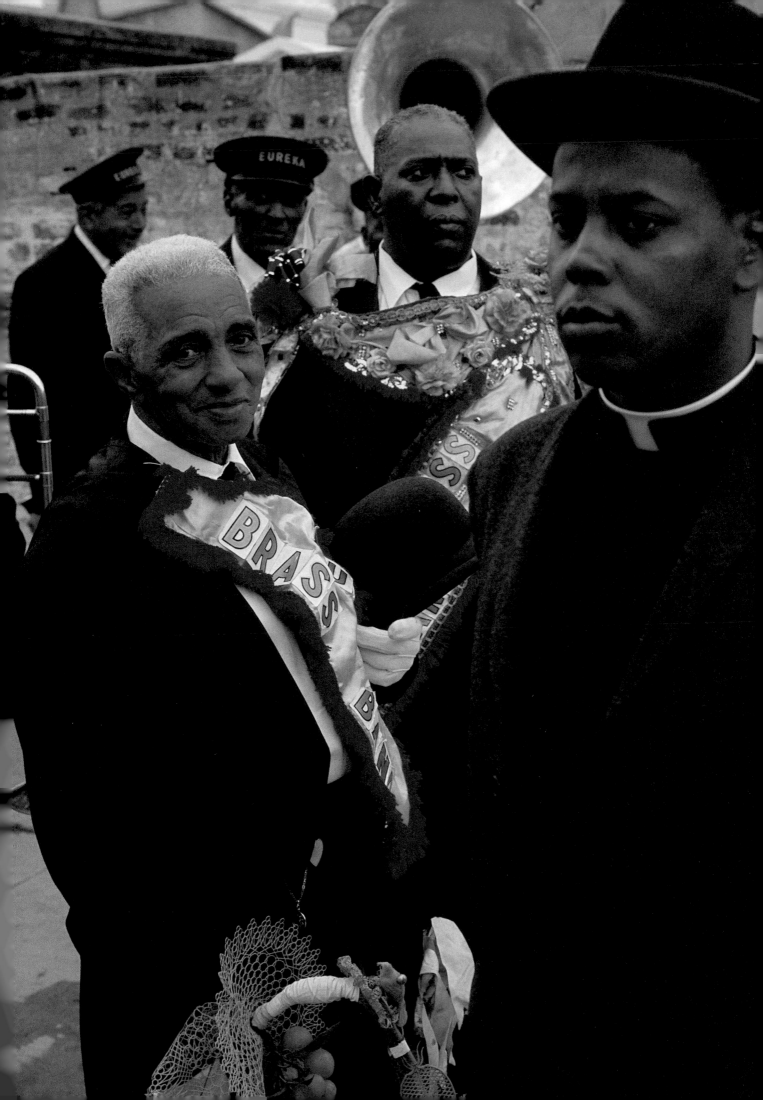

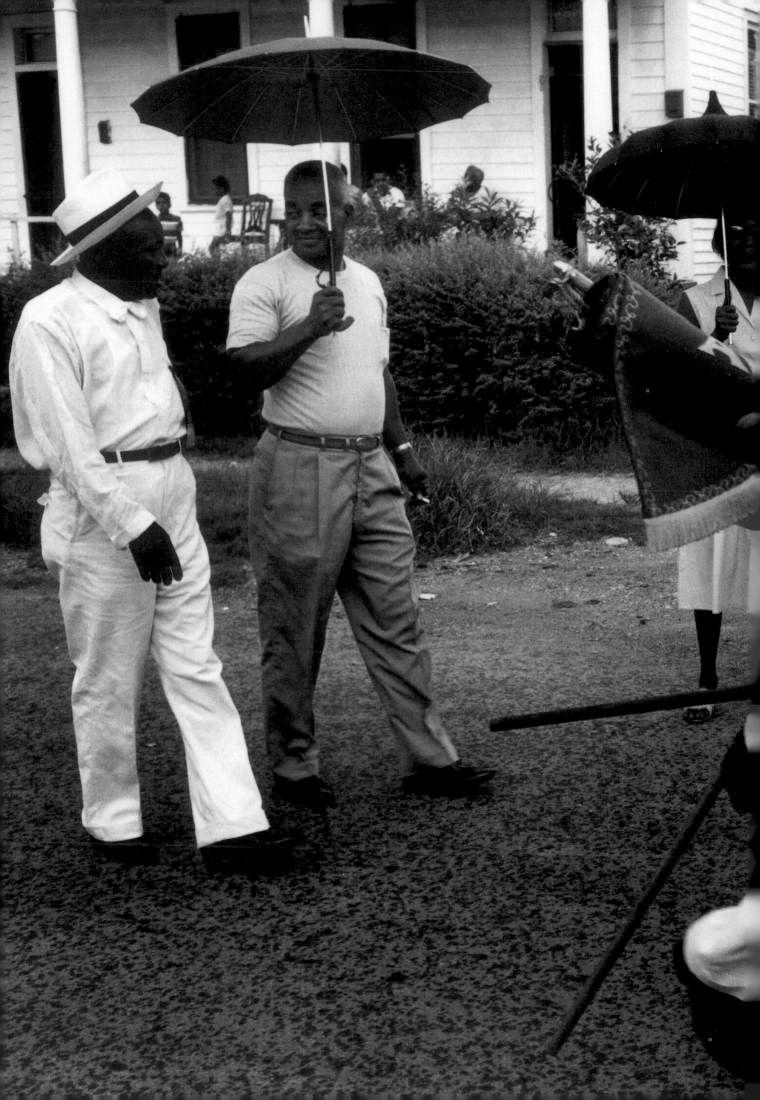

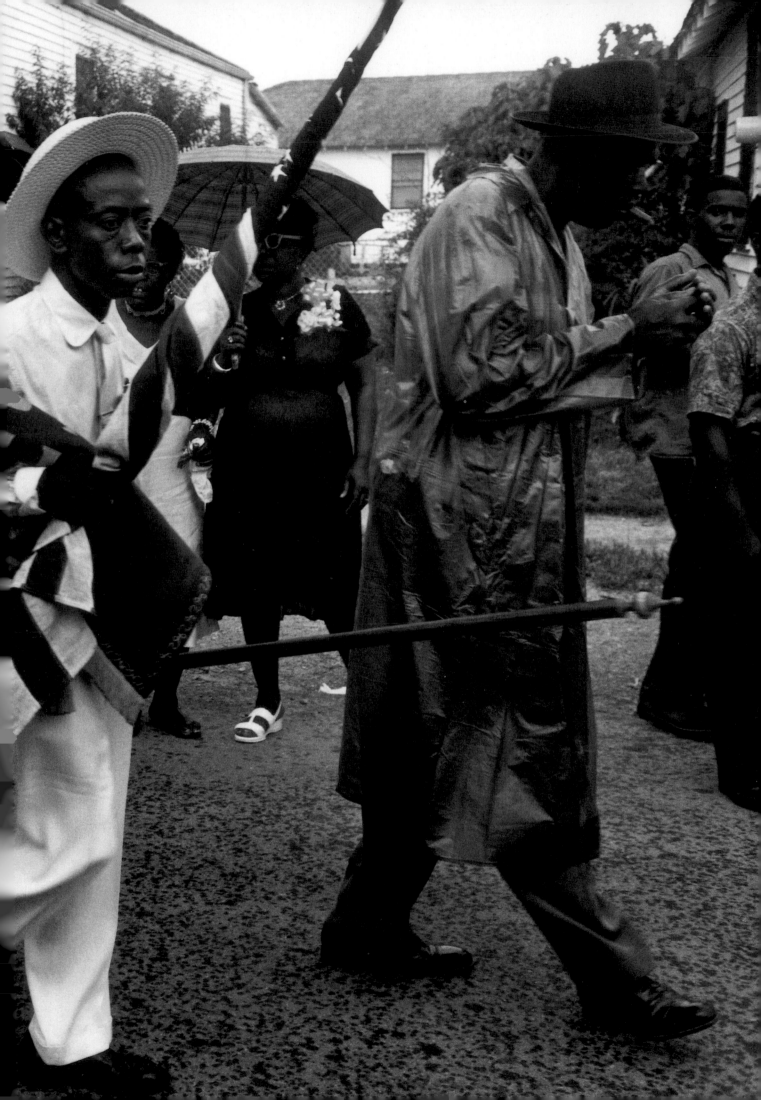

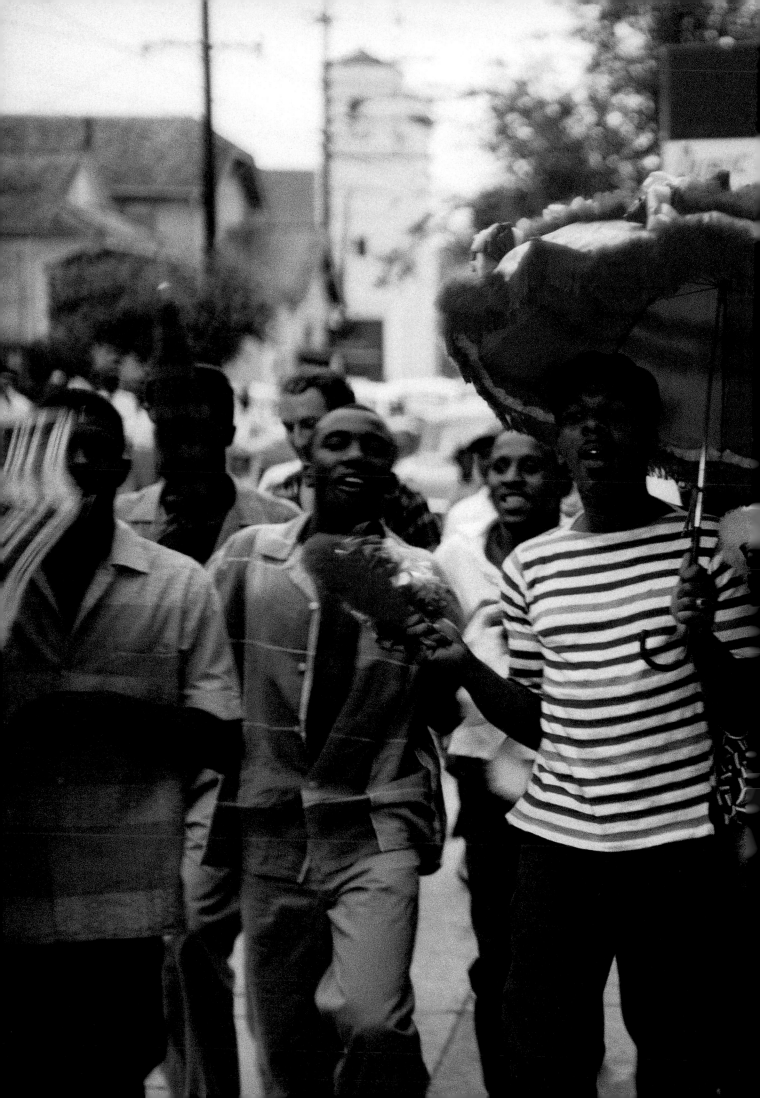

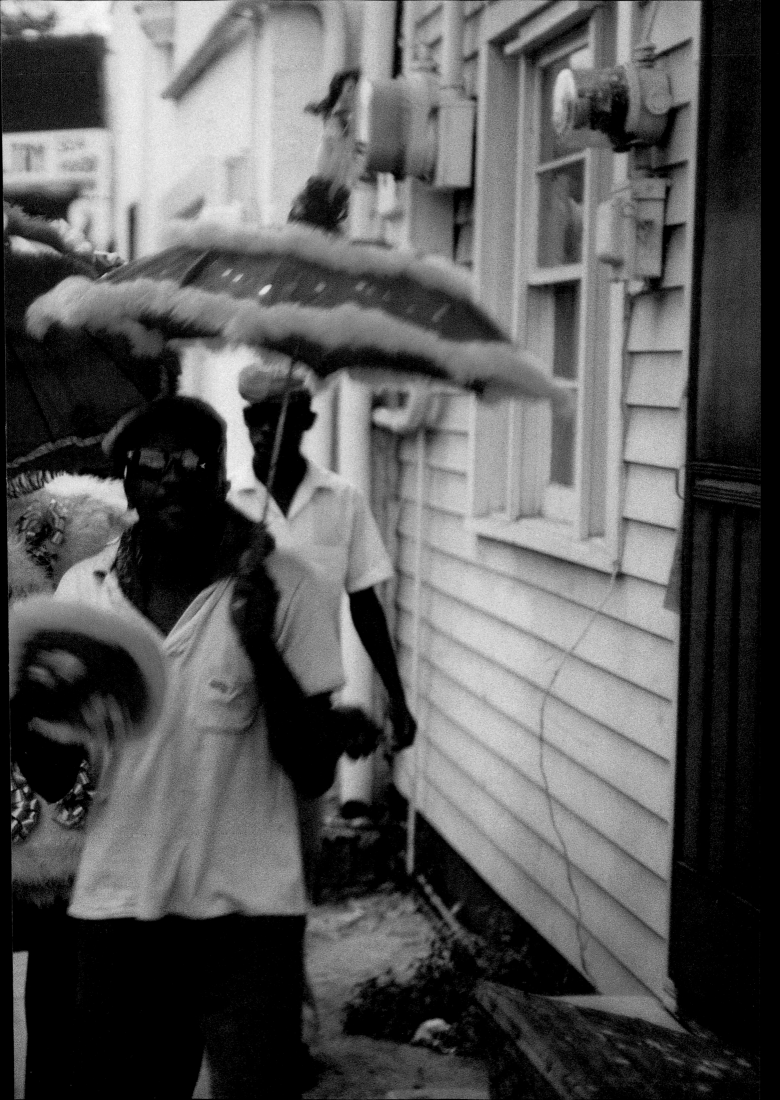

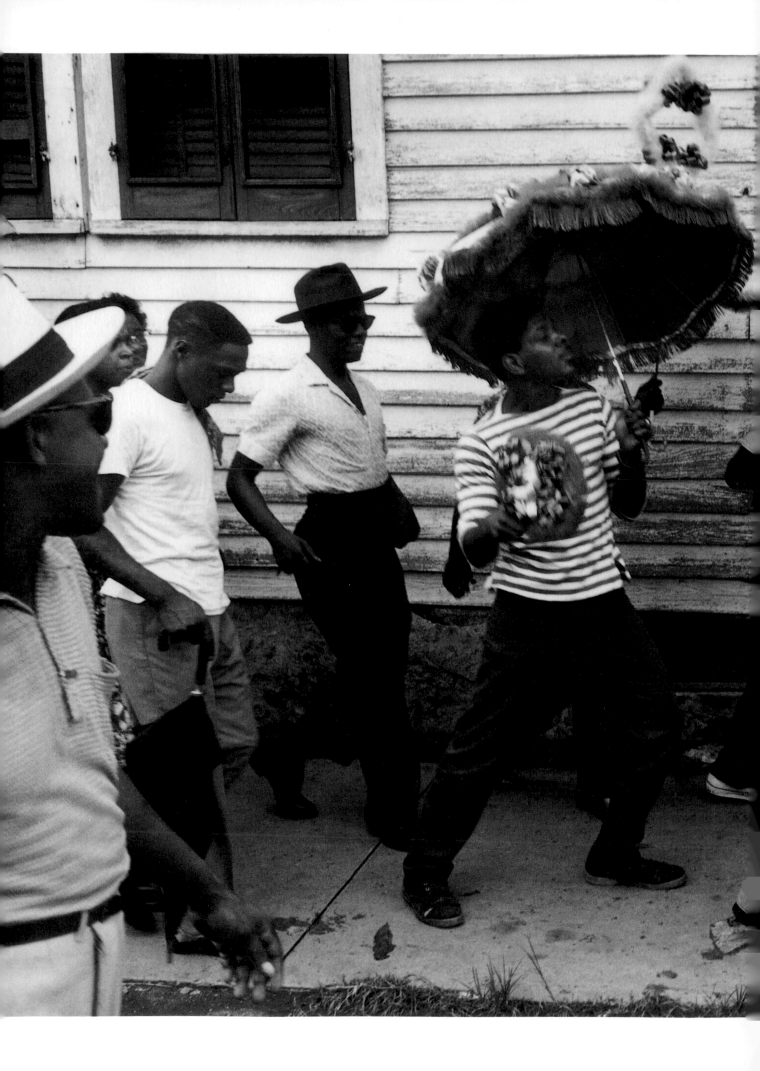

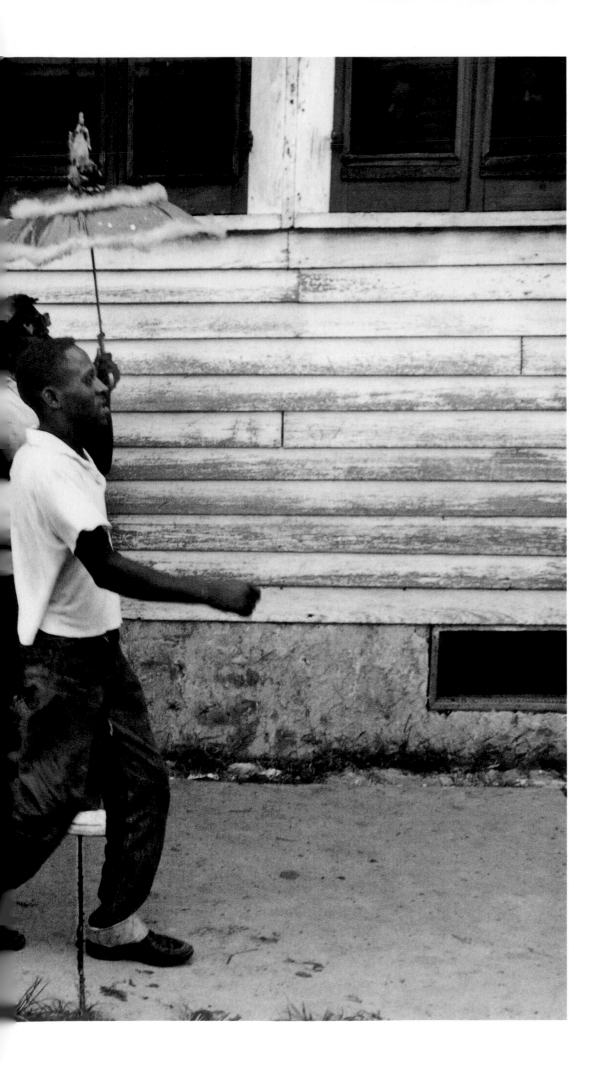

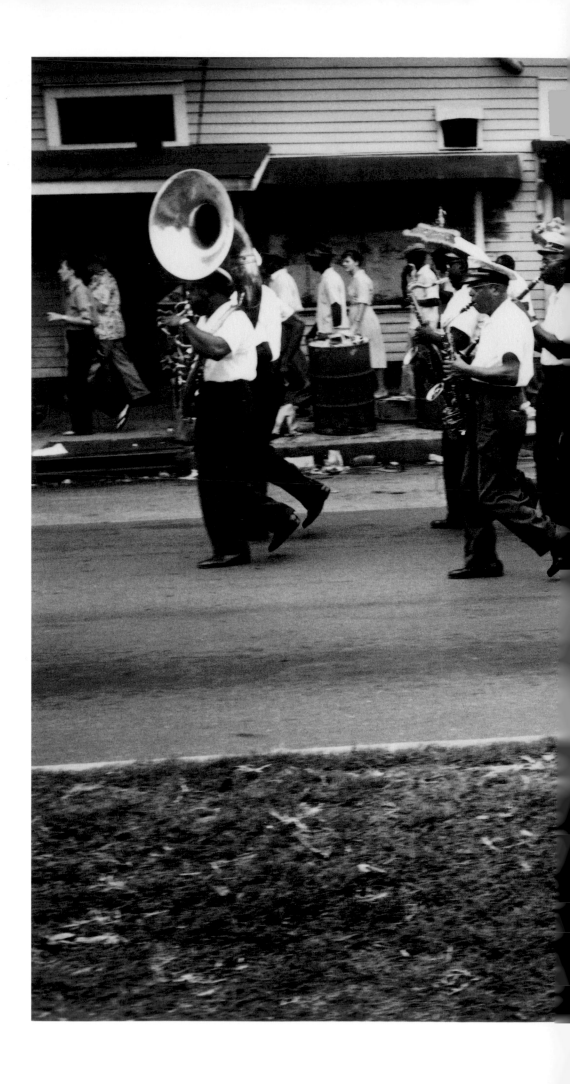

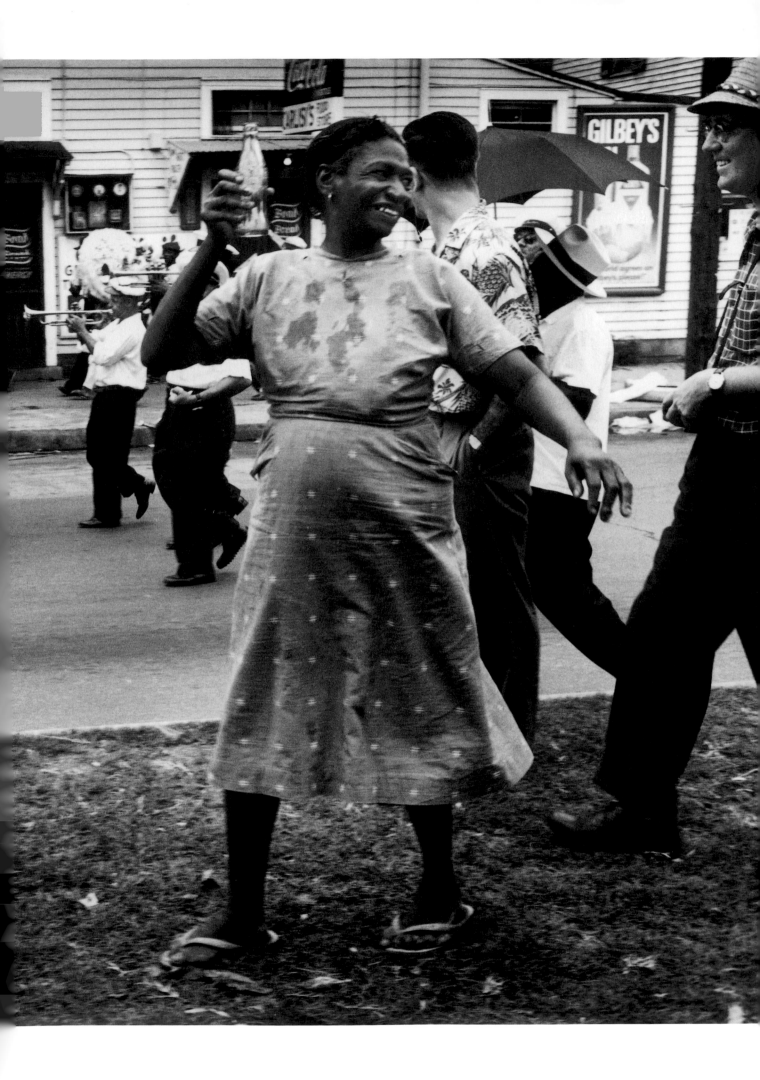

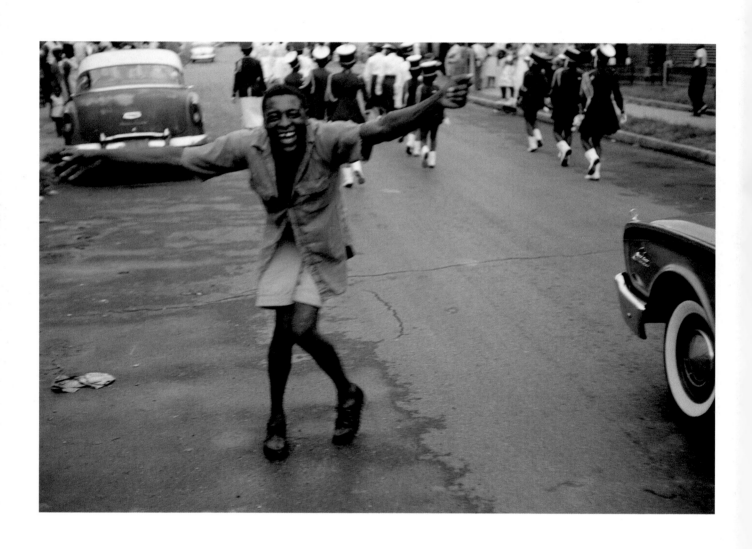

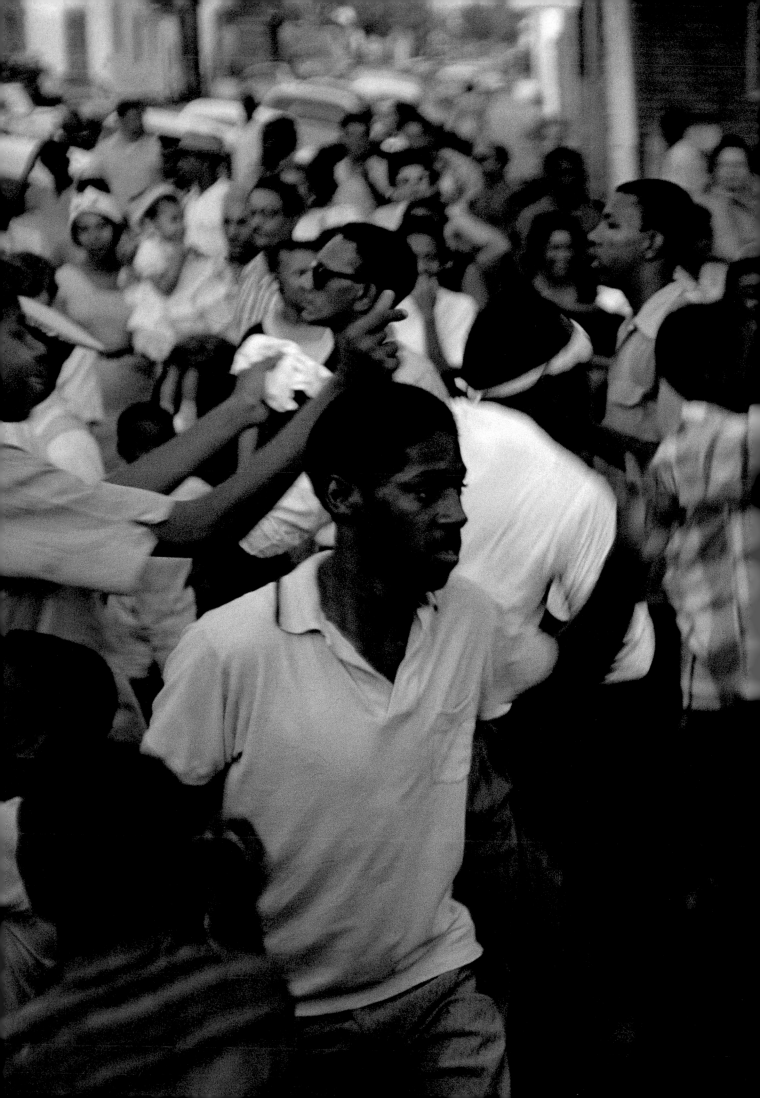

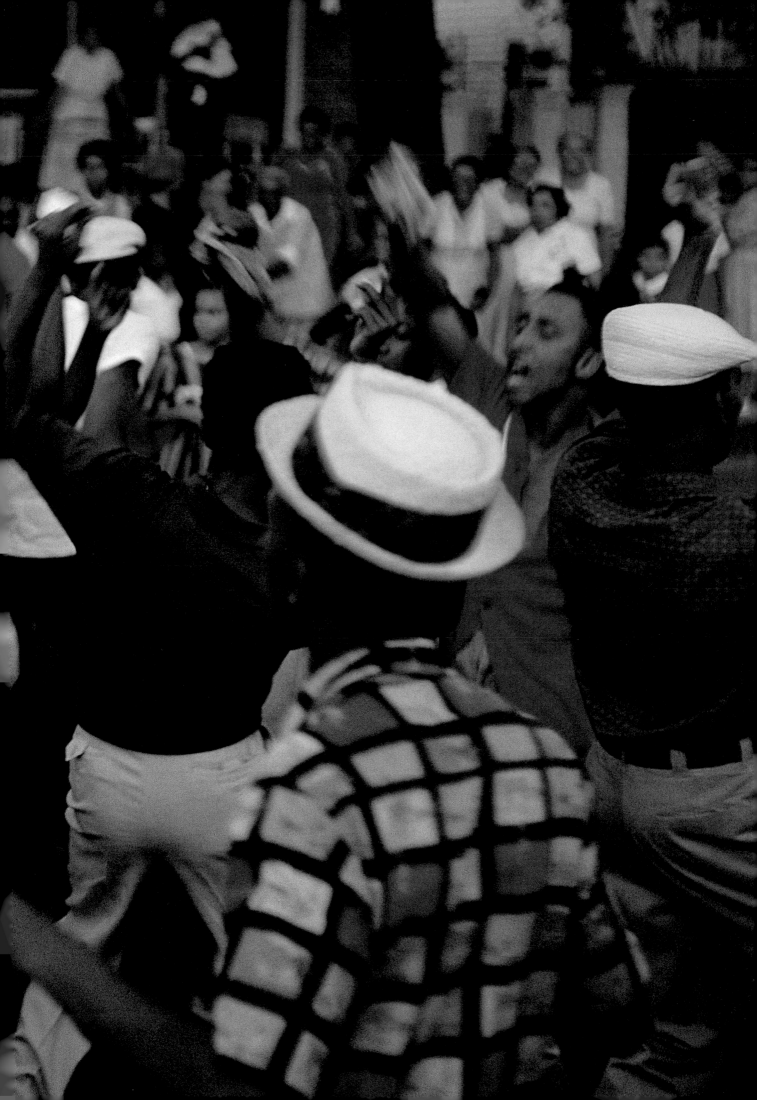

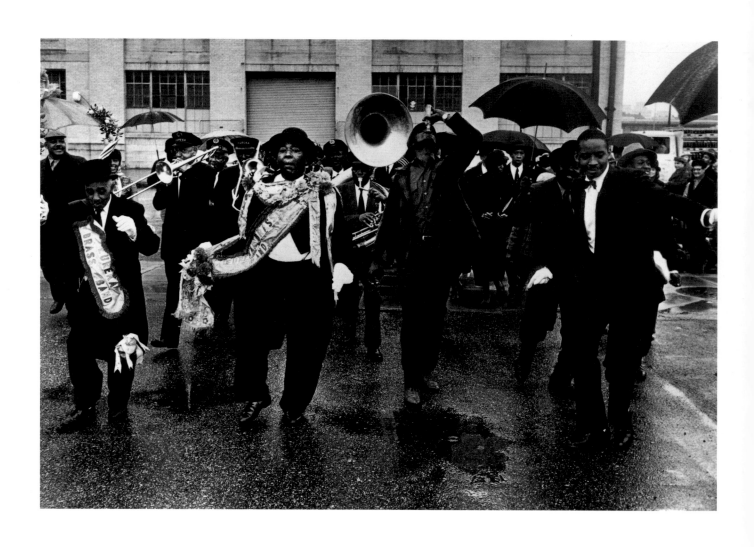

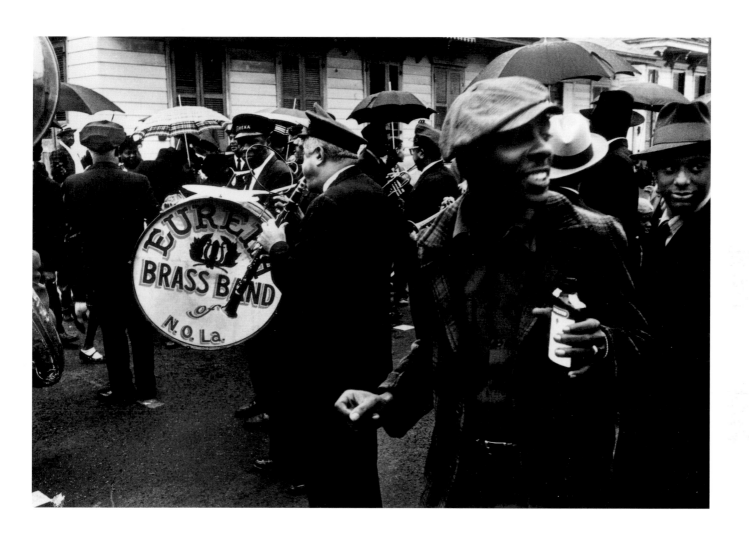

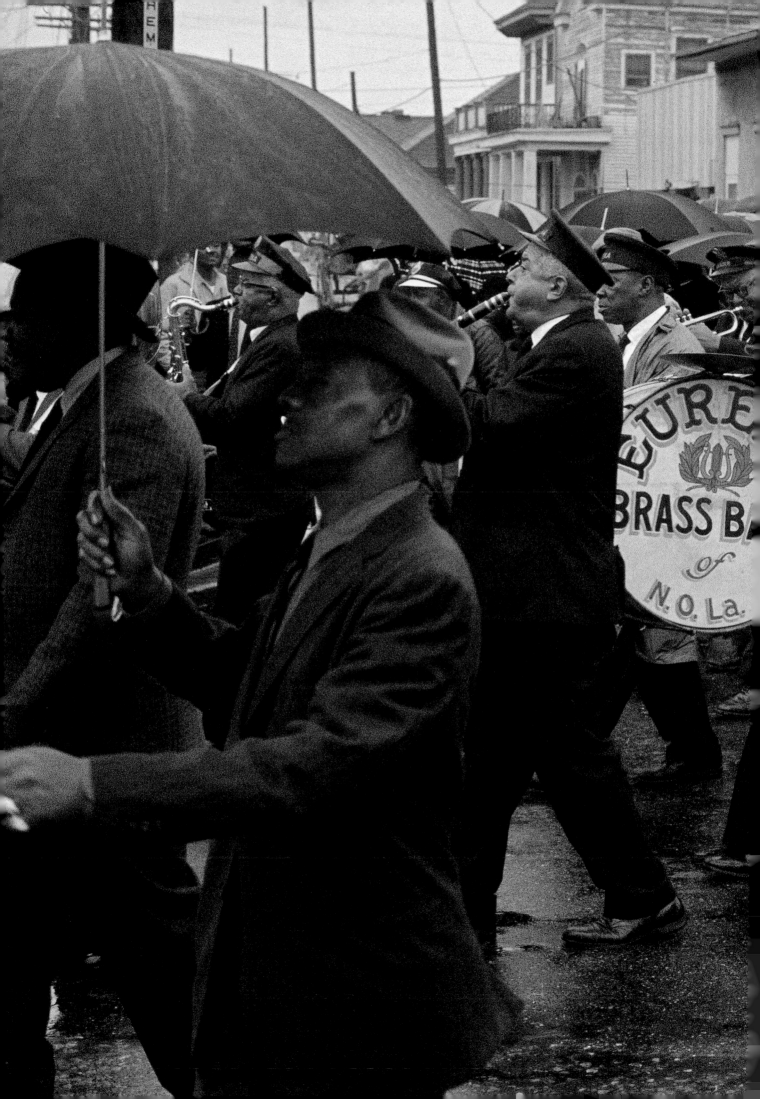

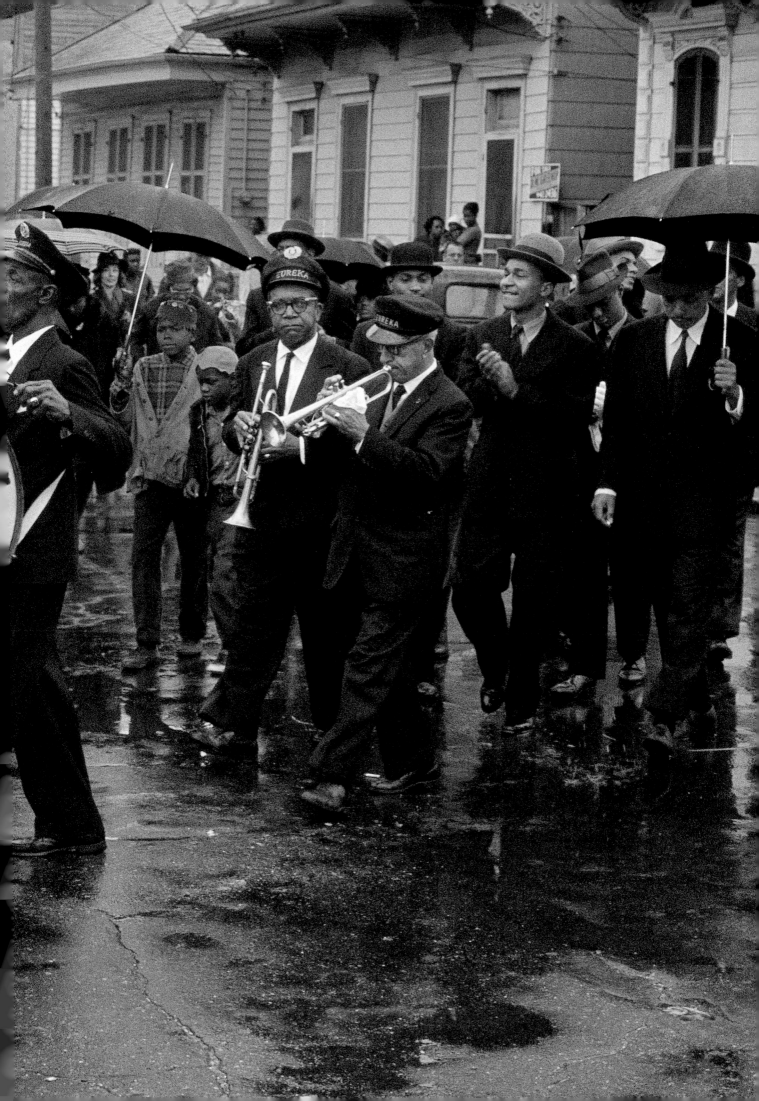

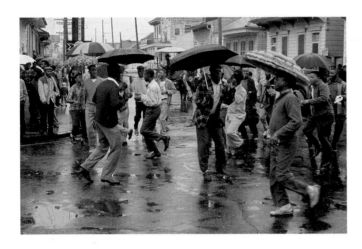

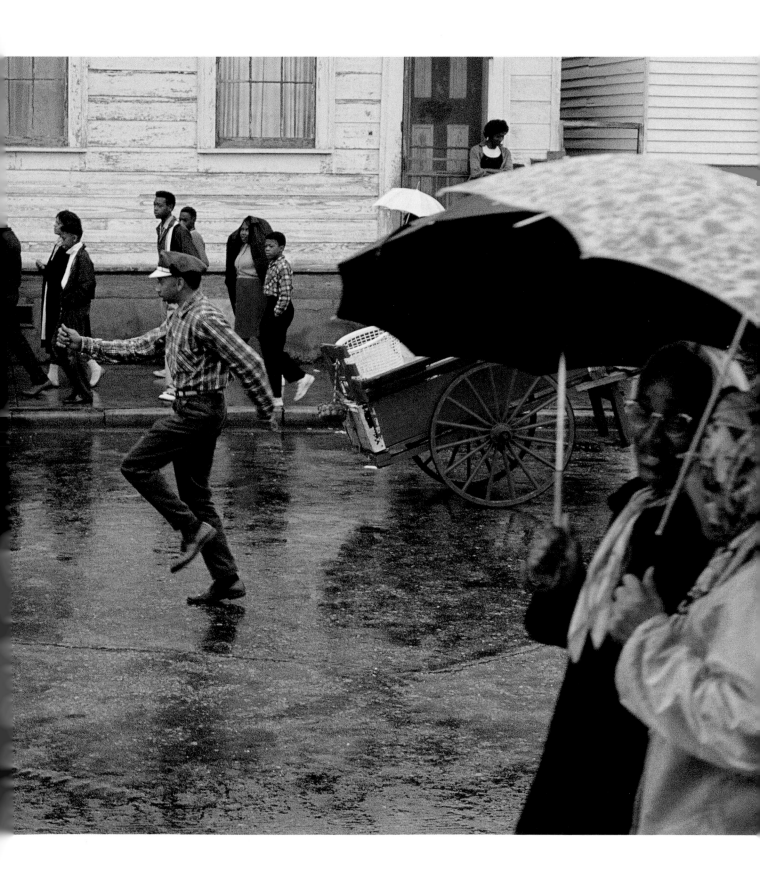

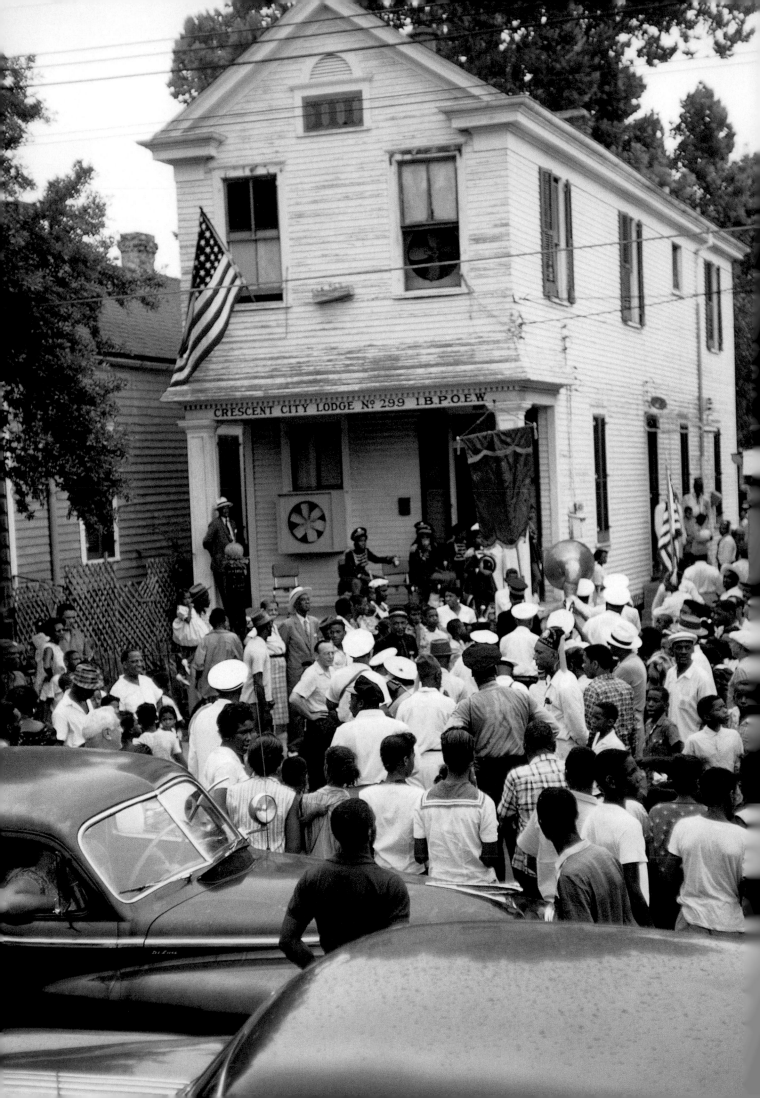

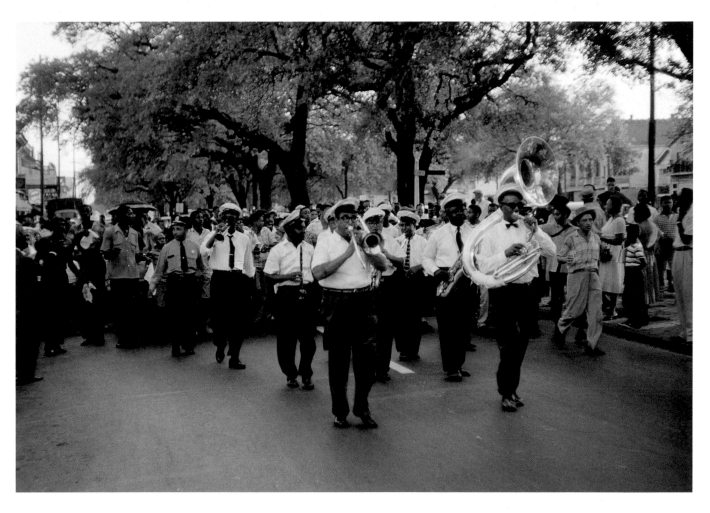

Pages 158 – 167 In New Orleans there can be several parades on the same day with the celebration of the funerals of lodge members, church functions and for most any big event or association.

Pages 158 – 167 À la Nouvelle-Orléans, on peut parfois assister à plusieurs processions dans la même journée, à l'occasion de l'enterrement du membre d'une loge, d'une fête religieuse, de la commémoration d'une association ou de n'importe quel grand événement.

Seiten 158 – 167 In New Orleans können am selben Tag mehrere Paraden gleichzeitig stattfinden: Trauerzüge für Mitglieder aus den Bruderschaften, kirchliche Prozessionen und Umzüge bei allen möglichen großen Veranstaltungen oder von Vereinen organisiert.

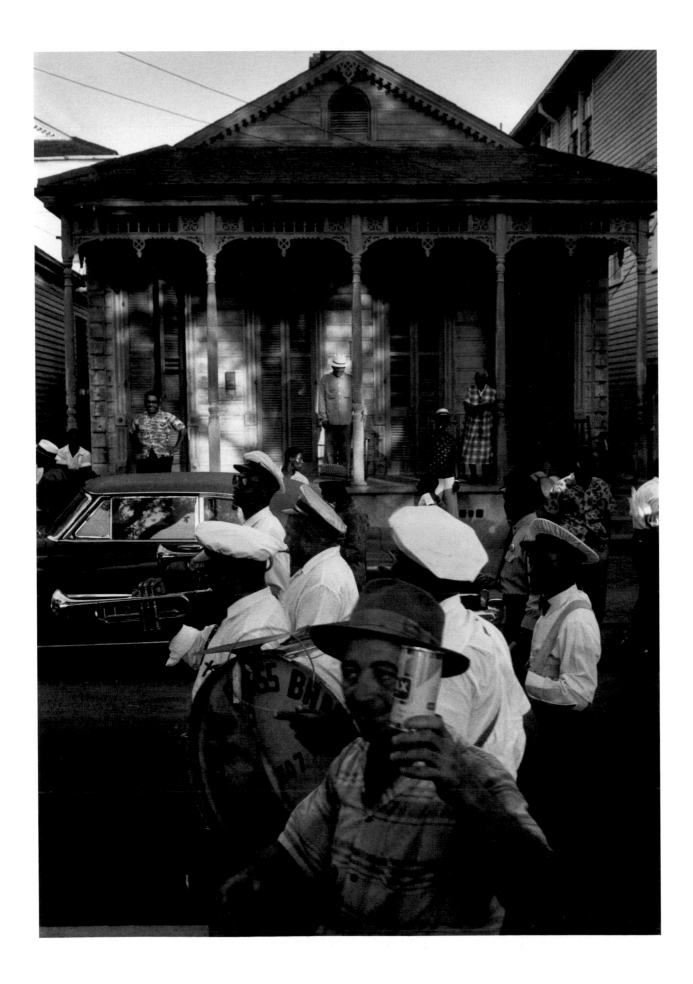

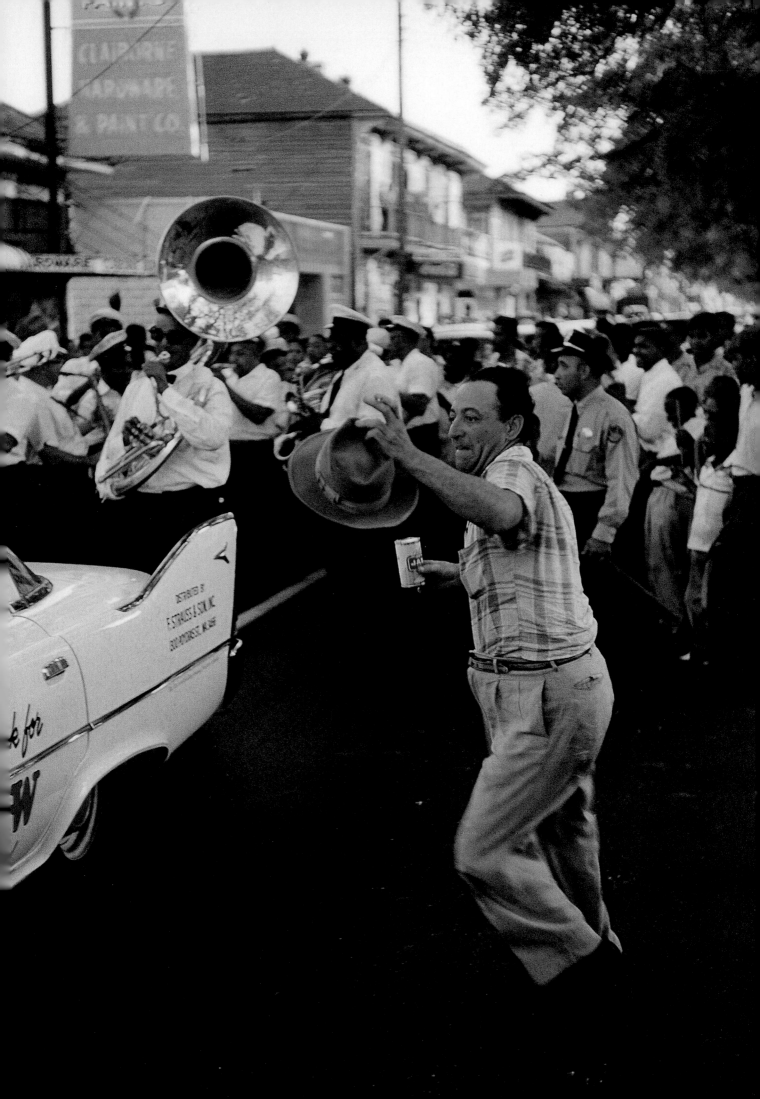

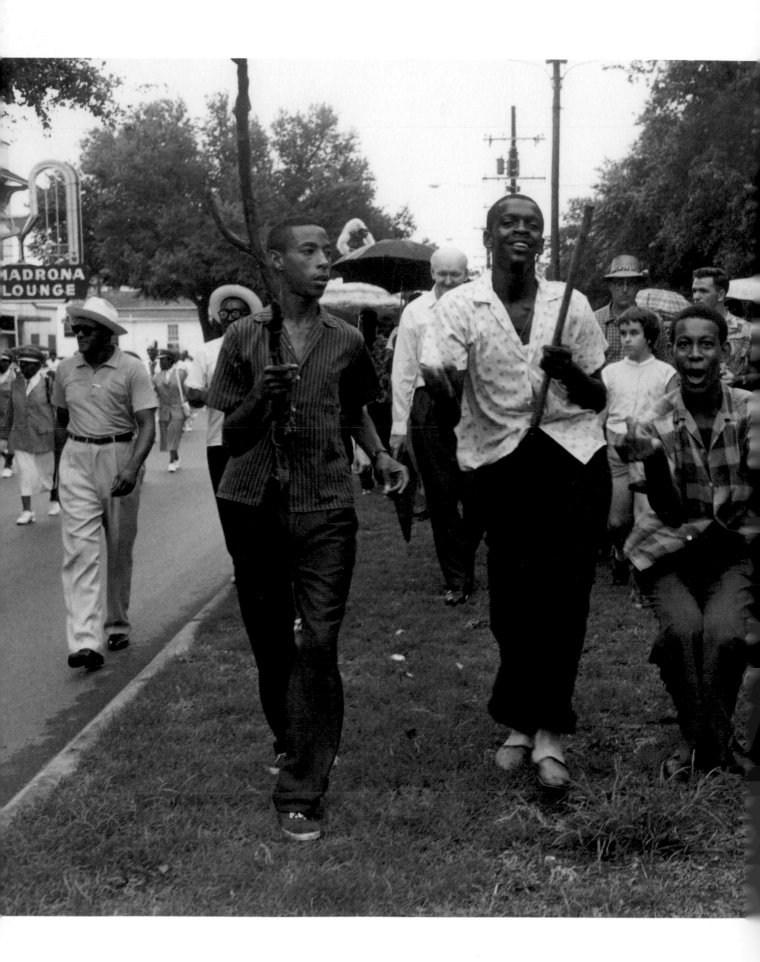

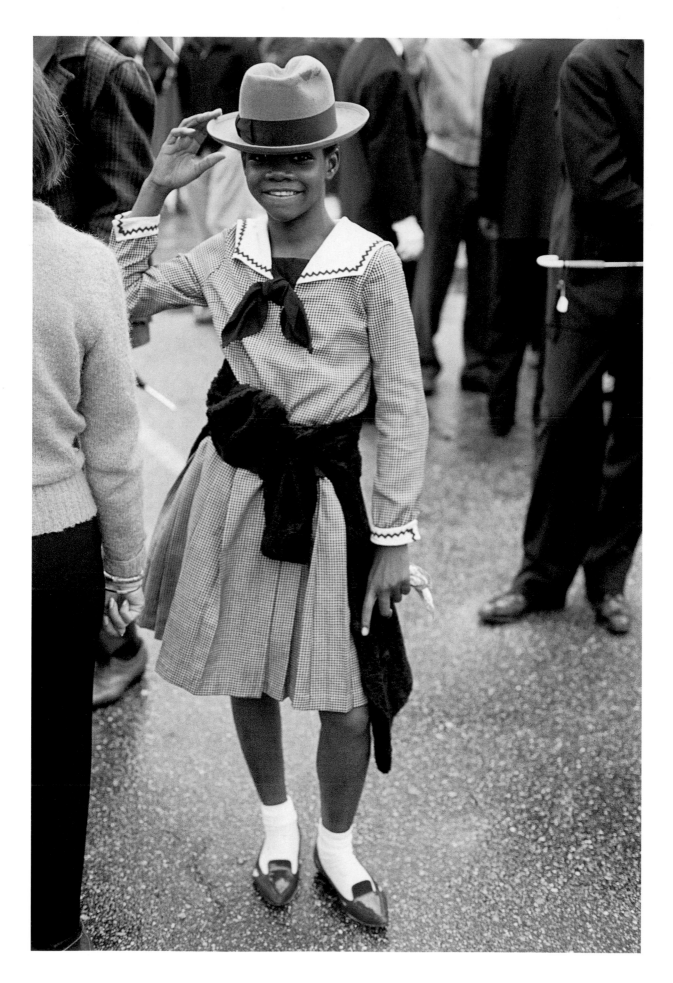

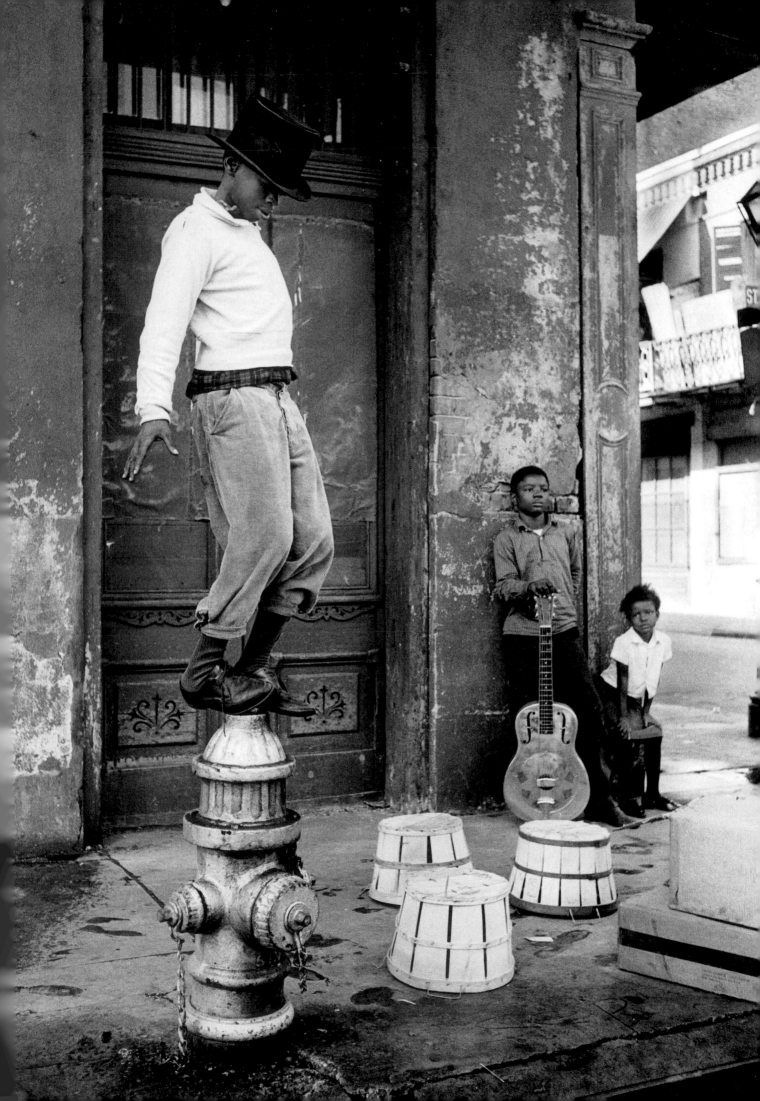

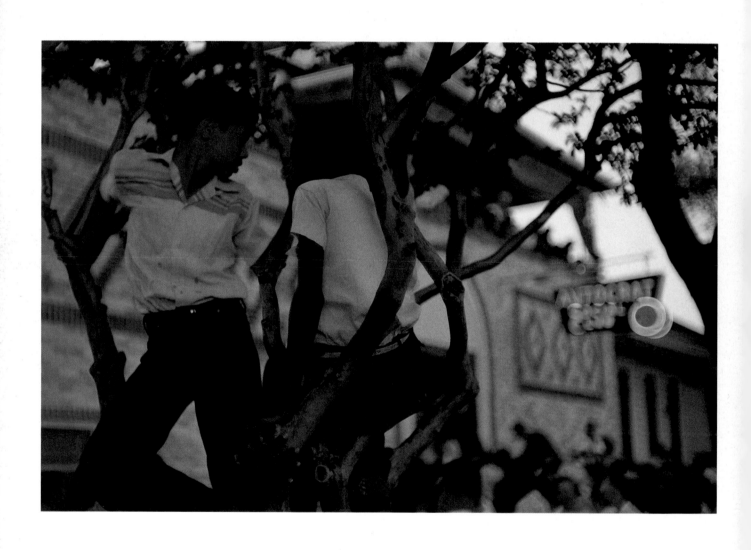

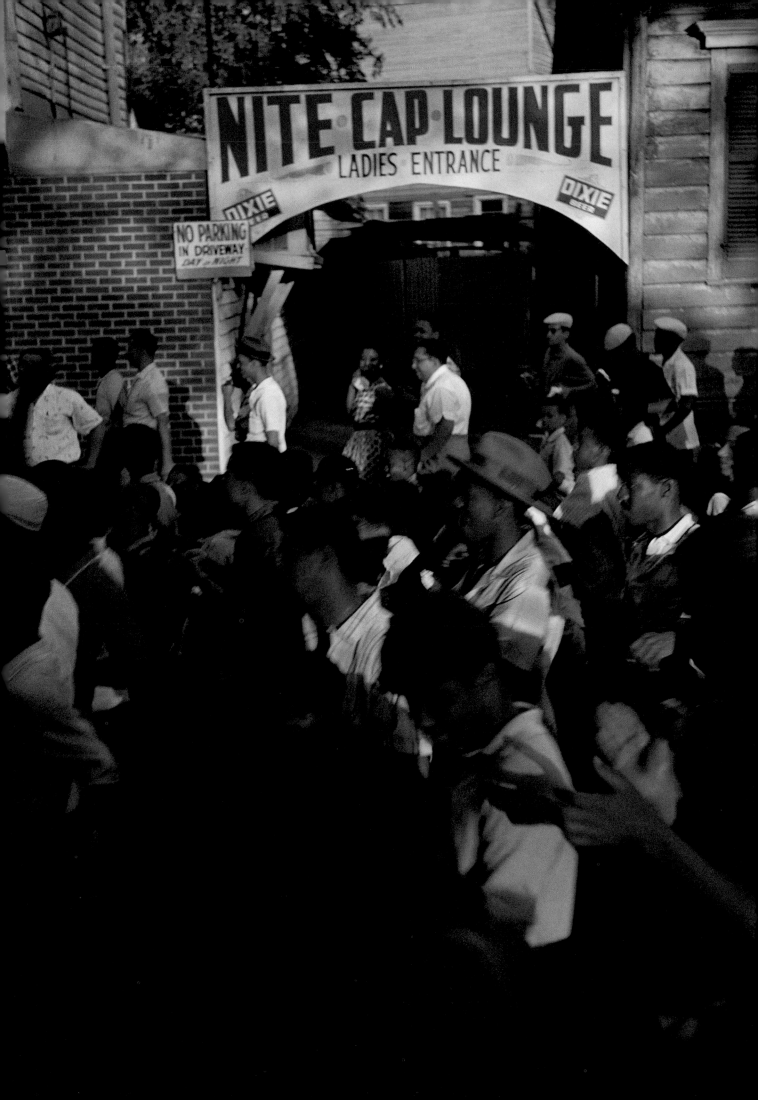

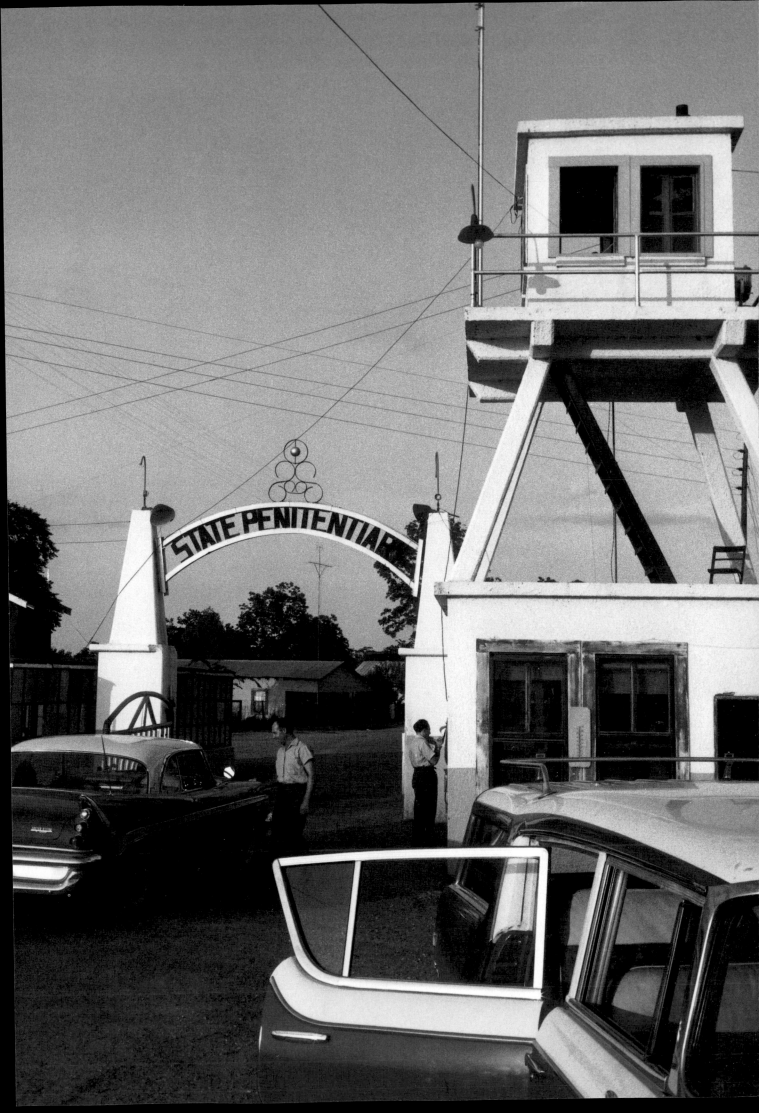

LOUISIANA STATE PENITENTIARY IN ANGOLA

"Jazz fans know it because Leadbelly, the famous country blues singer, 'did time' there for years."

Angola lies two hundred miles north of New Orleans, not far from a mighty bend in the Mississippi. The road that travels up from Baton Rouge ends there. You can't go anywhere else. It's as if you had come to the end of the world. But the "end" is actually the Louisiana State Penitentiary, in Angola. Jazz fans know it because Leadbelly, the famous country blues singer, "did time" there for years. Some of his most beautiful blues were written in the prison of Angola. Even today there are still blues, work songs, and spirituals in Louisiana State Penitentiary. There's all kinds of music there. Some three thousand prisoners are "doing time" in Angola. Half of them are Negroes, the other half whites. The white prisoners are given instruments for their ensembles and bands by the prison administration. The Negroes are hardly given any instruments at all. Nevertheless, there is two or three times as much musical activity among the

"When you play the guitar, you already get the blues when you're only just tuning. That's the best part of my life: the blues."

Negroes as there is among the whites. There is even a big band, led by an arranger serving time for drug addiction. Whoever comes to Angola as a drug addict has no hope of early release. Murderers can be pardoned after a certain number of years with good behavior.

The first blues singer we met in Angola was Hoagman Maxey. He comes from Las Vegas and was sentenced to twelve years in prison for manslaughter. Hoagman told us about a storm that had suddenly broken out the day before. He was at work on the prison plantation and had narrowly escaped being struck by lightning. We mentioned in passing that he would surely write a blues song about it one day, and right then and there, Hoagman played a few chords on his guitar and improvised his *Lightnin' Blues*. The amazing thing about the blues, however, is not just the melodies, but above all the lyrics. They capture moods and facts with simple, direct precision. The flexibility with which blues musicians find new uses for stereotypical old phrases and the inventiveness with which they coin new ones are impressive. This is true "jazz and poetry": jazz music seamlessly transformed into words, and also of course vice versa: blues poetry turned just as seamlessly into music. Hoagman says: "When you play the guitar, you already get the blues when you're only just tuning. That's the best part of my life: the blues." He described to Dr. Harry Oster, the folk music specialist of Louisiana State University, how he had come to the blues: "Once I had spent a whole night with a friend, and a girl came between us. It was already getting close to morning when she fetched a guitar and laid it in front of us. She said, it's now completely up to you—who can play? Well I couldn't, but the other one could. So she went with him—and at that very moment

I decided to learn the guitar and play the blues." In the evening all the different blues singers sang in a little room in Camp H, individually or together. The walls were covered with pictures from newspapers, mainly of various movie actresses or other well-built females. Guitar Welch sang the *Electric Chair Blues*:

> *It's funny, baby, how they always put you in the electric chair at one in the morning.*
> *The current's a lot stronger then. People don't need any more light.*

Roosevelt Charles had a very close brush with the electric chair. When he was in Angola for the first time in the 1930s, he met Leadbelly there. By now he is there for the fourth time. This time only for larceny; the first time it was for murder. He says he was only really guilty the first time. But if you've been here once, he said, you're no longer accepted as a normal human being: "When anything at all gets lost in your vicinity, right away they say you stole it; after all, you've already been at Angola. And something or other is always missing somewhere. You can't do anything but come back here again and again."

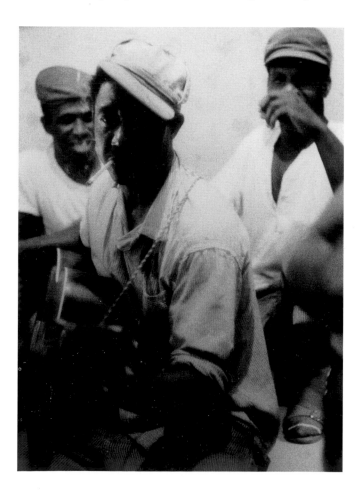

Roosevelt Charles first started singing the blues in prison. He also still sings work songs occasionally, the old work songs where a whole group of prisoners works together as a unit to the rhythm of the song. There are work songs that are sung while cutting reed or cutting down trees, while doing roadwork or digging ditches, while sewing and while brushing. A work song intended for road construction goes like this:

Oh if I'd known that the warden was so mean,
Oh my friend I would never have left New Orleans!
Ah, when I build my new house,
Baby, I'm going to build the chimney higher,
So the rats don't come in the chimney
And put out my fire…
Trouble, trouble is all I can see in the world.
When I clean this street, boys,
I'm amazed what's become of me.

There are also female prisoners in Angola. In the prison tailory, thirty or thirty-five women and girls work on the production line. Every one of them does the same task over and over from the beginning. They sang this work song while they worked:

There's something in me, Lord,
Something in me,
I can't explain what it is.
All I can say is:
Praise God that there's still something in you.
It's a heavenly flower, you know.
I ran into God one morning.
I was feeling so bad.
He took my burden from me,
And my poor heart was happy again.
All I can say is:
Praise God that there's still something in you.

Specialists often express the view that only the older prisoners still sing work songs today because of the introduction of machines, while blues is also sung by the younger prisoners. But there are already work songs whose rhythm was created to match the cadence of a machine, for example, that of a sewing machine in the women's division, or the pounding of a massive steam press. The worker at the steam press sings *Jesus Cares* in perfect time with the working of the machine:

Jesus takes care of me when I'm bowed down.
Jesus takes care of me, yes, he takes care of me.
I remember, when I was a little boy,
My father called me. He said:
Son, don't be sad, Jesus will always find a way.

In many of these blues songs, work songs, and spirituals, there is despair, bitterness, and fierce anger. Most of the prisoners realize that if it weren't for the conditions of life of the Negroes in the South and the racial discrimination and everything that goes along with it, they would not have become guilty. There is still separate justice for whites and blacks in many southern states today, even if such a thing has long since been officially prohibited by the Supreme Court in Washington. The prisoner in Mose Allison's *Parchman's Blues* (Parchman Penitentiary in the state of Mississippi is the counterpart of Angola Penitentiary in Louisiana) sings, "All I did was shoot my wife." Most listeners only experience that as comic, but the line also has another meaning. In the state of Mississippi it is not regarded as a capital offense for one Negro to kill another, based on the old practice that it is best not to worry about what the Negroes do to each other. But when a Negro does even the slightest thing to a white person, in most cases he does not escape with his life.

Another prisoner, Robert Pete Williams, said to Dr. Oster: "Music always pursued me. I tried to stop playing, because I thought I should prepare my soul for God. You have to realize, I was a Christian before I came here. I can also play spirituals, but I've strayed from God. He wanted me to become a preacher, but I didn't, and now I'm here. You know, I can't write music, everything I play I hear in the air. You can hear the sound as it comes to you. You know, I'm just going to go get my guitar—I'll be right back and I'll play it." And then Robert Pete Williams brought his guitar and sang this blues (I cite only the most characteristic lines of every song):

Lord, I feel so bad sometimes,
I feel like I'm getting weaker every day…
All I've got to do is pray.
That's the only thing that can help me here…
Sometimes it looks like my last day
Would be my best day…
Sometimes I think I'll never
See my little children again.
I was glad, somehow, that my poor mother was already dead.
My trouble would have afflicted her too much.
Lord, my trouble is making me weaker and weaker.
Sometimes, baby, I think I should just kill myself…

As Williams sang, the little room was full of prisoners. Others looked in through the window or the door, listened, and moaned "yeah" and "yes," "God" and "Lord" between the lines of the song.

Page 168 Entrance to the prison.
Page 169 Our host Hoagman Maxey was sentenced to twelve years for manslaughter.
Opposite Enjoying their pets and listening to their fellow inmates play music were the only entertaining diversions they experienced.

Page 168 L'entrée de la prison.
Page 169 Notre hôte Hoagman Maxey a été condamné à douze ans de prison pour homicide.
Ci-contre Les seules distractions des prisonniers consistent à jouer avec leurs animaux de compagnie et à écouter la musique de leurs codétenus.

Seite 168 Eingang zur Haftanstalt.
Seite 169 Unser Gastgeber Hoagman Maxey wurde wegen Totschlags zu zwölf Jahren Haft verurteilt.
Gegenüber Einzige Unterhaltung und Ablenkung waren ihre Tiere und die musizierenden Mithäftlinge.

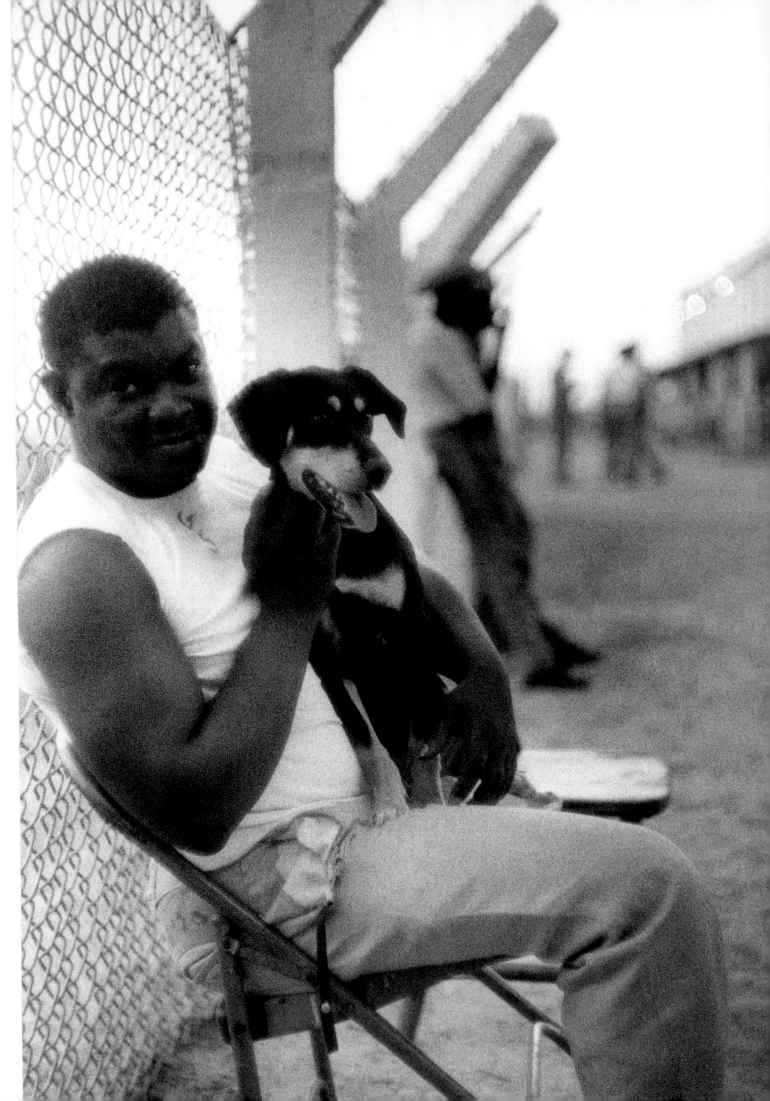

DAS LOUISIANA STAATSGEFÄNGNIS IN ANGOLA

»Jazzfreunde kennen es, weil Leadbelly, der berühmte Folkblues-Sänger, dort jahrelang ›saß‹.«

Angola liegt zweihundert Meilen nordwärts von New Orleans – unweit einer mächtigen Biegung des Mississippi. Die Straße, die von Baton Rouge heraufführt, endet dort. Man kann nirgendwo anders hin; es ist, als käme man ans Ende der Welt. Aber das »Ende« ist das Louisiana Staatsgefängnis in Angola. Jazzfreunde kennen es, weil Leadbelly, der berühmte Folkblues-Sänger, dort jahrelang »saß«. Einige seiner schönsten Blues sind im Gefängnis von Angola entstanden. Es gibt auch heute noch Blues, Worksongs und Spirituals im Louisiana-Staatsgefängnis. Es gibt alle Arten von Musik dort. In Angola »sitzen« etwa dreitausend Gefangene. Die eine Hälfte Neger, die andere Weiße. Die weißen Gefangenen erhalten von der Lagerleitung für ihre Kapellen und Bands Instrumente. Die Neger bekommen kaum Instrumente. Gleichwohl ist die musikalische Aktivität bei den Negern zwei- bis dreimal so stark wie bei den Weißen. Es gibt sogar eine Big Band, die von einem Arrangeur geleitet wird, der wegen Rauschgiftsucht verurteilt wurde. Wer als Rauschgiftsüchtiger nach Angola kommt, hat keine Chance, vorzeitig entlassen zu werden. Mörder können bei guter Führung nach einigen Jahren begnadigt werden.

»Wenn man die Gitarre spielt, bekommt man den Blues schon, wenn man gerade erst am Stimmen ist. Das ist der beste Teil meines Lebens: der Blues.«

Der erste Blues-Sänger, den wir in Angola kennenlernten, war Hoagman Maxey. Er stammt aus Las Vegas und wurde wegen Totschlags zu zwölf Jahren Gefängnis verurteilt. Hoagman erzählte uns von einem Gewitter, das gerade am Tag zuvor plötzlich losgebrochen sei. Er sei bei der Arbeit auf der Gefängnisplantage um ein Haar vom Blitz erschlagen worden. Wir erwähnten bei-

läufig, daß er gewiß eines Tages einen Blues darüber machen würde, und schon griff Hoagman einige Akkorde auf seiner Gitarre und improvisierte seinen *Lightnin' Blues*: den Blues vom Blitz. Das Erstaunliche dabei sind nicht nur die Melodien, sondern vor allem die Texte. Sie treffen Stimmungen und Fakten mit einfacher, direkter Präzision. Die Biegsamkeit, mit der alte, stereotype Phrasen immer wieder neu verwendet, und der Erfindungsreichtum, mit dem neue Phrasen geschaffen werden, sind bewundernswert. Dies ist die wahre »Jazz and Poetry«: die bruchlos in Worte verwandelte Jazzmusik – und natürlich auch umgekehrt: die ebenso bruchlos in Musik verwandelte Blues-Dichtung. Hoagman sagt: »Wenn man die Gitarre spielt, bekommt man den Blues schon, wenn man gerade erst am Stimmen ist. Das ist der beste Teil meines Lebens: der Blues.« Er erzählte Dr. Harry Oster, dem Volksmusikspezialisten der Louisiana State University, wie er zum Blues gekommen sei: »Einmal hatte ich eine ganze Nacht mit einem Freund verbracht, und ein Mädchen war zwischen uns. Es war schon gegen Morgen, als sie eine Gitarre holte und vor uns hinlegte. Sie meinte: Es liegt jetzt ganz an euch: wer kann spielen? Nun, ich konnte nicht, aber der andere konnte. Da ging sie mit ihm – und in der Minute habe ich mir vorgenommen, Gitarre zu lernen und Blues zu spielen.« Am Abend sangen alle die verschiedenen Blues-Sänger, einzeln und zusammen, in einem kleinen Raum des Camp H. Die Wände waren vollgeklebt mit Bildern aus Zeitungen, zumeist von irgendwelchen Filmschauspielerinnen oder sonstigen wohlausgestatteten weiblichen Wesen. Guitar Welch sang den *Electric Chair Blues*:

Komisch, Baby, warum sie einen immer um eins in der Nacht auf den elektrischen Stuhl setzen.
Der Strom ist viel stärker dann. Die Leute brauchen kein Licht mehr.

Hart am elektrischen Stuhl vorbeigegangen ist Roosevelt Charles. Als er das erste Mal in Angola war, in den dreißiger Jahren, hat er Leadbelly dort noch kennengelernt. Inzwischen sitzt er zum vierten Mal. Diesmal nur wegen Diebstahls, das erste Mal war es wegen Mordes. Er meint, daß er nur beim ersten Mal wirklich Schuld gehabt hätte. Aber wer einmal hiergewesen sei, würde nicht mehr als normaler Mensch akzeptiert: »Wenn irgend etwas in deiner Nähe verlorengeht, heißt es sofort, du hast es gestohlen, denn du warst ja doch schon mal in Angola. Und irgend etwas fehlt immer irgendwo. Du kannst nichts anderes machen, als immer wieder hierher zurückkommen.« Roosevelt Charles hat erst im Gefängnis angefangen, Blues zu singen. Er singt gelegentlich auch noch Worksongs, die alten Arbeitslieder, in deren Rhythmus eine ganze Gruppe von Gefangenen als eine geschlossene Einheit zusammenarbeitet. Es gibt Arbeitslieder, die beim Schilfschneiden und beim Baumfällen, bei Straßenreparaturen oder beim Graben, beim Nähen und beim Bürsten gesungen werden. In einem Worksong, der für den Straßenbau gedacht ist, heißt es:

Oh, wenn ich gewußt hätte, daß der Aufseher so gemein ist,
Oh, guter Kumpel, ich würde niemals New Orleans verlassen haben!
Ach, wenn ich mein neues Haus baue,
Baby, ich werd' den Schornstein höher bau'n,
Damit die Ratten nicht zum Schornstein hereinkommen
Und mir das Feuer ausmachen …
Kummer, Kummer ist alles, was ich in der Welt sehen kann.
Wenn ich diese Straße saubermache, Jungens,
Wundere ich mich, was aus mir geworden ist.

Es gibt auch weibliche Gefangene in Angola. In der Gefängnisschneiderei arbeiten 30 oder 35 Frauen und Mädchen am laufenden Band. Jede macht die gleiche Arbeit immer wieder von vorn. Dabei wurde der folgende Worksong gesungen:

Es gibt irgend etwas in mir, Herr,
Irgend etwas in mir,
Ich kann nicht erklären, was es ist.
Alles, was ich sagen kann, ist:
Lobe Gott, daß noch etwas in dir ist.
Es ist eine himmlische Blume, weißt du.
Ich habe Gott eines Morgens getroffen.
Es ging mir so schlecht.
Er nahm meine Last,
Und mein armes Herz wurde wieder froh.
Alles, was ich sagen kann, ist:
Lobe Gott, daß noch irgend etwas in dir ist.

Die Fachleute vertreten oft die Meinung, daß die Einführung der Maschinen daran schuld sei, daß heute nur noch die älteren der Gefangenen Worksongs singen, während Blues auch von den Jungen gesungen werden. Aber es gibt bereits Worksongs, deren Rhythmus zum Gang einer Maschine geschaffen wurde – etwa einer Nähmaschine in der Frauenabteilung oder zum Stampfen einer mächtigen Dampfpresse. Der Arbeiter an der Dampfpresse singt genau synchron zum Arbeitsgang der Maschine *Jesus Cares*:

Jesus kümmert sich um mich, wenn ich niedergedrückt bin.
Jesus kümmert sich um mich, ja, er kümmert sich um mich.
Ich erinnere mich, als ich ein kleiner Junge war,
Rief mich mein Vater. Er sagte:
Sohn, sei nicht traurig, Jesus wird immer einen Weg finden.

In vielen dieser Blues, Worksongs und Spirituals gibt es Verzweiflung, Bitterkeit und wilden Zorn. Die meisten Gefangenen wissen, daß sie nicht schuldig geworden wären ohne die Lebensbedingungen der Neger im Süden und ohne die Rassendiskriminierung und all das, was dazugehört. Immer noch gibt es in vielen Staaten des Südens verschiedene Rechtssprechung für Weiße und Schwarze – auch wenn das längst schon vom Obersten Gerichtshof in Washington offiziell verboten wurde. Der Gefangene in Mose Allisons *Parchman's Blues* (das Parchman-Gefängnis im Staate Mississippi ist das Gegenstück zum Angola Prison im Staate Louisiana) singt: »All I did was shoot my wife« – »Alles, was ich getan habe, war: Ich habe meine Frau erschossen.« Die meisten Zuhörer empfinden das nur als komisch, die Zeile hat aber auch noch eine andere Bedeutung: Es wird im Staate Mississippi nicht als Kapitalverbrechen gewertet, wenn ein Neger einen anderen umbringt – aus der alten Praxis heraus, daß man sich am besten nicht darum kümmert, was die Neger sich untereinander antun. Wenn aber ein Neger auch nur das Geringste einem Weißen antut, kommt er in den meisten Fällen nicht mit dem Leben davon.

Robert Pete Williams, ein anderer Gefangener, sagte zu Dr. Oster: »Die Musik hat mich immer verfolgt. Ich habe versucht, aufzuhören mit dem Spielen, weil ich dachte, ich sollte meine Seele für Gott vorbereiten. Sie müssen wissen, ich war ein christlicher Mann, bevor ich hierherkam. Ich kann auch Spirituals spielen, aber ich bin fort von Gott gegangen. Er wollte, daß ich ein Prediger werde, aber ich hab's nicht getan, und jetzt bin ich nun hier. Wissen Sie, ich kann keine Musik aufschreiben, alles was ich spiele, höre ich in der Luft. Du kannst den Klang hören, wie er zu dir kommt. Wissen Sie, ich hole gleich mal meine Gitarre, ich bin gleich wieder da und spiele es.« Und dann brachte Robert Pete Williams seine Gitarre und sang den folgenden Blues (ich versuche, jeweils nur die charakteristischen Zeilen zu übersetzen):

Herr, mir geht's so schlecht manchmal,
Ich glaube, ich werde jeden Tag schwächer …
Alles, was ich tun muß, ist beten.
Das ist das einzige, was mir hier helfen kann …
Manchmal sieht es so aus, als ob mein letzter Tag
Mein bester Tag würde …
Manchmal glaube ich, ich werde niemals mehr
Meine kleinen Kinder wiedersehn.
Irgendwie war ich froh, daß meine arme Mutter vorher gestorben ist.
Der Kummer mit mir hätte ihr zu sehr zugesetzt.
Herr, mein Kummer macht mich immer schwächer.
Manchmal glaube ich, Baby, ich sollte mich selbst umbringen …

Während Williams das sang, stand der kleine Raum voller Gefangener. Andere schauten zum Fenster oder zur Tür herein, hörten zu und stöhnten zwischen den einzelnen Zeilen »yeah« und »yes«, »God« und »Lord«.

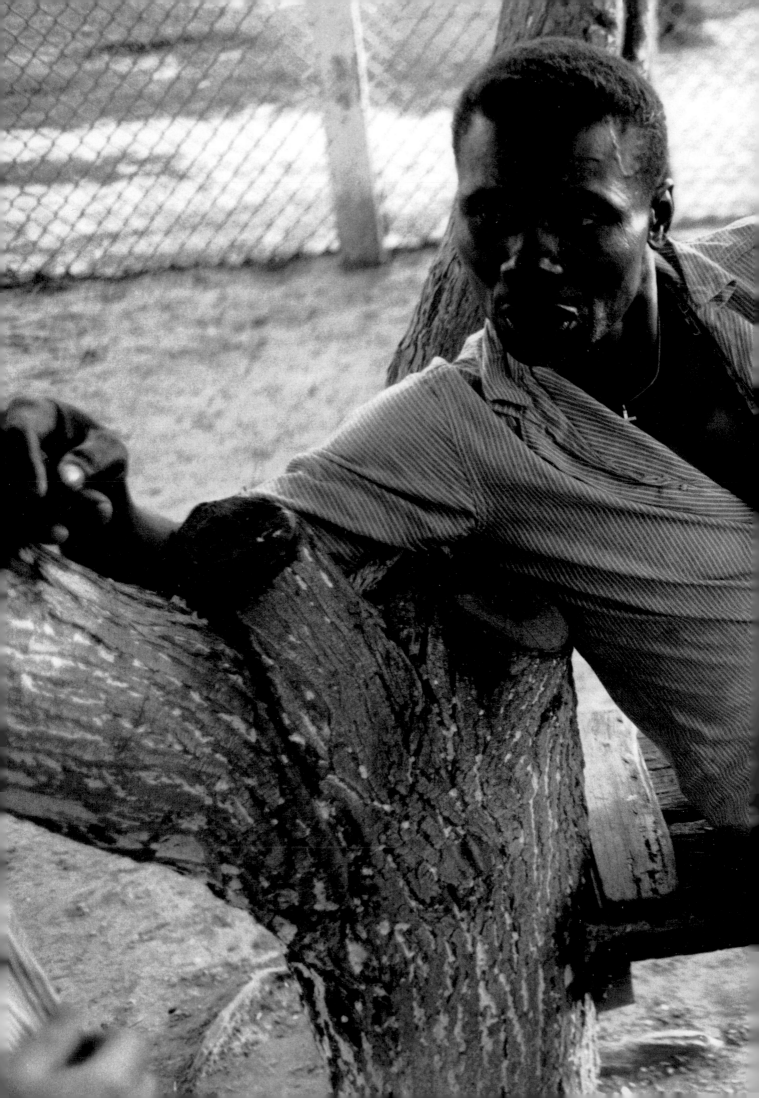

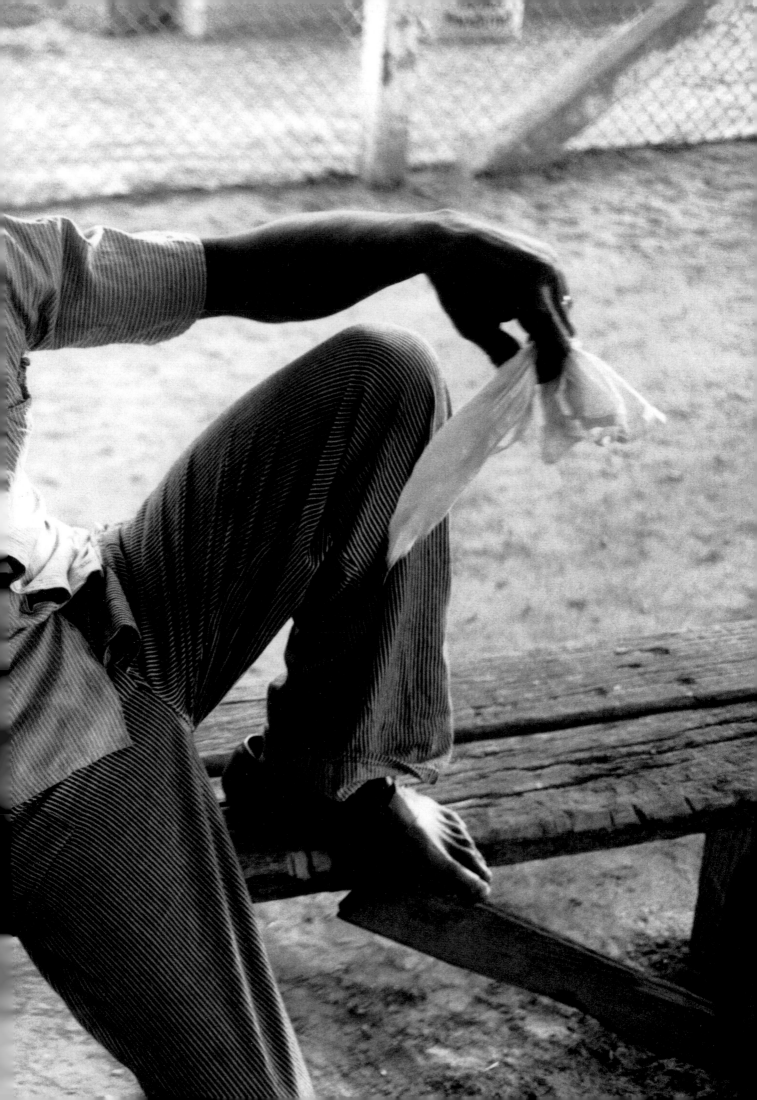

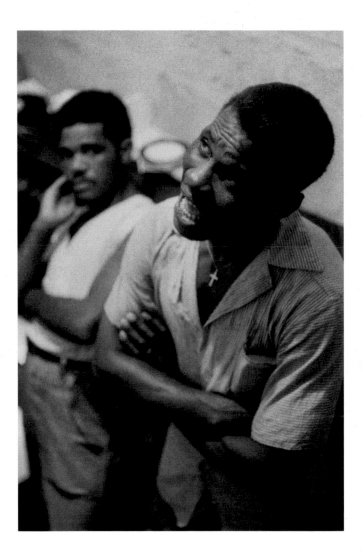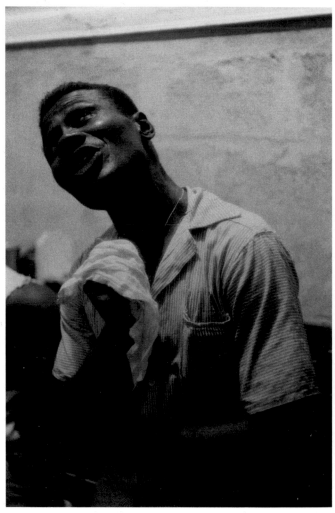

Pages 176 – 179 Roosevelt Charles, blues singer and prisoner.

Pages 176 – 179 Roosevelt Charles, chanteur de blues et détenu.

Seiten 176 – 179 Roosevelt Charles, Bluessänger und Häftling.

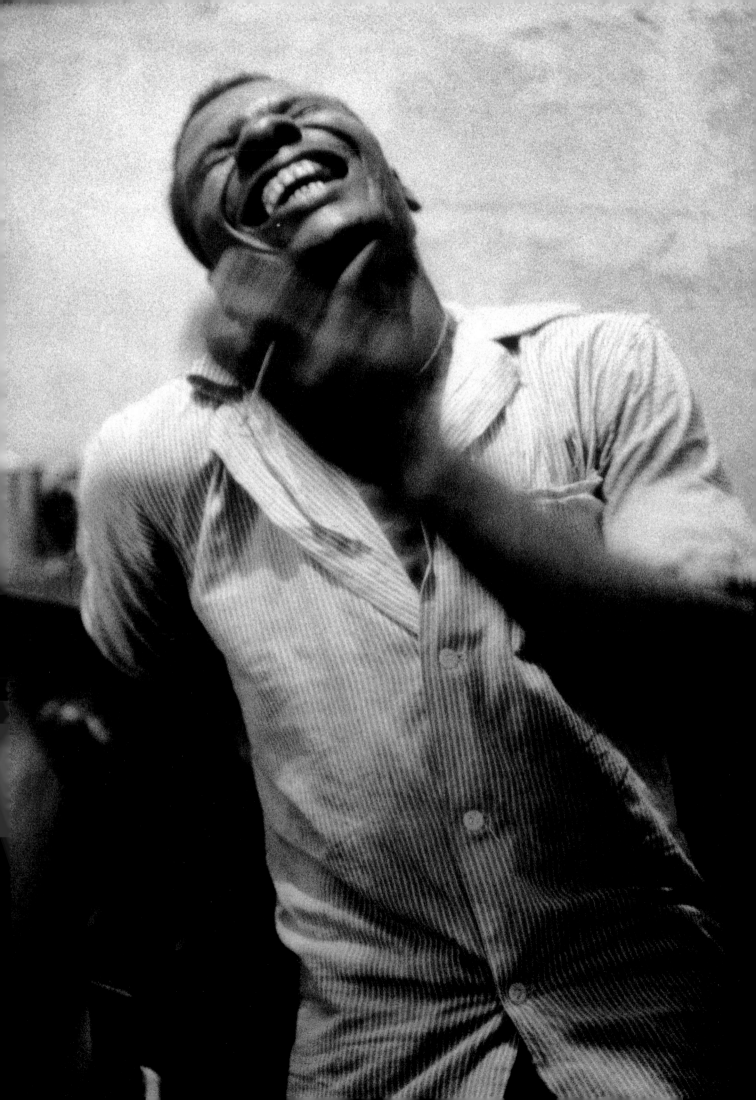

Right As the music played, the other prisoners listened and moaned "yeah", "yes", "God", and "Lord" between the phrases of the song.
Pages 182–183 Hoagman Maxey, the blues singer, was our host during our visit with the thousand or more prisoners.

À droite En écoutant leur compagnon, les autres prisonniers murmuraient et gémissaient « yeah », « yes », « God » et « Lord » entre chaque phrase de sa chanson.
Pages 182–183 Durant notre visite, le chanteur de blues Hoagman Maxey nous servit d'hôte auprès des mille détenus.

Rechts Während sie der Musik lauschten, stöhnten die übrigen Gefangenen »yeah«, »yes«, »God« und »Lord« zwischen den Phrasen des Liedes.
Seiten 182–183 Der Bluessänger Hoagman Maxey war bei unserem Besuch bei über tausend Häftlingen der Gastgeber.

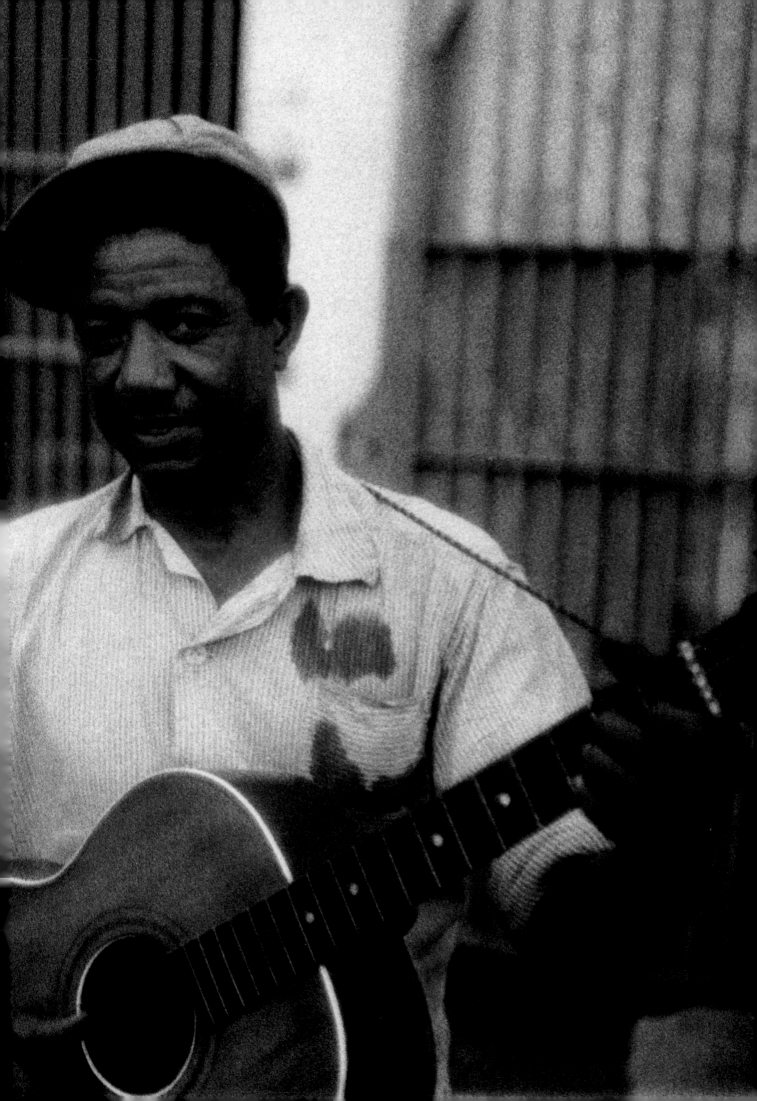

BIOGRAPHIES

William Claxton

Above William Claxton with his newly won *Lucie Award*, photographed by Len Prince, Los Angeles, 2004.

Ci-dessus William Claxton avec le Lucie Award qu'on vient de lui décerner, photographié par Len Prince à Los Angeles en 2004.

Oben William Claxton mit seinem soeben gewonnenen Lucie Award, fotografiert von Len Prince, Los Angeles, 2004.

Born and raised in Southern California, William Claxton holds a special place in the history of American photography. Since his earliest pictures in the 1950s, he has been creating photographs that have garnered attention for their intimate yet soulful feel.

Always noted for his sensitive and poetic style, Claxton has long been considered the preeminent photographer of jazz music. His jazz imagery has graced the covers of countless albums and magazine covers for over five decades.

In 1951, while a student at U.C.L.A., Claxton began to photograph a young and unknown trumpet player named Chet Baker. The resulting collection of images from these sessions has become known throughout the world of jazz music. Throughout the trumpeter's meteoric rise to fame and his equally dramatic demise, the Claxton images of Baker are largely credited as defining both his initial fame and posthumous legacy.

Since his early career—shooting for *LIFE*, *Paris Match*, and *Vogue*, among other magazines—Claxton has worked with and become friends with many Hollywood luminaries. His very personal pictures of Frank Sinatra, Marlene Dietrich, Steve McQueen and Judy Garland have made lasting impressions of the intimate moments coaxed from such traditionally private personalities. Well-known in the recording world, Claxton is one of the founding members of The Recording Academy (formerly called the National Academy of Recording Arts and Sciences—NARAS), producers of the Grammy Awards.

In 2003, he was awarded the distinguished *Lucie* at the International Photography Awards.

In the 1960s, Claxton collaborated with his wife, the noted fashion model Peggy Moffitt, to create a stunning collection of iconic fashion images featuring the revolutionary designs of Rudi Gernreich. A Claxton-directed film from this era, *Basic Black*, is considered by many to be the first "fashion video" and is now part of the collection of the Museum of Modern Art in New York. To this day, the Claxton/Moffitt/Gernreich images from this era continue to be hailed as masterful examples of modern style.

As the author of thirteen books and subject of dozens of exhibitions, William Claxton enjoys a worldwide audience for his work. Claxton lives in Beverly Hills with his wife and partner Peggy Moffitt. Their son Christopher, manages their photographic archives.

Steve Crist

Joachim E. Berendt

Above Joachim E. Berendt, New York City, 1960, photographed by Peggy Moffitt.

Ci-dessus Joachim E. Berendt à New York en 1960, photographié par Peggy Moffitt.

Oben Joachim E. Berendt, New York City, 1960, fotografiert von Peggy Moffitt.

In Germany he was called the "jazz pope", and indeed, Joachim Ernst Berendt was the most influential non-musician in the German jazz scene for more than 50 years.
Joachim Berendt was born July 20,1922 in Berlin and came into contact with jazz in the mid 1930s. His father was a Protestant pastor who fought against the Hitler regime and died in the concentration camps of Dachau. Berendt was called into military service from 1942–45, and after the war spent some time in prison camps. In 1946 he returned to Baden-Baden and became one of the founding members of South West German radio (Südwestfunk).

From the beginning at Südwestfunk, Berendt produced jazz broadcasts using his own extensive collection as well as material from radio archives in Berlin and Paris. He ultimately became director of the department, and many other radio stations modeled their jazz departments on the Baden-Baden model he created. At Südwestfunk he ultimately came to produce thousands of broadcasts for both radio and television. At the same time he produced more than 250 records, including many issued on the MPS-SABA label.

In 1953 he first published *Jazzbuch*, that was updated and translated into more than eighteen languages over the years. It became the most successful history book on jazz worldwide, selling more than 1.5 million copies. For over fifty years it remained the starting point for jazz lovers, as an information source about the history and aesthetics of jazz.

In 1960, Berendt traveled the United States with photographer William Claxton for the creation of *JAZZLIFE*, a seminal book that documented the American jazz scene. It has since become a highly sought after collectible. This volume produced by TASCHEN is a revised and shortened edition.

Berendt became more and more disillusioned with the development of jazz in the 1970s. As he had always been interested in the avant-garde aspects of music, he published a succession of books in which he reflected upon the psychology of listening more than upon any specific musical tradition. Upon his departure from radio in 1987, he organized workshops and gave lectures. As jazz was becoming less central to his life, he sold his collection of records, books and documents to the city of Darmstadt, Germany where it became the basis for the Jazzinstitut Darmstadt.

Berendt's last book *There Is No Way But To Go* was published in 1999. On the way to a reading from this book, he was hit by a car while crossing the street in Hamburg on February 3, 2000. He died the next day from his injuries.

Wolfram Knauer

BIOGRAPHIES

William Claxton

Above I was photographed in my first photo studio in Los Angeles by artist Pauline Annon.

Ci-dessus L'artiste Pauline Annon m'a photographié dans mon premier studio de photographe à Los Angeles.

Oben Die Künstlerin Pauline Annon fotografierte mich in meinem ersten Fotostudio in Los Angeles.

William Claxton, qui est né et a grandi dans le sud de la Californie, occupe une place à part dans l'histoire de la photographie américaine. Dès ses premières photos dans les années 50, ses images intimes et expressives ont retenu l'attention.

Connu pour son style sensible et poétique, Claxton a longtemps été considéré comme le photographe du jazz par excellence. Ses images de musiciens ont orné d'innombrables pochettes de disques et couvertures de magazine pendant plus de cinq décennies.

En 1952, alors qu'il étudiait à UCLA, il commencé à photographier un jeune trompettiste inconnu du nom de Chet Baker. Les images de ces séances sont désormais légendaires. Tout au long de l'ascension météorique du musicien jusqu'à sa fin tragique et tout aussi brutale, ses portraits par Claxton ont documenté et capturé sa célébrité naissante autant que sa gloire posthume.

Dès les débuts de sa carrière, au service de *LIFE*, *Paris Match* et *Vogue* entre autres magazines, Claxton a travaillé et s'est lié d'amitié avec de nombreuses sommités d'Hollywood. Ses portraits très personnels de Frank Sinatra, Marlene Dietrich, Steve McQueen et Judy Garland sont autant de témoignages intimes de ces personnalités pourtant réputées très secrètes. Bien connu dans le monde du disque, Claxton est l'un des membres fondateurs de la Recording Academy (autrefois appelée la NARAS, « National Academy of Recording Arts and Sciences »), qui produit les célèbres trophées de la musique, les Grammy Awards. En 2003, l'International Photography Awards lui a remis le prestigieux prix Lucie.

Dans les années 60, Claxton, en collaboration avec son épouse, le célèbre mannequin Peggy Moffitt, a produit une superbe série d'images de mode devenues emblématiques présentant les créations révolutionnaires de Rudi Gernreich. Le film qu'il a réalisé à la même époque, *Basic Black*, est considéré par beaucoup comme la première « vidéo de mode » et est désormais entré dans les collections du Museum of Modern Art de New York. À ce jour, ces images réunissant les talents de Claxton, de Mofitt et de Gernreich continuent d'être célébrées comme des exemples magistraux du style moderne.

Après avoir signé treize albums et fait l'objet de dizaines d'expositions, William Claxton est désormais connu et apprécié dans le monde entier. Il vit à Beverly Hills avec sa femme et associée Peggy Moffitt. Leur fils, Christopher, gère leurs archives photographiques.

Steve Crist

Joachim E. Berendt

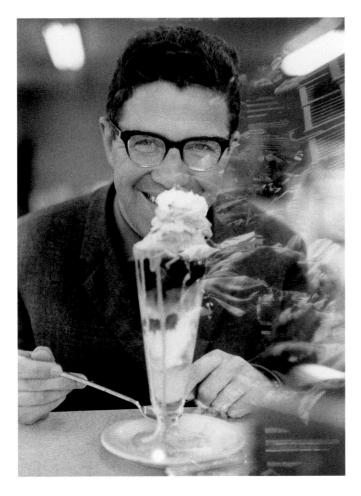

Above "Joe" Berendt at one of our many afternoon ice cream stops along the road.

Ci-dessus « Joe » Berendt, lors de l'une de nos nombreuses pauses « crème glacée » le long de la route.

Oben »Joe« Berendt bei einer unserer zahlreichen nachmittäglichen Eispausen während der Reise.

En Allemagne, on le surnommait « le pape du jazz ». De fait, pedant plus de cinquante ans, sans être musicien lui-même, Joachim-Ernst Berendt fut la personnalité la plus influente dans les milieux du jazz en Allemagne.

Né le 20 juillet 1922 à Berlin, il découvrit le jazz au milieu des années trente. Son père, un prêtre protestant, mourut dans le camp de concentration de Dachau après s'être opposé au régime d'Hitler. Appelé sous les drapeaux de 1942 à 1945, Joachim Berendt passa quelque temps dans des camps de prisonniers avant de s'installer à Baden-Baden, où il devint l'un des membres fondateurs de Südwestfunk (radio du sud-ouest). Dès ses débuts à Südwestfunk, il produisit des émissions de jazz, puisant dans sa considérable collection privée ainsi que dans des archives radiophoniques berlinoises et parisiennes. Il devint le directeur de la branche jazz et de nombreuses autres radios allemandes s'inspirèrent du modèle qu'il avait créé à Baden-Baden. À Südwestfunk, il enregistra des milliers d'heures d'émission pour la radio et la télévision. Parallèlement, il produisit plus de 250 disques, dont bon nombre édités par le label MPS-SABA.

En 1953, il publia *Jazzbuch*, qui fut régulièrement mis à jour au fil des ans et traduit dans plus de 18 langues. Ce devint le livre d'histoire du jazz le plus lu dans le monde, se vendant à plus de 1,5 million d'exemplaires. Pendant plus de cinquante ans, il fut le texte d'initiation au jazz par excellence pour tous les amateurs et l'ouvrage de référence sur l'histoire et l'esthétique du jazz. Ce volume-ci produit par TASCHEN est une édition revue, corrigée et raccourci.

En 1960, Berendt sillonna les États-Unis en compagnie du photographe William Claxton pour réaliser *JAZZLIFE*, un document majeur sur l'univers du jazz. C'est aujourd'hui une œuvre que les collectionneurs s'arrachent.

Au cours des années 1970, il fut de plus en plus déçu par l'évolution du jazz. S'étant toujours intéressé aux aspects avant-gardistes de la musique, il publia une série d'ouvrages dans lesquels il se penchait davantage sur la psychologie de l'écoute plutôt que sur une tradition musicale spécifique. Après avoir quitté la radio en 1987, il organisa des ateliers et donna des conférences. Le jazz occupant une place moins centrale dans sa vie, il vendit sa collection de disques, de livres et de documents relatifs au jazz à la ville de Darmstadt, en Allemagne, où elle devait bientôt devenir la base du Jazzinstitut Darmstadt.

Son dernier livre, *There is No Way but to Go,* fut publié en 1999. Le 3 février 2000, alors qu'il sortait d'une lecture de cet ouvrage, il fut renversé par une voiture en traversant une rue d'Hambourg. Il mourut le lendemain des suites de ses blessures. Sa contribution au jazz jouit aujourd'hui d'une reconnaissance internationale.

Wolfram Knauer

BIOGRAFIEN

William Claxton

Above / Opposite A contact sheet of photographs taken of Joe Berendt and me by my bride Peggy on a rooftop overlooking New York City.

Ci-dessus / Ci-contre Une planche contact des clichés pris par ma fiancée Peggy de Joe Berendt et de moi, New York.

Oben / Gegenüber Kontaktabzüge der Aufnahmen, die meine Braut Peggy von Joe Berendt und mir auf einer Dachterrasse mit Blick über New York City gemacht hat.

William Claxton, in Südkalifornien geboren und aufgewachsen, nimmt in der Geschichte der amerikanischen Fotografie einen besonderen Platz ein. Seit seinen frühesten Aufnahmen in den 1950er Jahren hat er Bilder geschaffen, die mit ihrer intimen, beseelten Atmosphäre die Aufmerksamkeit auf sich ziehen. Claxton, dessen einfühlsamer und poetischer Stil stets Beachtung fand, gilt seit langem als herausragender Fotograf der Jazzmusik. Seine Aufnahmen aus der Jazzszene schmücken seit über fünf Jahrzehnten die Covers von zahllosen Schallplattenalben und Zeitschriften.

1952, noch während seines Studiums an der University of California in Los Angeles, machte Claxton die ersten Aufnahmen von einem jungen und damals noch unbekannten Trompeter namens Chet Baker. Die Bildersammlung, die das Ergebnis dieser Fotosessions war, ist in der ganzen Welt der Jazzmusik bekannt geworden. Die Fotografien, mit denen Claxton den kometenhaften Aufstieg des Trompeters zum Ruhm und seinen ebenso dramatischen Niedergang begleitete, gelten in weiten Kreisen als Zeugnisse, die Bakers Erfolge in seinen Anfängen dokumentieren und gleichzeitig sein posthumes Vermächtnis darstellen.

Seit Beginn seiner Karriere – als Fotograf für *LIFE*, *Paris Match*, *Vogue* und andere Magazine – hat Claxton mit vielen Hollywoodgrößen zusammengearbeitet und mit ihnen Freundschaft geschlossen. Seine sehr persönlichen Aufnahmen von Frank Sinatra, Marlene Dietrich, Steve McQueen und Judy Garland führen auf einprägsame Weise die intimen Momente vor Augen, die er diesen in ihre Privatsphäre verkapselten Persönlichkeiten entlockt hat. Claxton, der auch in der Schallplattenbranche kein Unbekannter ist, gehört zu den Begründern der Recording Academy (vormals National Academy of Recording Arts & Science – NARAS), die den Grammy vergibt. 2003 wurde ihm von der IPA (International Photography Awards) der begehrte Lucie Award zuerkannt.

In den 1960er Jahren schuf Claxton gemeinsam mit seiner Frau Peggy Moffitt, die sich als Model einen Namen gemacht hat, eine überwältigende Fotoserie mit Aufnahmen der revolutionären Kollektionen des Modeschöpfers Rudi Gernreich, die zum Kultsymbol geworden sind. Ein Film aus dieser Zeit, *Basic Black*, der unter der Regie von William Claxton entstand, gilt als Vorläufer des »Modevideos« und befindet sich jetzt in der Sammlung des Museum of Modern Art in New York. Bis auf den heutigen Tag werden die Bilder des Teams Claxton, Moffitt und Gernreich als meisterhafte Beispiele des modernen Stils gerühmt.

William Claxton, der dreizehn Bücher veröffentlicht und seine Arbeiten in zahlreichen Ausstellungen gezeigt hat, verfügt über eine Fangemeinde in der ganzen Welt. Er lebt mit seiner Frau und Partnerin Peggy Moffitt in Beverly Hills. Ihr Sohn Christopher verwaltet das Fotoarchiv.

Steve Crist

Joachim E. Berendt

In Deutschland wurde er der »Jazzpapst« genannt, und tatsächlich war Joachim-Ernst Berendt in der deutschen Jazzszene über fünfzig Jahre lang der einflussreichste Nicht-Musiker.

Berendt wurde am 20. Juli 1922 in Berlin geboren und kam Mitte der 1930er Jahre mit dem Jazz in Kontakt. Sein Vater war ein evangelischer Pfarrer, der im Widerstand gegen das Hitlerregime kämpfte und im Konzentrationslager Dachau starb. Von 1942 bis 1945 diente Berendt in der Wehrmacht und verbrachte nach dem Krieg einige Zeit in Gefangenenlagern. 1946 kehrte er nach Baden-Baden zurück und gehörte dort zu den Mitbegründern des Südwestfunks. Seit seinen Anfängen bei diesem Sender produzierte er Jazzsendungen, für die er seine eigene umfangreiche Schallplattensammlung und Material aus den Rundfunkarchiven in Berlin und Paris benutzte. Er wurde schließlich Leiter der Jazzredaktion beim SWF und Vorbild für viele andere deutsche Rundfunkanstalten, die ihre Jazzabteilungen nach dem Baden-Badener Modell organisierten. Während seiner Zeit beim Südwestfunk produzierte er Tausende von Rundfunk- und Fernsehsendungen, dazu über 250 Schallplatten, von denen viele auf dem Label SABA/MPS erschienen.

1953 veröffentlichte Berendt *Das Jazzbuch*. Das Werk wurde in über achtzehn Sprachen übersetzt, im Laufe der Jahre immer wieder aktualisiert und ist mit einer Auflage von insgesamt über 1,5 Millionen Exemplaren das weltweit erfolgreichste Buch über die Geschichte des Jazz geworden. Über fünfzig Jahre lang blieb es für Jazzfreunde die erste Informationsquelle über die Entwicklung und das ästhetische Konzept des Jazz.

1960 unternahm Berendt mit dem Fotografen William Claxton eine Reise durch die USA, um für das grundlegende Werk *JAZZLIFE*, das die amerikanische Jazzszene dokumentieren sollte, Material zu sammeln. Das Buch erschien 1961 und ist inzwischen ein sehr begehrtes Sammlerstück. Der vorliegende Band, erschienen im TASCHEN Verlag, ist eine überarbeitete und gekürzte Ausgabe. Berendt machte sich angesichts der Entwicklung, die der Jazz in den 1970er Jahren nahm, immer weniger Illusionen. Da ihn die avantgardistischen Aspekte in der Musik schon immer interessiert hatten, veröffentlichte er eine Reihe von Büchern, in denen er sich statt mit einer bestimmten musikalischen Tradition vor allem mit der Psychologie des Hörens befasste. Nach seinem Abschied vom Rundfunk 1987 veranstaltete Berendt Seminare und hielt Vorträge. Da der Jazz in seinem Leben nun eine weniger zentrale Bedeutung einnahm, verkaufte er seine Jazzsammlung mit Schallplatten, Büchern und Dokumenten an die Stadt Darmstadt, wo sie bald den Grundstock bildete für das Jazzinstitut Darmstadt.

Berendts letztes Buch *Es gibt keinen Weg. Nur gehen* erschien 1999. Auf dem Weg zu einer Lesung aus diesem Buch in Hamburg wurde er am 3. Februar 2000 beim Überqueren der Straße von einem Auto erfasst und erlag am nächsten Tag seinen Verletzungen. Seine Verdienste um den Jazz finden bis heute weltweit Anerkennung.

Wolfram Knauer

INDEX

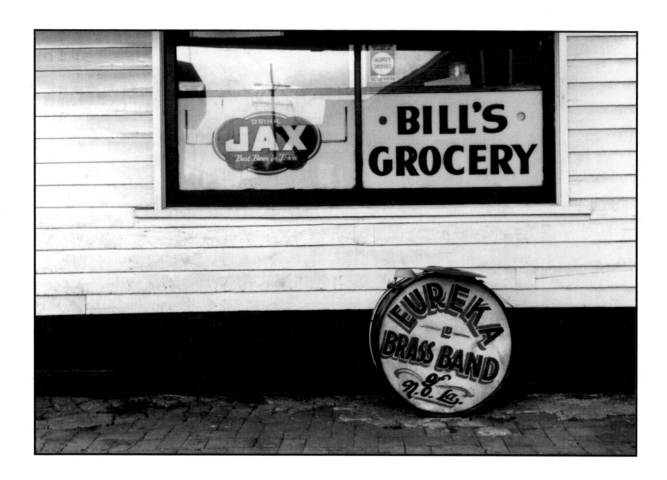

To stay informed about upcoming TASCHEN titles, please request our magazine at www.taschen.com/magazine or write to TASCHEN, Hohenzollernring 53, D–50672 Cologne, Germany, contact@taschen.com, Fax: +49-221-254919. We will be happy to send you a free copy of our magazine which is filled with information about all of our books.

© 2006 TASCHEN GmbH
Hohenzollernring 53, D-50672 Köln
www.taschen.com

All photographs © 2006 William Claxton
Foreword and text © 2006 William Claxton
www.williamclaxton.com

Photo editor & sequencing: Peggy Moffitt, Los Angeles
Editorial coordination: Ethel Seno, Los Angeles, Viktoria Hausmann, Cologne
Production: Stefan Klatte, Cologne
Translation from German to English: James Gussen, Somerville, Massachusetts
Translation from English to French: Philippe Safavi, Paris
Translation of English foreword to German: Gudrun Meier, Glinde

Printed in Spain
ISBN-13: 978-3-8228-1180-1
ISBN-10: 3-8228-1180-7